Muslims in the Western Imagination

Muslims in the Western Imagination

SOPHIA ROSE ARJANA

OXFORD
UNIVERSITY PRESS

OXFORD
UNIVERSITY PRESS

Oxford University Press is a department of the University of
Oxford. It furthers the University's objective of excellence in research,
scholarship, and education by publishing worldwide.

Oxford New York
Auckland Cape Town Dar es Salaam Hong Kong Karachi
Kuala Lumpur Madrid Melbourne Mexico City Nairobi
New Delhi Shanghai Taipei Toronto

With offices in
Argentina Austria Brazil Chile Czech Republic France Greece
Guatemala Hungary Italy Japan Poland Portugal Singapore
South Korea Switzerland Thailand Turkey Ukraine Vietnam

Oxford is a registered trademark of Oxford University Press
in the UK and certain other countries.

Published in the United States of America by
Oxford University Press
198 Madison Avenue, New York, NY 10016

Library of Congress Cataloging-in-Publication Data
Arjana, Sophia Rose.
Muslims in the Western imagination / Sophia Rose Arjana.
pages cm
Includes bibliographical references and index.
ISBN 978–0–19–932492–7 (hardcover : alk. paper)—ISBN 978–0–19–932493–4 (ebook)—
ISBN 978–0–19–932494–1 (ebook) 1. Islamophobia. 2. East and West. 3. Muslims—
Public opinion. I. Title.
BP52.S43 2015
305.6'97091821—dc23
2014011529

1 3 5 7 9 8 6 4 2
Printed in the United States of America
on acid-free paper

For Trayvon Martin and all victims of an imagination run riot.

We should never reduce the Other to our enemy, to the bearer of false knowledge, and so forth: always within him or her there is the Absolute of the impenetrable abyss of another person.

—SLAVOJ ZIZEK

Somehow we must be able to share each other's past in order to be knowingly in each other's present.

—JOHANNES FABIAN

Contents

Acknowledgements

SIX YEARS AGO I was formulating a dissertation topic focused on the dehumanization of Muslim men. With the help of several individuals, including Mark George, Pamela Eisenbaum, and Frank Seeburger, I settled on the subject of Muslim monsters. Through many conversations and edits, two complete rewrites of a large corpus of research, and many late nights, I have had the support of many colleagues, fellow scholars, students, friends, and family, all of whom I would like to thank here.

Books are a collaborative effort. Oxford University Press has provided support, feedback, and criticism at crucial stages in this project, for which I am grateful. My friend and editor Jean Charney deserves thanks for her countless pages of edits, notes, and suggestions. Friends and colleagues, in particular Julie Todd, Kelly Arora, R.J. Hernandez-Diaz, and Aaron Conley also gave me valuable feedback. My students, especially the cohort that graduated from Iliff School of Theology in 2014, offered endless encouragement, a gift for which I am thankful. The most important of these academic voices, however, is my colleague Jacob Kinnard, who deserves abundant credit and thanks for his patient reading, meticulous comments, and unwavering support on this project in its early stages. Finally, my husband and best friend, Bayu Arjana, has been a source of encouragement in the last stages of this book, showing kindness and grace through many months and countless hours of research, writing, and editing. To him and our children I am forever grateful.

Sophia R. Arjana
Iliff School of Theology

Muslims in the Western Imagination

Introduction

ISLAM IN THE WESTERN IMAGINATION

THIS BOOK ASKS the critical question, how did we get here, to this place of *hijab* bans and outlawed minarets, secret renditions of enemy combatants, Abu Ghraib, and GTMO? It is not simply a result of September 11, 2001, Madrid 2004, or London 2005, nor a culmination of events of the past decade or the past century. Terrorist attacks, wars in Iraq and Afghanistan, the increased movement of Muslim immigrants into northern and western Europe, and the visibility of Islam in general have contributed to a voicing of "the Muslim problem." However, these concerns represent old anxieties that lie within a multiplicity of times and spaces on the pages of manuscripts and canvases of paintings, in works of great drama, poetry, and fiction, within travel diaries and government documents, and on the screens of movie theaters. To find the answer to the question posed here, we must look at numerous fields of cultural production; there, we find a vision of Islam that is both familiar and unsettling. Within it, we must seek what is common. What is common is the Muslim monster.

The history of monsters is a subject addressed in several disciplines, among them history, theology, and religious studies. In this study, I will argue that imaginary Muslim monsters have determined the construction of the Muslim in Western thought. At times, these constructions have involved fantasies about Jewish and African bodies; at other times, they have reacted to anxieties surrounding categories beyond race—in particular, those related to religion, gender, and sexuality. To be clear, I am interested here in raising an awareness of these creatures—demons, giants, cannibals, vampires, zombies, and other monsters—that can help

us understand the status of Muslims today as stock characters in the Western imaginary landscape. The character of the homicidal terroristic Muslim stalks the Western social imaginary in print media, television, and film, but he has ancestors.

Muslim men are so dehumanized that since 9/11 they have become less than zero, an example of Agamben's "bare life," reduced to bodies held indefinitely, stripped of all legal rights afforded under US domestic and international law, force-fed like animals.[1] The stripping of identity, displays of sadomasochism and other sexual fantasies, and the manipulation of multiple bodies through hooding and piles of naked bodies are examples of biopower (the technology of power that manages human bodies). These acts recall terrible visions embedded in our collective historical memory, including "genocidal mass executions and graves."[2] Such crimes are not explained simply by the culture of the military industrial establishment. They are also an effect of fantasies about Muslims as non-human— fantasies that have spanned the ages.

An imperative point regarding the vocabulary used in this study is that the history of Muslim monsters is distinguished from what we think of as "Islamophobia," the particularistic attitude toward Muslims that scholars have often described as an aversion to or "anxiety of Islam."[3] Much of the scholarship has argued that contemporary Islamophobia is situated in political neoliberalism and the vision of the world it wishes to create, seen perhaps most vividly in the political discourse surrounding the attacks of September 11, 2001, and the War on Terror, which highlighted the Good Muslim/Bad Muslim trope by suggesting that any opposition to American militarism was tantamount to supporting the enemy.[4] I am concerned here with the West's *imaginaire* of Islam: the idea of the Muslim as a frightening adversary, an outside enemy that doesn't belong in modernity, who, due to an intrinsic alterity, must be excluded from the American and European landscapes.

Political Islamophobia, as represented by the image of veiled (*niqabi*) women disrupting the pristine, white, Christian Swiss countryside, is a recent phenomenon. In contrast, the characters documented in this study contribute to the construction of Muslims as uncivilized, hyper-violent permanent foreigners who, despite their global geographic distribution, ethnic and cultural diversity, and large numbers, are reduced and essentialized to a caricature of ridiculous proportions. Edward Said described this character as the "camel-riding, terroristic, hook-nosed, venal lecher."[5] Although human, he shares the banality and evil of Muslim monsters

from the past. Muslims are the monsters of the present, phantasms that result from an imaginary Islam that has been shaped over many centuries.

A serious concern of this study is the relationship between imaginary characters and living human beings. The sexual nature of many of the crimes committed at Abu Ghraib, images of which are now familiar— human pyramids of naked bodies, prisoners on dog leashes, the gratified smiles of the captors—aid in the process of dehumanization. Sexual imagery has been an integral part of Western discourse about Muslims from the beginning, from tales of Prophet Muhammad's unending supplies of sexual energy to the necrophilia associated with the character of Dracula. In Abu Ghraib, these fantasies were played out on real bodies, helping to excommunicate Muslims from the human community. As one scholar put it, "sexualized torture evicts Arabs from the community of men and from a common humanity."[6]

When we consider Muslim monsters as a corpus—a genealogy of images that are related, at times closely, and at times through several degrees of separation—it is evident that they contribute to the ways in which Muslims are conceptualized today—as interruptions that disturb normative humanity, civilization, and modernity. In sacred rituals that are public, such as the performance of prayer, Muslims represent a particularly irritating affront to liberalism. The pejorative statements made about Muslims in the public sphere are largely tolerated—a tolerance that is unthinkable for other communities. The dehumanization that occurs at the level of speech is carried further in fire bombings of mosques, verbal and physical attacks on *muhajabat* (Muslim women who veil), and other hate crimes. When unrestrained violence against Muslims is promoted and sanctioned by governments, as documented in cases of abuse and homicide at Abu Ghraib, Bagram Air Base, and Guantánamo Bay (GTMO), it makes more public abuses acceptable. The opposite is also true. Herein lies the central concern of these pages—that the imaginary violence perpetrated by Muslim monsters, as well as the figurative harm inflicted on these villainous characters, affects *real* Muslim bodies.

The task of documenting 1,300 years of Muslim characters is overwhelming in its scope, even when reduced to the subject of monsters. I have focused my analysis on a particular type of monster, one that is non-human or hybrid, male, and racialized (most of the monsters contained within this study are non-Anglo). Only a few white Muslim monsters, suffering from "the disease of Islam," are presented in this work. In these cases, anxieties surrounding religious and racial identity are

so pronounced that bodily structure alters, as in the cases of deformed Muslim infants magically transforming into beautiful, white babies when they rejoin the Church.

Chapter 1 discusses the parameters of this work and outlines the ways in which the category of monsters provides an important tool for understanding the history of Christian-Muslim relations. By looking at how monsters function in culture as a tableau onto which numerous fears and anxieties are placed, we can better understand their role in identity-formation. The period examined, roughly thirteen hundred years, suggests that monsters are not limited to pre-modernity, and that no one-to-one linkage exists between medieval creatures and those situated later, in the European Enlightenment, during the Orientalist heyday, or in the colonial American period. While the linkage may not be direct, many of the monsters covered in this study share similar characteristics to those that were first formulated in medieval times. These monsters *disturb the calm of white Christianity*, providing a standard contrary to normative humanity. In political discourse, Muslims continue to be framed as disturbances, assaulting Western civilization's ordered sensibilities. Islam is the kid who won't go along, exhibiting a "limitless pursuit of freedom, the illusion of an uncoerced interiority that can withstand the force of institutional disciplines."[7]

Chapter 2 provides the beginning of the genealogy that is laid out in this work. In order to understand why medieval Christians created Muslim monsters, it is necessary to first look at the ways in which community, identity, and epistemology functioned for the average man or woman living in Europe during the Middle Ages. Ideas about geography, race, morphology, and morality determined the monsters of the age, in part by limiting the human universe to a small territory such as the environs of Jerusalem, Rome, or another municipality, and in part by formulating a vision of identity that might be determined by anything from a hairstyle to skin color, as well as by viewing Christianity as *determinative* of normative humanity, while everything else existed as strange, foreign, and monstrous. Islam emerged at a time of uncertainty, doubt, and superstition, factors that contributed to the various mythologies about Muslims (often called Saracens) covered in this chapter, from narratives about Prophet Muhammad as an agent of the devil to tales of Arabs as a monstrous race from beyond the borders of the natural world.

Chapter 2 begins with the monsters found on the pages of medieval texts, the canvases of medieval psalters and paintings, and the many

stories that populated European imaginations in the nascent years of Islam and through the later Middle Ages. Of particular interest here are those creatures identified as Muslim/Saracen, African, and Jewish, or some combination thereof, pointing to two aspects of medieval sensibilities about the Other: first, that outsiders were often viewed as strange and terrifying, a trend that typically worsened with communities located far from the Christian center; and second, that the construction of Muslims as creatures was formulated to some degree by anxieties about Jews and Africans. Primarily, we see this in the Black Saracen—a dark-skinned, demonic, turban-wearing Christ-killer—and the *cynocephalus*, the dog-headed man who, in addition to howling, barking, and attacking Christians, was also depicted as the killer of Christ, cast as either a Jew or a Saracen or a hybrid of the two. These characters illustrate the ways in which numerous fears created *imaginative bodies*, bodies that justified the "crude treatment of those religious and ethnic others in any real-life confrontation."[8]

Chapter 3 transitions to the monsters that populated the Elizabethan Age, found in the great paintings of the Renaissance, two famous dramas by Marlowe and Shakespeare, tales of monstrous births, German stories of the Turkish East, and in a pastry that represents the dismembered body of a Muslim captive. Turkish characters appear in numerous Renaissance paintings that depict the crucifixion of Jesus or the martyrdom of a later saint, often alongside Jewish figures—a way of furthering the co-identification of Jews and Muslims popularized in medieval art. The overwhelming majority of these characters are Turkish, signaling a shift from Saracen/Arab and African characters to Turkish ones—evidence of European anxieties surrounding Ottoman power and a continued discomfort with Muslim bodies.

Although fewer in number, the monsters that followed the Elizabethan period often appeared in lands that Europeans wished to colonize. An example is the *croco-sapien*, the hybrid monster indigenous to the Nile River. In Chapter 4 particular attention is also given to Jewish-Muslim villains, many of which are situated in the discourse of Orientalism. I also examine how the wasteland, a landscape featured prominently in Orientalist poetry and drama, strongly influenced Gothic horror fiction, a genre of Romantic literature that includes numerous Oriental monsters, including a Moor named Zofloya and a Turkish vampire named Dracula. The dynamic quality of Gothic horror, with its resurrection of medievalism and Orientalist imagery, left an indelible mark on popular culture,

influencing European and North American writing, architecture, art, television, and motion pictures.

Chapter 5 shifts from Europe to the American continent. During the conquest of the Americas, Europeans claimed to observe all manner of monsters, some that resembled Plinian beasts and others that were described as devil-worshippers. The American Indians were described as Moors and their cities as New Cairo, evidence of the Maurophilia that occupied the European imagination. After the age of exploration, US settlers introduced a new category of Muslim monsters that came from the Barbary Coast, a re-emergence of the Black Saracen in new clothes, described as the "monsters of Africa." The Barbary monsters became stock characters in political discourse, adventure fiction, board games, and later, cinema, helping to establish Islam as a foreign religion that was initially connected to hatred against Africans and, later, African-Americans.

The remainder of Chapter 5 examines the Muslim monsters of film, including vampires, mummies, giants, aliens, and zombies. I discuss the presence of Orientalism in science fiction and other genres, a practice that has contributed to the vision of the East as a mysterious, distant, and dangerous space. In particular, I focus my attention on Dracula's Jewish and Muslim attributes and the relationship between Orientalism, mummies, and zombies.

Chapter 6 examines the ways in which later zombie films represent apocalyptic visions inspired in part by the events of September 11, 2001. Movies provided a vehicle for Muslim monsters to be displayed, and, I would argue, they continue to serve as the most dominant cultural force in the modern American milieu—a space in which Muslim monsters continue to be generated. The final chapter of this work also provides a broad discussion of the ways in which the violent discourse about Muslims affects the disciplinary practices imbedded in subcultures within the United States, including the military industrial establishment. Indeed, the fantasies documented in earlier chapters are played out on the bodies of Muslims at sites where "imperial racism, sexuality, and gender catastrophically collide."[9] These locations—Abu Ghraib, Bagram Air Base, GTMO—function as spaces in which the fantasies of Muslims as non-human are played out on real bodies. The crimes committed at Abu Ghraib and at other sites, despite their description as aberrations ("a few bad apples"), result from the historical continuities displayed in anti-Muslim discourse that features an imagery of horror and death.[10]

There are a number of ways in which one might voice objections to the argument that fantasies of Muslim monsters constitute the current *imaginaire* about Islam. One objection is the presence of non-monstrous Muslim characters, including the existence of a few positive Muslim representations of Muslim historical figures in European history, such as Salahuddin.[11] The positive and even romantic treatments of Muslims are, however, trivial when considered alongside the grand narrative about Islam, an overwhelmingly negative and dehumanizing treatment that has its origins in the Middle Ages, sees its development in pre-modernity, and is cemented into the Western consciousness through colonialism and Orientalism. In photos from Abu Ghraib, testimony from soldiers in Afghanistan and Iraq, and images from GTMO, where the bodies of Muslims continue to be brutalized, we can see just how powerful this discourse is.

Another objection that might be raised is that these images have only been seen, read, or digested by a few, and thus cannot exist as a powerful force in the construction of knowledge about Islam. This is countered by two facts: first, the large number of Muslim monsters found across numerous fields of cultural production and the disparate locations in which they function as social, literary, artistic, and filmic characters. Second, negative feelings are voiced by high numbers of non-Muslims against Islam and its followers. For example, European attitudes toward Muslims are far worse than attitudes toward other immigrants, a situation that is amplified in most eastern European states.[12]

Fantasies about Muslims are convincing. Muslim men are viewed as terroristic villains, despite the fact that statistically, an infinitesimally small number of Muslims participate in violent political acts. These representations matter; if they did not, we would not have "the Muslim problem," a phrase that American news host Bill O' Reilly uses to describe the existence of Muslims as a pestilence, a biblical descriptor that has anti-Semitic resonances of "the Jewish problem" and suggests that a solution must be found.

I want to change the question from "Why do they hate us?" and ask instead, "Why do we fear them?" This requires an examination of the ways in which Islam was first constructed, and the ways in which these early characters established a fantasy that has been difficult to let go of. However, before doing this work, I first need to establish the parameters, definitions, and methodology of this work, and this is the task of Chapter 1.

I

The Muslim Monster

The Muslim of Orientalism

Orientalism refers to many things—a colonial language, a system of classification, an artistic movement, an academic discipline, and an attitude about the world. Orientalism is important for the purposes of this study because it substantiates the Western *imaginaire* about Islam. It is, however, differentiated from the anti-Muslim discourse examined in the first half of this study and from Islamophobia, a generalized anxiety about Islam and Muslims. Orientalism is the vehicle through which the symbols and images generated by these various ideologies are delivered and through which the ludicrous is rendered believable. Orientalism did not invent Muslim monsters, but it helps to sustain their authenticity through an ideological system in which anything—orgasmic harems, flying carpets, fantastic and magical creatures—is possible.

The academic study of Islam began with the age of Orientalism in the eighteenth century and was deeply imbedded in the unabashed white male supremacy of eighteenth- and nineteenth-century colonialism that is still evident in discourse about Islam. Earlier studies of Prophet Muhammad were largely polemical, neglecting to include any Muslim sources and offering little biographical detail.[1] Enlightenment treatments of Islam typically rejected theological perspectives on Islam and instead offered romantic treatments of Islam as a civilized and reasonable tradition and cast Prophet Muhammad as a visionary philosopher. Yet these efforts to humanize Islam would hardly qualify as academic treatments.[2] It was not until the advent of Orientalism that Arabic, Turkish, Persian, and other relevant languages were included as a foundation of academic studies on Islam. Orientalism, situated in the textual studies

that dominated Protestant academia, established itself as the discipline that studies the Orient and all that it contained—its cultures, peoples, languages, customs, artistic traditions, and histories. Because the Oriental was deemed incapable of serious thought, only the European or American scholar could do this work. After all, the Orient was created by and for the West, and under this system, "objects are what they are *because* they are what they are, for once, for all time, for ontological reasons that no empirical material can either dislodge or alter."[3] No wonder the fantasies of the East have been so difficult to dismantle.

Homo islamicus (the "Islamic man") and "the Muslim mind" are examples of the fictions that established Occidental superiority. Texts served as the foundation of early Orientalist scholarship. "The essential characteristics of the members of the subspecies could be identified by the use of philological methods to study certain key texts which were regarded as embodying the core principles of Islamic civilization."[4] Such a process established the Muslim as a subject, rather than a human individual, formulating a character stuck in arrested development and incapable, unlike the white man, of adapting to modernity. This allowed the placement of Muslims in a time and space removed from the West's normative human community, which had progressed forward, unlike the legions stuck in the Islamic world.

The concept of environmental determinism, the idea that one's natural surroundings determined his or her entire being, also played a significant role in the formation of Orientalist Muslim characters. The static, backward Muslim was often seen a product of the desert environment, a mysterious and frightening landscape. In the genre of romantic Orientalism, this was illustrated in the wild, unrestrained behavior exhibited by Muslim villains, characters who often resembled their monstrous relatives of the past.

From the beginning, Orientalism has been committed to political projects that require the dehumanization of Muslims, especially Muslim men, who have been "linked to elements in Western society (delinquents, the insane, women, the poor) sharing an identity best described as lamentably alien."[5] In addition to alienating Muslims from the human community, these mythologies have helped to validate numerous colonial and imperial adventures.[6] Orientalist fantasies continue to sustain a vision that insists upon Western supremacy and everyone else's inferiority—a useful paradigm in a neocolonial world.[7] The same delusions have contributed to the ideological alienation of Muslims from normativity, leading to the

ways in which Muslims are seen today, as characters in a story the West has created about itself. The Orient, like the Western-created category called *mysticism*, which is often employed to describe "good Muslims" (i.e., Sufis and secularists), is a concept both "uncompromisingly Western and Christian."[8] Both the Orient and the Muslim exist in the mind of the West, bearing little semblance to reality.

In the eighteenth and nineteenth centuries, Europeans and Americans who visited Egypt, the Holy Land, or elsewhere in the region often experienced the chasm between their reality and fiction, while clinging to some part of the *imaginaire* about the East. During his travels in Egypt and the Holy Land in 1836, American traveler John Lloyd Stephens wrote,

> One by one I had seen the many illusions of my waking dreams fade away; the gorgeous pictures of Oriental scenes melt into nothing; but I still clung to the primitive simplicity and purity of the children of the desert; their temperament and abstinence, their contented poverty and contempt for luxuries, as approaching the true nobility of man's nature and sustaining the poetry of the "land of the East."[9]

Like other Europeans and Americans, he expressed a vision of a romanticized East inhabited by childlike, simplistic, and violent Arabs, Turks, and Imazighen.[10] In the twentieth and twenty-first centuries, this Orientalist vision has continued to have currency. The average person continues to hold visions of "the East," "the Orient," and "Muslims" that are situated in these old constructions. It is no wonder, given the constant stream of Orientalism and Islamophobia available in print media, television, and movies. The portrayal of Muslims as the antithesis of good Americans is not only common—it is the norm.

Orientalism continues to have political utility. When not vilified, Muslims are infantilized and feminized, much as they were in the past, described as a mass of children terrorized by violent men who can only be stopped with an extreme show of military strength through invasions, bombing campaigns, and drones.

> In Bush Junior's discourse, the "Oriental Other" was either emphasized as feminine and infantile (Afghan and Iraqi men, women, and children) or barbaric, beastly, and toxically masculine (al Qaida, Osama bin Laden, the Taliban, and Saddam Hussein). Thus, once

again both "Others" embodied qualities maintaining an essential gendered *inability* for self-determination. Bush Junior, like his father, was discursively constructed as the sole player granted agency in the international arena: The toxic masculine villains were creatures of nature who simply acted through bodily impulses rather than through rational and strategic logic and thus had to be controlled by Bush Junior. Afghan and Iraqi men, women, and children likewise were "passive *captive* things"—the metaphorical victims—whose fate was determined solely by the rescue and continued guidance of Bush Junior.[11]

The "toxically masculine" Muslim man is a character founded in the mythologies explored in this study.

For centuries, Muslim men have been characterized as monstrous beings, exhibiting many of the qualities portrayed by contemporary Orientalism. The idea that *all* Muslim men are naturally violent—blowing up buildings, planes, and markets, and willingly killing themselves in the process—is often explained as an innate Islamic impulse, a product of race, ethnicity, or religious impulse, at times cast as an "Islamic rage" that emerges from sexual repression and frustration.[12]

Muslims are surrounded with fictions that would be considered obscene if applied to other social groups, but through Orientalism, they are validated. The Slovenian philosopher Slavoj Zizek cautions against this "ideological constellation" that attributes "to the Other the naïve belief we are unable to sustain, transforming him or her into a 'subject supposed to believe.' "[13] Characterizations of Islam as a "violent religion" whose followers are naturally violent go against the statistical realities revealed when one measures the miniscule numbers of Muslims who participate in terrorism. It also legitimizes state violence, a point that William Cavanaugh and others have demonstrated in their work.[14]

Fantasies of both the Orient and Oriental tend to be strongly sensualized, situated in medieval ideas about the East and typified in portrayals of Muslim monsters. Male Muslim monsters are typically hyper-masculine—aggressive, overly sexual, and violent—characters that also function as tableaux of desire and fantasy. Descriptions of Oriental landscapes utilize a gendered vocabulary in which the land is romanced, conquered, and *penetrated*, like the symbolic "unveiling" of Muslim women, an act that has been linked to the rape fantasies of colonizing men.[15] The bulk of studies on desiring the Muslim Other are focused on

the male gaze and its fixation on Oriental females, harems, veils, and the like.[16] However, other Muslim characters, including the monsters examined here, are also repositories of Western desires and fantasies.[17] These fantasies range from the bestiality associated with medieval monsters like the *cynocephalus* to the homoeroticism and necrophilia evident in Gothic characters like Vathek and Dracula. In the modern age, the desire for Muslim boys and men is evident in studies of gay tourism, when Western men "travel to Arab countries to fulfill their desires for Arabs."[18] Tunisia and other "Eastern" locales are popular with expats and tourists seeking "Eastern pleasures," illustrating the continuing power of these fantasies in the Western imagination.[19] Like fantasies of the eroticized East, Muslim monsters function as a vital part of *imaginaire* about Islam. How exactly do we define these monsters that occupy the Western imagination?

Delineating the Monster

Monsters serve an important function in the construction of identity as characters against which we define ourselves, our normative behaviors and customs, and the larger community in which we live. This study is a *teratology of Islam*—a study of Muslim monsters: "Teratology thus makes possible a critical purchase on the processes of definition and exclusion by which the boundaries of what it means to be (authentically) human are drawn. What we are seeing is not essentialist doctrines of 'human nature' therefore, but the discourses and devices by which they are articulated. For every assertion of the definitively 'human' there is a refracted 'other'—the almost human, the monster, the alien—who shows the workings of the principles by which normative and exemplary humanity is defined."[20]

The creation of monsters is a political act, and monsters are political creatures. Each of the monsters examined in the following chapters emerged from a particular social milieu in which Jews, Africans, Arabs, Turks, Moors, women, homosexuals, and other subalterns were feared, desired, disliked, vilified, and, in some cases, exterminated—both imaginatively and in the real world. The creation of these monsters was a way to deal with unwanted communities, exemplifying Girard's notion of religious scapegoating, in which "[t]he victims are either expelled or destroyed. . . [in a] process of exclusion [based on] religious beliefs and practices."[21] In the cases examined here, whether communicated with the

printed word, on canvas, or in film, the monster is often expelled from the society he violates. By dehumanizing the Muslim as a dangerous monster, one can justify the extermination of this threat.

Medieval monsters were created along the contours of the Classical imagination, which is why we find early Muslims, often called Saracens, depicted alongside Plinian creatures including Blemmyae, Amazons, Cyclops, Panotii, and Ephiphagus, creatures that often regenerated as new monsters in the modern period. One example is the *cynocephalus*, a dog-headed man that dates from the Classical period and was identified as a Jewish *and* Muslim monster in the Middle Ages. Medieval Muslim monsters were often located in faraway lands, a strategy that helped identify Christians with the lands they themselves occupied and further identified these lands as not controlled by the foreign creatures who dwelled nearby.[22] Jews, Europe's internal enemies, were often conflated with Saracens and other foreigners despite their location within, or on the edges of, European communities. Identity was often shaped by ethnogenesis—a sense of origins situated in a limited understanding of geography that dominated much of the Middle Ages. Mythologies of a Jewish-Muslim conspiracy against Christendom abounded in claims of Jewish mosques and Muslim synagogues, in the paintings of Jews and Saracens crucifying the Son of God, and in plays depicting Christian narratives, including the Crucifixion and the Assumption of Mary, that were performed through the end of the Renaissance. Although these depictions do not represent monsters, they are included because of their contribution to the idea of the Muslim as a monstrous character.

The differences between pre-modern and modern monsters are numerous, and in some ways can be understood best through the series of transformations that occur in modernity. Charles Taylor has described this as a transition between enchantment and disenchantment, "the shift from symbol to mechanism."[23] Modernity's encounter with monsters profoundly changed the way these creatures function, through "Gothic mobility."[24] In pre-modernity, monsters—whether located inside or outside a territory's borders—were often restricted to the spaces that exist beyond the borders of a community or the "natural world." On medieval maps, the Plinian monstrous races are located in a region that lies south of Africa. Jewish monsters were often shown occupying areas near Christian communities. In one image, a Jew Dragon is shown in an underground dwelling representing hell, just below the earth. In contrast, Christian

encounters with Saracens often took place in Muslim territories, evil places where the sun was absent and every rock and stone was black.

Modernity altered the limits placed on the monster in more ways that one. Gothicism introduced adaptability—making the monster capable of transmogrifying into a variety of forms. Metamorphosis is symbolic of the creature's ability to move across land and water. The changing of one's body, seen in numerous Gothic texts, is a signifier of the genre's "movement across diverse geographical spaces."[25] Gothic mobility also granted monsters the ability to infect humans, increasing their sphere of influence, acts that were symbolic of European anxieties about racial purity. The early vampires featured in Le Fanu's *Carmilla* and Stoker's *Dracula* infect the European through biting, causing illness, conversion to monsterdom, and in some cases, death.[26] In these stories, Gothic monsters often attack white bodies, corrupting bloodlines, and causing bodily disintegration and decay.[27] When Dracula enters England, he violates both the nation's borders and English bloodlines. The threat of foreign infection is represented both in the disruption of bodies that turn monstrous as well as the possibility that Dracula's progeny will be carried on in Mina, whose child may be a hybrid monster. The theme of miscegenation is common in modern tales of Muslim monsters, much as they are in the Middle Ages and Renaissance.

Presently monsters seem to be everywhere, featured in children's cartoons and movies, in vampire and zombie films and television series, even invoked by Lady Gaga's "Little Monsters," the pet name for her legions of fans. Classifying this large category of characters—as humans, freaks, or creatures—is challenging. Monsters have a "protean" character, "changing from period to period as society's basic fears clothe themselves in fashionable or immediately accessible garments."[28] How, then, do we define the Muslim monster? The anthropologist David Gilmore has found that monsters often exhibit a set of common features, "great size and/ or remarkable strength; a prominent mouth with fangs or some other means of facilitating predation of humans; an urge to consume human flesh and/or blood; and hybridism, for they often combine human and animal features, or mix living and dead tissue, or manifest amalgams of discordant parts of various organisms."[29] Medieval, Renaissance, and Gothic monsters often exhibit these characteristics, but what about other Muslim monsters?

This study includes Muslim monsters that don't fit Gilmore's definition. For example, medieval and early modern representations of

historical characters are included when they are fantastic and fictionalized forms of the original person. These include representations of Prophet Muhammad as a demon and the image of Saladin with an avatar of Satan flying out of his mouth—seen in Matthew Paris's *Death of Saladin*, where a blackbird is shown exiting Saladin's mouth, "symbolizing his wicked soul" (Figure 1.1).[30]

The origins of the blackbird as a symbol of Satan are found in a popular story about St. Benedict: "Legend relates one day, while St. Benedict was at prayer, the Devil appeared to him in the form of a blackbird, seeking to divert his attention away from his devotions."[31] Here, Saladin is an example of a corrupted human. Such negative depictions of Muslim historical figures are included in this study only when a particular representation casts the individual as something un-human.[32]

The majority of monsters examined in this study are defined by the "toxic" masculinity pointed to earlier. Muslim monsters are not just masculine—they are outrageously so, with superhuman sexual powers, an otherworldly kind of strength, and an unfathomable propensity for violence. A few female monsters are included, but they are scarce when compared to the overwhelming number of romanticized female Muslim characters in the literature.[33] Like all monsters, the female characters included here—cannibalistic Saracens, vampires, and others—vary considerably depending on the anxiety in force, although the overwhelming majority of female Muslim monsters are cast as sexually toxic.

FIGURE 1.1 Death of Saladin. Matthew Paris, *Chronica Maiora*. England, ca. 1240–1255. Corpus Christi College, MS 16, ll, f. 13v.

Genealogy, Episteme, Habitus, and Doxa

The monster is a protean character. "The body that scares and appalls changes over time, as do the individual characteristics that add up to monstrosity, as do the preferred interpretations of monstrosity."[34] The Muslim monsters of the Middle Ages are not the same creatures featured in post-apocalyptic zombie films, even those that exhibit post-9/11 imagery. For this reason, monsters need to be seen as symbols of particular fears or anxieties. These creatures emerge from a particular milieu: "Monsters must be examined within the intricate matrix of relations (social, cultural, and literary-historical) which generate them. A mixed category, the monster resists any classification built on hierarchy."[35] Then the question becomes—how does one study a mixed category?

Muslim monsters take on numerous characteristics, some of which are disguised. Foucault's method of genealogical critique seeks to "disrupt fixed and essentialized accounts of the human subject," revealing what is hidden.[36] Genealogy not only seeks to reveal what is hidden, it shows how ideas of normativity are often situated in notions of alterity. Muslim monsters are examples of these signs of difference. Foucault's work examines how difference is encoded in institutions like the mental asylum and heterosexuality, both of which discipline the body through a system of knowledge that requires a bifurcation of normal/strange. Muslim monsters do this work as well, often through afflictions like gigantism, hypertrichosis, black or purple skin, and canine teeth. Like mental illness and non-normative sexuality, corruptions of the body are signs of abnormal humanity.

According to Foucault, *discourse* is composed of a series of statements and events that create an *archive*, and it is the job of the genealogist to uncover these archives and bring them into the light. One way to think of this book is as *an archive of Muslim monsters*. The unveiling of an archive can unsettle presumptions and challenge the way we think of the world, helping us to "search for new freedoms and new identities."[37] In Islamic language, this book is a *jihad*—an effort—to reveal Muslims as human beings instead of the phantasms they are often presented as.

Biopower—the definition, control, and punishment of the body through power—is a concern voiced repeatedly in Foucault's work. Muslim monsters are punished bodies. The body is open to all kinds of forces, so much so that it is a site of "perpetual disintegration."[38] In the case of Muslims, the body has been manipulated in numerous ways.

Foucault's argument that history exercises power on human bodies—and in some cases, invents subjects, including fantasies that are then attached to these bodies, called *phantasms*—helps us to understand why Muslim fictive bodies remain so powerful.

Pierre Bourdieu's notion of *habitus* complements Foucault's focus on the body as an instrument of power relations. Bourdieu defines the habitus as those "principles which generate and organize practices and representations that can be objectively adapted to their outcomes without presupposing a conscious aiming at ends or an express mastery of the operations necessary in order to attain them."[39] Habitus refers to the ideas and behaviors internalized by a given society, described as "the set of symbolically structured and socially inculcated dispositions of individual agents," which interact with *fields*, modes of cultural production that exist as a result of "symbolically mediated relations of domination."[40] In this study, I show how the fields of cultural production—literature, drama, art, cinema—helped to sustain a habitus about Islam that relies upon Muslim monsters.

Habitus never exists in isolation, but only in relation to the structured social space, which is determined by the *doxa*, the "shared cultural belief system on which *symbolic power*" rests.[41] Doxa underlies one's view of the world, which is of great importance in the production of imaginary Muslim monsters. For Bourdieu, symbolic power disguises the truth, masquerading what is really going on in the world of social relations, politics, and power. Power is a force that plays a significant role in the construction of the *imaginaire* about Muslim bodies. Bourdieu argues that power *produces constructed realities through the cultural material created and consumed by a social group*. In the Middle Ages, theologians, artists, and clergy created and responded to the *habitus*—a disposition that included a belief in angels, demons, and monstrous races—by satisfying the demands of the market. According to Bourdieu, this "space of literary or artistic position-takings" is determined by a "structured set of the manifestations of the social agents in the field," and it is the space in which literary and visual representations of Muslim monsters are produced.[42] We can see this today, in a market filled with anti-Muslim material, from books about the "Islamic threat" to the advent of "Terror TV," an entire genre of television shows that feature Muslim terrorists.

Foucault's *episteme* is the model for this study's historical approach. This book is organized in large historical periods—the Middle Ages, the Renaissance, the colonial period that intersects with Orientalism,

the Enlightenment and the Gothic, the age of exploration, the American colonial period, and the present. The episteme is a *code that determines how people understand and act within their world*, much like the doxa that underlies habitus.[43] Monsters must be examined within this milieu that generates them. To this end, in each chapter I identify the dominant forces in play to suggest why monsters emerge in the ways they do. It is my hope that this will help us gain a better understanding of the imaginary Muslim monster.

2

Medieval Muslim Monsters

I BEGIN THIS chapter by briefly discussing the category of history referred to as "the Middle Ages" as it relates to this work. A study that covers roughly 1,300 years offers an almost endless number of options for periodization.[1] This chapter covers the period coinciding with the beginnings of Islam up to the early Renaissance, for reasons that will become clear shortly. Historians, especially medievalists, have debated the start of the Middle Ages, marking it with the death of Theodosius in 395, the fall of the Western Empire in 476, and as late as the Muslim occupation of the Mediterranean in the seventh and eighth centuries.[2] Debates also surround the end of the medieval period, with some scholars equating it with the fall of Constantinople in 1453 and others with the European conquest of the Americas, beginning in 1492, or the year 1500 and the age of Humanism.[3]

In this study I look at the medieval period from the eighth century to the beginning of the Renaissance. I have chosen this periodization because early Christian reactions to Islam are situated in the eighth and ninth centuries, when we first see the emergence of Muslim monsters in the Christian imagination. Christian polemics, which often focused on Prophet Muhammad as the progenitor of a monstrous race of Saracens, among other things, are an important foundational source for later Muslim monsters. Most medieval Muslim monsters are of the Arab (Saracen), African, and Jewish variety, including the giant, man-eating Saracens of medieval romances and the Black Saracens, often shown in medieval art executing saints, harassing and killing Jesus, and murdering other Christian innocents. A shift in the racial/ethnic classification of Muslim monsters is not seen until the emergence of the Turks as a

world power in the fifteenth century, and I end the chapter at this point. To be clear, Arabs, Africans, and others are still cast as Muslim monsters after that time, but Turkish creatures join their ranks in high numbers. The anxieties surrounding the Ottomans are displayed in Shakespearean drama, the Turkish tales known collectively as *Turcica*, and the savory pie called the Turk's Head—a food that represents the consumption of Turkish flesh by a Christian soldier. These Turkish monsters are the focus of Chapter 3.

The central challenge with the cognomen "the Middle Ages" is that it constantly relates itself to the present.[4] This is why some scholars have suggested that medieval studies is a discipline caught in a colonial mind-set, that the medieval can never measure up to its offspring—the modern. Using "pre-modern" doesn't help with this issue because it also privileges modernity. The use of pre-modern "gives life only in anticipation of the modern, directing the period toward a telos of recognizability in the *now* that the pre-modern, as such, will always fail to satisfy."[5] The middle is invariably *stuck* between the Classical age and the Renaissance and the Enlightenment. Another critique of medieval studies is that its scholars have often taken a distanced view of the Middle Ages, which is "one of the primary sites by which it [Western historical consciousness] has consti-tuted itself."[6]

How does all of this relate to Muslim monsters? Medieval imagery is displayed in numerous post-medieval forms, even today. Medieval characters, themes, and narratives—the knight, the damsel, and the cru-sade—are seen in Gothic fiction, late modern architecture and art, sci-ence fiction and horror literature, and horror films. The monsters that continue to be popular today are situated in Gothic horror, a genre that resurrects medievalism while also employing Orientalism. At the very least, medievalism continues to have an aesthetic agency that has sur-vived into post-modernity.

Over the past 35 years, there has been a shift from seeing the medi-eval as the parent civilization of Western modernity to exposing a more "vivid and disturbing" Middle Ages.[7] One area of scholarship is medi-eval monster-making, seen in the work of medievalists and art histori-ans like Jeffrey Jerome Cohen, John Tolan, Michael Camille, and Debra Higgs Strickland. Whereas the Middle Ages is for some the foundation for modernity, for others it is viewed as "the quintessential 'other'" from which modernity differentiates itself.[8] One of the arguments I make, which is supported by this claim, is that medieval notions of alterity continue

to impact the ways in which the West thinks about Islam and her fol-
lowers. Nickolas Haydock calls this the *Saracen doxology*: "The medieval
portrait of the Saracen in general and of Mohammed in particular sur-
vives humanism, continues largely unabated through the Enlightenment,
gains renewed and altered vigor during the nineteenth-century revival of
chivalry and medievalism, and continues to surface unabashedly across
Western culture today."[9] The Middle Ages is the era in which anti-Muslim
rhetoric is founded, later to be resurrected by the Gothic movement and
sustained and legitimized by Orientalism.

How was Europe defined in the Middle Ages? Even when Europeans
have been pressed in recent years to define their borders, numerous
answers have emerged, from a Europe that excludes the Eastern regions
to a Europe that is situated in "the nineteenth century, an age that com-
bined the romantic political philosophies of Rousseau and Hegel with
'scientific' history and Indo-European philology to produce ethnic nation-
alism."[10] Medieval Europeans did not identify as belonging to a large
community. People living in a monastery or village did not think of them-
selves as *European*. Identity was situated in smaller spaces—the town,
city, or district. In other words, it was localized.

Medieval monsters were generally located along or beyond the borders
of Christian communities. Spaces outside the village, town, or city were
considered the domain of monsters, a convention seen today in horror
films, where monsters often occupy the hinterlands—the desert, forest, or
jungle.[11] On medieval maps (see Figure 2.1), Saracens are typically located
on the edges of Christian territory or beyond *the known world*, examples of
"boundary phenomena inseparable from their place at the territorial edge
and inside the symbolic structure."[12]

By the fourteenth century, this had changed with Ottoman incur-
sions in Bulgaria and Hungary. "Thus Islamic society was by no means
as distant as some Chaucerians have suggested, or as many late-medieval
Christians *might have wished it to be*."[13] At this point, miscegenation
and monstrous births became more prominent in stories of monstrous
Muslims, who were seen as having violated the boundaries of Christian
space.

In addition to geographical location, the other major factor in for-
mulating medieval identity was religion. Peter Brown argues that medi-
eval Christianity was not wholly established by religious elites and the
upper classes, but also determined by the masses of believers who vis-
ited relics, underwent exorcisms, and believed in the power of the devil, a

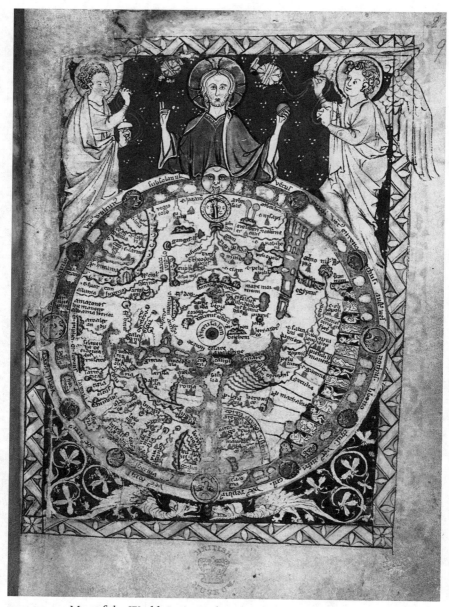

FIGURE 2.1 Map of the World. Latin Psalter. London, c. 13th–15th century. British Library, Add. 28681, f. 9.

figure associated with darkness.[14] Darkness was identified with Muslims through the Black Saracen, Islamic islands where the sun was blacked out and all the stones were black, and other images employing darkness—the antithesis to the light of Christ. These are ideas that determined, in part, the history of Christian-Muslim relations.

While the masses of believers influenced Christianity, in particular pilgrimage and the relics associated with it, the institutions of organized religion also shaped beliefs and attitudes in numerous ways. The ways in which Church doctrine impacted individual attitudes toward Islam is a broad subject not fully addressed here, outside the Christian polemics examined in this chapter. Notions of geography, race, and the constitution of community also influenced the ways Christians thought about foreigners and internal enemies like Jews and heretics. The Church had a paramount role in establishing and disseminating these beliefs, thus shaping the minds of believers. Dogma informed imagery, including the artistry of monsters. Talal Asad describes this process as *disciplinary*: "Note that here it is not mere symbols that implant true Christian dispositions, but power—ranging all the way from laws (imperial and ecclesiastical) and other sanctions (hellfire, death, salvation, good repute, peace) to the disciplinary practices of social institutions (family, school, city, church) and of human bodies (fasting, prayer, obedience, penance)."[15] If we think about this theoretically, employing Foucault and Bourdieu, the church disciplined the body and the mind, as well as supporting the artists who manufactured Muslim monsters (*fields*), creating an environment (*episteme*) in which people could not help but believe in an imaginary Islam (*phantasm*), for what other alternative did they have (*habitus*)?

North American medievalists have identified the twelfth and thirteenth centuries with the emergence of a "persecuting society," described as a "Foucaldian Panopticon of discipline and colonization" that sought to discipline and punish those who dissented from the Church's teachings.[16] Muslim monsters didn't suddenly emerge in these centuries. Disciplinary practices engendered an increased reliance on the imagination that sustained the monsters of antiquity and inspired new monsters. The medieval Christian Church's practices of exclusion and punitive discipline as a matter of theological doctrine resulted in the emergence of Muslim monsters and other fantastic creatures.

Muslims exist as a diverse set of characters in the Middle Ages. As we shall see, Prophet Muhammad was at times cast as a heretic, at other times as a schismatic, or as the Antichrist, or a frightening monster.

Muslims, called Saracens for much of the medieval period, were depicted as frightening hordes that signaled the End of Days, as a monstrous race, dog-headed men, demons, and more rarely, as the "chivalric counterparts of Christian knights."[17] In the remainder of this chapter, I focus on particular European locales—Britain, France, Germany, Austria—in which medieval imaginaries were created. Of course, numerous other communities invented Muslim monsters. This is by no means an exhaustive study of these creatures, who are undoubtedly hidden in maps, paintings, and other spaces seldom seen by the casual observer.

Medieval Epistemology

Before the creation of the nation-state, identity was shaped by ethnic status and a powerful sense of place. The recent scholarship on "medieval nationalisms," much of which are situated around Benedict Anderson's 1996 book *Imagined Communities: Reflections on the Origin and Spread of Nationalism*, does not suggest that medieval identities constituted some kind of pre-modern statehood.[18] Ethnogenesis, the formation of identity according to one's understanding of his or her origins, is a more apt descriptor for what went on in the Middle Ages. It was often deployed within medieval social communities, including families, as this example attests:

> Early in the eleventh century, an otherwise unknown Anglo-Saxon named Edward took to cutting his hair in the Norman fashion. He shaved the back half of his head and let dirty, long hair cover his face. His brother, thoroughly disgusted with Edward's new hairstyle, wrote him an angry letter, which has been preserved, "You despise your race and your ancestors," he seethed, "since in insult to them you dress [your hair] in Danish fashion with bared neck and blinded eyes. . . . He will be accursed who follows heathen practices in life and dishonours his own race."[19]

This suggests that community members had a strong sense of who they were and who, or *what*, they were not. Ethnogenesis organized social boundaries, offering "categories by which one might assert who belongs and who does not."[20] Even an act as minor as a haircut could challenge one's membership in a social community, a unit that suggested racial categories, something that played an instrumental role in the manufacturing of monsters.

The language of identity was strongly influenced by the Church. "The language of identity is always spoken in response to the language of morality."[21] Christianity, to some degree, determined people's sense of normativity. The "disciplinary practices" supported and manufactured by the Church aided in the "formulations of the self and manipulations of (or resistances to) others."[22] The others who existed within a social community (Jews) and outside it (Muslims and Africans) established a category of monsters.

The imagination functioned as a dominant source of knowledge, and fantasies about monsters, strange lands, and other chimeras constituted a weighty part of the early formulation of the Muslim characters examined in the following pages. This medieval reckoning employed the imaginative medieval narrative, which was "carried in images, stories, and legends."[23] A belief in monsters was one of the "stock features of the occidental mentality," and this figured prominently in the narratives that shaped people's lives.[24] For medieval Christians, monsters, demons, and all manner of fantastic creatures occupied the same world as humans. Typically, there was no separation of the human community and the world of the fantastic and the horrible, and this resulted in a constant and intense anxiety about Satan and other creatures, who could attack at any moment. Medieval Christians believed that "demons were everywhere ready to attack the souls and bodies of the unwary," a fear that contributed to a "terror of all mental conceptions."[25] This thinking created a world that was much like the modern horror film—terror was around every corner, in every glen, living in the forest, the cave, and the lake. Even the local church was not safe, as demons were observed to walk through the halls of sanctified spaces, often in the guise of a dark-skinned foreigner.

Hell was a favorite subject of medieval artists, often represented as a place occupied by every imaginable horror. Muslims were placed in hell (alongside Jews, in some cases) through a number of literary and artistic conventions. In literature and art, Saracens (often, but not always, representing Arabs) were portrayed as demons, black-skinned monsters, Satan, or souls condemned to the underworld. In these lines from *Richard Coeur de Lion*, Saracens are described as souls trapped in hell: "Allas Mahoun! What has he ment, This Ynglyssche dogge that hygthe Fouke? He is no man, he is a pouke, That out off helle is jstole!"[26] In many cases, the language is almost identical to that found in descriptions of devils in Harrowing of Hell dramas, thus equating Muslims to demons once again.[27]

For Christians, evil was a reality—the cause of illnesses, wars, and calamities—often personified in Satan, demons, and monsters. Satan was a character that dwelled among men. Demons as well occupied numerous spaces in the medieval imagination. According to Origen, the Antichrist forced humans to act out of accordance with God's rules through "evil *daimones* and evil angels."[28] Jews and Muslims were linked to these acts, and eventually, Muslims were placed at the Crucifixion and other pre-Islamic crimes. It is crucial to understand the central role that Jews played in medieval Christian thinking, for a number of reasons— among them, the fact that Jews and Muslims were linked in the minds of medieval Christians as nefarious co-conspirators. One simply cannot talk of Muslim monsters without Jewish ones. As characters in the medieval *imaginaire*, they often appeared together.

Jews were blamed for Christ's death and many ills that befell Christian communities, a seemingly endless list of calamities including crop failures, plagues, and foreign invasions. Visually, Jews were portrayed as cannibals, murderers, demons, and monsters. In one painting, a Jew-Dragon consumes humans in an underground lair. European Jews were also cast as non-monstrous villains, most commonly as the murderers of Christ and countless other Christian innocents. Medieval narratives claimed that Jews kidnapped, murdered, and ate Christian children, fantasies portrayed in paintings from the Middle Ages onward. Jewish men often appeared in paintings harassing Christ before his crucifixion and behaving similarly at the execution of saints. In bestiaries, Jews appear in the form of anti-Semitic hate signs, including the foxes and hyenas shown hunting the birds that represent Christ and his followers. These expressions of hate toward Christianity's "internal" enemy are strongly implicated in the manufacturing of Muslim monsters, in particular, in the Black Saracen and *cynocephalie*, and later in paintings of the Crucifixion that feature Jewish and Muslim onlookers.

The creation of medieval Jewish and Muslim imaginaries is due in part to Christians' efforts to understand themselves as a community. According to Steven Kruger, both Jews and Muslims "stood in simultaneous proximity and distance from the Western European Christian; that is, in positions that guaranteed them a certain ideological and emotional significance within the processes of self-definition."[29] This resulted in fantasies of a Jewish-Muslim conspiracy in which the enemies of Christendom cooperate as agents of Satan, intent on overturning God's order on earth

through military invasion, trickery, and magic. The characterization of Jews and Muslims as evil connivers is well established in the scholarship:

> The Christian net for the capture of Jews and other agents of Satan was spread wide to draw within it Saracens as well, for were they not also obviously in league with and abetted by the Jews? Moslem incursions at various times were, in fact, construed as forms of Jewish sabotage. All of this is but part of a larger phenomenon, or fantasy, in which the Saracens themselves were identified as demons, as Antichrist (so we have seen), but, more to the point, were believed to be in league with the Jews, even thought, for example, to have assisted them in the Crucifixion. Norman Cohn posits, in the face of this miraculous cooperation of Jews and Saracens in the popular demonology of the Middle Ages and Renaissance, that the only reason Christians were somewhat more obsessed with Jews was that they "lived scattered through Christian Europe."[30]

The Antichrist was often tied to Jewish and Muslim figures in theology, literature, and art. This was, after all, part of how Christians defined themselves against communities that stood in opposition for one reason or another. As Jeffrey Jerome Cohen puts it, "the classification of the Jews together with the Muslims" was one of the major "subsets in a larger genus of hermeneutically constructed infidels who undermined the unity of the Christian faith."[31] These ideas did not end with the onset of modernity, a point raised by some scholars of Orientalism and anti-Semitism, who have argued that the vilification of Jews and Muslims is a continuously related historical process. Without one, it is impossible to fully understand, or acknowledge, the other.

Anti-Jewish rhetoric and anti-Muslim rhetoric are similar. Guibert of Nogent's account of Muhammad's death describes an afflicted body, mirroring contemporaneous anti-Semitic writings about diseased Jewish bodies. The account of Muhammad's death in this work "echoes, in its focus on the body and bodily debility, the stories involving Jews in the *Memoirs*."[32] In Guibert's well-known account, pigs overtake Muhammad while he is while having an epileptic seizure and consume his body:

> Let us now recount the end of this great and marvelous law-giver. I have already said that he was subject to attacks of epilepsy: one day as he was walking alone, he fell attacked by one of his convulsions,

and while he was being tormented by it, some hogs, having come upon him, so completely devoured him that only his heels were found as remains. So thus this excellent law-giver is given over to the swine and eaten by them, so his evil rule was terminated as just, by a most vile end. And certainly, while his heels were left, it was without a doubt so that he could show those fools whom he had miserably seduced a witness of his perfidiousness and deceits.[33]

As this example shows, enemies are often constructed by institutions that have an interest in maintaining power. In medieval Europe, Christianity was the most powerful vessel of power, one that "created and worked through legal institutions, [the] different selves it shaped and responded to, and different categories of knowledge which it authorized and made available."[34] Christian identity was based on what was *perceived* to be normative, and because black skin functioned as a symbol of sin and evil, light-colored skin was privileged. "Race" was not a concept active in the medieval vocabulary, although bodily difference—including the color and tone of skin—certainly played a role in the formation of identity and in monster-making.

Anxieties surrounding ethnicity and bodily differences were imprinted on non-Christian bodies, in particular, on Jews, Muslims, and Africans. This was a medieval kind of racialization, characterized by Cohen as "a phenomenon of multiple category overlap rather than a distinctly verifiable or measurable 'thing'. . . (that is, race has no independent ontology), and race is therefore always written on and produced through the body (race is nonetheless biological)."[35] This medieval "multiple category overlap" echoes Foucault's argument that human bodies are determined by the "effects of power."[36] Muslim monsters are punished bodies, often suffering with more than one disease or affliction.[37]

As early as the fifth century, black skin functioned as a symbol of the devil and other menacing religious frights. Dark skin was understood as a theological consequence of sin. Gregory the Great claimed that Ethiopia was a sign of the fall of mankind, and other Christian writers followed suit, tying dark skin to sin and perdition.[38] Jeremiah surmised that the Ethiopian's skin could change like a leopard—one of many examples in which Africans were likened to animals.[39] Muslims were often depicted with black, blue, or purple skin. Muslims reportedly worshipped Venus, a black goddess "dressed in a gold robe with a striking red blob for its hellish tongue."[40] Islam has, from the beginning, been an identity situated in racial, ethnic, and cultural difference.

Artistically, good and evil were represented by color, often in shadings of light and dark. Pierre Remiet, a French illuminator of the fourteenth century, is well known for this convention. As Michael Camille notes:

> Remiet depicts earlier confrontations between the holy warriors of the Christian church and the "sarrasins" of Satan throughout the *Grandes Chroniques* and the *Mirior Historial*. These are conflicts visualized by Remiet, literally in black and white, between the cross and the dragon, the two signs carried as banners by the two sides in miniature—the white armies of the Church on the miniature's right and the black, turbaned armies of the 'other' on the 'sinister' side."[41]

In other cases, blue and purple were used to depict monstrosity, as in the iconic image from the Luttrell Psalter, where Richard the Lionheart fights Saladin, a purple-skinned, big-lipped, hook-nosed monster.

The preoccupation with skin color is also found in popular medieval literature. In the fourteenth-century *Cursor Mundi*, which includes legends of the Holy Cross, one story tells of King David's discovery of three rods that were blessed by Moses. Among their powers is the ability to transmogrify black monsters into white humans:

> The king met with four Saracens, who were black and blue as lead. . . . Never before that hour did anyone see so horribly shaped a creature. Their black hue was marvelous, and their mouths were in their breasts. . . . Their mouths were so broad, their eyes so large, that it made their faces repulsive. In their foreheads stood their eyes. . . [They say], "We are loathsome, but loathsome also are the soul and body both of a wicked man. . . ." David held [the rods] out to them to kiss; and they kneeled and kissed them. Immediately their skin became as white as milk, and they took on the hue of high blood, and all their appearance was made new.[42]

This narrative promises that the Muslim will be transformed into a human if he or she converts to Christianity. In another story, a Saracen infant is transformed from a lump into a human:

> His skin, that had been black and loathsome, became all white, and was spotless without blemish. And when the sultan saw that sight, well he believed on almighty God. . . . [He returns to his chamber:] Scarcely did she [his wife] recognize her lord. Then she knew well

in her mind that he did not believe at all in Mohammad, for his color was entirely changed.[43]

The identification of light skin with Christianity is found through the centuries in tales of Muslim monsters and monstrous births that follow the medieval formula of conversion and healing, the restoration of humanity to the true believer. For medieval Christians, there was no community of "white people," per se, even though foreigners were often represented with dark skin. Certainly, "race" as I am speaking of here is not constructed or politicized in the medieval mind in the same way as we find it in the modern *imaginaire*. However, in the Middle Ages we see the foundations of the ways in which "whiteness," race, and Christianity become connected over time.

As mentioned earlier, woods, mountains, and other wild places were viewed as *dark* places, regions of danger where demons, evil spirits, and monsters dwelled. The borderlands were equally frightening:

If these edges were dangerous, they were also powerful places. In folklore, betwixt and between are important zones of transformation. The edge of the water was where wisdom revealed itself; spirits were banished to the spaceless places "between the froth and the water" or "betwixt the bark and the tree." Similarly, temporal junctures between winter and summer, or between night and day, were dangerous moments of intersection with the Otherworld.[44]

The dark regions of hell also contained monsters identified as Jewish, Muslim, and African, featured in medieval paintings torturing humans. Hell represented the artistic antithesis to "the calm aesthetic numbness of heaven."[45] We find many more paintings of hell because heaven was, in the aesthetic sense, boring. Hell was seen as an imminent danger, a misstep away from the village or city if one was foolish.

Although demons and other monsters occupied *the human world*, what existed beyond the borders could be even more bizarre and horrifying. This helps to explain why most Muslim monsters were located in distant lands, frightening landscapes that had been forgotten by God, with no sun, no vegetation, only monsters. These places are later resurrected as part of the new medievalism of Gothic literature, seen in Transylvania and the far regions to which Frankenstein's monster briefly escapes in what may be understood as a visit home.

This makes sense given the semiology of monsters, which includes "fixing horror elsewhere, in an obviously and literally foreign body."[46] Saracens and Ethiopians existed along the edges of the universe, represented on maps with a normative center and dangerous borderlands, always occupied by strange and frightening creatures, Plinian monsters, and non-human races that served as examples of God's displeasure. These maps were theological tools which suggested that those who dwelled the farthest from the Christian center were the most dangerous. "In those maps that give a theological turn to geography, monstrous men are represented in a narrow band at the edge of the world, as far as possible from Jerusalem, the center of Christianity."[47] The classification of the Saracens as a monstrous race is a result of this cognitive mapping. By the time of the Crusades, Muslims were understood to be a race of creatures cursed by God and alienated from the human world:

> From the confines of Jerusalem and the city of Constantinople a horrible tale has gone forth and very frequently has been brought to our ears; namely, that a race from the kingdom of the Persian, an accursed race, a race utterly alienated from God, a generation, forsooth, which has neither directed its heart nor entrusted its spirit to God, has invaded the lands of those Christians and has depopulated them by the sword, pillage, and fire; has destroyed by cruel tortures; it has entirely destroyed the churches of God or appropriated them for the rites of its own religion. They destroy the altars, after having defiled them with their uncleanliness.[48]

In painting and architecture, bizarre creatures often lurk on the edges in psalters and bibles and in the corners of churches and cathedrals. In the Middle Ages, these figures functioned as "moralizations of sinfulness," and in the schema of monsters, as "extreme examples of the caricatured bodies that were used more generally to represent non-Christians and heretics."[49] Many religious manuscripts were populated with strange creatures, at times holding up a letter or a word. In the Canterbury Psalter, a horned creature stands in the text, holding up a letter.[50] In other cases, monstrous races float on the edges—symbols of the outsider status of Saracens, Africans, and other non-Christians.

Non-Christian territories were sinister spaces—far more dangerous than Christian territories, whatever monsters dwelled there. Muslim lands were dark and foreboding landscapes separated from the natural world.

According to one medieval account, Saracens lived in a land "[w]here the sun does not shine, not any grain grow. There falls no rain or dew. There are no stones that are not all black. Some say devils dwell there."[51] In a medieval Muslim island referenced in *Aliscans*, the lost island is so far removed from human society that it lays "outside the known world."[52] The following episode describes a meeting with a couple of monsters from this place:

> Behold along a beaten track, comes a Turk,
> Grishart was his name from the Lost Island,
> And his daughter Guineheart the hunchback
> Comes to eat the flesh of dead men.
> They do not acknowledge the old order.[53]

The frightening imagery depicted in the above poem was likely inspired by early treatments of Islam. The foundations of Muslim monsters are situated in these fantasies of early Muslims, specifically in the mythologies surrounding an Arab merchant named Muhammad.

Prophet Muhammad and the Monstrous Races

Early medieval writings about Islam often focus on Prophet Muhammad, who is variously presented as a heretic, a schismatic, Satan, and a monster. In polemical writings, Muhammad goes by a number of aliases, including Mahomet, Machometus, Machmit, Mathomus, Maumette, Machomis, Mahmet, and Mahom.[54] Most of the scholarship focuses on those polemics that describe the Prophet as a heretic or schismatic, a threat to the Church and its teachings. Scholars have placed less attention on other descriptions of Prophet Muhammad, who among other things, is cast as a demonic force, a human-animal hybrid, and a sexual monster with unending supplies of semen who harbored plans to rape the Virgin Mary in heaven. For medieval Christians, Muhammad was not considered a prophet, but rather as *Homo totus lubricus*, a sexual monster.[55] Early narratives about the Prophet are an integral part of the history of Muslim monsters because they established some of the dominant fantasies about Muslim men that persist even today. Prophet Muhammad was the first Muslim individual cast as a monster, influencing many of the characters that followed him, especially the ones who exhibit hyper-sexuality and violent behaviors.

The dominant vision expressed in medieval Christian writings about Islam's founder is that he was a monster who begot a monstrous race, a sexual monster with impressive powers, including a super-supply of semen—a gift that is magically transferred to all Muslim men, who, according to at least one text, had penises the size of trees. Early Christians often identified Muhammad with Biblical monsters. In one example, Alvarus identifies the Prophet with both Behemoth and Leviathan.[56] Pope Innocent III claimed that Muhammad was the Antichrist:

> A certain son of perdition, Muhammad the pseudo-prophet, arose. Through worldly enticements and carnal delights he seduced many people away from the truth. His perfidy has prospered until this day. Yet we trust in God, Who has already given us a good omen that the end of this beast is drawing near. The number [of this beast] according to the Apocalypse of John, is 666, of which almost six hundred years have been completed.[57]

Polemicists were often quite creative in their evaluations of Islam. Some claimed that Muhammad was a pervert who took innocuous lines in the Qur'an and refashioned them to satisfy his carnal desires. In *Liber Denudationis Ostensionis Aut Patefaciens*, the Qur'anic instruction, "God will not take you to task for what is unintentional in your oath," was explained as, "[a]nd thus he [Muhammad] perjured himself and had sex with that woman again. See how much impiety he officially established on account of this so that he might commit adultery freely."[58] The mythology that Prophet Muhammad was a pervert, expressed in the claims that he planned to rape the Virgin Mary in heaven and had unending supplies of semen, is an important part of the story of Muslim monsters. Originally identified with Prophet Muhammad, these fantasies were eventually attached to all Muslim men and they stuck. Today, Muslim men are often depicted as rapists and pedophiles, characterizations rooted in the Middle Ages.

The Prophet was blamed for "casting down the holy institutions of marriage" and representing the "ruin of virginity."[59] In medieval texts, Saracens and other Muslims are described as exhibiting the same characteristics. Christian writers presented the Muslim heaven—*jannah*—as a sexual playground, characterizing Islam as a religion focused on sex both in life and in the hereafter. The *Chronicles of Theophanes Confessor*

describes Muhammad as "the precursor to the Antichrist," and then goes on to describe heaven in lascivious terms.[60] Like many Christian accounts of *jannah*, sex is described as a reward for committing violence against Christians:

> [Muhammad] Taught his subjects that he who kills an enemy or is killed by an enemy goes to Paradise; and that this paradise was one of carnal eating and drinking and intercourse with women, and had a river of wine, honey, and milk, and that the women were not like the ones down here, but different ones, and that the intercourse was long-lasting and the pleasure continuous; and other things of profligacy and stupidity. . . .[61]

The Cordoban abbot Speraindeo described *jannah* in similar terms, writing, "In the next life, they [the Muslims] say, all the faithful shall be carried off to paradise. There beautiful women will be granted to us by God, far more exquisite than the mortal kind and laid on for our delight. . . . This is not a paradise but a brothel, a most obscene place."[62] The beautiful women alluded to in these accounts, presented to those who commit violence in the name of Islam, are the *houris*—black-eyed nymphs who pleasure Muslim men for eternity. A popular theme in medieval discourse about Islam, the trope remains popular today with those who argue that Islam is a perverse and violent religion.[63]

Sexual violence, especially acts attempted or committed against the most innocent—virgins and children—is also ascribed to Muslim men. The writings of Eulogius include an invented biography of Muhammad, who "gave his soul to hell," "fills the stomach of gods," and "committed not only his own soul, but the soul of many, to hell," and who planned to rape the Virgin Mary when he reached heaven.[64] Eulogius writes, "I will not repeat the sacrilege which that impure dog [Muhammad] dared proffer about the Blessed Virgin, Queen of the World, holy mother of our venerable Lord and Savior. He claimed. . . that in the next world he would deflower her."[65] The fantasy of Muslim men raping women is a powerful one, and it has remained part of the social imaginary, exhibited today in anti-Muslim discourse from South Asia to Europe.[66]

Pederasty was a crime often attached to the Prophet and other Muslim men, an example of the sexual monstrosity associated with Islam and, in particular, Arabs. The story of Pelagius, a Christian boy who was martyred when he rejected a caliph's sexual advances, is one

of many cases in which Muslim men were cast as pedophiles who targeted Christian children.[67] The narratives surrounding this martyr suggest that the caliph intended to have anal intercourse with Pelagius. In one version, the caliph is described as "corrupted by sodomitic vices."[68] Pelagius replies to the caliph, Abd al Rahman III, "It is not proper for a man purified through baptism in Christ, To bow down his unsullied neck to a barbarous love, Nor for a Christian anointed with holy oil, To be captured by the kiss of the Demon's filthy associate."[69] After fighting off the caliph's sexual advances, Pelagius is thrown over a wall but survives. After two more attempts to kill him, Pelagius is finally martyred when his head is cut off.[70]

In this religio-political narrative, Pelagius symbolizes the innocence of Christ and the purity of Christianity, and the caliph represents the sinful, deviant, and violent religion of Islam. The story also functions as a political narrative about the "assault" of Spain by the Muslims and the continued subjugation of the Christians living under Muslim rule there. As Lisa Weston writes:

> The result of the metaphorical "rape" of Christian Cordoba is a kingdom in which difference both exists and does not exist. That is, the text and its narrator clearly distinguish the Christians and their defeated king from the rather overdetermined barbarous, violent pagan forces and their first leader: the "perfidious race of Saracens," "the leader of a barbarian people," "a man perverse and profane," "a perverse tyrant."[71]

Claims of Muslim sexual monstrosity were not restricted to polygamy and pedophilia. Fantasies of Muslim sexual power included Prophet Muhammad's superhuman sexual abilities and energy, which influenced later mythologies, including claims of abnormally large genitalia possessed by Muslim men. One Christian text claims that upon entering heaven, Muslim males were rewarded with a penis so long that it required "seventy Christians and seventy Jews to carry it before him."[72] Many centuries later, during the colonial era, Europeans claimed that *croco-sapiens* roamed the Nile, crocodiles with Egyptian—that is, Muslim—genitalia.[73]

The works of Paul Alvarus, a contemporary of Eulogius, feature some of the most sexually graphic writings of the period. This extensive quote taken from the *Indiculus luninonis* describes Prophet Muhammad's

abnormal supply of semen, which was gifted to him by Venus, the goddess with the unusually large tongue that Muslims supposedly worshipped:

> In their disturbing teachings, these ones [that is, the Muslims] recount and babble, as if proclaiming something noble, that this pimp of theirs, preoccupied with the activity of seduction, had obtained the power of Aphrodite in excess of other men; that he had received as a gift from his god a more abundant "will of Venus" than others; that he had a greater quantity of liquid for his foul activities than the rest; that he could distribute this fluid with less effort than could other men; and that he had been given the endurance in coitus and indeed the abundance of more than forty men for exercising his lust for women. The foul, fertile abundance of his rank loins [came] not from God, the begetter of all things, as this most evil robber dreamed, but from Venus, the ridiculous mate of Vulcan, that is, from the wife of fire.[74]

In the following excerpt from the same text, Alvarus describes the regeneration of the hymen, among other sexual miracles, that supposedly take place in the Muslim heaven:

> There is no one so lost to his lusts and so soiled with the dirt of his sty as this pimp polluted with putridity. As we said, he enjoys the wives of other men like a pimp, concealing the scabbiness of his filth behind an angelic command, promising as a gift for those who believe in him harlots for the taking, scattered about in the paradise of his god; harlots bound by no limit in coitus so that the extreme heat [of passion] is not terminated in the usual space of one hour, but is multiplied by seventy times for the enjoyment of men—the same sort of flowing enjoyment that is typically associated with asses. The lethargic inhabitant of this paradise will have an increased [quantity of] fluid and a heightened sexual desire. And the virginity lost [by the harlot] through each act of coitus in the course of this prolonged villainy will be restored, despite the perforation [of the hymen] by the inflexible reed, so that it may be of [further] service to those enjoying it. And neither the tearing of the ruptured hymen nor its remending will inflict terrible pain on those who undergo it, but will delight both [partners] with the sweetness of pleasure, furnishing their minds with even more

desire to engage in it again, thus not curtailing but extending their renewed and ardent gluttony.[75]

Many of the polemics against Islam are framed within concerns about Christian orthodoxy and typically include charges of idolatry and heresy. These writings often identify Muslims with Satan, a figure strongly implicated in many Muslim monsters. The Venerable Bede wrote, "the Saracens occupy the same ideological space as the erring, the worldly and the gentiles in opposition to the spiritual fraternity: in short, as enemies of the church they are in the company of Jews, Philistines, heretics and the devil."[76] Satan was among the many idols that Muslims were accused of worshipping. One of the earliest references to Muslim devil-worshippers is found in Jerome's writings, where he refers to a Lucifer-worshipping cult in pre-Islamic, fourth century Arabia.[77]

In writings about Islam penned by famous Christians like Jerome and Bede, it is worth remembering that much of the so-called knowledge produced about Islam was based on folk tales about monsters and mythical narratives about the East and its associated mysteries. These early works were nothing but musings and conjecture, written by individuals who had never opened the pages of a Qur'an or met a Muslim. When Bede attempts to validate his opinions about Islam, writing, *"ex priorum maxime scriptis hinc inde collectis ea quae promeremus didicimus"*—"I have chiefly obtained my material from here and there, chiefly from the writings of earlier writers," we must take the "here and there" to mean his sources were, at best, creative musings on Islam with no correlation with reality.[78] In the early centuries of Islam, Christians were essentially writing in the dark; even during the Crusades, they were woefully ignorant of Islam. Anglo-Saxon perceptions of Islam "were formed in a Christian literary matrix, since most people had no chance to witness Islam for themselves or to hear a first-hand report—and even a pilgrim to Jerusalem such as Atculf or Willibald had been informed to some extent by the Christian literary corpus before arriving in Saracen territory."[79] Literary and artistic representations of Christian-Muslim encounters often reflect a reliance on mythology, as seen in the descriptions of the purple-skinned Saracens and Muslim dog-headed men that Christian soldiers encountered in battle.

In addition to the dangers posed by Prophet Muhammad, others warned that the new religion was a sign of the End of Days.[80] In *Bede's Ecclesiastical History*, two comets serve to forewarn the world of the arrival of the Saracens:

In the year of our Lord 729 two comets appeared around the sun, striking great terror into all beholders. One of them preceded the sun as it rose in the morning and the other followed it as it set at night, seeming to portend dire disaster to east and west alike. One comet was the forerunner of the day and the other of the night, to indicate that mankind was threatened by calamities both by day and by night. They had fiery torch-like trains which faced north-wards as if poised to start a fire. They appeared in the month of January and remained for almost a fortnight. At this time a terrible plague of Saracens ravaged Gaul with cruel bloodshed and not long afterwards they received the due reward of their treachery in the same kingdom.[81]

Bede was not alone in his appraisal of the Saracens as a sign of the final reckoning. Sebeos identified the Saracens as one of the four Beasts of the Apocalypse, along with the Greeks, Sassanians, and the people of the "North."[82] In other writings, Muslims are described as a "burning and lethal" poisonous wind, "setting alight the tall and beautiful trees in the garden," or as the Beast, complete with iron teeth and copper talons, or as a monster from the desert.[83] There are also descriptions of Muhammad as a monster, including one that depicts him as a creature "with the head of a man, the neck of a horse and the body of a bird."[84]

Although depictions of individual Muslim monsters exist that share the characterizations of Prophet Muhammad described above, the domi-nant Muslim monsters of the medieval period existed as *families of crea-tures*—the monstrous race of Saracens established by Muhammad, the cannibalistic Muslim giants of medieval romances, Muslim *cynocephalie* (dog-headed men), and the many Black Saracens, monsters that combined the most monstrous qualities ascribed to Jewish, Muslim, and African peoples. As noted above, Muslim characters were inspired by a myriad of things—Classical monsters, biblical prophecy, anxieties about Jews and foreigners, and the medieval episteme of monsters, which included the belief in a very small human community surrounded by a world of fright-ening creatures.

While the dominant narrative about Muslims is filled with these mon-sters, not all medieval writings about Islam are negative. Some of the most positive examples are found in Islamic Spain, penned by *Mozarebs*.[85] In the *Chronicle of 741*, Muhammad is described as "a prescient man, a foreseer of future events," whom Muslims treat "with great honor and

reverence as they affirm him to be an apostle of God and a prophet in all of their sacraments and scriptures."[86] The daily contact between Jews, Christians, and Muslims living in Andalusia, coupled with a lack of inter-religious warfare, helps to explain why these writings emerge.[87] Saladin, the Kurdish leader who helped to reclaim the Holy Land from the Christians in the twelfth century, received positive treatment by several Christian writers. Ambroise describes him as, "that generous, that valiant Saracen."[88] In Italian medieval romances, Saracens were often cast as Muslim versions of Christian knights who "belong to an identical, idealized world; they wear the same kind of armour, use the same rituals, share the same ideals, enjoy hunting, dancing, and parties in the same way and always live in similar beautiful castles, palaces, and gardens."[89]

The Saracens were also described as Muhammad's progeny—a monstrous race that spawned a number of creatures, including one of the more popular characters of the medieval Christian imagination— the Black Saracen. Considerable debate surrounds the etymology of "Saracen." The most exhaustive investigation of the history of the word is found in Irfan Shahid's study of the presence of Arabs in pre-Islamic Roman territory. Shahid explains that the word *Saraceni* had a number of meanings that were grouped into classifications based on "linguistic, ethnic, and geographical" groups situated in the "problem of the image of Arabs in ancient and medieval times."[90] These classifications included *sharq/sharqi/sharqiyyin* (east/easterner/easterners), *sariq/sariqin* (thieves/ marauders/plunderers), and *s'raq* (barrenness).[91]

Saracens are described in various accounts as the progeny of Hagar, of Muhammad, or of the Antichrist himself.[92] While *Saracen* initially referred only to Arabs, it was soon applied to Muslims, Ethiopians, and Jews. In the medieval Christian world, Jews and Muslims were considered partners in crime. Situated in polemics against Islam that included narrations of Prophet Muhammad's life are resonances of the account of Jesus's betrayal by Judas. In some versions of the story of Muhammad's death, we find that "[t]hese events of Mahomet's death appear to be suggested by Judas's betrayal of his Master, the Last Supper, Christ's ascent of both the Mount of Olives and the Calvary, and the Resurrection."[93] Using the same narrative structure, but with differing outcomes, ensured that the audience would have a takeaway—Christ is risen and Muhammad is the Antichrist.

The identification of the Hagarenes, described as a lowly, racially degenerate race, with the Muslims is another way in which the appearance of

Islam was explained. John of Damascus, who wrote about the Hagarenes, claimed the black stone of the *ka'aba* was worn smooth because "Abraham has sexual intercourse with Hagar on it."[94] This race was constructed along theological lines, and much like the Saracens, the Hagarenes were a community that was alienated from God. The earliest reference to this group is found in Nicetas of Byzantium's ninth-century text, *A Refutation of the False Book Written by Muhammad*, in which he describes Muslims as the descendants of the slave girl Hagar.[95] Hagar is depicted as a black-skinned slave who begat a dark, strange race that was excommunicated from the Christian—and by extension, the human—community.

The invention of the Hagarenes was due in part to the medieval racial classifications expounded by Isidore of Seville, who divided the people of the world into 72 types, all originating from Noah's sons, Ham, Shem, and Japheth.[96] The offspring of Ham also played a role in racial constructions of Muslims through the identification of Saracens with Africans, who were classified as Hamitic.[97] These powerful ideas are later seen in the efforts of Europeans to explain away the "high civilization" of the Egyptians, arguing that they must have been "Caucasian, far removed from the inferior Negro."[98] According to this logic, only a light-skinned race could have built the pyramids and other great monuments of Egypt.

Goths, Jews, and Muslims were also believed to be the offspring of the biblical beasts Gog and Magog, which were at times conflated into one beast named Gagmagog.[99] Jews were identified with two beasts from *Mandeville's Travels*, as well as other monstrous races from fantastic tales.[100] Geoffrey of Monmouth identified Gagmagog with the Goths.[101] Matthew Paris identified the monsters with the Tartars, who, according to several Christian accounts, had been imprisoned by Alexander, and "when unleashed, would bring an end to the world."[102]

The Ethiopians were another monstrous race connected to Muslims. It is important here to reiterate that in the medieval view, non-Egyptian Africans were often referred to as "Ethiopians." Like the Saracens, they were considered members of a monstrous non-human race fixated on sex and violence. As one text suggests, "In the East, especially in hot regions, bestial and wanton people. . . easily embark on the path that leads them to death."[103] Saracens were often portrayed with black or purple skin, as in the paintings of Black Saracens and in the numerous medieval texts in which Black Muslims are featured. Two examples can be found in *Guy of Warwick*, where both the Muslim whom the hero fights in Constantinople and the Irish dragon he destroys are black, a color that represented Satan

in medieval iconography.[104] The Muslim with dark skin is one of the consistent images that we find in the history of Muslim monsters. It is sustained by numerous anxieties surrounding Africans and Muslims, including the Moors of Spain and North Africa, and later, the Barbary beasts that populate the North American imaginary. The other dominant association situated in notions of racial alterity is seen in those Muslim monsters that have a Jewish identity, a subject to which I now turn.

Jewish Muslims

An archive of Muslim monsters must include their cousins, the Jewish monsters. Jews and Muslims were often confused in the minds of medieval Christians, a result of the myriad ways in which they were co-identified in the theology, literature, and art of the period. The joint vilification of Jews and Muslims in the Middle Ages continued into the Renaissance. Medieval Muslim monsters like the Black Saracen, a Muslim-Ethiopian-Jewish hybrid, and the *cynocephalus*, which had both Jewish and Muslim incarnations, often exhibited anti-Semitic Jewish characteristics. Typically, the way this was expressed was through the actions of these monsters, who were shown harassing, torturing, and killing Christian saints, and also were depicted as the executioners of Jesus. As early as the 690s, Jews were accused of being in cahoots with the Muslims, referred to as their "Hebrew" brethren by King Egica of Spain.[105]

Throughout the Middle Ages, Muslims were often described as "tainted with Judaism."[106] Christian theologians argued that both Jewish and Muslim religious practices were flawed and heretical, and further-more, that they were collaborators, either in conspiring to undo the Church or—and this is where the monsters often appear—mutilating and killing Christian men, women, and children. Renaissance paintings of the crucifixion, the martyrdom of saints, and other scenes often feature Jewish and Muslim (typically, Turkish) figures participating in these crimes.

Charges of Muslim idolatry were ascribed to Jews. In this letter written by Patriarch Germanus to Thomas of Claudiopolis, both Jews and Muslims are accused of worshipping idols:

The word of truth stops the mouth of these by the mention of their own peculiar abominations, branding with infamy the hea-then with the wickedness and abominations of Gentile sacrifices and fables, making the Jews to blush, not only by reminding

them of the frequent lapses of their fathers into idolatry, but, fur-
ther, of their own opposition to the divine law that made such a
boasting of holding. . . . With respect to the Saracens, since they
also seem to be among those who urge these charges against us,
it will be quite enough for their shame and confusion to allege
against them their invocation which even they make in the wil-
derness to a lifeless stone, namely that which is called Chobar,
and the rest of their vain conversation received by traditions from
their fathers as, for instance, the ludicrous mysteries of their sol-
emn festivals.[107]

Muslim places of worship were termed not only *mahommeries* (mosques),
but were also described as synagogues, one of the many ways in which
Muslims were framed as "new Jews," a charge that continued to be
made throughout the Middle Ages.[108] One example of this is found in
the *Chanson de Roland*, where Christian soldiers destroy the idols found
in "les sinagoges e les mahumeries."[109] Paintings with Jewish Saracens
and Ishmaelite Muslims also present a confusing picture of Jewish and
Muslim identities. In the *Roman de Mahomet*, Islam is characterized as
a religion whose followers, "seduced by the luxurious 'miracle' of a land
flowing with milk and honey, are led to embrace the 'law of Moses' com-
plete with a return to the 'circumcision of the flesh.' "[110]

Passion plays included Jewish characters praying to the "almighty
Mahomet" and featured "hideously deformed and dark-skinned Saracens
along with the usual Jews."[111] The Towneley Cycle featured Prophet
Muhammad as "the god of the Jews," a character that "embodies the
fulfillment of Old Testament villains and a warning of the approaching
Apocalypse."[112] The Towneley Crucifixion also included tyrants like Herod
and Pilate, who instructed the audience to remove their hats and pros-
trate flat on the ground as if performing the Islamic prayer, in another
reference to the tyrant's god—Muhammad.[113] In the same play, "the sol-
diers who crucified Christ invoke 'Mahowne' as if they were Moslems not
Romans."[114]

Jews and Muslims played a central role in the medieval social imagina-
tion. For the average Christian, "[a]nti-Jewishness was a structural feature
of late medieval society."[115] In plays depicting the Assumption, Jews were
often portrayed as Satan or demons, in the same way that Muslims, espe-
cially Black Saracens, were represented, creating even more confusion in
the minds of the medieval and Renaissance audiences.[116]

Often the Jewish and Muslim hybrid characters that exhibited "diseased and debased bodies" were located in the same space, presented as partners in evildoings against Christian innocents.[117] Guibert of Nogent's descriptions of Jews as being deformed and infectious and Dante's image of both Muhammad and Ali's bodily degeneration in hell are but two examples.[118] In Dante's *Inferno*, Prophet Muhammad is located in the ninth *bolgia* of hell, and Lucifer is located in the region of hell identified as the Jewish quarter.[119] Although these cases do not fit the definition of "monster," the grotesqueness of these Jewish and Muslim bodies helped to alienate these communities from humanity because of their deficient state.

The numerous connections made between Jews and Muslims in the Christian imaginary result in a number of interesting literary and visual presentations. As noted earlier, during the medieval period "Saracen" becomes a widely used pejorative term. One example is that of the Jewish Sarrazin or Saracen, suggesting that in some instances Christians conflated Jews and Muslims into one body. In an image from the Holkham Bible (Figure 2.2), Ishmaelites are labeled as "sarrazins" and are portrayed with dark skin and turbans.[120]

This is not only an example of transference, or commingling, in which anti-Semitism and anti-Saracenism are joined.[121] The Jewish Sarrazin is an early example of the charge of Jews and Muslims as Christianity's eternal enemies, even more significant because these representations become stock characters in Renaissance paintings of the Crucifixion and the execution of Christian saints. The linkage of Jews and Muslims/Saracens was so common that it was "difficult to name the one group without conjuring up the other."[122] We find Jewish and Muslim figures side by side in these scenes, whipping Christ, stoking the fires of an executioner, and observing these scenes with perverse expressions of enjoyment. After the Renaissance, Jews and Muslims continued to be vilified in European discourse, a topic covered in the chapter on Orientalism. The purported relationship between Jews and Muslims as co-conspirators existed in the Christian *imaginaire* for centuries. It was not ultimately extinguished until Jews were finally considered capable of assimilating—something that didn't take place until the late twentieth century and that has yet to happen for Muslims.

Anthropophagy and the Muslim Monster

Anthropophagy is a politicized act, often situated in polemics against one group or another. During the Crusades, Christian soldiers consumed

FIGURE 2.2 Three Attempts to Trap Christ. Holkham Bible Picture Book. England, c. 1320–1330. British Library, Add. 47682, f. 27v.

bodies of the fallen enemy at Ma'ara, an episode documented by historians. The same claims were made against Muslims, often in tales of Saracen monsters who devoured Christian bodies on the battlefield. Historically, claims of cannibalism (often completely unfounded) have been used to legitimize territorial conquests and to vilify a religious or racial Other. One only needs to look at the history of anti-Semitic fantasies of Jewish cannibalism of Christian children to see how powerful this imagery is. Cannibalism is a common characteristic of medieval monsters, and it persists into the modern period, for instance, in cinematic adaptations of Bram Stoker's tale of Dracula, a Jewish and Ottoman monster who literally sucks the life out of his victims.[123] Fictional cannibal narratives are featured in numerous adventure and horror fictions in the modern period. These are all stories designed to cast the Other as so uncivilized, so removed from the human community, that he or she enjoys the taste of human flesh.[124] In the early modern period, these fantasies are an integral part of the European quest for territory, even in spaces that were exoticized, like Tahiti. Cannibal fiction is a genre that "has gained its entire meaning from within the discourse of European colonialism."[125] However, the foundations of this genre are much older, situated in martyrologies and other medieval narratives.

Medieval images of demons and monsters often feature the consumption of humans, typically in portrayals that show the dismemberment of Christians in some gruesome fashion. The fear of being consumed and ingested by the enemy is situated in medieval Christian beliefs surrounding the body of the saint, who, after Christ, functioned as the dominant symbol of resurrection through literary and visual media that communicated "potent fantasies of violent dismemberment and reintegration."[126] In accounts of Christian travels in the Holy Land, the fear of bodily corruption was expressed in the Saracen monster, a figure that often enjoyed eating Christian flesh. These stories and images formulated the fantasies of Muslim cannibalism: "United by the appropriation of a metaphor, these writers deploy images of anatomical mutilation to symbolize mutilated subjectivities, identities whose borders have been unmade."[127] Death through the consumption of the body by an enemy was a way to remind medieval Christians of the promise of resurrection. Carolyn Bynum explains the Hell-Mouth, which consumed Christian bodies, in this way: "damnation is eternal swallowing and digestion; eternal partition; the mouth of hell is a real mouth; second, final death is mastication. . . redemption therefore is triumph over fragmentation, digestion, and rot."[128] Only resurrection, which was exclusive to Christians, would restore the body to its original state.

Cannibalistic monsters played an exigent role in the Christian narrative of death and resurrection. In one medieval painting (Figure 2.3), Christian soldiers are shown being cooked and eaten by a group of monstrous Tartars.

The horror represented in this scene serves as the preface to a miraculous resolution—when Christ would restore the dismembered, burned, and destroyed bodies of true believers. The images of cannibalism found in both medieval writing and art are an expression "for Orthodox Christian believers ideas of what happened to people's bodies after they died," which were, "cast prominently in the imagery of cannibalism."[129] Resurrection is the opposite of decay and regurgitation; it is a complete restoration of body and soul: "regurgitation, the reassembly of dispersed parts, the restoration of limbs (re-memberment), the returning of flesh to bare bones, the re-covering with skin. . . . The orthodox medieval Christian understood resurrection as involving the step-by-step reversal of cannibalistic destruction, with intact perfection of the body as the end result."[130] It is no surprise, then, that Muslim monsters are shown participating in the Crucifixion and dismembering Christian soldiers and saints as well as, in some cases,

FIGURE 2.3 Tartar Feast. Matthew Paris, Chronica Maiora. England, c. 1240–1255. Corpus Christi College, MS 16, ll, f. 167r.

consuming their flesh and bones. In Renaissance paintings, examined in the following chapter, Jewish and Muslim figures are often shown killing and dismembering Christian bodies in a preface to the meal.

Saracens are often described in medieval texts as cannibalistic giants. In some narratives this is subtle, such as the *Torrent of Portyngale*, where the giants are not named as Saracens but their identity is implied. In this story, the hero seamlessly "moves from killing giants to killing Saracens."[131] The oppositions presented in *Portyngale* are fundamentally religious, creating a link among *all* of the non-Christian creatures the Christian knight encounters. Medieval romances present "a succession of defining cultural encounters where notions of the civilized and the bestial, the innocent and the guilty, the monstrous and the manly are brought face to face."[132] In some cases, Saracen giants are mixed with other nefarious creatures: "The sequence of giant-killings shows a coherence and design that suggests a problem is at hand in this romance, one that resolves only in the poem's ultimate embrace of different kinds of cultural encounter—between just and treacherous rulers, Christian and Saracen knights, chivalric and ascetic males."[133]

In other stories, Saracen giants, cannibalistic or not, were clearly identified. They were so large and dangerous that only the bravest knights, like Roland or Orlando, had a chance against one. A monster in *Guy of Warwick* is an example of a supernatural creature that was "hard to kill." As the text warns, "For if he looked on you with anger, sternly with his black eyes, so grim he is to see that no matter how bold you have been in

the past, you don't dare wage battle on him, nor fight against him."[134] Even Saracens who are not giants have monstrous qualities, such as the ability to regenerate. According to medieval tales, "[w]e cannot kill so many of them but what we find another," and, "[f]rom their tents they come forth like rain driven by the wind."[135]

Ferrau is the Saracen giant most commonly featured in medieval romances. Alternatively called Ferraguto, Ferragus, Fernagu, and Ferracutus, the creature survives in some form into the modern period.[136] Ferrau is a powerful monster that in several stories is finally killed by Roland or Orlando. In the *Historia Karoli Magni et Rotholandi*, Roland vanquishes Ferracutus.[137] The source of the monster's strength is his navel; only by attacking his sexual organs can he be destroyed. In addition to the giant Saracen monster, the text also describes an Islamic idol so imbued with evil that the statue killed birds that landed on it:

> The Saracens had a tradition that the idol Mahomet, which they worshipped, was made by himself in his lifetime; and that by the help of a legion of devils it was by magic art imbued with such irresistible strength that it could not be broken. If any Christian approached it he was exposed to great danger; but when the Saracens came to appease Mahomet, and make their supplications to him, they returned in safety. The birds that chanced to light upon it were immediately struck dead.[138]

Saracen giants continue to function as popular monsters in the Renaissance. In two other narratives, *L'entrée d'Espagne* and *Orlando Furioso*, a much later adaptation of the story featuring Orlando, Saracen giants, King Arthur, and Charlemagne, Orlando is the hero. In the *Sultan of Babylon*, Muslim soldiers have blue, yellow, or black skin, ride into battle on beasts, and one soldier, named Estragote, is a black-skinned giant with a boar's head:

> *And Estrgot with him he mette*
> *With bores hede, blake and donne.*
> *For as a bore an hede hadde*
> *And grete mace stronge as stele.*[139]

In medieval texts, female Muslim monsters typically appear as black, blue, or purple-skinned giants, equally as frightening as their male

counterparts. These characters exemplify the "hybridization of misogyny and racism through a triple confluence of representations: the wild woman, personified vice, and 'death itself, *la mort*, feminized through grammatical gender.'"[140] In contrast to later female Muslim characters, most of whom are desirable, most medieval monsters have zero sex appeal. Amiete, a Saracen giantess that appears in *Fierbras*, with her huge mouth and wide hips, is sexually monstrous but not "sexy":

> *Ce est une gaiande plus noire que peuree;*
> *Grant ot la fourceure et le quele avoit lee*
> *Et si avoit de haut une lance levee,*
> *Les ex avoit plus rouges que n'est flambé alumee;*
> *Moult est de tout laide et deffiguree.*
> She was a giant blacker than pepper;
> With great hips and a wide mouth;
> With the height of an upright lance,
> Her eyes redder than a lighted torch;
> She is utterly ugly and disfigured.[141]

Flohart, another Saracen giantess found in *Aliscans*, is even more terrifying. This monster is three times as tall as a man, breathes smoke, and tears Christian soldiers apart like French bread:

> She was fifteen feet tall, and as such the French were terrified of her.
> She was wrapped in the skin of a buffalo.[142]
> From her mouth issued a great fiery smoke,
> So that the troops were immediately burnt alive.[143]
> Flohart grabbed the ventail and tore his hauberk from him with her teeth.
> And then she devoured him like he was cheese.[144]

Medieval literature includes other types of female Muslim characters, many of whom figure prominently in conversion narratives. Saracen females who convert to Christianity are usually represented as white, a reversal of the dark-skinned or Black Saracen male monster.[145] White Muslim females do not represent "a realistic portrayal of the medieval French view of the Saracen body but illustrate desire on the part of the white male authors of the text."[146] These characters are not realistic portrayals, but rather expressions of desire for the exotic Other, which was often situated in fantasies about racial and sexual difference. As Robert

Young argues, "The identification of racial with sexual degeneracy was clearly always overdetermined in those whose subversive bronzed bodies bore witness to a transgressive act of perverse desire."[147] Numerous cases exist in medieval literature that combined fantasies about Muslims and Africans, such as the Muslim idol of Venus with a huge mouth and red tongue and the black-skinned Saracen giants whose strength is located in their sexual organ or navel.

Dark-skinned Muslims found in medieval psalters, paintings, poetry, and romances are not always monstrous, but their blackness indicates that they are evil. In an image from fourteenth-century France depicting a battle, the Muslim soldiers wear turbans and have dark eyes, but perhaps what is most interesting is the face on their shields—an African man. This is but one indication of how Muslims were related not just to Jews, but also to Africans.

The monster that encapsulated all three of these entities—Saracen, Jew, and black African—is the Black Saracen. This is a hybrid monster, an African (implicated as Satan by his dark skin), Jewish (depicted executing a saint), and Muslim (by the moniker "Saracen" as well as by the turban he often wears). With his black, purple, or brown skin, large lips, and curly hair, this monster is clearly meant to represent an Ethiopian, that is, a non-Egyptian African. Satan often masqueraded as a serpent, a dragon, or a human with blackened skin. The Black Saracen is but one of the many forms that Satan took, a symbol of evil walking the earth:

> The damned were often shown being tormented by serpents in visions of Hell, and this was depicted in medieval art. More usually, however, in earlier and later literature the demon has the appearance of a black man, an Ethiopian, or "an Indian boy." In older Greek legend ghosts were sometimes "of a horrid black color," and, in his paintings of the underworld, Polygnotus depicted the demon Eurynomous as blue-black. An early reference to the Devil as black occurs in the Life of St. Anthony, and a demon cast out of an image in the Acts of Bartholomew is "like an Ethiopian, black as soot." Pope Gregory the Great describes the black demons that carry off wicked souls to Hell. This became one of the most common aspects of demons through the Middle Ages.[148]

Many medieval tales include a black figure. Hermanus, the abbot of Mariensatt, claimed to have seen a variety of demonic creatures sneaking into his church, including a dragon and "a monstrous Ethiopian."[149]

In medieval art, the Black Saracen is often shown harassing Christ or murdering a Christian saint. One of the most striking examples of this visual narrative is found in the Luttrell Psalter's *Execution of St. John the Baptist*, where a purple-skinned figure is shown beheading the saint. The Chichester Psalter (13th c.) includes several images of Black Saracens surrounding, harassing, or harming Christ. In the first image, "The Betrayal" (Figure 2.4), Christ is surrounded by a number of figures, including Black Saracens, identified by their dark skin and turbans.

In the second example, "The Scourging" (Figure 2.5), two of these figures beat Christ, placed on either side of him. These executioners can

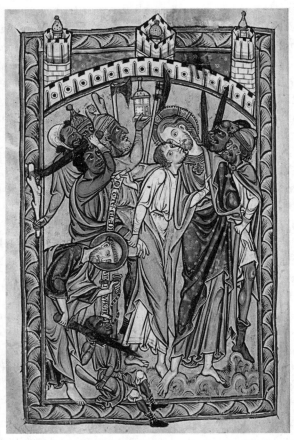

FIGURE 2.4 The Betrayal. Chichester Psalter, c. 1250. University of Manchester Library, Latin MS24, 150v.

easily be identified as Black Saracens because of their dark skin and turbans.

In *Guy of Warwick*, dark skin functions as a Saracen marker—an image that appears repeatedly in the text. It is seen when the hero disguises himself in blackface, where "Guy prepares the reader to associate blackness with Islam" by dyeing his hair and face black, taking on an "Eastern personality."[150] The Saracen monster in Warwick resembles the executioner in the Luttrell Psalter, described in the text as "a fende, þat comen were out of helle."[151]

Jews are implicated in the character of the Black Saracen because of their role, in Christian narratives, as the killers of Christ. This is a story

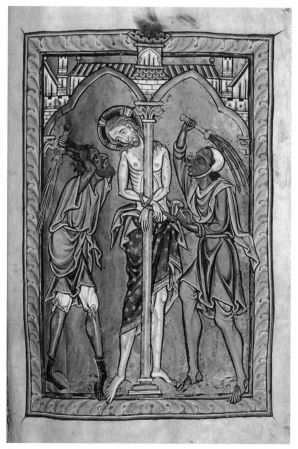

FIGURE 2.5 The Scourging. Chichester Psalter, c. 1250. University of Manchester Library, Latin MS24, 151r.

told in numerous spaces during the Middle Ages. In some cases, the monsters are disguised. Such is the case of the medieval bestiary. In this genre, the killers of Christ are often cast as dogs. Both Jews and Muslims are described as dogs and, as we shall see, are depicted as dog-headed men. The bestiary is one way in which monstrous identities are established, through Jewish symbols that are then transferred onto Muslim characters in Muslim *cynocephalie*.

Animals are popular fixtures in medieval art, often representing biblical figures in religious narratives, many of which focused on the death of Christ and the martyrdom of later Christians. The stereotype of Jews as devious killers is portrayed in bestiaries through the animals that symbolized them—the hyena, fox, and dog—and the Jewish *cynocephalie*, dog-headed monsters featured in both literature and art. Scenes in these bestiaries often show one of the animals (a Jew) attacking a bird (Christ). An analysis of such a scene should take into account three factors: the composition of the scene, the actors, and their positions relative to each other. The religious scholar Jacob Kinnard describes this as an "ontological dialectical" relationship.[152] This opposition identifies the villain, the victim, and the broader religious narrative at work.[153] The line between animal and monster is situated in a rich vocabulary reflecting a wide array of creatures:

> The Bestiary or book of beasts is also surprisingly coy about what constitutes a *monstrum* or *belua* or even a *bestia* as opposed to a mere animal. After recounting the creation story, the Aberdeen Bestiary divides the category *animalia* into several subcategories: *quadrupedia* are animals like deer that are "neque bestia. . . nedque iumenta" ("neither wild beasts. . . nor beasts of burden"); *pecus* refers to "omne quod humana lingua et effigie caret" ("anything which lacks human speech or appearance"), but generally means edible animals like cattle and pigs; *iumenta* are, simply enough, beasts of burden; *armenta* are *animalia* suitable for use in war, such as horses; and finally, *greges* are "caprarum et ovum" ("flocks of goats and sheep").[154]

The fox and hyena are both *animalia* and *monstrum*. As symbols of the monstrous Jew who hunts and kills Christ and his followers, they function as hate signs. The fox (*vulpes*) is a well-recognized "hate sign" in the language of anti-Semitism that symbolizes the Jew's deceptive nature.[155]

The stories told on the pages of these manuscripts typically show a fox tricking a bird, resulting in its capture. "The fox is a symbol of the devil, who pretends to be dead before those who live according to the flesh [the birds], whom he traps and devours."[156]

The hyena (*yena*) is another anti-Semitic "hate sign" identified with the Jew, offering "one of the most straightforward allegories" of the Jew as the devil found in these texts.[157] The hyena resembles the dog-headed man in its identification as a canine, and the hyena's voice resembles a human.[158] In the stories told about *cynocephalie* in battle against Christian soldiers, they are often described as whinnying, barking, and howling, as hyenas do. I would postulate that the hyena, a popular symbol of Jews, inspired the Jewish dog-headed men of medieval lore. The *cynocephalus* is an old monster, one long associated with evil.

The *cynocephalus*, or dog-headed man, is a popular medieval monster that is identified as both a Jew and a Muslim in literature and painting. In the Middle Ages, human-animal hybrids are often connected to religious monsters, which are found in oppositional scenes with Christ, representing the cosmic struggle between evil and good, darkness and light. Hybrid monsters "operate [as a] major locus of the experience of horror," thanks to their appearance as human and monster.[159] The *cynocephalus* is more frightening than other medieval hybrids because of the descriptions that surround the monsters—they growl, bark, and often consume their victim.

Jewish dog-men appear in medieval texts with less frequency than their Muslim counterparts, which may be due to the threat that Islam posed militarily and politically, the social position of Jews in Christian communities, and the additional spaces in which anti-Jewish characters are found, including the bestiary. Artistic depictions of Jewish and Muslim dog-men are rare, although the Khludov Psalter contains an image of Jews as *cynocephalie*, piercing Christ's body with lances. An image from the Barberini Psalter closely resembles accounts of Muslim *cynocephalie* in battle with Christians, suggesting that literary depictions were executed pictorially, at least in this case. The existence of Jewish *cynocephalie* in texts has been described by Kathleen Corrigan: "In the illustrations of both Psalm 21 and Psalm 68:22 the artists have taken great care to emphasize the wickedness of the Jews. The Jews are caricatured, labeled as dogs, and depicted as dog-headed men."[160] This image of Jewish *cynocephalie* as Christ-killers reinforces a common medieval trope about both Jews and Muslims as the executioners of Christ, because the existence of one, as I have argued

earlier, conjured up the appearance of the other. In early Renaissance art, Jews and Muslims are often pictured together, present at the Crucifixion, as in Figure 2.6, a fifteenth-century painting of the Passion.

The origins of anti-Semitism are easily identified in the numerous Christian texts that charge Jews with killing Christ. These texts describe Jews as dogs and libel them with other accusations. The anthropology of Muslims as Christ-killers is less clear. In his work, Michael Camille mentions a painting of Muhammad that depicts him "wounding and attacking Christ," suggesting that images of Muslims in the same schema as Jewish executioners were in fact produced.[161] Despite the lack of pictorial images, Muslim *cynocephalie* are portrayed as Christ-killers and the enemies of Christian soldiers in texts. Muslim *cynocephalie* are prominent medieval monsters:

> Beginning with Pseudo-Methodius, both religious and secular writers associated or identified the followers of prophet Muhammad with the monstrous races. Throughout the protracted struggle (has it ever ended?), the Black Saracen is often depicted as a minion of the devil, a child of fornication, a crude outlaw covered with hair and wielding a club. In medieval sources, Muhammad himself becomes a Christian heretic who is thrown on a dung heap to be devoured by dogs and pigs. The mid-thirteenth century *Pseudo-Turpin* describes the Muslim Saracen warriors battling Charlemagne as "horned demonic Lares" (i.e., man-eating *cynocephalics*).[162]

References to Muslim *cynocephalie* in medieval romances are quite common. In the *Song of Roland*, Saracens are described as "whining" and "yelping."[163] Other descriptions of Muslim monsters in the text include Plinian monsters, some with canine qualities. There are "the Milceni, with their large heads and piglike bristles," "the Canaanites, who are simply ugly," "giants from Malprose," and "the Argoille, who bark like dogs."[164] *Cynocephalie* were often situated on the edges of medieval maps alongside *Ipopodes, Agrophagi*, and Ethiopians with four eyes—all monstrous races alienated from God and relinquished to the non-human edges of the world.[165] They occupied the same space as Saracens. Occasionally, non-Muslim *cynocephalie* appear in medieval texts, identified with the pagans that Muslims were at times associated with. Aliscans is identified as a pagan king and also is likened to the Saracen monsters in several ways—"his hair is curly and unkempt, his nails leonine, his eyes like fiery

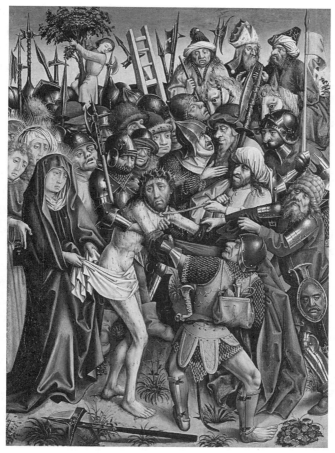

FIGURE 2.6 Entkleidung Christi (Christ Taken to Golgotha). Meister der Karlsruhe Passion. Germany, c. 1440–1450. Staatliche Kunstalle Karlsruhe.

coals," and "[h]is teeth are canine and he attacks in battle by clawing and biting," like a mad dog.[166]

The canine behaviors of Saracen dog-men strongly suggest anthropophagy. Muslim *cynocephalie* are cannibalistic, killing their enemy and consuming them, much like other Muslim monsters, including the Saracen giants with glaring white teeth and black skin who rip humans apart and eat them alive.[167] While texts do not necessarily describe Muslim dog-headed men consuming Christian bodies, it is implied in the behavior exhibited on the battlefield. In some cases, Muslim *cynocephalie* are rendered speechless: "they could not speak or shout, but like hounds bared their teeth and barked."[168]

Both Jews and Muslims appeared as dog-headed men in a number of medieval texts and paintings that identified them as monsters associated with the devil. The association of dogs with Jews continues to the modern period; and while I do not provide a complete anthropology here, I would like to point to the importance of this particular anti-Semitic hate sign, which contributes to, and is supported by, Muslim dog-headed monsters. The association of dogs with Satan informs this relationship:

> The dog was interpreted as a manifestation of the Devil, especially in medieval times. Christ's tormentors were referred to as cruel, evil dogs in written and pictorial documents. As a derogatory epithet, "dog" might be applied to any enemy, especially to the Jews, an epithet that began with its use in the New Testament, where "dogs" may be seen metaphorically to refer to the Jews.[169]

The identification of Jews with dogs is situated in Christian writings of the fourth and fifth centuries that predate Islam. John Crysostom's *Homilies Against the Jews* reads, "Although those Jews had been called to the adoption of sons, *they fell to kinship with dogs; we who were dogs received the strength, through God's grace,* to put aside the irrational nature, which was ours, and to rise to the honor of sons. . . *they became dogs, and we became the children.*"[170] According to this narrative, Christians escaped the fate of Jews, who were alienated from God and punished, very much like the monstrous races, including the Saracens, who were described as dogs, dog-headed men, and other creatures.

Jew-dogs were viewed as filthy, contaminating Christians, a belief that generated a number of rules surrounding Christian relations with Jews. Citing Paul [I Corinthians 6:12], Christian theologians argued that sharing a meal with Jews was paramount to "fornicating against one's own body."[171] In Renaissance paintings, dogs are often shown barking and sneering at Christ—symbolizing Jews. In Hieronymus Bosch's painting *The Bearing of the Cross*, it is evident who Christ's tormentors are. The dogs in this image "reflect the sentiment already expressed in the *Meditations Vitae Christ* that *truly He was surrounded by many terrible, strong and ferocious dogs.*"[172] The identification of Jews as dogs—ravenous, wild, and cannibalistic—continued for centuries. In the eighteenth century, Jewish dogs were accused of eating children, narratives based on late medieval and Renaissance paintings of Jews *and* Muslims killing Christian children. Even though the blood libel mythology attached to

Jews was not applied to Muslims, the two appear side by side in artistic depictions of gruesome scenes in which a Christian, often a child, is tortured, killed, and eaten. The Muslims portrayed in some of the later paintings depicting such scenes of horror wear Turkish clothing and, in some cases, include a Black Turk. It is to these scenes and others from Elizabethan England, the European Renaissance, and beyond, that I will turn in Chapter 3.

3

Turkish Monsters

THE YEAR 1453 marks the beginning of Ottoman rule in a conquered Byzantium, a period that commences with the sacking of Constantinople. In writings from the period, Christians described the "ravishment" and "horrifying details" of the sacking of the former Byzantine capital, at the same time that charges against the "barbarian" North African Muslims were made, a descriptor summarily attached to the Turks in that year.[1] At this point, Turkish monsters emerged alongside Arab/Saracen and African Muslim monsters. As the Ottomans increased in power, the Turk became an icon of difference and a symbol of monstrosity. In a Christian account of the siege of Rhodes, the Grand Turk is described as a "wild beast" whose "thirst for human blood was insatiable."[2] Other descriptions of monstrous Turks followed in dramatic works, literature, art, and even food. Lutheran commentaries described the Turks, like the Jews, as devious bloodhounds and the "personification of the Devil," among other things.[3] Although medieval anxieties about Saracens and Africans persisted, they were joined by new fears surrounding the Ottomans.

European attitudes toward the Ottomans generated the dominant symbols that will be examined in this chapter. The Ottoman Empire was frequently described as the Antichrist, a monster, or a beast, as "that monster of Turkish tyranny [that] hath too long reigned and laid the earth desolate."[4] The inhabitants of Ottoman territories didn't fare much better. Turkish people were identified with Satan, much like the Saracen in earlier centuries. "Prejudices against the Turks reached a climax in the oft-expressed notion that they were incarnate devils or at any rate the chosen followers of Satan, that they all derived from hell or were all going there."[5] Renaissance studies that focused on the possible origins

of the Turks frequently relied on medieval fables of monstrous races and mysterious lands. In some cases, the ancestry of the Turks was linked to the Scythians, one of the groups associated with monstrous races in Shakespearean dramas and other writings. Scythians were often featured in medieval writings about monsters, and a Scythian origin, when not explicitly linked to monsters, was still cited as an explanation of the Turk's barbarism.[6]

Political alliances with the Ottomans did little to temper European attitudes. France had extended periods of positive relations with the Ottomans, but this did not result in a change in French attitudes toward Turkish people.[7] French Renaissance philosophers writing about the grotesque named it the "arabesque," thus linking Islam with disgust.[8] Michel Baudier charged, "18 out of 20 Ottoman sultans abandoned themselves to the love of boys and used them as women."[9] Pope Pius II accused Turks of being "wallowed in lust" and "addicted to prostitution and rape."[10] Early Protestants harbored similar views. Luther famously referred to the pope and Muhammad as the "bloodhound and the devil," and accused Muslims of "dog-marriage," a charge reflecting earlier characterizations of Muslims as dogs.[11] He and other Protestants also referred to Catholicism as "Turkopapalism."[12] Vitriol against Muslims, including their portrayal as monstrous characters, was spread through literature and art.

The end of the Middle Ages, rather than resulting in a reduction in monsters, opened the door to all kinds of "scientific" studies of miraculous creatures living on newly discovered islands and continents. Fantasies about giants, Amazons, and others were fairly common, and while these subjects will be examined more fully in the subsequent chapters, it is important to say something here about the new opportunities for monster-making. When Europeans encountered these new territories, their imaginations went into overdrive; thus during the Age of Exploration numerous monsters were purportedly observed in the Americas, the South Pacific, and other colonial spaces. This began with the sighting of islands in the Americas and the South Pacific, places that inspired a sense of mystery and wonder. For the European, "the unknown island is conceived as a self-contained possible world for the colonial imagination, a place where anything unexpected can happen."[13]

In Elizabethan drama and other genres of contemporaneous literature, we see this in the "monsters and other wonders [that] were so important in Renaissance literature."[14] Monsters were not limited to the New World or Oceania, however. Encounters with the monstrous races and creatures

that lived in the East continued to occupy the European *imaginaire*. Andre
Thevet's description of a Red Sea "monster of the size and proportion
of a tiger without a tail, but [with] the face of a well-formed man" is but
one example of the human-animal hybrids that continued to be associ-
ated with Muslim territories.[15] Turks figure prominently in these stories
of monsters, due to the many geographical spaces they occupied as well as
the threat that Ottoman power posed to the Europeans.

As in the Middle Ages, Muslims in the Renaissance were viewed as
creatures alienated from God, a fact demonstrated in the monstrous races
featured in Shakespearean-era dramas. The role of imagination is a criti-
cal part of this story. The English had a particularly astute understand-
ing of how this faculty functioned in relation to the mind; in fact, this
understanding bears an uncanny resemblance to Bourdieu's concern
with fantasy masquerading as reality. According to this view, "[a]lways
the imagination of fantasy is seen as a power operating in a framework
of other faculties and functions. In a definite hierarchical order of com-
munication, knowledge travels from the so-called 'outer' senses (the five
primary senses), to the 'inner' (Common Sense, Imagination and/or
Fantasy, Sensible Reason, and Memory, which occupy cells in the brain),
and thus to the highest rational, incorporeal powers (the Intellect or Wit
or Understanding, and the Will)."[16] The internalization of fantasies about
Jews and Muslims depended upon "the transmission of data through a
hierarchy of powers."[17]

Other monsters were found at home, showing that the belief in super-
natural creatures was not restricted to the appeal of the exotic and foreign.
Stories of monstrous births surged with the reign of Elizabeth I, symp-
tomatic of the male anxiety provoked by women in power.[18] Domestic
political events were often blamed on the birth or sudden appearance
of non-human or hybrid creatures. In 1645, a pamphlet claimed that the
birth of monsters served as an ominous sign of the first English Civil
War: "Hath not Nature altered her course so much, that women frame of
pure flesh and blood bring forth ugly and deformed Monsters; and con-
trariwise, Beasts bringeth forth humane shapes contrary to their kind."[19]
Reports of monsters were made in the American colonies as well, often in
reference to religious and political outsiders, as found in the stories and
artistic depictions of Mary Dyer's monstrous infant.[20]

Some Muslim monsters—Saracen giants and Black Saracens, Jewish
and Muslim *cynocephalie*—disappeared from texts and paintings. In par-
ticular cases, cultural types replaced the families of Muslim monstrous

races that medieval artists painted. For example, the foreign characters in Giotto's frescoes were patterned after Mediterranean and Asiatic peoples, "[i]n all these cases the representatives of historically and geographically distant countries no longer appear as monsters, masks, or puppets, but as human beings, sometimes of authentic portraiture."[21] However, this did not entail an end to Muslim monsters.

Turbaned Villains

Renaissance paintings of the Crucifixion often feature a snarling dog, a symbol of the Jew-dog, and turbaned figures who are shown harassing and injuring Christ or taking part in the execution of a Christian saint— much like the images of dog-headed men in medieval paintings. Jews also continued to be identified as canines in literature. *The Merchant of Venice* describes Shylock as a dog. "[Shylock is] the embodiment of his species. And the Jew's Jewish heart is wholly obdurate. He is a force of evil as strong as nature itself. No longer a dog to be controlled by beating and kicking, he has become an untamable wolf, an inferno of evil and hatred."[22] The turban, a common feature of medieval depictions of Saracens, persisted as a dominant symbol of the Muslim during the Renaissance. Curiously, it also appears in depictions of Jews in some paintings, possibly caused by the association of the turban with rabbinic clothing:

> In 1624 the theologian Joseph Hall associated the turban with the Israelite High Priest, but more than anything else, the English associated the turban with Islam. Throughout the seventeenth century, travel books with frontispieces portraying the divisions of the world and the empires of man presented the Turk/Muslim potentate with a turban. Even the engraving of the Prophet "Mahomet," which appeared in Alexander Ross's survey of world religions, shows that seventeenth-century Britons believed the turban to have first been donned by the founder of Islam himself.[23]

The portrayal of Jews with turbans may have also been due in part to the "Orientalizing" of both Jews and Muslims, who often appear side by side in Renaissance paintings wearing turbans. One case is found in Giovanni Antonio de Pordenone's painting of the Crucifixion in Cremona Cathedral. Turbaned Jews appear in Renaissance paintings that lack Muslim characters, such as the Limbourg Brothers' *Nativity*, which

features a Jewish figure with a "bulky 'Turkish'-style turban."[24] Ivan Davidson Kalmar has examined the use of the turban on Jewish subjects in Renaissance paintings, such as the example in Rembrandt's *David and Uriah*: "In Christian art, it is a common practice to represent Biblical Jews as if they were Muslims."[25] In some cases, Turkish imagery was incorporated into the Jewish figures: "In *David and Uriah*, for instance the two men's Ottoman-style turbans play a dominant part on the composition."[26] Here, Jewish and Muslim imagery is used much as it was in the Renaissance—to create a Jewish Muslim. In the Renaissance, these figures are not Jewish Sarrazins but Jewish Turks—Jews wearing turbans, Ottoman coats, and other Turkish accoutrements.

Another way that the presentation of Jewish and Muslim monsters altered during the Renaissance involved artistic skill. Instead of relying on purple or black skin, canine heads, or pig faces to represent monstrosity, the portrayal of facial expressions became popular. The production of Passion plays and the publication of Renaissance writings on the Passion influenced the graphic representations on the canvas, seen in the torment on Christ's face as well as the sinister and grotesque faces of the villains, who were often Jews and Muslims.[27] During the Renaissance, Jews and Muslims continued to be presented as a related enemy that helped to constitute European identity—"the shadow of an ageless ghost."[28]

In the Renaissance, the peoples of the Orient also appeared as decoration, a convention that began in thirteenth-century Italy, as a result of both Muslim tourists visiting Siena and Florence and the Italian tourists who visited the Islamic cities of Damascus, Aleppo, and Cairo. Trade played a significant role in these encounters, both in the promotion of tourism and the creation of wealth—the production of which supported the building projects in Venice inspired by Oriental architecture.[29] In addition to the Eastern styles subsumed in Venetian architecture, another result was seen in great paintings. Much like the Oriental characters, settings, and accoutrements present in Shakespearean drama, in Renaissance painting we see a continued interest in the East: "There are peasants and Bedouins in short coats and small turbans, or in North African hooded mantles; Syrians and men from Iraq with strongly-marked, bearded faces, long-flowing garments, often with embroidered Tiraz bands on their upper arms, mighty turbans and long neck- or breast-cloths; stout, brown Egyptians and Nubians with small turbans," and others, including Turks.[30]

In Renaissance art, the placement of figures, as in earlier centuries, spoke volumes about the themes being communicated. In some cases,

Jewish and Muslim villains are shown actively participating in crimes against Christians; in other cases, they are presented as the enemy through their placement on the canvas, even when the figures are inactive. In the *Triumph of Saint Thomas Aquinas* (c. 1340, Pisa, Santa Caterina), Averroes (Ibn Rushd), the great Muslim philosopher, appears below the Saint's feet, and his text is turned upside down to symbolize its blasphemous status.[31] In fifteenth-century painting, depictions illustrating the Church's victory over heresy were directed at the Turkish threat, although at times they showed both Jew and Muslim, "in the representation of symbolic threats."[32]

Jewish and Muslim characters also continued to appear in paintings depicting the suffering of Christ, as onlookers, instigators, or the murderers of the Son of God. In some examples, they wear turbans and have hooked noses—identifying them with Satan. This graphic quality was inspired by the popularity of the Passion.[33] Medieval and Renaissance narratives of the Passion co-identified Jews and Muslims, through such conventions as Jews praying to Mahomet and Muslims identified as Romans. These stories greatly impacted the art of the period.

It is difficult, if not impossible, to differentiate between Jewish and Muslim characters in many Renaissance paintings of Christ's arrest, torture, and death. Both continued to be portrayed as Christ-killers, appearing in scenes of the Crucifixion and executions of Christian martyrs. These are graphic depictions of violence, at times almost pornographic in their display of bodies and the violence done to them. In one depiction of the martyrdom of a Christian child titled the *Ritual Murder of Simon of Trent* (Cerveno, Parocchio San Martino), murderers surround the young victim in a scene that includes a turbaned man. Whether this figure is a Jew or Muslim is hard to say, given that Jews were sometimes portrayed with turbans. Jews and Muslims were often represented as co-criminals. In some paintings, the hierarchical arrangement was shifted, and the Muslim villain was replaced with a Jewish one, or vice versa. In the *Norsa Madonna* (c. 1499), the Muslim figure of Averroes seen in the Triumph of Saint Thomas Aquinas (c. 1323) is replaced with a Jewish family.[34] These paintings represent the ways in which Jews and Muslims were interchangeable in the minds of Christians as enemies *par excellence*.

Inspired by the medieval tradition of Muslim Christ-killers, and encouraged in part by the Passion and its anti-Semitic themes, Renaissance artists often depicted the executioners of Christian saints with turbans, typically wearing Turkish costumes. These depictions of

Turks as Christ-killers required a kind of time travel—an assumption that Ottomans were somehow present during an era that predated them by more than a thousand years:

> Muslim Turks were shown performing the biblical Massacre of the Innocents. A turbaned Pontius Pilate festooned a decorative balcony in Lorch in Upper Austria and elsewhere. Jesus's tormentors on his way to Calvary, along with the Pharisees and their henchmen, wore Turkish headdresses and brandished scimitars. Turks were coupled with the trials of this world as well. Sometime after 1480, the cathedral church of Graz commissioned a picture of God with three lances named 'Hunger, Sword, and Pestilence.' Beneath them were three specific plagues—locusts, the Plague, and the Turks.[35]

But of course this makes sense, given the medieval association of Jews and Muslims, seen in the charges that Muslims were "New Jews," the images of Jewish Sarrazins, and other examples of co-identification. In Renaissance painting, Jewish and Muslim figures often appear side by side, accompanied by symbols that further confuse the categories of Jew and Muslim. On a wall painting at the San Sacro Benedictine monastery in Subiaco, the flags surrounding the scene of Christ bearing the Cross include flags with Jewish badges and Muslim crescents.[36]

Christian attitudes toward the body changed with the Renaissance, due in part to a renewed interest in medicine and the sciences. During earlier centuries, there was a fear of bodily mutilation and dismemberment, an anxiety that contributed to the resurrection narrative expressed in the cannibalism mythologies that dominated medieval narratives featuring Muslim monsters.[37] During the years leading up to the Renaissance, in the period often identified by scholars as the proto-Renaissance, some of the taboos surrounding dissection and autopsies were lifted, resulting in the (purported) discovery of miracles hidden inside the bodies of saints and martyrs. These miracles served as proof that the miracle of Christ was evident in the mutilated bodies of his most devoted followers. For example, in 1308, Chiara of Montefalco died in the monastery where she served as abbess. The narrative about her body begins with a miracle—there is no bodily decay for five days, despite the summer temperatures—and continues after her body is preserved and then eviscerated.[38] Several years later, at her *processus* (which was unsuccessful), a nun from Chiara's

Umbrian monastery who was present at the dissection testified about what she had witnessed:

> And after the other nuns had left, Sister Francesca of Foligno, who is now dead, and Illuminata and Marina and Elena, who is now dead, went to cut open the body, and the said Francesca cut it open from the back with her own hand, as they had decided. And they took out the entrails in the oratory that evening. On the following evening, after vespers or thereabouts, the said Francesca, Margarita and Lucia and Caterina went to get the heart, which was in the box, as they later told the other nuns. And they said Francesca of Foligno cut open the heart with her own hand, and opening it they found in the heart a cross, or the image of a crucified Christ.[39]

The claims made about Chiara's body suggest that mutilation and resurrection were evidence of "the association of dismemberment and sanctity [that] continued to permeate popular attitudes into the sixteenth century."[40] Stories of mutilation and death at the hands of a religious enemy allowed the Church to suggest that the existence of miracles was inherent in the only true religion.

During the Renaissance, artists often included Turkish figures participating in the torture, mutilation, and execution of Christian saints. Three examples are Altichiero's *Beheading of St. George*, the Master of the Figdor Deposition's *Martyrdom of St. Lucy*, and Balthasar Moret's *Martyrdom of St. Tarbula*. Altichiero's painting is the mildest in terms of the violence depicted, as St. George is shown kneeling, awaiting his execution, surrounded by a large group of turbaned figures. The other two paintings are far more gruesome. In the *Martyrdom of St. Lucy*, turbaned figures look on as Lucy, who has already been put to the flame, stands in prayer. A Roman soldier pierces her heart. In the last example, the *Martyrdom of St. Tarbula* (Figure 3.1), turbaned figures observe the dismemberment of the saint. According to the narratives surrounding her death, Tarbula was cut in half, then dismembered and burned.

These Renaissance scenes display the suffering and martyrdom of the saints through decapitation, fire, and dismemberment, functioning in a similar way to the medieval theme of Saracen cannibalism. Both images reinforced the Christian narrative of the resurrection. Such scenes relate that even after torture, death, and decay, the eventual restoration by the hand of Christ will take place:

Malo mihi tortor violet quàm membra Cytheris:
Integra sum secto corpore sponsa Dei.

FIGURE 3.1 *Martyrdom of St. Tarbula.* Petro Bivero. Belgium, c. 1634. Utrecht, University Library, WRT 98-60, p. 61.

> Medieval images of the body have [their] role in medieval piety. . . . Medieval images of the body have less to do with sexuality than with fertility and decay. Control, discipline, even torture of the flesh is, in medieval devotion, not so much the physical rejection of physicality as the elevation of it—a horrible but delicious elevation—into a means of access to the divine.[41]

Although Turkish figures, typified by light skin and turbans, were commonly featured in Renaissance depictions of Christian martyrs, black Muslims make appearances as well. It is likely that this character is the

Black Turk, a character as connected to the devil, much like his prede-
cessor, the Black Saracen. In some cases, this character was identified
as a "Moor," a word used as a general descriptor for all Muslims. Black
Muslims were often featured in scenes that portrayed the devil. Following
the Battle of Lepanto in 1571, there was a parade featuring a Black African
as Charon, the ferryman who transported souls to Hades, as well as the
occupant of the boat, an Ottoman, both symbols of Islamic damnation.[42]
In a painting that depicts the murder of Justine, a black African wields
the dagger that will end her life, while Ottomans look on.[43] This scene
is repeated in several paintings that illustrate the martyrdom of saints,
scenes in which Ottomans are present, as either fair-skinned or African,
playing the role of onlookers, instigators, or participants.

Black Muslim characters appear in venues other than painting, includ-
ing the African Muslim monsters featured in Shakespearean-era drama
and the Austrian theater masks depicting Satan as a Black Saracen.[44]
In some of these masks, the physiognomy of Satan was replicated in an
exact fashion in a representation of a Black Muslim. Late medieval theater
masks of Satan feature black skin with warts, a large hooked nose, and a
crown. In a detail from the painting *Resurrection of Christ*, a Muslim is
depicted in just that way, with black skin, a wart on his cheek (the other
cheek is hidden), a large, hooked nose, and a turban (see Figure 3.2).

During the Renaissance, the black Muslim continued to occupy
a place in the Christian imaginary as a nefarious figure and enemy of
Christendom, as in Figure 2.5, where he participates in the torture of
Christ. Satan continued to be called a long list of names related to skin
color, including the black knight, black man, big Negro, black Jehovah,
and black Ethiopian.[45] Medieval and Renaissance art are certainly not the
only places we find such depictions, but they are more overtly linked to
Satan than in later periods. *The Disrobing of Christ* is another painting
featuring a villain—a Black Saracen, Moor, or Turk. In this example, a
Muslim is shown harassing Christ; also of interest is a character who car-
ries a shield with an African man's face on it, mirroring a medieval paint-
ing of Saracens carrying shields with African men on their faces. In this
case, the African is depicted with black skin, a large, hooked nose, and a
turban. In these images, we see the persistence of the trope of the Black
Muslim. Through his skin tone, he is implicated as a sinister enemy.

According to the Renaissance episteme, God's punishment was often
expressed on the bodies of Muslim characters. The existence of the Turks
was seen as a punishment for Christian sin. Evidence of God's wrath was

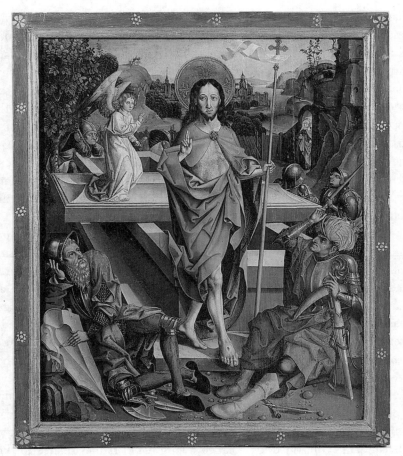

FIGURE 3.2 *Resurrection of Christ.* Artist of Wolfgang Katzheimer's Circle. Germany, c. 1490, Tiroler Landesmuseum Ferdinandeum, Innsbruck.

seen in many spaces. "The Renaissance detected scourges of God everywhere. They ranged from Timur, particularly under his Marlovian guise as Tamburlaine, to the less probable instance of lawyers ('Corrupt Lawyers are no doubt a scourge of God'). The most consistent invocation of this traditional belief was made in connection to the Ottoman Empire."[46] This way of seeing the Ottomans as both a curse and an enemy helped to create the Muslim monsters of the age.

Turcica, German collections of stories about Turks, include fantastic tales of perverse sexual behaviors and other disturbing stories of Ottoman life. The *Turcica* often focus on behaviors known as *sodomia*, a collection of acts that referred to any sexual act deviating from "normal" Christian

practices. Stories narrated in these collections detail the victimization of innocents, including children, females, and dead Christians. In one story, Turkish soldiers have sex with corpses—Christians killed in the fall of Constantinople.[47] Another tale claims that Muslims "have it off with those fish that possess sexual organs."[48] One strongly disturbing story tells of an old woman who disguises herself as a man, revealing herself to the bride—a beautiful virgin—on her wedding night.[49]

Other European literary genres feature milder Turkish monsters. English literature and drama typically portray the Turks as heretics who prayed to a god named "Mahomet, Mawmet, Mahoun, or Mahound," part of a pantheon that included "Apollin, Termagent, and other devilish idols."[50] Shakespeare and his contemporaries, who often presented Muslims as the central villains in their plays, often showed a fondness for Oriental accoutrements—carpets, costumes, tapestries, and furniture, as in *The Comedy of Errors* and *The Taming of the Shrew*. Examples include, "In the desk / That's cover'd o'er with Turkish tapestry," "My hangings all of Tyrian tapestry," and "Turkish cushions boss'd with pearl."[51] Few positive accounts of Muslim characters are found in Elizabethan writing, dramas or otherwise, usually following the old formulas of Islam as a heresy, Muhammad as the Antichrist, and Muslims as monsters. One exception is a purely descriptive, and thus non-polemical, account of Muslims that includes details of the Moors' rituals: "They turne their faces eastward when they kill anything. They use beades, and pray to saints."[52] Such descriptions reflect the Renaissance practice of describing foreigners in what we might call academic terms, seen as well in Venetian and other schools of painting.

In Elizabethan England, portrayals of Prophet Muhammad often relied on medieval polemics, resulting in characterizations as a heretic and sexual pervert. In some examples from literature and drama, the Prophet took the form of a monster, a dreaded beast, or as a "Mungrell born" creature with a scalded head.[53] As we have seen, by Shakespeare's time, the Turk had replaced the Arab as the dominant symbol of Islam, a shift that impacted representations of Muslim characters, whether of a human or monstrous nature. In William Painter's *The Palace of Pleasure*, the Turk is "wicked" and "cruel," with beastly attributes: the sultan's "madness" is more terrifying than "a wild lioness," and his "beastliness" "far exceeded [that of] beasts."[54]

Negative depictions of Muslim characters featured in Elizabethan drama are numerous as well. Tamburlaine and Othello are representative

of the monsters we are interested in here. As hybrids belonging to more than one monstrous race, they threatened notions of English racial purity. Tamburlaine is the central monster in Marlowe's play *Tamburlaine the Great*. However, before turning our attention to him, there is the Ottoman sultan Bayazid, who was the first portrayal of an Ottoman sultan on the stage.[55] He, too, is a monster, albeit a less complex one than Tamburlaine. Bayazid is described as a member of the "detestable and cursed sect of Islam," who appeals to his "god" Mahomet—a monster with "purple blood," which courses through the veins of all Turks.[56] Bajazet, the more prominent Turkish character in Marlowe's drama (the "Great Turk"), is also a dehumanized character, a member of the damned and vile race of Turks. Bajazet is unapologetically Muslim; he swears by "Mahomet's sepulcher, And by the holy Alcoran," and, like an animal, is put in a cage by Tamburlaine.[57] In contrast, Tamburlaine swears his allegiance to his sword, "that conquered Persia."[58] In formulating these characters, Marlowe was likely influenced by the account of Turkish history penned by John Foxe, published in 1570 and again in 1576 and 1583, before the publication of *Tamburlaine*.[59] Foxe relies on medieval theology, and specifically the history of the Church, in his account of the Turks.

> The sect of Muhammed began in 666, and the beast of the Apocalypse bore the same number. The rise of the Ottoman empire in 1300 coincided almost exactly with the time appointed for Satan's release and the renewed period of oppression and persecution forecast by Revelation. And it also coincided with the completed corruption of the Church under Boniface VIII.[60]

Tamburlaine's identity as a Muslim is less than subtle, expressed in the set of oppositions established in the text. Much like the set of dissentient characters seen in the medieval bestiary, he is an anti-Christian character. In Marlowe's other masterpiece, *The Jew of Malta*, the structure also establishes "an organizational scheme of Christendom versus its enemies."[61] While in *The Jew of Malta* these conflicts are more overt, displayed in the revenge of the title character against the Christians who surround him, in *Tamburlaine*, the title character's Muslim identity is expressed through the essentially "medieval" conception of Islam and of Christian/Muslim oppositions.[62]

Tamburlaine is described as a "monster that hath drunk a sea of blood," suggesting that he drinks the blood of humans.[63] He is identified

as a hydra, the multi-headed monster with the upper body of a woman and the lower body of a snake.[64] He is a monster alienated from God:

> *A monster of five hundred thousand heads,*
> *Compact of rapine, piracy, and spoil,*
> *The sum of men, the hate and scourge of God,*
> *Raves in Egyptia, and annoyeth us.*
> *My lord, it is the bloody Tamburlaine.*[65]

This description relies on the medieval depictions of Muslims as members of a monstrous race. Tamburlaine is a giant with fiery eyes, like the Saracen giants of medieval romances. His furrowed eyebrows reflect images of the Black Saracen as Satan found on medieval drama masks and in Renaissance paintings:

> *Of stature tall, and straightly fashioned,*
> *Like his desire, lift upwards and divine;*
> *So large of limbs, his joints so strongly knit,*
> *Such breadth of shoulders as might mainly bear*
> *Old Atlas' burden; 'twixt his manly pitch,*
> *A pearl more worth than all the world is plac'd,*
> *Wherein by curious sovereignty of art*
> *Are fix'd his piercing instruments of sight,*
> *Whose fiery circles bear encompassed*
> *A heaven of heavenly bodies in their spheres,*
> *That guides his steps and actions to the throne*
> *Where honour sits invested royally;*
> *Pale of complexion, wrought in him with passion,*
> *Thirsting with sovereignty and love of arms;*
> *His lofty brows in folds do figure death,*
> *And in their smoothness amity and life;*
> *About them hangs a knot of amber hair,*
> *Wrapped in curls, as fierce Achilles' was,*
> *On which the breath of heaven delights to play,*
> *Making it dance with wanton majesty;*
> *His arms and fingers long and sinewy,*
> *Betokening valour and excess of strength;*
> *In every part proportion'd like the man*
> *Should make the world subdu'd to Tamburlaine.*[66]

Tamburlaine is a member of at least four monstrous races—a hydra, a giant, and the offspring of both the Scythians and Tartars. The Scythians are attached to a 2,300-year-old mythology surrounding their supposed primitivism, cannibalism, and general monstrosity.[67] Tamburlaine's monstrosity is predicated in part on his Scythian and Tartarian blood-lines, as argued by Burnett: "Certainly, the joint attachment—both 'Scythian' and 'Tartarian'—of Tamburlaine has its place in the period's larger debates about developing national identity. But Marlowe's ethnic detailing comes alive, I would suggest, not only in material and trading connections but also via the mythic 'monstrous' inhabitants peopling Scythia and Tartaria in the social imaginary."[68] The Church fathers often referred to the Scythians as a monstrous race cursed by God. Tertullian described the Scythians as barbarians and cannibals, Orosius claimed they drank human blood instead of milk, and Jerome wrote that they "devour their slaughtered parents, kinsmen, neighbors, when they reach old age."[69] According to medieval and Renaissance texts, the Scythians were the offspring of Magog (and Gog), the biblical monster responsible for the plagues of Jews, Muslims, and other non-Christians.[70] This belief was expressed on maps illustrating the distribution of monstrous races in Europe and Asia. Shakespeare also makes an allusion to the Scythian appetite for human flesh in *King Lear*:

> Let it be so; thy truth, then, be thy dower:
> For, by the sacred radiance of the sun,
> The mysteries of Hecate, and the night;
> By all the operation of the orbs
> From whom we do exist, and cease to be;
> Here I disclaim all my paternal care,
> Propinquity and property of blood,
> And as a stranger to my heart and me
> Hold thee, from this, for ever. The barbarous Scythian,
> Or he that makes his generation messes
> To gorge his appetite, shall to my bosom
> Be as well neighbour'd, pitied, and relieved,
> As thou my sometime daughter.[71]

According to the *Carta Marina* (1516), the monsters occupying Tartaria—the Tartars—were located behind the mountain range that imprisoned Gog and Magog.[72] The *Carta Marina*, which is contemporary

with Marlowe and Shakespeare, shows a number of monstrous races that live in Tartaria, including *Parossites* (humans with miniature mouths who do not eat but survive on the steam that rises from cooking meat), *cynocephalie* (this particular variety of dog-heads had feet resembling cattle, a human head, and a dog's face), the unnamed (creatures with kneeless legs and no human speech), and the Samoyeds (wild men whose clothes and houses were made from animal skins).[73] Tamburlaine is the offspring of these creatures. He is a Muslim monster.

The identity of Shakespeare's Othello is a bit more complicated. While he denies his Muslim identity, and speaks strongly against Muslims in the play, his Moorish ancestry is what eventually does Othello in. Othello makes clear his hatred for the Turks, including the final scene before his death, when he calls the Muslim a "circumcised dog."[74] Yet, his descent into madness is predicated on his racial and religious foundations. He is unable to escape either his blackness or his Muslim bloodlines.

Othello is a hybrid monster of sorts, doubly cursed with African and other monstrous bloodlines. The belief that Africans were demons and monsters still dominated Europe during Shakespeare's time. In Stephen Bateman's study of monsters published in 1581, Africans are called "Black Monsters" and are described as such: "*Ethiopes*, a people in the West part of Ethiopia: also there are those black men, that have four eyes: and it is said that in Eripia be found very comely bodied men, notwithstanding they are long necked, and mouthed as a crane, the other part of the head like a man."[75] These fantasies were associated with all Africans, including Moors like Othello, whose black skin was associated with perdition and evil. In the twentieth century, Othello is more commonly associated with the tragic character portrayed on the stage by great thespians like Ira Aldridge and Paul Robeson, rather than with an African monster.[76] However, Elizabethans "associated [Africans] in the popular imagination with monsters, so that the play's numerous references to monstrosity would have resonated with Othello's racial characteristics to establish his extreme difference to typical Europeans."[77] Elizabethans thought that Africans *were* monsters. The constellation of attitudes concerning Africans was widespread and historically situated: "From Spanish hatred of the Moors, reinforced by the general Christian hatred of Mohammedans and by experiences of piratical depredations, came the Elizabethan emphasis upon the cruelty of these people—and upon their blackness."[78]

Stories of monstrous births and of demons, hairy beasts, and multi-headed creatures, often connected to the presence of Africans,

abounded in the popular press in newspapers and broadsheets in London
and other cities. A 1605 pamphlet titled *Strange News* claims a num-
ber of strange and grotesque births; an African is depicted alongside
a four-headed monster and a skeletal beast.[79] This is by no means the
only report of an African monster born alongside other monsters. Pierre
Boiastuau's 1589 publication includes the following description of beastly
infants:

> Damascenus a grave author doth assure this to be true, that being
> present with Charles, the iiiv. Emperor and king of Bohemia, there
> was brought to him a maid, rough and covered with hair like a bear,
> which the mother had brought forth in so hideous and deformed
> a shape, by having too much regard to the picture of S[aint] John
> clothed with a beast's skin, the which was tied or made fast con-
> tinually during her conception at her bed's feet. By the like means
> Hippocrates saved a princess accused of adultery, for that she was
> delivered of a child black like a *Ethiopian*, her husband being of a fair
> and white complexion, which by the persuasion of Hippocrates, was
> absolved and pardoned, for that child was like unto a [picture of a]
> *Moor*, accustomably tied at her bed.[80]

These reports about monstrous births reflect fears surrounding misce-
genation. At the same time that *Othello*, a play about the mixing of races
through the sexual union of Othello and Desdemona, is performed on
the stage, such creatures were thought to exist.[81] According to European
sources from the era, the sexual union of different races and even distinct
religions created horrible monsters. Ambroise Paré, a physician who lived
in sixteenth-century France, wrote a book on these horrors, titled *Des
Monstres et Prodiges*, in which he described the dangers of such relations:

> There are monsters that are born with a form that is half-animal
> and the other human, or retaining everything about them from
> animals, which are produced by sodomists and atheists who "join
> together" and break out of their bonds—unnaturally—with ani-
> mals, and from this are born several hideous monsters that bring
> great shame to those who look at them or speak of them.[82]

Like many texts on monsters, *Des Monstres* had a sensual element. The
original edition contained a section on lesbianism (considered a form of

monstrosity) that included "a graphic description of the female genitals," removed from later editions.[83]

Miscegenation is a central theme in *Othello*, expressed in both the act of mixed-race sex and the horrors it could create. The image of Othello and Desdemona having sex is described as "an old black ram. . . tupping [a] white ewe" and "the beast with two backs."[84] This union would result in a family of monsters, illustrated in Iago's warning that, "[y]ou'll have your nephews neigh to you; you'll have coursers for cousins, and gennets for Germans."[85] Later in the play he issues another warning, stating: "Hell and Night / Must bring this monstrous birth to the world's light."[86] The repulsion surrounding the union of Othello and Desdemona is explicitly tied to the Moor's identity as an African. Public reaction to *Othello*'s racial coupling was expressed centuries later, when a Russian lady described this union in the following way:

> Not the Moscow Maly Theatre, but the African jungle should have been filled and resounded with. . . the cries of this black, powerful, howling flesh. But by the very fact that the flesh is so powerful—that is genuinely black, so naturally un-white does it howl—that savage flesh did its savage work. It murdered and crushed the spirit. . . one's spirit cannot accept it—and in place of the highest enjoyment, this blatant flesh introduced into art, this natural black Othello, pardon me, only causes. . . revulsion.[87]

Othello's race identifies him as a monster. Even though he tries to act human, he meets an inescapable fate. Like Edward Scissorhands returning to the house on the hill, Othello cannot escape *what* he is—a monster. He ultimately proves, *"abluis Aethiopem, quid frustra"*—"You wash the Ethiopian, Why the labor in vain." Othello is and will always be a monster, "demonic hellfire, burnt by hellfire and cursed by God."[88] The text is quite clear on Othello's nature, calling him "horrible and grim."[89] Othello's identity is suggested when he discloses his intimate knowledge of monstrous races, at one point telling Desdemona about "[t]he Anthropophagi, and men whose heads, Do grow beneath their shoulders," creatures he has obviously seen in person.[90] He knows about the cannibals and *Blemmyae* because he had lived among them. According to the medieval and Renaissance episteme, Muslims had an intimate knowledge of the domain of monsters. Members of Shakespeare's audience viewed Africa as a land of horrors, with flames that reached as high as the moon

and cannibalistic Anthropophagi, creatures without heads, satyrs, and Troglodytes who lived in caves.[91]

Othello is a pseudo-Mahomet, recycling an old trope about the Muslim prophet—that he was an epileptic. Christian writers often accused Muhammad of being epileptic (considered a mental illness), as in the story cited earlier of his consumption by pigs after a seizure.[92] Othello is accused of being an epileptic, just like the Prophet:

> The Moor's ordeal parodies the physical collapse that accompanies an episode of divine possession—he kneels with Iago, falls down, and then undergoes a seizure like those experienced by other "prophesying" victims of "the falling sickness," a malady associated with both sacred and Satanic inspiration. Othello's epilepsy recalls that of the ur-Moor, Muhammad.[93]

Othello expresses another threat—the danger of "Turning Turk," where an Englishman (or woman) would become Turk, transforming into a violent beast. The English were fearful that Islam would turn "good Protestants to a state of damnation" due to the Muslim's "sexual/sensual temptation" and his (or her) "wrathful passion for power."[94] In *Othello*, this is expressed clearly in the lines, "Are we turned Turks, and to ourselves do that, Which heaven hath forbid the Ottomites?"[95] The only way for Othello to extinguish this part of himself is by suicide, "killing the Turk he has become."[96] Many images of Turks, including those which are cannibalized and decapitated, occupy the European imagination, and I now turn to these.

The Turk's Head

During the Renaissance and for centuries following, the Turk is an eponymous figure—in paintings, in literature and drama, in advertisements, and even appearing as a popular food. Business signage for pubs, coffeehouses, and tobacco houses often displayed a Turk, Saracen, or Blackamoor ("Black Moor") wearing a turban and brandishing a scimitar. Modern renderings of these signs are still used, typically at pubs and restaurants in Great Britain, such as the one at Waltham Abbey.[97] These more recent renditions are tame in comparison to the extinct signs of Elizabethan England, which included portrayals of the Turk, Saracen, and Blackamoor as a monster. Written sources provide clues about what

Elizabethan-era renderings of monstrous Saracens, Turks, and Moors looked like. One source describes an image of a Saracen in the following manner: "[he had] a Sarazins face, his nose too long for his lips, his cheeks like the jawes of a horse, his eyes like a Smithes forge."[98] In one commentary on these images that dates from 1634, they are described as having "huge, terrible faces (as you still see on the sign of the Saracen's head)."[99] While these images are identified as "Saracen," Saracens, Turks, and Moors were interchangeable categories, exchangeable descriptors of the Muslim enemy. In most cases, "no clear distinction was popularly drawn between Turks and Saracens."[100] Much like the late twentieth century, when "the Arab" was often used as a symbol for all Muslims, the Saracen, Turk, and Moor served as fluid signifiers of Muslim identity in earlier centuries.

The class of images identified as "Turk's Head" signs were often identified with a particular sultan, such as Morat/Amurath or Soliman/Suleiman.[101] These signs were more numerous than those depicting the Saracen, suggesting that the Turk functioned as a dominant symbol in this context.[102] Turk's Head signs were often associated with inns as well as coffee houses, the latter thanks to the introduction of coffee to Europe by the Ottomans circa 1529.[103] One modern example of a coffee shop with such a sign is Mile's, established in 1659.[104] Signs showing the Blackamoor's Head, which are no longer in use, were associated with tobacco houses and often showed "[p]ipe-smoking negroes, with feathered head-dresses and quilts."[105] The Blackamoor, or Black Moor, functioned as a negative sign, representing darkness, evil, and monstrosity, much as in earlier centuries. The Blackamoor also represented Satan in the "Bag of Nails" sign, popular until the eighteenth-century. This sign is still featured in London with a Turkish figure (see Figure 3.3).

The sign's history is explained here:

> The *Bag of Nails* was once a very common sign; there was in Larwood's time one still remaining in Arabella Row, Pimlico, and there is still one in Buckingham Palace Rd. About 1770 there might have been seen at the front of the house the original sign which depicted a satyr of the woods, and a group of Bacchanals. The satyr having been painted black with cloven feet, it was by common consent called the Devil, while the Bacchanalians were transmuted into a *Bag of Nails*. This however was only an old slang name for the house, for, in a conspiracy of 1765 one of the witnesses says "He went

FIGURE 3.3 Bag of Nails Sign. London. Courtesy of Fatima Van Hattum.

into a public-house, the sign of the *Devil & Bag of Nails*, for so that gentry called it upon themselves (though it was the *Blackamoor's Head & Woolpack*), by Buckingham Gate." This is presumably the *Bag o' Nails* still remaining in Buckingham Palace Rd.[106]

The Turk's Head is also the name given to a savory pie popular in Britain and France during the Elizabethan period that represented a cannibalistic feast of Turkish flesh. Typically, this pie was a grotesque caricature of a Turk or Saracen's face. By eating it, Christians consumed the enemy in an act of symbolic cannibalism. Its roots lie in a fictitious narrative of Christians eating Saracens in the medieval romance *Richard Couer de Lion*. The Turk's Head pie and its variations, a jelly and a pastry

(the *kugelhupf*), are further examples of how the Turk functioned in the European habitus as a dominant monster.

The Turk's Head pie was intended to resemble the bizarre and non-human physiognomy of the Turk or Saracen. Its "outlandish features" and "upturned face" in the crust that decorates the pie constitute a culinary representation of the Muslim monster.[107] A few recipes of the earlier French version of the pastry, called *Teste de Turke*, survive, including this one, which suggests how the covering on the pie could resemble a monstrous face: "[put] sugar on top, then a generous layer of ground pistachio nuts; the color of the ground nuts, red, yellow, and green. The head [of hair] should be black, arranged to resemble the hair of a woman, in a black bowl, with the face of a man set on top."[108] Variations on the Turk's Head included a jelly and pastry and varied in appearance, allowing for the representation of different Muslims, providing an "easy shift between Turk, Moor, and Black."[109] A recipe for the *Teste de Turke* found in an old French cookbook, is as follows:

> Here is a dish which is called Turk's head. Take pork and hens and cut into small pieces; then grind in a mortar, and put in good spices and saffron; put in plenty of eggs, some bread, and some whole almonds; all of the above-mentioned ingredients are to be ground together thoroughly in a mortar; then take a well-washed pig's stomach, stuff with the filling, and cook well; when it is done, take a skewer and pierce it through the middle and remove the skin [i.e., the stomach]; then take the egg yolks and beat them well with sugar in a bowl, and brush the roast all over.[110]

This recipe is a key part of the story of the monstrous Turk, especially in the use of a pig's skin. There is no evidence that the skin used in a Turk's Head pie ever came from an actual Turk, but the stomach casing is significant in its reference to the Islamic prohibition against eating pork, which Europeans knew well. By using swine to create an image of a Muslim, one symbolically insulted Islam through a culinary act. This pastry, which survives today, may well be based on a tale in *Richard Coeur de Lion*, in which Christian knights consume Turkish flesh, baked in the form of a pie.

Although the Turk's Head pie was probably inspired by medieval literature, it was not until the development of the French *tourtes* (the European *torte* and American tart) in the sixteenth century, made possible by the

invention of short crust pastry, that the Turk's Head pie became a popu-
lar food.[111] The dish signals how Europeans envisioned Muslims. In the
consumption of this food, a performance of symbolic cannibalism takes
place. "No fourteenth-century English cook is known to have prepared
for consumption the flesh of a real Turk, yet [we have] the Turk's Head, a
sweet-and-sour meat pie shaped and decorated to resemble the outlandish
features of a stereotyped Saracen."[112]

As we know from the previous chapter, tales of Saracen cannibalism
were a popular feature in the medieval imaginary. Anthropophagy often
played a prominent role in the *chansons de geste*, but in these stories it is
the Saracen—in most cases, a black-skinned or hairy Muslim giant—who
consumes the Christian.[113] However, in *Richard Couer de Lion*, there is
a reversal of this scenario, when two meals are made with the flesh of
executed Saracens; the first for Christian knights and the second for their
Muslim guests. Richard "instructs the cook to behead the highest rank-
ing captives in his prison, shave and boil the heads, and then serve them
up, each with a little name label attached to its forehead and with the
mouth stretched in 'a hideous grin,'" a grin that is still seen in modern
renderings of the dish.[114]

The Turk's Head pie functions as a symbol of Richard's fictitious can-
nibalistic meal, a retelling of "the spectacle of severed Saracens' heads,
stripped of hair, cooked, and laid out, face up and grinning, on serving
platters."[115] This imagery says something meaningful about the ways in
which Muslims are dehumanized. In the case of the Turk's Head pie, the
subject is figuratively decapitated, chopped up, cooked, and eaten, reduc-
ing him to a pastry that displays a deformed image of the creature he
once was. Cannibalism was not totally unheard of during this era. Some
Londoners practiced medicinal cannibalism and preferred that the cadav-
ers they consumed came from Libya.[116]

The Turk's Head remained a dominant symbol of Islam in Britain for
some time. In addition to its use on signage and in the Turk's Head pie,
it is also found in other parts of Europe. In 2010, I visited Schönbrunn
Palace, the summer residence of the Hapsburgs, where I made an unex-
pected discovery—a painting in Maria Theresa's "Carousel Room" that
depicts the carousel game (see Figure 3.4). In this case, there is a curious
addition, the decapitated head of a man floating in the background—a
"Turk's head."

The Ladies' Carousel was a favorite pastime of Maria Theresa's. In one
part of the game, an effigy of a decapitated Turk's head was used. Few

references to the Habsburg version of the game exist, but we know quite a bit about the equestrian game that was played in the court of Sweden's Queen Christina, which was quite similar.

The carousel game played in the seventeenth and eighteenth centuries at royal courts in Stockholm, Vienna, and other European courts originated in the Middle Ages, where the running of horses and performance of chivalric games like jousting were common forms of entertainment.[117] These games evolved into the *trionfi*, popular during the Italian Renaissance.[118] Due to its relative isolation and the closing of all printing presses by Gustavus Vasa, the Renaissance was late in reaching Sweden.[119] The carousel game played at Queen Christina's court predates Maria Theresa's reign by a century, as Christina's coronation took place in 1650. There is no image of a floating Turk's head at the court in Stockholm [Storkyran], but there is a good description of the carousel at Christina's procession: "The procession was led by Mars alongside another personification of war and three riders. The equestrian figures represented war

FIGURE 3.4 *Ladies Carousel*. Martins van Meytens. Austria, c. 1765. Schonnbrunn Palace.

conducted for the homeland, freedom and religion, that is to say, the righteous war that had been earlier embodied in some of the ballets."[120]

The first record we have of the Ladies' Carousel at Queen Christina's court is in 1654.[121] During the game, "[s]ome women competed with each other in catching suspended rings with their lances, sitting in sledges drawn by horses and with men at the reins."[122] This detailed description of the carousel game includes an explanation of the floating Turk's head:

> These carousels, the entertaining successors of medieval tournaments, were exceedingly popular in the Baroque era. Ladies' carousels continued to be performed in the Winter Riding School until the end of the nineteenth century. As the programme for the ceremony of 1743 days, the participants in the carousel, all ladies of noble birth, were dressed as "amazons" and wore leather trousers underneath their dresses. Like at medieval tournaments, figures, which were "in part Moors, in part other mythological figures," and had heads of clay which had to be knocked off with lances by the riders on horseback and with epees by the ladies driving in the carriages, were put up in the manege of the Winter Riding School. The ladies also had to demonstrate their skill with the pistol and the javelin.[123]

The ghostly figure in the background of the painting in Austria represents the clay effigy of a Turk's head, an object that, although already decapitated, was knocked off its pedestal. This description from a Habsburg emissary of an Ottoman military commander suggests how Turks were viewed by the Austrians: "A thick bodied eunuch with sallow complexion, he had, 'a sour look, scowling eyes, broad shoulders that stuck up, from which his head extruded as from a valley. With two teeth like boars' tusks dominating his mouth [and] his voice, hoarse. . . he was the Fourth Fury."[124] The carousel game offered a way for the Turkish monster to be exterminated through the imagination.

In addition to the example of the carousel painting, other Muslim monsters continued to be generated during the Enlightenment. Carl Linnaeus, the famous Swedish Enlightenment scientist, classified a species of beings—*Homo monstrous*—monsters that were delineated from human beings.[125] *Homo monstrous* was then divided into three types of monsters—*Homo troglodytes*, *Homo caudatus*, and *Homo marinus*.[126] Linnaeus influenced later generations of scientists, including those who

traveled on voyages of exploration. Many monsters were purportedly observed on these voyages, including some in regions of the globe that Europeans only "discovered" in the fifteenth century and after.

At this point, we enter modernity, a transition perhaps best understood as a number of shifts in consciousness in which religion remained a powerful force in people's lives but existed as one of several options, instead of the explanation for all matter in the universe. As Charles Taylor explains, Christians "changed not just from a condition where most people lived 'naively' in a construal (part Christian, part related to 'spirits' of pagan origin) as simple reality, to one in which almost no one is capable of this, but all see their option as one among many."[127] This affected the way monsters were created in profound ways. Because of the Enlightenment, not all monsters were theologically constructed. Many monsters were the result of the scientific imagination. Still, the past continued to influence the present in numerous ways:

> Educated Europeans of the early Enlightenment inherited a view of foreign peoples which was part-fantasy and part-hearsay, little more than an exotic fiction with which to expose the venality of European life, as in Montesquieu's Persian Letters, or reportage shaped in such a way as to administer a crude justification for economic penetration and religious conquest, as in Richard Haklut or Samuel Purchase.[128]

During the eighteenth and nineteenth centuries, Muslim monsters were viewed as existing in a world of limitless possibilities that arose through an age of scientific discoveries and geographic exploration. Inspired by a resurrection of medievalism and the emergence of Orientalism, many new Muslim monsters emerged.

4

The Monsters of Orientalism

IN THE EIGHTEENTH and nineteenth centuries, we see "an intensification of the persecution of marginals." African, Jewish, Muslim, and American Indian bodies continued to serve as signs of evil. All magic was black, and it was associated with Jews, Muslims, women, witches, and folk healers. In modernity, "[t]he first effect of disenchantment was not to do away with demons," but actually, to cause "the demons to get concentrated."[1] One of the places where demons got concentrated was in foreign bodies.

These centuries continued to see the production of fantastic Muslim characters, including monsters. Several prominent philosophical, intellectual, and artistic movements affected the production of Muslim monsters, including the Enlightenment, Orientalism, and Romanticism, with its rich offshoot, the Gothic, resulting in an episteme of continued anti-Muslim rhetoric that was largely situated in fantasies that first emerged in the Middle Ages. The Enlightenment's focus on science, for all of its rationalism, included a rebirth of teratology, the study of monsters inspired by "monstrous births."[2] The focus on scientific inquiry also inspired monsters that were the result of exploration, mapping, and the discovery of new lands. Francis Bacon, whose work *Novum Organon* served as the model for Enlightenment scientific endeavors, urged that all monsters be documented, a task taken seriously by generations of scientists.[3]

The Enlightenment's focus on rationalism and science did the opposite of what might be expected, inspiring new legions of monsters in domestic and foreign spaces, rather than eradicating them. This makes sense if we accept Charles Taylor's argument that evil became even more generalized in modernity, which was further impacted by Protestantism's

suppression of iconography. All of this inspired new categories of monsters that emerged as a way for the imagination to express itself in socially acceptable ways that did not offend religious morals. "Perhaps frustrated by the loss of fanciful creatures as officially sanctioned displacements, many people instead turned their attention at this time to human scapegoating."[4] Mythologies about witches, vampires, and werewolves were situated in particular social groups and classes. Like other monstrous characters, the medieval Wild Man, depicted as a giant with large, exposed sexual organs, survived into modernity, yet another manifestations of the West's "repressed corners of human desire and anxiety and fear."[5]

Gender also figured in the creation of modern monsters. Whereas in the Middle Ages and Renaissance demons were largely identified with particular bodies, particularly Jews, Africans, and Muslims, in modernity, monsters were everywhere. *Indigenous* monsters, the English, French, German, and other European creatures that inhabited the European landscape, included the "monstrous births" attributed to maternal sin, the presence of foreign bodies, and cases of miscegenation blamed on minority groups living in Europe. Many of these cases involved gender and sexuality, whether in the identity of the monster (witches) or in the desire of a particular body (the Jewess, the Muslimah, the Polynesian, and so forth).

When these monsters emerged in the popular imagination, anxieties about women were on the rise. The Romantic movement inspired the genre of Gothic horror, which includes a corpus of frightening images related to femininity. Indeed, women are the "curious thread running through this labyrinth."[6] In one story, a dead infant is held by an incompetent mother; in another, a horrible female monster is created and then destroyed; and there are the murderous women, at times cast as Catholics (a sign of medievalism and decay) and at other times as Orientals, or immoral Christian women, who pay dearly for their slutty ways.[7]

European monsters were also situated in anxieties outside of gender. One famous example is the tales of beasts that roamed the Massif Central region of France, an area known as Gévaudan. Like many other monsters of the late eighteenth century, these beasts (probably wolves that attacked women and children tending sheep) were explained as a consequence of Divine unrest.[8] Beliefs in witches and fairies, satyrs, and other hybrids (including dog-men) were accompanied by stories of supernatural animals that could create sickness or death by glancing at their victim.[9] One theory of the Gévaudan monster(s) was that it came from the East—a

monstrous Simian from Malaysia.[10] It was also identified as a hyena, a beast long associated, as we have seen, with Jews.[11]

Monsters also continued to appear abroad, often in colonial spaces that functioned simultaneously as sites of desire and repulsion, expressions of the European mindset of the time, a "proto-anthropology with racist and political overtones."[12] Exotic monsters, from the giant cannibals of Fiji to the *croco-sapiens* of Egypt, continued to populate the imaginations of tourists, explorers, and the even the most brilliant scientists. Unfamiliar landscapes inspired new monsters, a result of the European (and later, American) attitudes surrounding untamed places, places that were scary in and of themselves. "But forests and mountains—and with them deserts, jungles, even islands—need not to be populated to be fearsome. It was enough that these places were wild: *that* was the trigger to the terror."[13]

Muslims were not the only people depicted as monsters. Exotic locales inspired treatments of the inhabitants that were more sensual than monstrous, such as Tahiti and Hawai'i, where frightening descriptions of the territories and peoples emerged. Europeans and Americans described the gods of Polynesia as monstrous characters, even demonic. The goddess Pele, from the perspective of indigenous Hawaiians, serves as the ruler of a dangerous environment.[14] For *haole* (white) missionaries and scholars, however, she was often represented as a horrendous monster, a hideous old hag who murdered for pleasure.[15] The exaggerations of Fijian body size, of Tahitian cannibalism, and of other peoples in Oceania often utilized a language rich in monstrous imagery.

Whereas the Enlightenment generated monsters in the spirit of endless possibilities, the Romantic movement challenged the Enlightenment's vision of an ordered and rational universe, emphasizing particular themes—passion, individualism, and imagination.[16] This led to even more monsters. The Enlightenment started in the seventeenth century and ended in the late eighteenth century; the Romantic period ran from 1798 to 1824, ending with the death of Lord Byron.[17] I am less concerned with the details of periodization than with the fact that *both* the Enlightenment and Romanticism inspired new Muslim monsters. As mentioned above, Enlightenment monsters were often framed as a result of science, such as the creatures purportedly seen by explorers. In contrast, Romantic and Gothic monsters represent the chaos in the world, often reflecting pre-modern sensibilities, including a reliance on medieval narrative structures and imagery. As a child of Romanticism,

the Gothic was also critical of the Enlightenment. In the words of Scott Poole, "the Gothic form slapped the face of Enlightenment rationalism with supernatural themes, often politicizing its critique of reason."[18]

It is probably safe to say that Orientalism created more villains than monsters, in romantic Orientalist literature, painting, and architecture. It also influenced larger European and American attitudes toward the East, Islam, and Muslims through its promotion of fantasies, including frightening depictions of landscapes inhabited with all manner of terrible things. Ideas of a fantastic East full of marvelous wonders, a desert wasteland occupied by monsters, and the differences represented in Muslim bodies informed modern horror, particularly through Orientalism's presence in Gothic fiction. Orientalism's influence on this genre relies on a resurrection of medievalism, including its Muslim horrors. In Gothic fiction, we find a number of frightening Muslim monsters, from a Muslim demon called Zofloya to a blood-sucking vampire named Dracula. These monsters represent new anxieties and reflect old phantasms about race, foreign bodies, miscegenation, and even cannibalism. Before examining these characters, however, let us look at some of the Muslim monsters generated by the Enlightenment.

Monsters of Early Modernity

For Enlightenment philosophers, there is evidence of what Benedict Robinson has called a "crisis of representation," the struggle between humanism and the imagination evident in the treatment of Muhammad and Islam in general, which wavers between a measured rationalism and polemical superstition.[19] Leibniz was one of several philosophers who faced this crisis in his writings: Was Muhammad an enlightened thinker, a medieval humanist, or a force of destruction and evil?

> In the history of Western responses to Islam, what is fascinating about Leibniz is that he exemplifies a certain ideological overlap, a peculiar transition between a theological repudiation of Islam (Muslims as enemies of Christ) and an early Enlightenment rejection of the "Mohammedan" (Muslims as enemies of reason and civilization). Sometimes Leibniz's Mohammedan is the Erbfeind or hereditary enemy/ritual foe, other times he is elevated to the status of mere barbarian, whilst on rare occasions he is even grudgingly acknowledged to be the professor of a natural (though still errant) philosophy.[20]

Critiques of religion, especially of Catholicism, represent a large part of the Enlightenment corpus, and reflect several anthropocentric shifts, including "the idea that we owe God anything further than the realization of his plan," "the decline of hell," and an end to the "sense of mystery" that dominated pre-modern thinking.[21] Often, Islam was employed as a symbol of Catholicism (or religion in general), a way to disguise contempt for Christian dogma: "the encyclopedists used Oriental difference as a structuring trope to criticize their own society."[22] This symbol is easily identified in some of the works of Voltaire and others.

The harsh polemics of the Middle Ages and Renaissance are less common in Enlightenment works, but do exist. Leibniz depicts Muslims as an accumulation of "barbarous Mohammedans, lazy Turks, and lascivious Egyptians."[23] He also insists that Muslims are fatalistic, a result of Islam's inability to deal with its foundations—what he refers to as the *Fatum Mahometanum*.[24] These works raise serious questions about Islamic theology, such as the organization of the Qur'an and the "ridiculous titles" of its chapters (*surahs*) that, from the perspective of Europeans, had no relationship to content.[25]

In some of these writings, Islam is lauded for its rejection of idol worship, which several Enlightenment philosophers viewed as an irrational behavior that Christians should stop participating in.[26] As shown above, Leibniz, while critical of Muslims in general, compliments Muhammad, describing him as a natural philosopher who transformed natural religion into law. In one instance, he writes, "[Muhammad] showed no divergence from the great dogmas of natural theology. . . and abolished in many countries heathen superstitions which were contrary to the true doctrine of the unity of God and the immortality of souls."[27] Islam is also credited with enriching German language and culture through the production of Arabic and Turkish philosophical works.[28]

Voltaire's play *Le Fanatisme ou Mahomet le Prophete*, despite its title, represents Muhammad as a rational thinker and a romantic figure. In his *Philosophical Dictionary*, Voltaire was strongly critical of the stereotypes surrounding Islam as a sensual religion, "I tell you again, ignorant imbeciles, whom other ignoramuses have made believe that the Mohammedan religion is voluptuous and sensual, there is not a word of truth in it; you have been deceived on this point as on so many others."[29] He also charged that Christians have projected their own idolatrous practices on Muslims: "I conclude by noting that in the times we named the Middle Ages, we called the country of the Mohammedans heathendom.

We qualified as idolaters, image-worshippers, a people who have a horror of images. We must admit once more that the Turks would be more pardonable to take us for idolaters when they see our altars loaded with images and statues."[30] In these examples, we see some of the more positive treatments of Islam.

In a few cases, Muhammad is compared to other famous historical characters. Two Enlightenment philosophers, Chevalier de Jaucourt and Voltaire, compare him to Alexander the Great. De Jaucourt is primarily known as an encyclopedist, and in his comparison with Alexander he writes, "He had a lively and powerful eloquence, stripped of reason and logic, which was necessary for the Arabs; an air of authority and insinuation, animated by piercing eyes and a good physique; the intrepidity of Alexander; the liberty, and the sobriety that Alexander needed to become a great man."[31] Voltaire, never one to mince words, compares Muhammad to Jesus in a biting critique of Christianity: "At least his lies were more noble, and his fanaticism more generous. At least Mahomet wrote and fought; Jesus did not know how to write nor how to defend himself. Mahomet had the courage of Alexander. . . and your Jesus sweated blood and water as soon as he was condemned."[32]

The Enlightenment was populated with fantasies about magical lands occupied by foreign monsters, including Muslims. Until James Cook's second voyage during the years 1772–1775, the myth of *terra australis incognito* remained a formative influence on European map-making. The theory was that this continent, located in the Southern Hemisphere, balanced the earth so it would not tip over.[33] Even when this myth was disproved, others emerged—for instance, of the perfect humans who lived in Otaheite (accompanied by exaggerated reports of public orgasmic rituals and massive cannibalistic occasions), the giants of Fiji, and other magical places and peoples.[34] Some of the same mythologies are in place today. When I visited Fiji in 1995, one could purchase "flesh platters" (instead of wooden plates) and "cannibal forks" (instead of salad tongs), and the originals of these items, as well as "evidence" of Fiji's giants, were on display at the museum in Suva. As these examples attest, the South Pacific, "in a debased sense remains, a place of dreams," and nightmares.[35] The growing popularity of books during this period in part explains why the mythologies have become part of the modern social imaginary. "Culturally arrogant and ethnocentric observations of non-European peoples were given immortality in western culture by the printed page."[36] Muslim lands were also prone to exaggeration and fantasy.

Like Oceania, the Orient was represented as a place of dreams and night-mares, which were often expressed along gender lines. Miscegenation, an anxiety rather pronounced when it came to many exotic locales, is often absent in Polynesian romances, which frequently include a white man romancing a Tahitian, Hawaiian, or other Polynesian maiden.[37] The fan-tasies associated with the South Pacific influenced some of the ways in which Muslims were represented, especially in Romantic fiction, such as the novellas penned by Pierre Loti. Loti wrote himself into many love stories with foreign, nubile, young women, including both Polynesian and Muslim maidens. In *The Marriage of Loti*, he falls in love with a Tahitian named Rarahu, and in *Aziyade*, with a Turkish girl. These two excerpts, which describe the two characters, demonstrate how Polynesian and Muslim females functioned as almost identical objects of desire in Romantic fiction:

> Rarahu had tawny black eyes, full of exotic languor, of wheedling softness, like those of kittens when one strokes them. Her eyelashes were so long, so black, that one might have taken them for painted feathers. Her nose was short and delicate, like that in certain Arab faces. Her mouth, a little wider and more cleft than in the clas-sic type, had deep corners with a delicious contour. . . . Her hair, perfumed with sandalwood, was long, straight, and a little coarse. Her entire body from head to toe was the dusky brick-red hue of the light earthenware of ancient Etruria.[38]
>
> The lady of the eyes rose and showed herself down to her gir-dle, in the long stiff folds of a Turkish *fereje* (mantle) of green silk embroidered in silver. A white veil was arranged with care over her head, revealing only her forehead and her enormous eyes. The irises were of a vivid emerald, that sea-green hue celebrated by the Eastern poets of old.[39]

Romanticism contributes to the Western *imaginaire* surrounding Islam, even today. Fantasies about maidens and monsters influenced the ways in which Orientalism constructed Jewish and Muslim men and women. Polynesian men were sexually objectified, at times as much as their female counterparts, and the same was true for Muslims. In the genre of Romantic Orientalism, we find descriptions of the East as a "ter-rain of bitumen pools, river-bores, whirlpools and rainbows in moving waters."[40] What Mohammad Sharafuddin calls "romantic moralism," in

which Arabs were "not merely superstitious people, but cultured beings capable of spiritual experience," was quite rare in comparison to the large numbers of negative depictions in the literature and art of the period.[41]

The fantasies generated about South Pacific islands situated in Romantic ideals like the uncorrupted man—the noble savage—emerged out of environmental determinism. In colonial accounts of Otahiete (Tahiti), beautiful men and women frolic in turquoise lagoons, greet foreigners with garlands of flowers, and have large sex orgies in public. The desire for Tahitian women resulted in the growing value of nails from European ships as an important commodity traded for sexual favors.[42] In contrast to the numerous depictions of Polynesians as perfect, unspoiled humans, Arabs were seldom represented as noble savages. One exception is James Bruce, a Scottish explorer who traveled extensively in North Africa:

> The dictates of nature in the heart of the honest Pagan [i.e., the Arab nomad], constantly employed in long, lonely and dangerous voyages, awakened him often to reflect who that Providence was that invisibly governed him. . . . Possessed of charity, steady in his duty to his parents, full of veneration for his superiors, attentive and merciful even to his beasts; in a word, containing in his heart the principles of the first religion, which God has inculcated in the heart of Noah, the Arab was already prepared to embrace a much more perfect one than what Christianity, at that time, disfigured by folly and superstition, appeared to him to be.[43]

The Romantic treatment of Polynesians and Orientals (both Jew and Muslim) are accompanied by stories of monsters occupying islands in the South Pacific and the deserts of Arabia. One example is found in *The Life and Astonishing Adventures of John Daniel* (1751), in which Daniel travels in a "flying machine" to a South Pacific island inhabited by humanoid sea creatures. These monsters:

> bore the exact resemblance of the human species in their erect posture and limbs, save their mouths were as broad as whole faces, and had very little chins; their arms seemed all bone, and very thin, their hands had very long fingers, and webbed between with long claws on them, and their feet were just the same, with very little heel; their legs and thighs long, and straight, with long scales on

them, and the other parts of their bodies were exactly human but covered with the same hair as a seal.[44]

European travelers in the Orient also claimed that human/animal hybrids roamed the land and water. In Egypt they claimed to have observed a human/crocodile hybrid, which is not the only Muslim monster that occupies the Orient. With a few exceptions, the monsters of Orientalism are radically different from their predecessors—human-animal hybrids, sea monsters, and the like were replaced by images of Muslim men as morally depraved and hyper-violent villains. This was not the end of monsters, but rather a transitory period that re-defined them:

> The consequence of this [Enlightenment] critique is not the disappearance of the monster. During the Enlightenment, teratological galleries will remain an important category of the imagination. However, the monsters of modernity do not possess the same radical alterity of their classical and medieval predecessors but are rather the excrescence of an almost domestic world, mere deviations from the figures of normality. The sciences of physiognomy and criminology begin to describe, instead of sinners against God and nature, a constellation of degenerates, such as rapists.[45]

The noble savages of Romantic Orientalism soon faded away, to be replaced by degenerate and evil Arab men—characters determined, in part, by a desire for the Muslim female. Although these are not the imaginary, non-human monsters examined thus far, Oriental villains strongly influence the monsters found in Gothic horror fiction and later in horror films, which make them an important part of the archive of Muslim monsters.

Orientalism

With the invasion of Egypt by Napoleon in 1798, the French embarked on a grand colonial project that, as one of its effects, established Orientalism as the colonial and scholarly movement that survives to this day. As Julie Kalman explains,

> The initial work of Napoleon's intellectual army gained momentum following his campaign, and, through the first half of the nineteenth century, the great scholar of the Orient Silvestre de

Sacy—who was to train a generation of Orientalists—led the charge of academics, writers, artists, and adventurers who served as mediators for those in France, interpreting and packaging the Orient for French consumption.[46]

Early Orientalists were predominantly men, with only a few female exceptions like Freya Stark and Gertrude Bell. These individuals invented the Orient—the "romantic projection of Western masculinity upon the East, the expression of a boyish love of adventure upon the territory and body of the natives.[47] Orientalism has an incredible power as the discourse "embedded in a long intertextual chain" that begins in the Middle Ages and continues to be expressed today in everything from political science to contemporary art.[48]

In its most limited definition, Orientalism created the Western-defined territorial and cultural fiction that is an integral part of Occidentalism, an identity predicated upon the exoticized and inferior Orient. This *cognitive mapping* of the Orient resulted in the drawing of borders and the reduction of complex social and cultural groups to meaningless identities. The framing of the Orient as a wild and uncontrolled environment helped to explain why the Oriental was viewed as "irrational, depraved (fallen), childlike, 'different' "—the opposite of the European, the American, the Christian.[49] In literature, art, and cinema, such characterizations are seen in the Muslim despot (who cannot help but be violent because he is a product of his environment and religion, both unrestrained and violent) and the Oriental landscapes found in Gothic horror, which feature blood-streaked skies and medievalesque subterranean chasms that swallow the innocent victims of Muslim monsters.

Orientalism also has a less terrifying side, a place where we see Romanticism showing itself in the depictions of Muslims that were so popular in the eighteenth and nineteenth centuries. Romantic Orientalism reflects the "romantic moralism" favored by a few writers, but the focus is more often on the Orient as a place of dreams and fantasies—fantastic palaces, endless feasts with exotic foods, harems occupied by numerous beautiful maidens, Eastern ornaments, and furniture—than on good Muslims. James Thomsen's *Castle of Indolence* demonstrates this particular reliance on Oriental exoticism:

> *Such the gay splendor; luxurious state,*
> *Of Califs old, who on the Tygris shore*

> *In mighty Bagdat, populous and great,*
> *Held their bright court, where was of ladie shore;*
> *And verse, love, music, still the garland wore.*[50]

Typically, Romantic Orientalism features a negative male character suffering from arrested development and, in many cases, a villain, often a Turkish despot, reflecting the ongoing anxiety posed by the Ottomans and Islam in general.

> Islam seemed to Southey to be dominated by tyranny and submission. From the sources available to him on the Near Orient, he could hardly have perceived Islamic society as being otherwise. Almost all orientalists' sources, from d'Herbelot's *Bibliotèque orientale* to Henley's notes on Beckford's *Vathek*, repeat stories that centre on oriental tyranny of one kind or another. Sale's account of the ancient Arab king of Tasm, the Yemeni Jewish king, Dhu Nowas, and the Nooman of Hirah are only three among innumerable examples.[51]

Most of the great Romantic poets were strongly influenced by Orientalism. Shelley described the Turks as a race that would "reign in hell."[52] His poem *Hellas* describes the rape of virgins and impaling of soldiers by Turkish soldiers, "Go! Bid them pay themselves / With Christian blood! Are there no Grecian virgins / Whose shrieks and spasms and tears they may enjoy? / No infidel children to impale on spears?"[53] Byron's poem *Turkish Tales* also references Turkish crimes:

> *But thou, false Infidel! Shalt writhe*
> *Beneath avenging Monkir's scythe;*
> *And from its torment 'scape alone*
> *To wander round lost Eblis' throne;*
> *And fire unquench'd, unquenchable—*
> *Around—within—they heart shall dwell,*
> *Nor ear can hear, nor tongue can tell*
> *The tortures of that inward hell!*[54]

In surveying the literature, it can be hard to differentiate between Oriental Jews and Oriental Muslims, be they Arab, Turk, Persian, or North African, because they were all depicted as "backwards, degenerate,

uncivilized, and retarded."[55] This follows from Orientalism's tendency to define everything outside Occidental space in broad strokes, placing it into an order that benefits the West and its agents:

> To the great modern system for the classification of cultures Said gave the name Orientalism and viewed the hierarchies of this system as marking the presence of a "reconstructed religious impulse, a naturalized supernaturalism." The emergence of this modern classification of cultures does not represent for Said "a sudden access of objective knowledge" but rather "a set of structures inherited from the past, secularized, redisposed, and re-formed by such disciplines as philology, which in turn were naturalized, modernized, and laicized substitutes for (or versions of) Christian supernaturalism."[56]

Orientalism is another place where we find Jewish-Muslim relationships expressed. As several scholars have argued, it is an ideology that closely resembles anti-Semitism.[57] During his lifetime, Said suggested that the two share a similar anthropology in European discourse. This position has been taken up to some degree by other scholars. As stated in previous chapters, in the Middle Ages, Jews and Muslims were often equated in the minds of Christians, and this shared identity continues to be expressed in Renaissance paintings of Jews and Muslims wearing turbans, either harassing Christ or executing a saint. But this is not what Said was pointing to, and in fact, his work addresses colonialism and modernity, not the history of Islamophobia. As he explains, Orientalism is not a detached intellectual project:

> The nexus of knowledge and power creating "the Oriental" and in a sense obliterating him as a human being is therefore not for me an exclusively academic matter. Yet it is an intellectual matter of some very obvious importance. I have been able to put to use my humanistic and political concerns for the analysis and description of a very worldly matter, the rise, the development, and consolidation of Orientalism. Too often literature and culture are presumed to be politically, even historically innocent; it has regularly seemed otherwise to me, and certainly my study of Orientalism has convinced me (and I hope it will convince my literary colleagues) that society and literary culture can only be studied together. In addition, and

by an almost inescapable logic, I have found myself writing the history of a strange, secret sharer of Western anti-Semitism. That anti-Semitism and, as I have discussed it in its Islamic branch, Orientalism resemble each other very closely is a historical, cultural, and political truth that needs only be mentioned to an Arab Palestinian for its irony to be perfectly understood.[58]

Arguing against Said, some have suggested that this connection is situated only in power—that Orientalism and anti-Semitism are deployed in similar ways, but beyond this, no relationship exists between the two. James Pasto challenges the notion that these are "comparable discourses."[59] Bryan S. Turner disagrees with this view. By citing the Orientalist constructs of Islam and Judaism, Turner provides a way of seeing the two systems of thought as only discernable by the shortcomings ascribed to Muslims and Jews:

> Although Edward Said has argued that there is a tenacious persistence within the Orientalist discourse by which Islam is reproduced in western analysis, it can also be said that the accounting scheme for understanding Judaism is equally persistent. Whereas Islam appears as a series of gaps, Judaism is represented as a system of contradictory combinations: usurious behavior and traditional economics; a universal God and an exclusive pariah membership; a rational anti-magical ethos and irrational practices. The problem of "the Jewish question" can thus be seen as a problem of locating Judaism at the intersections of rational/irrationality, universalism/particularism, exclusion/inclusion and of modernity/tradition. Within Orientalism, there are two related discourses for Semites: the Islamic discourse of gaps and the Judaic discourse of contradictions.[60]

In my evaluation, Turner's analysis misses something important: Muslims were often described as possessing the same characteristics as Jews, suggesting that there is even more of a relationship than outlined above. Like Jews, Muslims are described as a racial type, represented by the Arab in Orientalist "scholarship."

An article on the Arab personality type describes Muslims as members of a pariah community, characterized by "irrationality or emotionalism, rigidity of thought, extreme suspiciousness and mistrust, free-floating

hostility. . . fatalism, laziness, [a] lack of cooperative spirit, and [finally] authoritarianism."[61] Even when the Orientalist assigned different negative attributes to the Muslim and Jew, the differences often disappear from view. As Gil Anidjar explains, "Enemies both, the Jew and Arab receive distinct determinations, one military and political, the other theological. This is not to say that other, indeed, even the same determinations were to disappear entirely from view—and we have seen that in regard to enemies, the distinction between them always was a weak distinction structurally, one that tended towards its own vanishing."[62]

The Orientalist and, in particular, German fondness for anti-Semitism supports Said's contention that Orientalism and anti-Semitism are related. The Orientalist view of the Semite, those people who cannot "shake loose the pastoral, desert environment of his tent and tribe," also reveals a hatred of Jews.[63] In fact, the Gottingen historian August Ludwig invented the modern concept of Semitism to describe all the peoples of the Orient—Jews and Muslims—a concept that is later incorporated into the fantasies of German Aryanism and an Indo-Germanic heritage.[64] Another key figure in this story is the Enlightenment writer John David Michaelis, who argued that the southern climate in which Jews evolved made assimilation impossible. As he put it, Jews were an "unmixed race [*ungemischte Race*] of a more southern people" that "even in ten generations" could not become German.[65] According to this view, Jews were a product of the Orient and should be deported to a "southern" climate with the "cruel heat" they were used to.[66] Johann Gottfried Herder critiqued Michaelis, citing his 1761–1763 expedition to Arabia for failing to adequately include Muslims in his Semitic qualification. Herder, reflecting a view that becomes a common one in Orientalist discourse, famously argued that it "is unimportant from which particular 'tribe' this Oriental might derive, whether he is a Jew, Muslim, or Christian. . . [there] is a vision of the essential Oriental."[67] As we know, this discourse was influential in many circles. For instance, Ezra Pound, well known for his anti-Semitism, writes that the "near-Eastern races" are a "group unto themselves" living in the "Jew Asia."[68]

In Orientalist discourse, even when Jews and Muslims are portrayed in different ways, the category of "Oriental" remains in play. In some cases, Jews are less vilified than Muslims, and in other cases the reverse. Reina Lewis describes this as "the latent anti-Semitic aggressions that were otherwise camouflaged or side-lined by a series of periodically more overt hostilities towards the more distant and more successfully 'othered' people

of the colonies [Muslims]."[69] In much of the literature, Oriental Jews are depicted as greedy, such as in a nineteenth-century travel book with this description of the Jewish men of Istanbul—"Moses the guide is a merchant, and when he is not attending to business in one branch he is attending to it in another."[70] Nicolas de Nicolay's remark, "the detestable nation of the Jews [these are] men full of malice, fraud, deceit," provides another example of Christian depiction of Jews as greedy, untrustworthy, and a bit dangerous.[71] Muslims were portrayed as greedy, but also cruel and violent, both in writings and in pictorial images from the colonial period.

The Oriental, whether Jew or Muslim, develops as a "transtemporal, transindividual category, purporting to predict every discrete 'act' of 'Semitic' behavior on the basis of some pre-existing 'Semitic' essence, and aiming to interpret all aspects of human life and activity in terms of some 'Semitic' element."[72] In the literature, Oriental Semites are often described as relics of the past, a type that lived "outside history."[73] Muslims and Jews were commonly compared to each other, "nomadic Arabs, conveniently enough. . . remained trapped in the state of childhood [seen as] characteristic of the ancient Israelites."[74]

The notion that the Oriental was trapped in time is expressed in W. M. L. de Wette's description of Judaism as a "degenerate, petrified" state, and originates in descriptions of the Orient as an extreme, dangerous, and stagnant region.[75] Such descriptions originate in ancient times. One example is found in Procopius's statement, "it seemed to the Homeritae a difficult thing to cross a country which extended so far that a long time was required for the journey across it, and then to go against a people much more warlike than themselves."[76] The condition of the Oriental was believed to be a product of his "desert mode of existence. . . [that] foster the extremes in emotions so characteristic" of Muslims, which resulted in "blurred perception and the inability to distinguish between truth and falsehood."[77] Neither Jew nor Muslim could be trusted because of the irrational nature that their wild and uninhibited desert environment engendered. In one colonial-era drawing, a Muslim holy man is pictured jumping up and down on a sick child to cure him of an ailment.

Depictions of the petrified Orient and arrested Oriental are not restricted to Orientalist scholarship. Ralph Waldo Emerson wrote this little gem contrasting the Oriental and Western environs and their people:

Oriental life and society, especially in the southern nations, stand in violent contrast with the multitudinous detail, the secular

stability, and the vast average of comfort of the Western nations. Life in the East is fierce, short, hazardous, and in extremes. Its elements are few and simple, not exhibiting the long range of undulation of European existence, but rapidly reaching the best and the worst. The rich feed on fruits and game—the poor, on a watermelon's peel. All or nothing is the genius of the Oriental life. Favour of the Sultan, or his displeasure, is a question of Fate. A war is undertaken for an epigram or a distich, as in Europe for a duchy. The prolific sun and the sudden and rank plenty which this heat engenders, makes subsistence easy. On the other side, the desert, the simoon, the lion and the plague engender it, and life hangs on the contingency of a kin of water more or less.[78]

In the genre of fiction known as "The Arab of the Desert," the desert "symbolized the alleged unproductive, fossilized nature of the Arab and Muslim world," which was in need of European stewardship.[79] Because of their arrested development, the Arab, Turk, and African could not take care of themselves and needed outside help.

In colonial-era literature, Muslim characters are presented as greedy, untrustworthy, backward, and violent—the "key menacing figure" in the Oriental milieu—a product of the desert's wild and petrified nature.[80] Descriptions of Egypt often refer to barbarity and cruelty, both reflected in depictions of the men of the region. In a review of the novel *Sethos*, Egypt is "that nation of sages, and of savages; the source of philosophic illumination, and the sink of barbarous ignorance; the mistress of the mightiest and the tributary of the meanest; earth's palace of splendor, and her hospital of wretchedness."[81] The use of "mistress" is not accidental. The Orient was envisioned as a place awaiting European conquest, and European men traveling to Oriental shores often referred to it as "a voyage towards Woman."[82]

Orientalist descriptions of Muslim women are an extension of the Orient as a commodity. Muslim women were described as exhibiting a "revolting immorality," and exhibiting their unrestrained sexuality in public, much like the depictions of other desirable non-European females.[83] In one description, Muslim dancers perform in "a blaze of Oriental vice," "heads and breasts now thrown back, now thrown forward to within a hand's breath of my face, their flesh quivering."[84] Classification and acquisition were key processes in the Orientalist project, and "the desire to sexually possess the other" was a key "part of [the] colonialist heritage."[85]

In Gerard de Nerval's *Voyage en Orient*, he confesses, "It is essential that I shall unite myself with some innocent young girl belonging to this sacred soil which is the original fatherland of us all, and drench myself once again in the life-giving springs of humanity, from which flowed the poetry and religion of our fathers."[86]

This viewpoint was not restricted to the Muslim; typically, "[s]ex and sexuality are important sites in which other peoples and places tend to be exoticized."[87] The Oriental Jewess is also a part of Orientalist discourse, and like her Muslim counterpart, she was contrasted to the Jewish man, a figure of repulsion and disgust. In Charles Didier's writings on Morocco, we have an indication of how Jews were viewed in Orientalist discourse:

> The lowest passions of humanity, avarice and fear, are the two distinctive traits of the modern children of Israel; they wear its indelible mark on their face and in their entire person. They look at you with a sidelong and worried expression, and they mask the terror that possesses their heart under a syrupy smile that is painful to look at when studied. The Jew does not speak; he whispers like a prisoner who fears waking his executioner who has fallen asleep. The Jew does not walk; he glides along the walls, his eyes on the lookout, his ears pricked, and he turns corners closely, like a thief under pursuit. . . . The Jew's ugliness is a highly specific ugliness and it belongs only to him. There is no deformity in his trait; yet, faithful mirror to his interior life, his physiognomy has an ignobility and a brutality about it that cannot be defined, which is striking at the first glance, and which is invincibly repulsive. It is a moral ugliness; it is the soul that is deformed, and which is reproduced in each of the features.[88]

In contrast, the Jewess exists as a seductive and desirable commodity that European and American men longed to possess.

> The sensuality of Oriental women was one of the main themes in French representations of the Orient, and Jewish women were included in this imagery. . . . Men from disparate fields such as Hugo and the painter Eugene Delacroix—as well as the lesser known writer Charles Didier—all found in the Orient and its Jewess something that was sufficiently distant to be idealized and made mysterious, but which nonetheless retained elements of familiarity. All

contributed to the ambiguous image of the Jewess who was both spiritual and carnal: beautiful, sensual, and knowing."[89]

Sexual fantasies of Oriental women were not limited to seductive Muslim and Jewish females, but often included the darker aspects of the sexual power attached to these figures.[90] This led to the production of some of the only female Muslim monsters found outside the Middle Ages. Muslim female monsters emerged in the colonial era because of the multiplicity of ways that Muslim female bodies were envisioned— "as mother, evil seducer, licentious aberration."[91] This gave the imagination new space in which to create monsters. Flaubert is well known for his sexual exploits with Muslim males and females, including his fondness for young boys. The following scene from *Salammbo* describes an Oriental goddess's inner chamber as a phantasmagoric scene of horrors:

> A dazzling light made them drop their eyes. All around they saw an infinite number of beasts, lean, panting, brandishing their claws, and mixed one on top of the other in mysterious and frightening confusion. Serpents had feet, bulls wings, man-headed fish were eating fruit, flowers were blossoming in crocodile's jaws, and elephants with raised trunks passed proud as eagles through the blue sky. Their incomplete or multiple limbs were swollen by their terrible exertions. As they put out their tongues they looked as though they were trying to force out their souls; and every shape was to be found there, as if a seed pod had burst in a sudden explosion and emptied itself over the walls of the room.[92]

Early Orientalist horror is full of female Muslim monsters such as the ape-like creature in *She*, a "two-thousand year old demonic half-goddess, whose beauty literally blinds her beholders, and whose touch kills them."[93] Authored by Henry Rider Haggard, *She* (1886) is an interesting text, reflecting gender and racial insecurities in Victorian England. The monster, whose name is Ayesha (the name of one of the Prophet's wives), self-identifies as an Arab, at one point exclaiming, "for Arabian am I by birth, even 'al Arab al 'Ariba (an Arab of the Arabs), and of the race of our father Yarab, the son of Khatan. . . of the true Arab blood."[94] In this tale of horror, Ayesha has complete control over men, which she uses to infect and pollute the pure bloodlines of the white race. Ayesha (Aisha), one of

the Prophet's wives, is described in Christian polemics as being particu-
larly sensual, as this character is.[95]

Female Muslim monsters, like their male counterparts, were sym-
bols of fear. Anxieties surrounding race, sexual desire, and identity
found a place for expression in these characters, even the ones who were
human-like. Take, for example, *Jane Eyre's* Bertha, the West Indian wife of
Rochester: "What it was, whether beast or human being, one could not, at
first sight, tell: it groveled, seemingly, on all fours; it snatched and growled
like some strange wild animal; but it was covered with clothing; and a
quantity of dark, grizzled hair, wild as a man, hid its head and face."[96]

Many Oriental monsters were related to the Turks, while others
were attached to Arab, African, and Persian bodies. Attitudes toward
the Ottomans continued to generate fantastic stories about non-Turkish
Muslims living under Ottoman rule. In the eighteenth century, English
travelers in Egypt claimed that a creature existed that was part crocodile
and part human. According to one account, "their [sexual] members [were]
like" those of humans.[97] A century later, another *croco-sapien* appeared in
an anti-Catholic comic in an American newspaper, a case in which fan-
tasies about Hindus sacrificing their children to crocodiles were placed
upon Catholic bodies—proof of the power of Orientalist monsters.[98]

The Egyptian *croco-sapien* is an example of the construction of marvel-
ous fictive creatures that were situated in fantasies about Muslims. It is
worth remembering here that fantasies about Muslim sexual monstros-
ity have a long history; one only needs to recall the claims of Prophet
Muhammad's sexual superpowers, the reports of gargantuan Muslim
penises that Jews and Christians would have to carry into heaven, or
the wild stories contained in the *Turcica*. The *croco-sapien* is but another
example of a wild and fantastic monster that emerged out of the habitus
of Muslim monsters:

> Crocodiles were clearly a different thing: actually existing creatures
> from far distant areas, especially dangerous ones of monstrous size
> that inhabit both land and water, might well have seemed to cross
> between human and animal orders. Nor, perhaps, should it be sur-
> prising that sexual difference was a specific site of such contra-
> vention since it was fondly imagined that the lands ruled by the
> Ottomans were a place where all manner of bizarre and un-natural
> forms of sexuality could be found.[99]

Orientalism is a pervasive intellectual movement that became broadly cultural, influencing fashion, advertising, architecture, literature, art, and eventually, film. To preface the following section, it is necessary to understand Orientalism as the source or inspiration for an endless number of commodities. The consumption of these products represents the European and American possession of the Orient and its people. In many cases, the consumption was literal—seen in purchasable commodities—textiles, lighting fixtures, furniture, *objets d'art*, jewelry, and other products. In other cases, it was metaphorical, such as viewing harem photographs or an Orientalist painting of a nude Muslim female. "Consumer Orientalism" resulted from growing consumerism, along with a desire to possess a token of Otherness. As Diego Saglia explains, "Romantic uses of the East are distinguished by an increased representational accuracy and a growing materiality of the orient within an overarching 'consumer orientalism.' The East is more and more readily available in a metropolitan space which sees a burgeoning consumption of the oriental in the shape of products, objects, visual experiences and literary texts."[100]

Another way in which people experienced the Orient was through literature, exemplified in Bram Stoker's adoption of a travel diary as a narrative device in *Dracula*. Stories were often set in an Oriental locale (also the case with Dracula, set in former Ottoman territory), exotic lands fraught with dangers, as in Beckford's *Vathek*, whose central character is a Muslim ultimately damned for his numerous sins, including homosexuality and mass murder of a group of naked young boys. Gothic horror, a subgenre of Romantic literature that will be examined in the following chapter, was aligned with the growing popularity of Orientalism.

As an area of consumption and production—the assemblage, demolition and reconstitution of otherness—the oriental undergoes important transformations in Romantic-period culture and, perhaps most conspicuously, in literary discourse where this shift emerges in the transition from "pseudo-oriental" eighteenth-century textuality to the more accurate, archaeologically documented works of Romantic literature, a development parallel to the contemporaneous popularization of the orient in the form of objects, spectacles and narratives.[101]

Romanticism and the Gothic

Romantic literature contributed to the creation of Muslim monsters through its depiction of Arabs, Moors, Turks, and Persians as depraved, violent, and cruel. In Gothic horror, which emerges from the Romantic genre, representations of Muslim men as villains are expanded to characters that can only be described as monsters. Gothic horror, "the fiction of the haunted castle, the blackly lowering villain. . . ghosts, vampires,"[102] is a reaction to the Enlightenment. It challenged the "rational project" of the Enlightenment, proposing instead a world of passion, terror, and horror, rejecting order and reasonableness.[103] This brief genealogy of the Romantic and Gothic genres helps us to understand how the two are historically and stylistically related, and how they stand in opposition to the Enlightenment:

> The historical origins of Gothic writing in the eighteenth century are simultaneously political and aesthetic. Rising along with the English novel during the same decades that are the prelude to Romanticism, the Gothic in its narrative form engages issues of beauty, the character of the sublime and the grotesque, the political dynamics of British culture (especially with regard to the kind of social change that comes to be represented by the French revolution), the quality of being English (including the holding of anti-Catholic religious attitudes), the structure of the economy (especially concerning property in a market economy and gift-exchange), and the place of women in hierarchies of power. Stylistically, the Gothic has always been excessive in its responses to conventions that foster the order and clarity of realistic representations, conventions that embody a cultural insistence on containment. The essentially anti-realistic character of Gothic writing from the beginning creates in advance a compatibility with modernist writing.[104]

The word "Gothic" poses definitional challenges due to the large number of styles it refers to. Jack Morgan has argued for a definition that applies to both "the horror genre as well as to its particular 18th century manifestations," which I am adopting here.[105] Gothic monsters differ from their predecessors by virtue of their mobility (among other features). These creatures often travel to London and other European sites, violating the borders that keep Christians safe. Gothic's resurrection of medievalism

is seen in its storylines, characters, settings, and accoutrements. Gothic Muslim monsters have a "diabolic monstrosity" similar to the Muslim monsters examined in earlier eras.[106] They enjoy the hunt and the kill.

Gothic horror is a genre marked by racism, chauvinism, and misogyny. Its monsters are typically non-white—Oriental, African, or otherwise non-European—creatures that pose a threat to Western masculinity, culture, and racial sanctity. Dracula, a hybrid Jewish-Turkish vampire, is pallid, a condition based on his endless need for more human blood, an affliction situated in part in mythologies of Jewish male menstruation. He is sexually ambiguous and opportunistic. Possessing a harem but still unsatisfied, he victimizes men and young children as well as European women. As the book begins, the Englishman Jonathon Harker departs the civilized world of Vienna and Munich, "leaving the West and entering the East," and enters the wasteland of Transylvania, passing through a town that still bears the marks of a seventeenth-century war (it is arrested in time, like all of the East), with roadside shrines and "peasants meeting him with warnings or charms and gifts to ward off evil."[107] This landscape is "primitive, sublime, and horrifying."[108] The wasteland of Transylvania functions as a character in Stoker's text, a malevolent monster that entraps and terrorizes (and often kills) all those who enter it.

In Gothic horror tales, monsters often transform an innocuous "Western" environment when they cross into it, exemplifying the danger of foreign bodies and the fear of reverse-colonization.[109] When he crosses the boundary from the East (Transylvania) into the West (civilized Europe), Dracula immediately begins infecting the pure racial bloodlines of Britain, an expression of the concerns about Irish, Jewish, and Turkish racial contamination. All of this—Dracula's poly-sexuality, his violation of English borders, and his insatiable appetite for human flesh—are symptomatic of British anxiety about race, reverse colonialism, and sex. Like other Muslim monsters, Dracula represents a long list of desires, including lesbianism and oral sex.

Gender figures prominently in Gothic narratives in monsters cast as nuns, mothers, and other females and as landscapes that function as symbols of female genitalia. In the Gothic, "[a]rt withdraws into caverns, castles, prison-cells, tombs, coffins. Gothic is a style of claustrophobic sensuality. *Its closed spaces are demonic wombs.* The gothic novel is sexually archaic; it withdraws into chthonian darkness."[110] The tales examined below all express this sensibility: in Beckford's *Vathek*, massacred boys are thrown into a subterranean pit; in *Zofloya*, there is no escape from

the large dark forest that surrounds the victims; and in *Dracula*, there are numerous prisons—Dracula's castle, the coffins, the mental hospital, and the illness that consumes Lucy and the monster's other victims. These spaces are, as Paglia notes, all womb-like. Gender often characterizes Gothic monsters. Dracula is gender-ambiguous; he is presented as almost androgynous—attractive to both Jonathon and Mina—a Gothic David Bowie.

Gothic monsters are often sexual monsters. Zofloya is a Moorish Satan. Seductive and attractive, he is simultaneously repulsive and desirable. Vathek is queer, and when egged on by his dark-skinned Indian lover (a monster with green teeth and pasty, discolored skin), he becomes a sadomasochistic pedophile, murdering young naked boys in a homoerotic carnival of horror.[111] Dracula sucks on the flesh of his victims, both male and female, adult and child, and his copulation with humans, like Othello's with Desdemona, always carries the threat of monstrous offspring. Muslim monsters express "the conventional assortment of Gothic atrocities—incest, necrophilia, necromancy, murder, and other forms of abuse."[112]

Orientalism and medievalism are prominent themes in Romantic literature. For these writers and poets, medieval culture was "the undiluted source of the modern in its primal, pure form."[113] Epic journeys and tales, such as the search for the Grail, were retold in Romantic poetry and fiction, with heroes like King Arthur and Sir Gawain posed against familiar enemies—Jews and Muslims. In Milton's *Paradise Lost*, the Saracens are described in the typical medieval fashion:

> *What resounds*
> *In Fable or Romance of Uther's Son*
> *Begirt with British and Armoric Knights;*
> *And all who since, Baptiz'd or Infidel*
> *Jousted in Aspramount or Montalban,*
> *Damasco, or Marocco, or Trebisond,*
> *Or whom Biserta sent from Afric shore*
> *When Charlemain with all his Peerage fell*
> *By Fontarabbia.*[114]

The Christian knight was often featured in the Gothic narrative. The knight is "heir to the ancient Germanic tradition of freedom and honour, of loyalty to the leader and heroic courage in war. On the other

hand he is a Christian, whose deeds must be just, whose love pure, and whose sword must be used only to serve the weak and the poor."[115] The enemies of Romantic and Gothic literature are the same ones that we find in the *chansons de geste* and other medieval genres. In *Paradise Lost*, Satan is called the "great sultan."[116] In Browning's *Childe Roland to the Dark Tower Came*, from 1855, a medieval battle between Christians and Jews is referenced when the character passes by the site of the long-ago conflict.[117]

The revival of medievalism also influenced the visual arts, often including representations of monsters. One particularly interesting example is the Italian theme park called Parco di Mostri, whose ruins still stand today. This attraction, built between the years 1523 and 1585, remained popular during the eighteenth and nineteenth centuries and still stands today.[118] Medieval aesthetics were also expressed in the Gothic style seen in the architecture of the period. William Beckford, the eccentric author of *Vathek*, took his fascination with the medieval so seriously that he became delusional, building a medieval retreat that included the highest spire in England (which collapsed while he was away in London), a 12-mile wall, and a pack of wild dogs reminiscent of the pack of wolves that surround Dracula's castle.[119] On one occasion an "uninvited visitor (the cousin of the painter W. P. Firth) was treated graciously by Beckford, then informed of the dogs that evening as he was ushered out the door. He spent the night in a tree."[120] Beckford incorporated Orientalism into his medieval lifestyle, calling himself "the caliph" and referring to his estate, Fonthill, as "Bagdad," and identifying with his title character, Vathek.[121] In his writing, Beckford was inspired by the darker imagery associated with Orientalism. In *Vathek*, "the monstrous, threatening genii found in *The Thousand One Nights* (more commonly known as *The Arabian Nights*)," were replaced with skies streaked with blood, a demonic Indian, and a monster named Vathek who commits numerous crimes, including the immolation (in a fiery pit resembling the hell-chambers seen in medieval painting) of 50 children.[122]

Romanticism rejected the Enlightenment's insistence on observable matter and rationalism, instead focusing on the subconscious, dreams, and a wild imagination. As Paul Goetsch explains, "The pre-Romantic and Romantic discourse on imagination and superstition emerged from the Enlightenment's context of skepticism. Various writers criticized the high evaluation of reason and the predominance of scientific rationalism."[123]

In Gothic horror, dreams often functioned as warnings, as in *Zofloya, the Moor,* when Victoria has a dream of the Moor shortly before he appears before her. In *Dracula,* dreams function as a space of the subconscious where the monster and his victims meet. In many examples from the literature, dreams are liminal spaces where the worlds of reality and fantasy collide.[124] Lord Byron's poem titled "The Dream" argues that these states are not only powerful, but also prophetic:

> *Our life is twofold; Sleep hath its own world,*
> *A boundary between the things misnamed*
> *Death and existence; Sleep hath its own world,*
> *And a wide realm of wild reality,*
> *And dreams in their development have breath,*
> *And tears, and tortures, and the touch of joy;*
> *They leave a weight upon our waking thoughts,*
> *They take a weight off from waking toils,*
> *They do divide our being; they become*
> *A portion of ourselves as of our time,*
> *And look like heralds of eternity;*
> *They pass like spirits of the past—they speak*
> *Like sibyls of the future; they have power—*
> *The tyranny of pleasure and of pain;*
> *They make us what we were not—what they will,*
> *And shake us with the vision that's gone by,*
> *The dread of vanished shadows—Are they so?*
> *Is not the past all shadow?—What are they?*
> *Creations of the mind?—The mind can make*
> *Substances, and people planets of its own*
> *With beings brighter than have been, and give*
> *A breath to forms which can outlive all flesh.*
> *I would recall a vision which I dreamed*
> *Perchance in sleep—for in itself a thought,*
> *A slumbering thought, is capable of years,*
> *And curdles a long life into one hour.*[125]

The dreams and nightmares that inspired Gothic tales were often fueled by drug use. De Quincey's nightmare took him to Africa, Indostan, and Egypt, a subconscious journey filled with monsters likely induced by opium consumption:

I was stared at, hooted at, grinned at, chattered at, by monkeys, by paroquets, by cockatoos, I ran into pagodas: and was fixed, for centuries, at the summit, or in secret rooms; I was the idol; I was the priest; I was worshipped; I was sacrificed. I fled from the wrath of Brama through all the forests of Asia: Vishnu hated me: Seeva laid wait for me. I came suddenly upon Isis and Osiris: I had done a deed, they said, which the iblis and crocodile trembled at. I was buried, for a thousand years, in stone coffins, with mummies and sphinxes, in narrow chambers at the heart of eternal pyramids. I was kissed, with cancerous kisses, by crocodiles; and laid, confounded with all unutterable slimy things, amongst reeds and Nilotic mud.[126]

Masterpieces of horror were also influenced by drug use. Mary Shelley's masterpiece of horror, *Frankenstein*, written when she was just 19, may have been fueled by an opium trip. As dramatized in Ken Russell's 1986 film *Gothic*, Shelley and a group of her friends spend a strange night at Diodati on the shore of Lake Geneva, in which drug consumption and the reading of horror tales inspired not only *Frankenstein*, but also Dr. Polidori's story *The Vampyre*, which served as an inspiration for Bram Stoker's *Dracula*. Russell's film assumes that opium was consumed by all those present, and while this cannot be proven, it is certainly the case that Mary relied on the drug to help alleviate her chronic health problems (she died at the age of 53, likely succumbing to meningioma).[127] The events on the night in question follow here:

On the night of June 16 [1816], the Shelley party dined at Diodati and was caught in a torrential downpour; they spent most of the night around the fireplace reading aloud a book of German horror stories. This inspired Byron to propose they each write a similar ghost story. On the night of June 21, Mary had a "waking dream," or nightmare, that fueled her vivid imagination and created the core plot for her classic novel, *Frankenstein*. Dr. Polidori, who later committed suicide, submitted *The Vampyre*, reported to be the inspiration for Bram Stoker's *Dracula*.[128]

The vision that Mary Shelley experienced on June 21 was a "waking opium dream," and included the hallucinations that inspired *Frankenstein*.[129]

Not surprisingly, Shelley's text has Orientalist overtones. Frankenstein's monster is an amalgam of different body parts and pieces, and the manner in which Shelley describes the creature reflects the same anxieties surrounding masculinity and race that are expressed in the other Gothic horror tales examined in this chapter. Shelley's husband's poetry often expresses a strong dislike for Turks, such as in *Hellas*, but Percy was also enamored with some aspects of the Ottoman culture, especially the "harem philosophy," which he identified with the Godwinian philosophy of free love, much to Mary's discomfort.[130] Orientalism, as stated earlier in this chapter, was an important part of the Romantic-Gothic milieu, and appears to have influenced the writing of *Frankenstein* in several places, such as the numerous references to Turks and in the description of Henry Clerval's studies of the Orient:

> He came to the university with the design of making himself complete master of the Oriental languages, as thus he should open a field for the plan of life he had marked out for himself. Resolved to pursue no inglorious career, he turned his eyes towards the East as affording scope for his spirit of enterprise. The Persian, Arabic, and Sanskrit languages engaged his attention.[131]

The "Creature" in Shelley's book is a giant and is repeatedly likened to a mummy, as well as being identified as an Oriental. His size is monstrous—"a being which had the shape of a man, but apparently of gigantic stature."[132] References to his resemblance to an Egyptian mummy include Victor's comment, "A mummy again endued with animation could not be so hideous as that wretch" and Captain Walton's observation, "As he hung over the coffin, his face was concealed by long locks of ragged hair; but one vast hand was extended, in colour and apparent texture, like that of a mummy."[133] When *Frankenstein* was written, Orientalism and Egyptology were popular in Britain. These interests eventually led to the writing of mummy tales and films, which will be examined in the following chapter.

Frankenstein's monster is described as a "savage" who, during his exile, inhabits a far-away land north of the "wilds of Tartary and Russia."[134] His grotesque, yellow pallor is contrasted with Victor's normal white skin tone.[135] The monster's skin color and hair are repeatedly compared to normal (white) humans. From the beginning, race helps to organize the narrative: the monster's "first lessons include an ordering of the world at once

racist, imperialist, and sexist—an oppositional structure ironically reinforced by his own exile away from the company of man."[136] *Frankenstein's* monster is a symbol of racial alterity. Mary was influenced by her exposure to narratives about Africa and the West Indies. According to her journal, Mary read the first two volumes of Mungo Park's study of West Africa and in 1816, the year Frankenstein was penned, Mary and Percy read the third volume of this study.[137]

The monster kills several humans, including Dr. Frankenstein's younger brother. But in his murder of the doctor's bride, Elizabeth, one finds an uncanny resemblance to another monster—Othello. This may be a double inspiration for Frankenstein's monster, who is described as both a mummy (Oriental) and an African throughout the book. In the 1818 edition, "the sharp contrast between the hazel-eyed, auburn-haired, high browed, fragile white woman and the dark monster" is evident, and in the 1831 edition, it is even more so, as this passage suggests: "Her hair was the brightest living gold. . . her brow was clear and ample, her blue eyes cloudless. . . none could behold her without looking on her as a distinct species, a being heaven-sent, and bearing a celestial stamp in all her features."[138]

The creature is described as Elizabeth's "racial negative; dark-haired, low-browed, with watery and yellowed eyes."[139] This scene's resemblance to Othello's murder of Desdemona is uncanny—the dark-skinned monster, the white female victim who lies in her bed, the juxtaposition of black and white, and the suggestion of rape, or, in the words of one scholar, "as murder in the lieu of rape."[140] The underlying anxiety about miscegenation ultimately keeps Dr. Frankenstein from producing a viable mate for his creature. Such a creation would "become ten thousand times more malignant than her mate. . . [because] one of the first results of those sympathies for which the demon thirsted would be children, and a race of devils would be propagated upon the earth who might make the very existence of man a condition precarious and full of terror."[141] Hundreds of years after *Othello* was first performed on the stage, the same anxieties surrounding racial difference remained.

The Orient plays a major role in Gothic texts that feature Muslim monsters. One of the ways it does this is through the imagery of desert landscapes, which influence the wastelands of horror so common in the narratives examined in this chapter. The desert has been associated with death since the pre-Christian era, and in the modern period it remains a place where monsters lie in wait for humans to make a fatal mistake.[142]

In the Christian tradition, the desert is the home of demons and serves as the battleground between good and evil. As David Jasper writes, these ideas persist. "In the mythic imagination of the poet the desert is becoming the Wasteland, and worse. The centuries of the Christian church have awakened the nightmare, the demons that the Fathers fought."[143] The wasteland plays an important role in Gothic horror, whether as a desert, forest, or prison-like regions such as Transylvania. The use of medieval wastelands, especially those found in chivalric tales, is a common fixture in Gothic horror. In Browning's famous poem about Roland, the land is afflicted with illness and death:

> What made those holes and rents
> In the dock's harsh swarth leaves, buried as to balk
> All hope of greenness?
> As for the grass it grew as scant as hair
> In leprosy; thin dry blades pricked the mud
> Which underneath looked kneaded up with blood.
> Now blotches rankling, colored gray and grim,
> Now patches where some leanness of the soil's
> Broke into moss or substances like boils;
> Then came some palsied oak.[144]

This landscape is a place of "death, despair, disease, blood, and battle; with wild slimy animals, hell, slavery, pain, or disease," but young Roland also encounters giants and other creatures that represent Muslims.[145] Browning's poem was inspired by earlier versions of the story that include more monsters than his narrative. However, Roland's journey to a final battle, where he will fight the enemies of Christendom, suggests who the enemies are.[146] Roland's journey takes place in a wasteland, a space identified with evil:

> Writers in all centuries have compared their worlds to wastelands. Ezekiel writes of the Valley of Dry Bones. Virgil's Aeneas traverses the misty plains of the dark underworld. Dante's "indifferent" wander aimlessly in shadows. Milton pictures Christ tempted in the wilderness, while Shakespeare portrays Lear storm-wracked on a bleak and desolate heath. Bunyan's Pilgrim trudges a dark path through the blasted Valley of the Shadow of Death. Each age has invested the wasteland image with its own meaning.[147]

The desert is the prominent wasteland in Orientalist writings. One description of Egypt calls it a cursed land, much like the Saracen territories of the Middle Ages, a place where "every blade of grass, and every tree, every drop of water, and every grain of dust, man and beast, and holy light. . . all. . . testify in a wonderful degree the displeasure of the Almighty."[148] In another text, the Sphinx is described as a "malevolent yet seductive beast-woman" that is the cause of "decay, mortality, the fall of cities, and the death of the gods."[149] In yet another example, Philby's description of the anticipation of his crossing of the *Rub al Khali* describes the desert as a nightmare:

I had not encouraged myself to think in terms of Petra or Tutankhamon, but my brain had caught the very mood of the shifting sands—always in motion, gentle or violent, as the sea itself—and my dreams these nights were nightmare vistas of long low barrack buildings whirling around on perpetually radiating gravel rays of a sandy desert, while I took rounds of angles on ever moving objects with a theodolite set on a revolving floor. It was the strangest experience of my life. And now I was about to draw the veil from the mysteries on which I had pondered so long with all the devotion of a pilgrim setting out for Eleusis or the seat of Jupiter Ammon.[150]

Like Philby's description, the Orient of Gothic horror is "dark, sinister, and macabre."[151] The desert featured in the Castilian tale *Don Belianis of Greece* is described much like the medieval Saracen island discussed earlier. This is a dreadful place:

It may rightly be termed the Desert of Death; for all the Fields are blasted, and continual Mildews burn each plant, the Trees are bare, and on their naked tops, naught but Owls sit perching and Ravens building, no kindly Sunbeams shed their cheering Lustre, but all as melancholy as the Gloome of Death: here Ghosts do nightly Roam, and the infernal Spirits that obey the great Magitian.[152]

In Thomson's *The City of Dreadful Night*, the desert is not simply a foreboding place—it is full of monsters:

As I came through the desert thus it was
As I came through the desert: All was black,

In heaven no single star, no earth no track;
A brooding hush without a stir or note,
The air so thick it clotted in my throat;
And thus for hours; then some enormous things
Swooped past with savage cries and clanking wings.[153]

The landscapes of Gothic horror reflect these foreboding spaces. Zofloya's victims occupy cavernous and dark homes and creepy and labyrinthine forests. Vathek's kingdom is a shop of horrors, with a giant eye that follows every move, skies full of human blood, and hellish chasms in which masses of innocent children are sacrificed. Dracula lives in Transylvania, a land that even today is associated with monsters. The desert is important because it was the original wasteland. It is the space that inspired these other environs of horror.

Five Gothic Monsters
Zofloya the Moor

Zofloya tells the story of the spoiled, malicious, and vengeful Victoria, who is led by a dark-skinned Moor named Zofloya to commit numerous crimes. As in many Gothic tales, the subconscious plays a central role in this text. Dreams are moments of revelation that "influence one's waking life and reveal an inner psychical or spiritual awakening."[154] Victoria's sexual desire for the Moor, who at the story's conclusion reveals his true identity as Satan, is one of the secrets hidden in the subconscious. Before the unraveling of Victoria's life begins, she dreams of the Moor, who then appears:

She found herself alone, in a remote part of the garden. Presently she beheld, approaching towards her, a group of shadowy figures; they appeared to hover in mid air, but at no great distance from the earth, and, as they came nearer, she discerned, that though of a deadly paleness, their features were beautiful and serene. These passed gradually; when as if from the midst of them, she beheld advancing a Moor, of noble and majestic form. He was clad in a habit of white and gold; on his head he wore a white turban, which sparkled with emeralds, and was surmounted by a waving feather of green; his arms and legs, which were bare, were encircled with

the finest oriental pearl; he wore a collar of gold round his throat, and his ears were decorated with gold rings of an enormous size.[155]

The Moor disappears at the beginning of the story, returning as Satan, making it unclear whether he was the beast all along. The only clue that something has changed in him is found in Victoria's comment that he seemed "different before and after his appearance."[156] It is unclear when his body became inhabited by the evil being. In one dream, Victoria identifies the Moor with both sexual attraction and horror. Like other African/ Muslim monsters, Zofloya is a strongly sexual character:

She now saw herself in a church brilliantly illuminated, when, horrible to her eyes, approaching the altar near where she stood, appeared Lilla, led by Henriquez and attired as a bride! In the instant that their hands were about to be joined, the Moor she had beheld in her preceding dream appeared to start between them, and beckoned her towards him; involuntarily she drew near him, and touched his hand, when Berenza stood at her side, and seizing her arm, endeavored to pull her away. 'Wilt thou be mine?' in a hurried voice, whispered the Moor in her ear, 'and none then shall oppose thee.' But Victoria hesitated, and cast her eyes upon Henriquez: the Moor stepped back, and again the hand of Henriquez became joined with Lilla's. 'Wilt thou be mine?' exclaimed the Moor in a loud voice, 'and the marriage shall not be!'—'Oh, yes, yes!' eagerly cried Victoria, overcome by intense horror at the thoughts of their union.—In an instant she occupied the place of Lilla; and Lilla, no longer the blooming maid, but a pallid spectre, fled shrieking through the aisles of the church, while Berenza, suddenly wounded by an invisible hand, sunk covered in blood at the foot of the altar! Exultation filled the bosom of Victoria; she attempted to take the hand of Henriquez; but casting her eyes upon him, she beheld him changed to a frightful skeleton, and in terror awoke![157]

It should be pointed out that Victoria is an unsavory character. Although Zofloya/Satan is the catalyst for her growing hysteria and the murders that ensue, Victoria's selfishness, jealousy, and malice are highlighted in the text. Like many Gothic texts, there is a female villain of sorts, and while not as gruesome as some (cadaverous nuns or vampires that eat

infants, for example), *Zofloya* is in some ways typical in its negative treatment of female characters.

Zofloya's identification with darkness is expressed through his physiognomy and supernatural powers. This "demonizing of dark skin" is linked with his magical powers, evil, and identity as Satan, all of which portray him as a "dark monster."[158] Zofloya the Moor *is* Satan. Either way you slice it, he is "the Devil, or the devil-within."[159] Like the Saracen giants of the past, Zofloya is "towering as a demi-god, with his plumed and turbaned head, his dark form contrasted."[160] The darkness of his skin is brought up repeatedly in the text. He has a "towering figure," "dark brows," and eyes that "shot fire."[161] Zofloya's black skin, size, and malevolent stare are symbolic of his dark spirit, expressed in his speech, including, "Does the Signora believe, then, that the Moor Zofloya hath a heart dark as his countenance?"[162]

Zofloya's knowledge of black magic and miraculous powers also point to his demonic nature. When he returns from his disappearance, Zofloya reports that he was saved from certain death by his "possession of a secret transmitted to me by my ancestors."[163] These ancestors are Moors, African Muslims who dabbled in black magic. In addition to sorcery, Zofloya is telepathic, able to read Victoria's mind, a power that Dracula and other monsters also possess. Victoria asks, "But, how have you the power of divining my thoughts?"[164] Zofloya conjures up eerie songs, which Victoria always hears right before the Moor appears before her:

> A soul-enchanting melody rose gradually in swelling notes upon her ear; she paused to listen—her mind became calmed, and wrapt in attention. She wondered at the magical powers of the invisible musician. In a few minutes it sunk in thrilling cadence, and was heard no more.
>
> The gloom of Victoria's mind began to return, and, angry that any external circumstance should have had power for a moment to interrupt the despondency of her thoughts, she prepared, disgusted as she was at not having met Zofloya, to leave the forest. As she hastily turned, however, suddenly she encountered him.[165]

Zofloya reveals his identity moments before murdering Victoria, first teasing her with, "Yes, I it was, that under the semblance of the Moorish slave—appeared to thee first in thy dreams."[166] Moments before she is thrown to her death, Victoria looks up to the Moor and sees that he has transmogrified into a Thing:

[she] raised her eyes—horrible was the sight which met them!—
no traces of the beautiful Zofloya remained,—but in his place,
stripped, as in her dream, of his gaudy habiliments, stood a figure,
fierce, gigantic, and hideous to behold!—Terror and despair seized
the soul of Victoria; she shrieked, and would have fallen from the
dizzying height, had not his hand, who appeared Zofloya no longer,
seized her with a grasp of iron by the neck![167]

Moments later, the Moor reveals his identity, exclaiming, "Behold me as
I am!—no longer that which I appear to be, but the sworn enemy of all
created nature, by men called—SATAN!"[168] Then, "with a loud demoniac
laugh," he pushes Victoria over the cliff to her death.[169] In some ways, this
is an unsurprising end to *Zofloya*, for the monster's identity is signaled
from the beginning, when he is described as a Black Muslim.

Vathek

Vathek is "a work of the fantastic."[170] Its features include a coal-skinned
demon named "the Indian," a homicidal, queer Arab villain, skies
streaked with blood, corpses emerging from the earth, a traveling Tower
of Babel, magic slippers, and the mass murder of 50 naked boys. *Vathek*
takes place in the Orient, a landscape filled with horrors from the earth
to the sky. In a graveyard, ghouls rise up from the earth—"a hollow
noise was heard in the earth; the surface shoved up into heaps; and the
ghouls, on all sides, protruded their noses to inhale the effluvia, which
the carcasses of the woodmen began to emit."[171] In another scene, the
sultan Vathek looks up to see that the blue sky has become "streaked over
with streams of blood, which reached from the valley even to the city of
Samarah."[172] *Vathek* is a text populated with frights: "Vathek's terrible
optic, which dealt death and confusion all about him, the giaour [the
Indian] as football, the giaour as insatiable quaffer of the blood of chil-
dren, the dizzy heights of the tower of Carathis, and the olfactory appeal
of the pyre thereon composed of stale mummies and loyal servants."[173]
Reflecting a pattern common to many Gothic horror tales, including
Dracula, the nightmarish environment in this text functions as a charac-
ter, another monster in the story. In Beckford's tale, the other two promi-
nent monsters are Vathek and the Indian. Vathek's mother is also evil
(remember, most Gothic horror texts have a malevolent woman), but she
plays a secondary role in the story.[174]

Vathek is a typical Oriental despot, "pleasing and majestic," but also malevolent and powerful, possessing magical powers, including the ability to strike someone dead with his angry stare.[175] The towering "quasi-Babel" tower that Vathek constructs in Samarah follows him wherever he goes.[176] In the original French edition, it is clear where he gets his magical powers—"*se coi[t] initié dans les mystères astrologiques*"—Vathek is a practitioner of dark magic.[177] Vathek's monstrosity is also predicated on the character's multiple sexualities, which includes a large harem of beautiful women:

> The fifth palace, denominated "The Retreat of Joy, or the Dangerous," was frequented by troops of young females beautiful as the houris, and no less seducing, who never failed to receive with caresses all whom the Caliph allowed to approach them; for he was by no means disposed to be jealous, as his own women were secluded within the palace he inhabited himself. Notwithstanding the sensuality in which Vathek indulged, he experienced no abatement in the love of his people, who thought that a sovereign immersed in pleasure was not less tolerable to his subjects than one that employed himself in creating him foes.[178]

Like Dracula, Vathek is polysexual. He likes women, men, and young, nubile children. Vathek's homosexuality was likely influenced by Beckford's own relationships, which included a lengthy affair with a young male aristocrat.[179] It is significant that monstrosity is a central part of this text because, although the act of anal penetration between Vathek and the Indian is not specified, it is intimated. During this period, "the term 'monstrous' was used as a constructive synonym for the bodies and desires of queer men."[180] When Vathek kisses the Indian, lip on lip, it is presented as a queer and grotesque act: "In the transports of his joy, Vathek leaped upon the neck of the frightful Indian, and kissed his horrid mouth and his hollow cheeks, as though they had been the coral lips and the lilies and roses of his most beautiful wives."[181] This kiss is the Gothic equivalent of sodomy.

The Indian is identified as a monster in the text. "This man, or rather monster instead of making a reply, thrice rubbed his forehead, which, as well as his body, was blacker than ebony; four times clapped his paunch, the projection of which was enormous; opened wide his huge eyes, which glowed like firebrands; began to laugh with a hideous noise, and discovered

his long amber-coloured teeth, bestreaked with green."[182] The monster's inability to speak, his black skin, and his evil laughter all suggest that he is a demon. He also possesses supernatural powers and gifts—a number of strange and magical items, including "slippers, which enabled the feet to walk; knives that cut without the motion of a hand; sabers which dealt the blow at the person they were wished to strike."[183] The Indian's saber, which changes its script daily, is a talisman of the devil.[184] In the original French text, the Indian is identified as Satan. Like other manifestations of demons, the Indian should not be looked at directly. He is so physically grotesque that when Vathek's guards arrest him they are unable to look at him and must avert their eyes: "the very guards, who arrested him, were forced to shut their eyes, as they led him along."[185]

One of the interesting complexities in this text is that Vathek, identified as an Arab Muslim, is persuaded to reject Islam and follow the path of Satan. Beckford's treatment of the Muslim male is predicated on the idea that he is essentially evil, a homosexual, a pedophile, and a child murderer. The culmination of evil is expressed in the immolation of 50 young boys, who are stripped naked and observed by Vathek and the Indian, who display both "demonic powers and physical monstrosity."[186] This horrible scene is described in great detail in the text:

> The fifty competitors were soon stripped, and presented to the admiration of the spectators that suppleness and grace of their delicate limbs. Their eyes sparkled with a joy, which those of their fond parents reflected. Every one offered wishes for the little candidate nearest his heart, and doubted not of his being victorious. A breathless suspense awaited the contest of these amiable and innocent victims. . . .
>
> Vathek, who was still standing at the edge of the chasm, called out, with all his might:—"Let my fifty little favourites approach me, separately; and let them come in the order of their success. To the first, I will give my diamond bracelet; to the second, my collar of emeralds; to the third, my aigrette of rubies; to the fourth, my girdle of topazes; and to the rest, each a part of my dress, even down to my slippers."
>
> This declaration was received with reiterated acclamations; and all extolled the liberality of a prince, who would thus strip himself, for the amusement of his subjects, and the encouragement of the rising generation. The Caliph, in the meanwhile, undressed

himself by degrees; and, raising his arm as high as he was able, made each of the prizes glitter in the air; but, whilst he delivered it, with one hand, to the child, who sprung forward to receive it; he, with the other, pushed the poor innocent into the gulph; where the Giaour, with a sullen muttering, incessantly repeated; "more! more!"[187]

This scene communicates several ideas about the Orient and its monsters. The first is that for the Muslim, the taking of life is an enjoyable act. As Dani Cavallaro argues, "The idea of the child as disposable Other meant to feed the insatiable desire of a tyrannical adult goes hand in hand with the notion of the East as the West's Other: a depraved, irrational, sultry incarnation of both the Western fear of and fascination with cultural and geographical alterity."[188] However, there is more to the West/East paradigm than the disregard for life. In this scene, the victims are stripped naked, then are viewed by Vathek, the Indian, and others in an episode of pornographic violence. As the children are thrown into the fiery pit, Vathek is stripping himself, eventually becoming naked with the children, suggesting at a minimum that Vathek and the Indian are enjoying moments of sexual titillation—moments heightened by the exclamations of "more! more!"—rather obvious referents to an act of sexual copulation. The mass murder of these children is told in the form of a sexual narrative—there is foreplay, undressing, penetration, and ecstasy. Vathek, like other Muslim male characters of the past, is a sexual monster.

Bram Stoker's Muslim Monsters

As we have seen, anthropophagy is a literary device that is "frequently used to mark the boundary between one community and its others."[189] The consumption of human flesh identifies the monster in Bram Stoker's text, but it is also an act that infects and transforms its victims. Muslim monsters are common to many of the Gothic horror tales penned by Stoker—*Dracula, The Lair of the White Worm, The Beetle, The Lady of the Shroud,* and *The Jewel of the Seven Stars.* Cannibalism represents more than the consumption of human flesh: it is a symbol of the threat posed to cultural, religious, and racial integrity. Dracula is a hybrid creature—a Jew, an Ottoman Turk, and the last of the race of vampires. Lady Arabella is a female version of the Count: she bites her victims and then drags them into an underground pit, where she transforms into a giant, white

serpentine worm and eats them alive. The monster in *The Beetle* is a not a vampire, but comes from the East and transmogrifies, like Dracula and Arabella. In each case, these monsters invade Europe, symptomatic of the fears surrounding reverse colonization—"the return of the native."

The shadow cast by Anglo-Saxon racism on Stoker's work, especially *Dracula*, cannot be discounted. Stoker clearly harbored some anxieties that were rooted in his Anglo-Irish identity, but he was also inspired by American racial mythology. Stoker personally knew Buffalo Bill Cody, the Western showman whose shows expressed "the regeneration of the white race through frontier conflict and technological progress."[190] The character Quincey Morris (who is a casualty in the fight against Dracula) was based on Cody, and like the American entertainer, Morris uses Western technology (in the form of guns and a frontiersmen Bowie knife) in the crusade against the count.[191] Both Cody and Stoker were concerned with the protection of the white race, as well as its regeneration through the protection of the frontier. The difference is that for Stoker, the frontier—a wasteland called Transylvania—functioned as a character in the story, a monster that was as dangerous as Dracula and his accomplices. The frontier functioned as a political site. "Cody believed in it as the salvation of the white race; Stoker's view was much gloomier, at least in his most famous novel, wherein frontiers become almost as dangerous to the race as vampires themselves."[192]

At the time that Stoker's horror tales were written and whites were eradicating American Indians from the American West, Europe was preoccupied with its own racial phantasms. In *Frankenstein*, for example, we see this in the exile of the monster far from Britain. The monster here is representative of all Others—anyone not white, Protestant, and racially clean. "The image and fantasy of the Other, whether monster, immigrant, Jew, or 'Oriental' fueled the British conviction that their island and unitary identity was imperiled by encroaching hordes of inefficient and physically undesirable aliens. That fear, compounded by popular science and pamphleteers, predicted the impending degeneration of Empire and the mongrelization of the white race."[193] This is expressed in Gothic horror fiction, in Stoker's tales of three Muslim monsters that terrorize the West.

Dracula is an anti-Catholic text. Superstitious Transylvanians and roadside shrines are dismissed by Jonathon Harker as relics of a former time, code for "weird, Catholic stuff." Stoker, a member of the Church of Ireland, clearly harbored some ill feelings toward Catholics and their religious

accoutrements, but these elements also reflect the Romantic-Gothic pre-occupation with medievalism, a period that the Gothic style inextricably identified with Catholicism. In fact, the entire campaign to kill Dracula is framed as a Crusade, much like medieval battles against the Saracen:

> This crusade is conducted by the lawyer Harker and other Westerners of good standing, a nobleman and a doctor from England, Van Helsing as a representative of Teutonic blood, and Morris, a courageous big-game hunter. The men fail to save Lucy Westerna by donating their blood to her. However, as a team they display sufficient energy to kill the vampire Lucy, find Dracula's coffins and sterilize them, and drive their owner to his country.[194]

Dracula is a product of racial hybridity, a Jew and an Ottoman Turk with a measure of Hun and vampire thrown in. Dracula's supernatural pow-ers include the ability to shape-shift into animals, turn into mist, control his victims through hypnosis, cast no shadow, and slide along the floor. Dracula symbolizes the degeneration of racial purity, reflecting the popu-larity of degeneration theory at the time Stoker was writing. "Vampires are represented as sexually predatory immigrants who infect and enslave the weak and the unwary. Vampires contaminate flesh and blood; they disrupt national and racial certainty."[195]

Each of Dracula's races contributes to his monstrosity, albeit in dif-ferent ways. His Semitic qualities reveal his Jewish identity. The book, "with its bloodsucking, gold-grubbing, hooked-nose monster, shows that *Dracula* is a clearly anti-Semitic text."[196] The count is a Jewish monster.

> Dracula, then, resembles the Jew of anti-Semitic discourse in several ways: his appearance, his relation to money/gold, his parasitism, his degeneracy, his impermanence or lack of allegiance to a fatherland, and his femininity. Dracula's physical aspect, his physiognomy is a particularly clear cipher for the specificity of his ethnic monstros-ity. When Jonathon Harker meets the count on his visit to Castle Dracula in Transylvania, he describes Dracula in terms of a "very marked physiognomy." He notes an aquiline nose with "peculiarly arched nostrils," massive eyebrows and "bushy hair," a cruel mouth and "peculiarly sharp white teeth," pale ears which were "extremely pointed at the top," and a general aspect of "extraordinary pallor"...

Visually, the connection between Dracula and other fictional Jews is quite strong.[197]

The sharp white teeth and pointed ears reflect Dracula's canine features, which are related to his ability to transmogrify into a dog, wolf, or *cynocephalus*—all tied to Jewish and Muslim monsters. The count's odd lifestyle and behaviors are obviously situated in anti-Semitic discourse, especially the references to wealth and greed. When Dracula is pricked, he "does not bleed, he sheds gold."[198] He hoards gold in his castle in a dusty room that Jonathon discovers when exploring the structure, writing in his diary, "The only thing I found was a great heap of gold in one corner— gold of all kinds, Roman, and British, and Austrian, and Hungarian, and Greek, and Turkish money, covered with a film of dust, as though it had lain long in the ground."[199]

Dracula is one example of the Semitic characters that were in vogue in European literature, but there are others. In *Trilby*, Svengali is described as an "Oriental Israelite Hebrew Jew, [which is] the source of his evil nature."[200] He is a monster, but unlike Dracula his malevolence is *completely* determined by his Jewishness.[201] A Jewish monster from an earlier era is Shakespeare's Shylock, a character described as "a giant of a fellow, [with a] powerful hooked nose, hair sticking up, a wild grey beard, threateningly pointed eyebrows, a sorrowful mouth with clean-shaven upper lip, astoundingly deep eyes and [a] nose like a bird of prey."[202]

Dracula's pale skin color identifies him as a monster, but what does the "extraordinary pallor," the almost translucent quality of his skin, say about his racial identity?[203] This is situated in his identity as a Jew. Accusations of Jews as the killers of Christ and later of the murder and consumption of Christian children often included ancillary fantasies: among these are myths of Jewish male menstruation, genital hemorrhoids, and internal hemorrhaging of blood. These bleeding afflictions are explained as God's punishments for Jewish crimes. In a thirteenth-century commentary, Hugh of St. Clair writes:

He smote his enemies in their posteriors. . . . This it is read (I Sam 5) that mice bubbled up from the earth, and the Lord smote the Gazan nation in their anus [lit. 'secret place']; and the mice gnawed the tumour which protruded from their colons. It was to their everlasting shame because such an infirmity was most vile. And some say that the Jews bear this shame, that in vengeance for

the Passion of the Lord they suffer a flux of blood. And that is why they are pale.[204]

All the punishments meted upon the Jews cause a lot of bloodletting, which requires the consumption of Christian flesh, well known in the anti-Semitic tales surrounding Passover in which Jews used the blood of Christian children in the baking of *matsot*.[205] What is less frequently discussed, however, is the complexion of Jewish people. According to an early fourteenth-century text, the paleness of the Jews was due to their "superfluidity of gross blood," which made the men bleed "from their anuses" and caused them to appear "sad, antisocial, pallid."[206]

Like the stories of Jews killing Christian children to consume their blood, *Dracula* also tells the story of a Jewish monster who consumes the blood of Christians. Dracula's Jewish nature is also implicated through the themes of disease, infection, and disintegration. According to Andrew Smith, the text "articulates a contemporary anti-Semitic view in the association between the Count, eastern Europe and disease, which tapped into a popular anxiety of an 'alien invasion' of Jews."[207] *Dracula* is not the only text that includes a vampiric monster; such a figure also is found in Braddon's story of "Good Lady Ducayne," which expresses the "anti-Semitic racial unconscious" that was so evident in nineteenth-century Britain.[208]

The count is also a Muslim monster, an identity predicated in part on his monster's home, Transylvania, a wasteland identified with the East. From the very first paragraph in Jonathon Harker's journal, it is evident where he is headed: "The impression I had was that we were leaving the West and entering the East; the most western of splendid bridges over the Danube, which is here of noble width and depth, took in among the traditions of Turkish rule."[209] In Gothic fiction, the Danube was often used to delineate the Christian and Islamic worlds. In *The Magic Ring* (1825), the opening scene takes place at the river, where pilgrims and crusading soldiers sing a song that "expressed contempt of the Saracens, and admiration of the English King Richard the Lion Heart, whose forces had just then gone forth like a thunder-storm, destructive and yet beneficial, into the Holy Land."[210] Across the Danube lie the Balkans; Western European perception of these lands aids in the portrayals of Europeans as heroes and everyone else as villains through a process that treated "the Balkans as the site of the primitive, archaic, and irrational," in which "the strategy of exoticization renders the vampire story more plausible."[211] In *Dracula*, this is expressed in a conflict between "heroes with dangerous monsters

but also a conflict between the West and the East."[212] The Orient's poor relationship with time is another expression of Dracula's Orientalist milieu, seen in the disintegration of old Europe, the lateness of the train, and Harker's annoyance at it being late; all are "symptomatic of the 'oriental' ways of Europe on the wrong (that is, eastern) side of the Danube."[213]

The Balkan state of Transylvania is a site of racial degeneration referred to in the text as the "whirlpool of European races."[214] Its inhabitants are "infected" with Turkish bloodlines. The theme of racial pollution, as noted earlier, is a central part of the story, and the vampire's cannibalism is a symbol of the threat of miscegenation. Stoker, an Irish Protestant, was, like many of his compatriots, fixated on the dangers posed by Irish Catholics:

> For LeFanu and Stoker, both members of the Protestant Anglo-Irish ruling class of nineteenth-century Ireland, these legends [of vamps, vampires, necrophiles, and necrophilles] were at once local folklore and metaphors for their class's anxieties about the unhyphenated Irish, who were emerging from centuries of suppression to demand political and economic power. The Anglo-Irish feared intermarriage with the Irish, which would lead to racial degeneration, and the loss of power which would inevitably follow letting the Irish gain ownership of land. These anxieties underlie such works as *Carmilla* and *Dracula*.[215]

In *Dracula*, this is repeatedly expressed through a mixture of desire and fear: "Once a victim's blood was mixed with that of the vampire the person became irremediably lost and created other victims by blood mixture."[216] The Count is s hybrid monster, and his identity as a Christian further complicates things. He is both a "hybriditian Ottomanized European" and "a dissonant figure fitting uncomfortably, a blasphemous Christian hero."[217]

Dracula is a Turk. He admits his Ottoman bloodlines when he laments, "Woe was it that his own unworthy brother [a Dracula ancestor], when he had fallen, sold his people to the Turk and brought the shame of slavery on them!"[218] The Count functions as a symbol of the weakened Ottoman Empire: he is a "composite figure straining to represent coherently all the social forces that the disintegrating Ottoman Empire brought to light."[219] Dracula admits his Muslim bloodlines when he says the invaders of Transylvania, whom his ancestors were mingled with, were of "the blood of those old witches" that joined "with the devils in the desert."[220]

His Jewish-Muslim-witch-devil nature makes him monstrous because, in addition to the anti-Semitic and anti-Muslim identities, he is of a mixed race, which makes him even more degenerate.

During the writing of *Dracula* (1894–1896), the British press often reported on Turkish massacres of Armenians, contributing to the anxiety surrounding Ottoman power.[221] *Dracula* is inspired by this and other Orientalist discourse: "The Count's transgressions and aggressions are placed in the context, provided by innumerable travel narratives, of late-Victorian forays into the 'East.' "[222] Several lines of Jonathon Harker's description of Transylvania closely echo Charles Boner's travel narrative (1865) of Transylvania:

> The diversity of character which the various physiognomies present that meet you at every step, also tell of the many nations which are here brought together. . . . The slim, lithe Hungarian. . . the more oriental Wallachian, with softer, sensual air,—in her style of dress and even in her carriage unlike a dweller in the West; a Moldavian princess, wrapped in a Turkish shawl. . . . And now a Serb marches proudly past, his countenance as calm as a Turk's; or a Constantinople merchant sweeps along in his loose robes and snowy turban.[223]

Jonathon's journal entries describing his journey from West to East include themes often found in Oriental travel journals—complaints about the trip, observations about the strange "locals," and comments on exotic foods, sights, and experiences.

Dracula has an aquiline nose, a common attribute of Muslims found in numerous writings, including another of Stoker's Muslim vampires. In *The Mystery of the Sea* (1902), the villain Don Bernardino is described as having this feature: "Don Bernardino, with his high aquiline nose and black eyes of eagle keenness, his proud bearing and the very swarthiness which told of Moorish descent."[224] Later in the story, it is revealed that this Moor, like Dracula, is a monster.

> As he spoke, his canine teeth began to show. He knew that what he had to tell was wrong; and being determined to brazen it out, the cruelty which lay behind his strength became manifest. . . . Spain was once the possession of the Moors, and the noblest of the old families had some black blood in them. . . . The old diabolism

whence sprung fantee and hoo-doo seemed to gleem out in the grim smile of incarnate, rebellious purpose.[225]

In Stoker's work, Muslim bloodlines signal racial hybridity and identify the monster. The vampiresses also have aquiline noses, as Jonathon describes:

> In the moonlight opposite me were three young women, ladies by their dress and manner. I thought at the time I must be dreaming when I saw them, for, though the moonlight was behind them, they threw no shadow on the floor. They came close to me, and looked at me for some time, and then whispered together. Two were dark, and had high *aquiline* noses, like the Count, and great dark, piercing eyes that seemed to be almost red when contrasted with the pale yellow moon.[226]

Dracula's female vampires comprise his harem. As David Glover argues, "Jonathon's. . . seduction by the Count's three 'brides'. . . reinforces Dracula's identification with the mysterious East, for it is modeled upon the conceit that the influence of Turkish culture on Vlad the Impaler, following his youthful days in Istanbul, would have led him to keep a harem."[227] The encounter between Jonathon and these female creatures is one of the most sexually explicit in the text. It is yet another example of the Western idea of the harem as a den of delight, a site of unimaginable pleasures.[228]

> The other was fair, as far as can be, with great wavy masses of golden hair and eyes like pale sapphires. . . . The girl went on her knees, and bent over me, simply gloating. There was a deliberate voluptuousness which was both thrilling and repulsive, and as she arched her neck she actually licked her lips like an animal, till I could see in the moonlight the moisture shining on the scarlet lips and on the red tongue as it lapped the white sharp teeth. . . . I could feel the soft, shivering touch of her lips on the super-sensitive skin of my throat, and the hard dents of two sharp teeth, just touching and pausing there. I closed my eyes with languorous ecstasy and waited—waited with beating heart.[229]

When fellatio is suggested ("just touching and pausing there"), Dracula intervenes and stops the encounter, which is met with anger from the

vampiresses, one of whom protests, "You yourself never loved."[230] The Count orders the three to retreat, which they do, retiring to a secret place in the castle. Jonathon is sickened by how Dracula satiates their desire— with a living child whom they cannibalize as he looks on in horror.

Orientalist literature often features a rescue fantasy in which a white woman must be rescued from a Muslim abductor. This fantasy later becomes popularized in films. In his pursuit of Lucy and Mina, the Count tries to add to his harem. When he is cornered at his home in Piccadilly, he refers to the possession of these women as part of his vendetta against the crusading heroes who have come after him. "My revenge is just beginning. I will spread it over centuries, and time is on my side. The girls you all love are mine already; and through them you and others shall yet be mine—my creatures, to do my bidding and to be my jackals when I want to feed."[231]

Dracula's supernatural powers include the ability to change form to a dog or bat. Canines function as a symbol of monstrosity in the text, but whether they attempt to forewarn Dracula's victims or are part of his menagerie of horrors is unclear. In the opening pages of the story, as Jonathon travels through Transylvania he is surrounded by the howling of dogs:

> Then a dog began to howl somewhere in a farmhouse far down the road—a long, agonized wailing, as if from fear. The sound was taken up by another dog, and then another and another, till, borne on the wind which now sighed softly through the Pass, a wild howling began, which seemed to come from all over the country, as far as the imagination could grasp it through the gloom of the night.[232]

When Jonathon arrives at the castle, in a coach that is driven by Dracula, the dogs encircle the coach:

> At last there came a time when the driver went further afield than he had yet gone, and during his absence, the horses began to tremble worse then ever and to snort and scream with fright. I could not see any cause for it, for the howling of the wolves had ceased altogether, but just then the moon, sailing through the black clouds, appeared behind the jagged crest of beetling, pine-clad rock, and by its light I saw around us a ring of white wolves, with white teeth and lolling red tongues, with long, sinewy limbs and shaggy hair.[233]

The fact that Dracula transmogrifies into a dog later in the story is not accidental.[234] This takes places in London, when Dracula is stalking Lucy.[235] He changes into a dog and then a bat. "Then outside the shrubbery I heard a sort of howl like a dog's, but more fierce and deeper. Then I went to the window and looked out, but could see nothing, except a big bat which had evidently been buffeting its wings against the window."[236] The presence of dogs, wolves, and a howling Dracula do not necessarily signify that the vampire is a *cynocephalus*, but they strongly suggest it.

Another monstrous aspect of Dracula's monstrosity is situated in his identity as the devil, a product of the hybrid race that is signified by the Count's family name. He admits this lineage when he says, "What devil or what witch was ever so great as Atilla, whose blood flows through these veins."[237] Although the vampire is not associated with the devil in Romanian folk literature, the etymology contributes to the lore surrounding Vlad the Impaler and other European tales about vampires. The Romanian word for devil is, after all, *dracul*.[238]

Dracula is many monsters—a Jew, a Muslim, a Hun, a *dracul*, the devil. As other scholars have pointed out, the crusade against the monster is symbolic of the mixed Ottoman bloodlines that have infected Europe, threatening Anglo-Saxon purity. Stoker had a purpose in writing Dracula situated in racial politics: "[He] is setting in motion a deligitimization of the Ottoman history of Europe through the figure of the vampire, whose hybrid identification (a result of his history) as both Christian and Ottoman, makes him monstrous and ultimately incoherent, a source of history that logically (but also anxiously) needs to be silenced."[239] This silencing can only be achieved through the impalement and beheading of all vampires, which in the eyes of the heroes, eliminates the threat of Islam in Europe.

But there is a problem. Although Mina Harker lives, she has been infected with the monster's blood. The book ends with Mina giving birth to a child that may be part-*dracul*, suggesting that miscegenation will go on.[240] This pensive ending to the story of Dracula establishes the model for contemporary representations of hybridity, found in horror and science fiction literature and film to this day.

> Dracula provides a model, replicated in later works, for the emergence of hybridity as the character of the future and of modern experience. In this regard, the mixed blood of Mina Harker's child at the book's end is comparable to the mixed character of the foetus

carried by Lilith Lyapo, the protagonist of Octavia Butler's science fiction novel *Dawn* (1987), after her sexual encounters with an alien. It is an open question whether the cultural anxieties that underlie both *Dracula* and *Dawn* have altered or abated significantly in the past hundred years.[241]

Other works of Stoker's are embedded with Orientalism. *The Lady of the Shroud* (1909) is a Gothic fantasy that focuses on the decline of the Ottoman Empire. In this story, Teuta poses as a vampire in order to protect herself from the Turks and is ultimately kidnapped by the Sultan, who plans to rape her and add her to his harem, much like Dracula's pursuit of Lucy and Mina. Stoker published two other major works featuring Muslim monsters. *The Lair of the White Worm* (1911) features a vampire, a female version of Dracula who takes the form of a giant, white serpentine-worm named Lady Arabella.[242] Like Lucy, she attacks children and consumes their flesh. Arabella's lair, a deep, underground snake's pit, is reminiscent of the subterranean hell-pits of the Middle Ages: it is a dark underworld from which humans cannot escape.[243]

Stoker was keenly interested in the East. We see this in the use of travel narratives in *Dracula*, the Count's harem, and numerous other references to Ottomans, Islam, and the "desert." *The Jewel of the Seven Stars* reflects the West's fascination with the East, especially Egypt's mummies.[244] Egyptology emerged as a subfield of Orientalism that affected numerous modes of cultural production, including architecture and cinema. Stoker knew far more about the Orient than the average popular writer, and in the case of Egypt this knowledge was translated onto the page:

> Replete with references to Egyptology, *Jewel* demonstrates that Stoker wove his own creative impulses in with his research. . . . Greaves was a professor of astronomy, who published *Pyramidographia* in 1646, and Ibn Abd Alkohin, the first historian of Islamic Egypt, died in 871 [characters mentioned on page 117 of the text]. Elsewhere in *Jewel*, Stoker refers to Young, Champollion, Birch, Lepsius, Rosellini, Salvolini, Mariette Bay, Budge and Flinders Petrie, all expert Egyptologists.[245]

His 1903 tale of an Egyptian mummy is perhaps most telling of Stoker's fascination with the Orient. *The Jewel of the Seven Stars* focuses on the resurrection of Queen Tera, who, when alive, had "power over

Sleep and Will" as well as the ability to outwit members of the Egyptian priestly order.[246] Once she is brought back to life, every character except one dies in her chamber as it fills up with black smoke. This scene is the an example of the Egyptology craze that was then taking over Britain and America, resulting in a seemingly unending cycle of "zombie curse" stories as well as mummy films, which will be examined in the following chapter. In the final scene of the book, Queen Tera has been carried to safety by the young barrister Malcolm Ross, while his beloved Margaret Trelawny has been accidentally left in the crypt. Ross finds Margaret lying on the floor, "her hands before her face," and on her face "a glassy stare. . . more terrible than an open glare."[247]

Richard Marsh's *The Beetle*, published at the same time as *Dracula*, was far more popular than Bram Stoker's release, which is, of course, now considered a classic of horror. The monster in *The Beetle*, who was called "the Oriental," shared several interesting qualities with the vampire. She transmogrifies into other forms—a man and a monster—just as Dracula changes into a bat, dog, or simply vanishes.[248] This monster, at its most frightening, becomes a large scarab beetle. "The Oriental" crosses into Western territory and, like Dracula, goes on a killing rampage in London. A key difference between the two monsters lies in the part of the Orient they represent. While Dracula is a symbol of the Ottoman Turk, the scarab beetle is an Egyptian symbol, tied to the Egyptomania that was then influencing European and American popular culture from architecture and furniture to the installation of copies of the colossi from Abu Simbel at the Crystal Palace, first in Hyde Park and then at Sydenham.[249] It also influenced cinema, a subject that will be revisited in the next chapter, which focuses on the monsters of America from the fifteenth century to the present.

5

Muslim Monsters in the Americas

IN THIS CHAPTER I return to the Middle Ages, examining how the late medieval episteme affected the ways in which the New World and its peoples were constructed. Explorers and colonists, whether Spanish, Portuguese, English, or French, functioned in a medieval milieu, a world that featured numerous mythologies: cities of gold, a fictive continent that balanced the world called *terra australis incognito*, another landmass that Europeans called the Terrestrial Paradise, and the monsters that inhabited these spaces.

In the previous chapter, I discussed the cross-pollination of Romanticism and Orientalism and its effect on Muslim characters. Here, the focus is on the medieval imagination and its role in the formulation of American Muslim monsters, a process that begins in the age of exploration, continues in the American colonies and in the frontier of the American West, and remains in force today. American monsters are a result of long historical processes, for "there exists a natural continuity between the Middle Ages in Europe—and especially the Spanish Middle Ages—and the early institutional and cultural life of the Ibero-American colonies."[1]

European explorers used a language steeped in anti-Muslim rhetoric, which insisted that Arabs, Turks, Moors, and other Muslims were non-human. The Spaniards had a particularly strong anxiety surrounding Muslims (*Moriscos*) rooted in the racial purity laws that emerged after the Reconquista. Muslims who managed to remain in Spain had to contend with the outlawing of Muslim practices, dress, and even the use of Arabic.[2] For Spanish explorers, the people they encountered in the Americas were not people, but monsters of Plinian and medieval varieties,

including Muslim creatures. Spain was "the land of perennial crusading."[3] Columbus believed that the Central American island he encountered was Scythia, a place long believed by Europeans to be inhabited by monstrous races.[4] Conquerors and settlers thought of Indians as monsters, as seen in the genocidal campaigns launched against them, which included rape, torture, dismemberment, and murder. For instance, when Taino individuals failed to fulfill their obligation of producing a Hawk's bell full of gold biannually, "they would be severely punished, up to and including their hands cut off which surely meant bleeding to death."[5] These crimes were in part due to the medieval mythologies in vogue at the time, including the crusading mentality, which was enforced far beyond the confines of Europe and the Mediterranean.

In later centuries, European settlers engaged in a similar program of vilification and genocide of American Indians. While early explorers were functioning in a medieval world, later settlers still appealed to the narratives and themes embedded in the Middle Ages. Early colonists from England and elsewhere in Europe were also engaged in a slightly different project from their ancestors. Concerned with the conquest of land and the elimination of its inhabitants, they were also engaged in the project of formulating a new identity based on notions of Christian destiny, Anglo-Saxon mythology, racism, and Gothic sensibilities rooted in the medieval episteme. The emergence of these communities is a broad subject not taken up here, except in the context of early US colonial history. The manner in which early Americans spoke about the land they occupied was situated in a Christian doctrine that validated white privilege, a mindset that was extended to the indigenous inhabitants of "New Israel." In Robert Bellah's oft-quoted article on American civil religion, he illustrates how the belief in an America determined by Christian destiny formed the basis of American political discourse, a language that necessitates, even today, the inclusion of Christian language in order to be legitimate. The identification of the United States of America with Israel, and white settlers with the Israelites, is expressed in the speeches of Jefferson, Lincoln, and other famous white Americans. Jefferson's second inaugural included these words: "I shall need, too, the favor of that Being in whose hands we are, who led our fathers, as Israel of old, from their native land and planted them in a country flowing with all the necessaries and comforts of life."[6] As Bellah points out, American identity is rooted in a sense of divine agency and Christian destiny. "Behind the civil religion at every point lie Biblical archetypes: Exodus, Chosen People, Promised Land,

New Jerusalem, Sacrificial Death and Rebirth. But it is also genuinely American and genuinely new."[7]

This ideology has resulted in the creation of many enemies—American Indians, Africans, Catholics, Mexicans, and Muslims—and is even encoded in governmental policies and laws, a fact documented by Steven Newcomb, who argues that the shameful abuse of American Indians is situated in "the Old Testament story of the chosen people and the promised land."[8] The fact that such crimes are celebrated in a national holiday says something very powerful about the American habitus and its blatant disregard for historical facts. American Indian scholars have described this as "the White history of violence."[9] As anyone who has ever read the frontier tales of the American West knows, American Indian characters epitomize the brutality and terror that non-whites (purportedly) presented to white settlers, something often expressed in stories of white women being kidnapped, raped, and murdered. Consider the John Vanderlyn painting *The Death of Jane McCrea*, which shows two Indians murdering a white woman. One holds her head while the other raises a hatchet. The murderers are not simply enemies but monsters, giants twice as wide as their victim. The story of Jane McCrea was retold numerous times in works of frontier fiction, in which Indians are described as "monsters, only human in outward form."[10] Captivity narratives, rape fantasies, and rescue stories, while originally focusing on American Indians, are later applied to Africans, Muslims, and African-Americans.

Alongside Protestant Christianity, whiteness, which was often framed in ancient and medieval mythologies, was the other qualifier of early American identity. Numerous examples of Anglo-Saxon mythology are found in the historical record. Thomas Jefferson hoped to place replicas of Hengist and Horsa on the seal of the new country, claiming that these figures are "from whom we claim the honor of being descended, and whose political principles and form of government we have assumed."[11] Jefferson also viewed the Old Testament pillar of fire, which like the myth of Hengist and Horsa is found in Bede's tome on Britain, not as an emblem of protection but as a symbol of conquest.[12] As the American medieval historian Charles Homer Haskins remarked, "English is in a sense early American history."[13] Racial Anglo-Saxonism is seen in many other spaces not elaborated upon here. Once used to exclude Irish, Italians, Spanish, and Asians from the privilege of citizenship, Anglo-Saxonism is now seen in campaigns for English-only programs and legislation targeted at Mexican and other American immigrant communities, including Muslims. The 1930

presidential address of the Medieval Academy included these words: "It [The Middle Ages] lies close to us. In it arose many of *our* most important institutions. *Our* social life, *our* customs—*our* ideals, *our* superstitions and fears and hopes—came to *us directly from this period*; and no present-day analysis can give a complete account of *our* civilization unless it is supplemented by a profound study of the forces and forms of life, good and evil, which we have inherited from it."[14]

As we learned in the previous chapter, the medieval re-emerges in Gothic style. This is seen in the United States as well, in a tradition that includes ghosts, hauntings, and monsters, as well as culture. Gothic resonances are found in numerous spaces, including architecture, cinema, art, and even academia. Take, for instance, the focus of North American medievalists on the grotesque and the bizarre, as seen in the work of William Ian Miller and Carol Bynum. Mark Edmunson argues the Gothic is a foundational part of the American episteme, that the United States is a "nation of ideals. . . . [and] a nation of hard disillusionment, with a fiercely reactive Gothic imagination."[15] The ghosts of Jefferson, Lincoln, Martin Luther King Jr., and Malcolm X haunt the present, and then there are the monsters.

Jeffrey Jerome Cohen opens his edited collection of articles on monsters with the statement, "We live in a time of monsters," a contention I do not bicker with.[16] He goes on to discuss the American milieu, a complex space that engenders the fear and anxiety in which monsters flourish. America is "a society that has created and commodified 'ambient fear'—a kind of total fear that saturates day-to-day living, prodding and silently antagonizing but never speaking its own name. This anxiety manifests itself symptomatically as a cultural fascination with monsters—a fixation that is born of the twin desire to name that which is difficult to apprehend and to domesticate (and therefore disempower) that which threatens."[17] September 11, 2001, only worsened the American condition, creating many new spaces for monsters to flourish.

One of the reasons that early American history is an important part of the story of Muslim monsters is found in the mythologies of white America. Muslims, like American Indians and African-Americans, stand in opposition to the idea of the United States as a utopia. In the US imagination, Muslims are not white, and they certainly aren't Christian. Their origins are murky and distant, as opposed to the ancestral Anglo-Saxon lands with which many white Americans still identify. Muslims have always been posited as an external threat that, in addition to America's

many internal enemies, including American Indians, African-Americans, Mexicans, queers, and feminists, threaten the American dream.

Monsters in the New World
Indio-Moors and Barbary Beasts

As mentioned earlier, when Spanish explorers reached the "New World" they transferred existent fears and anxieties about Moors onto the inhabitants of the Americas, whom they called "New Moors."[18] In Barbara Fuchs's study of Maurophilia, she documents the "Spanish racial hysteria" that, while "almost impossible to determine in any authentic fashion," was nonetheless part of the story of early modern Spain.[19] The obsession with *limpieza de sangre* (blood purity) is but one of the ways in which Spanish anxieties surrounding Muslims was in force, and it became part of the *habitus* of Spanish explorers.[20] The anxieties surrounding Islam were not restricted to the Iberian Peninsula; in locations as diverse as Cuzco, Peru, and Bristol, England, anti-Muslim rhetoric continued to be voiced:

> Cuzco, Peru, 1570. As Viceroy Francisco de Toledo makes his formal entrance into the city, he is greeted with elaborate pageantry. In the main square, once site of the Inca festivals, a Moorish castle and an enchanted wood have been erected for the celebration. The mock-Moors emerge from the castle to capture young women at a fountain, only to be pursued by valiant Christian knights, who engage them in fierce mock combat. The conquistadors play "themselves." The Moors are played by the Indians.
>
> Bristol, England, 1613. To celebrate Queen Anne's visit, the city stages a water-combat between a Christian ship and two Turkish galleys. After a lively mock battle, the "Turks" are brought as prisoners before the Queen, who laughingly observes that they are "not only like Turks by their apparel, but by their countenances."[21]

The Muslim problem loomed large in the minds of Spanish, Portuguese, and other European explorers. Even the fantasy of Muslim dog-men was transmogrified onto new foreign bodies, people described as cannibalistic monsters, among other things.

> The typical image of the cannibal-monsters was that of the cynocephalus. The first references to fantastic dog-headed peoples

living in Asia date from the pre-Socratic period. They then come to inspire the medieval imagination. Marco Polo discovers, on an island, anthropophagi with dog's heads. Columbus is the first to mention the presence of man-eaters in the New World, whom he claims have dog's heads.[22]

In his journals, Columbus claims to have witnessed, "men with one eye only, and others with faces that were man-eaters, accustomed upon taking a prisoner to cut his throat, drink his blood and dismember him."[23] This landscape was occupied with Plinian monsters, demon-worshippers, Amazons, a race of humanoid creatures with tails, and dragons.[24] A dragon was reportedly killed by a gallant (explorer) knight in one of numerous tales about the Americas that was modeled upon medieval romances, which are stories, as we well know, populated with Muslim monsters.[25] The importance of chivalry is reflected in the journals of numerous explorers, an example of the medieval episteme that framed colonial adventures. Giants, another type of monster featured in medieval tales of chivalry, were spotted in Brazil and Patagonia during the sixteenth century.[26]

The *cynocephalie* and dragons seen in Europe and the Americas were not alone. Other monsters appeared in colonial spaces. Much like Jewish and Muslim *cynocephalie*, Black Saracens, and giants of the Middle Ages, New World monsters were a product of anxieties about the Other that were "imbedded within or distorted by demonizing fantasies."[27] The European fantasies of the Wild Man and Woman are evident in descriptions of American Indians as "savage and incontinent," "unable to manage their own affairs," with a "child-like mentality."[28] Paintings, drawings, and other artistic representations all testify to the monstrous races that purportedly occupied South America resembling Amazons, giants, and other ancient monsters.[29] All of this is not surprising, given the medieval mindset that was still in force at the time of conquest.

The mediaeval world was surrounded by a realm of fable. Beyond the known lands there existed others, populated in medieval fantasy (drawn, it is true, from ancient sources, and distorted) by all kinds of mythical beings, monsters, enchantments so charmingly depicted in mediaeval *mappaemundi*. Such were, for instance, the giants, pygmies, gimnosophists, sciopodies, Amazons, cynocephali, boys with white hair, people who lived only on smells, headless

beings with eyes on the stomach, bearded women, etc., so dear to the minds of St. Isidore, together with griffons, dragons, the Sea of Darkness, the Land of Prester John. As the discoverers of the late fifteenth and early sixteenth centuries came to venture to the edges of the world it was supposed that, sooner or later, they would encounter some of these mythical figures whose existence was, at least for a great number of them, beyond dispute.[30]

Explorers constructed a complex narrative about the people they encountered. This included claims that they were devil-worshippers, as if American Indians were lapsed Christians. American Indians were also identified with Muslims. These *New Moors* were "imagined as extensions of either the defeated Moors or the still-troublesome Moriscos."[31] They were also punished *as if* they were Muslims.

So interchangeable were Muslims and Indians in the conquistador's minds that they called Indians 'Muslims' and Indian temples 'mosques.' At one time, according to Bernal Diaz's account, the Spaniards even considered naming the first city they saw as Great Cairo. Aztecs were often associated with the Moors, so much so that when battling the Indians, 'the Spaniards often invoked the aid of holy figures such as the Virgin Mary or St. James, known in Spanish as Santiago Matamoros, patron saint of Spain against the Moors' (rechristened Mata-indios to better suit his new or renewed role).[32]

Given the broader history of colonialism, if such views had not been an indelible part of the Conquistador episteme, things wouldn't have been much different. Still, one cannot discount the fact that the "exportation of epic and romance to the Americas" created a way for Muslim monsters to show themselves once again, this time in the New World.[33]

During the American colonial era, stories of monsters were not uncommon. This is not surprising, given that early colonists were from the very places that invented or sustained the fantasies of *monsterdom*: "They were all at home in an intellectual terrain that was literally swarming with monsters."[34] Lands far away or recently discovered by Europeans were thought to be especially ripe for encounters with non-human creatures. Familiar Muslim characters, including monsters, also continued to reappear in the later centuries of modernity. In 1727, a popular Portuguese

book described a frightening Turkish monster—a gargantuan figure whose breath caused a giant, eerie light to appear.[35]

As illustrated earlier, neither the Renaissance nor the Enlightenment eliminated monsters from the landscape, either imaginatively or artistically. The Reformation's effect on monsters was situated in theological explanations of causality. Monsters and other strange phenomena were explained as having different causes or origins, but the results were the same. After the Reformation, some theologians ruled out the possibility of miracles, instead proposing that "special providences" continued to be seen in the world, one example being the birth of monstrous beings.[36] In some cases these providential acts were viewed positively, and in other cases, negatively, but they were often used as ammunition, by Protestants against Catholics, by Catholics against Lutherans, and by many Christian sects against Muslims.[37]

Even without foreign monsters, America was a landscape filled with imaginary characters. Frontier monsters in rivers, forests, deserts, and caves populated the American imagination. It is not accidental that these monsters inhabited the same spaces as American Indians. Stories of water monsters in the Ohio and other rivers were often described as "demonic" due to their proximity to American Indians or otherwise related to an indigenous narrative, often implicating American Indians with some kind of maleficence.[38] The language of savagism employed in such narratives excluded American Indians from the human family. Savagism is a language situated in notions of monstrosity: "Images of the Indian as a beast drew on legends of monsters, wild men, and quasi-human creatures that had long been part of the European tradition."[39] Even today, a belief in strange creatures is often associated with American Indian spaces, such as the Yucca Man, a monster that resulted from the birth of a monstrous infant abandoned by his parents in the desert.[40]

By the end of the American Revolutionary War, a new monster dominated the imagination about Islam—the Barbary Muslim. Fantasies of African monstrosity, including sexual abnormality, contributed to the ways in which Africans, and later African slaves and African-Americans, were constructed in the American imaginary. Accounts of African apes and their great sexual organs were attached to the men and women of Africa, who were characterized as being "as libidinous as apes," related to Satan, and the consorts of witches.[41] Depictions of African Muslims incorporated the same ideas.

The Barbary Muslims are associated with the Barbary Coast of North Africa and piracy. Captivity stories, like the tales of American Indian kidnappings of white settlers, "emphasized the victimization of the Christian and the inhumanity of the non-Christian."[42] Muslims were described in these stories as the "Monsters of Africa" that were associated with the "powers of Darkness."[43] After appearing in literary narratives, these monsters quickly entered other fields of cultural production, eventually becoming popular villains in dime store novels and later, theme parks and films:

> In addition to the published historical accounts of slavery in North Africa, the Barbary captivity topos appeared in at least four early American novels, nine early plays, ten dime novels, and almost a dozen Hollywood movies. The Barbary captivity scenario even provided adventures for Tom Swift and for the sharp-shooting cowboy Tom Mix, as well as sailing into the modern romance novel under such titles as Barbary Bride and Angelique in Barbary. Barbary slave galleys were used to sell the Packard Custom Eight De Luxe automobile in the 1930s, and children could even play the "Pirates of the Barbary Coast" board game.[44]

Filmic Barbary monsters are numerous, and include the 1975 Sean Connery-Candice Bergen movie *The Wind and the Lion*. The film is loosely based on the 1904 kidnapping of Jon Perdicaris and his father-in-law, Cromwell Varley, who, when released by their captor, described their lodgings to the *New York Times* as "Mr. Perdicaris's Summer Home."[45] Their captor Raisuli was described as "a tribal gentleman of the old school, lodging his captives in a magnificent tent and dining with them each evening."[46] In the film, these details are transformed, starting with "the balding businessman Joe Perdicaris," who "is transmogrified into a nubile Candice Bergen."[47] The captor (played by Sean Connery) beheads people with a smile and a wink while uttering Arabic phrases like "Bismillah." Even though he does not rape or murder the Perdicaris family—a widow and her two innocent children all dressed in white—the threat is ever present. Bergen's character's white virginal dress, juxtaposed to her captor's dark skin and clothing, is an example of the "chromatic sexual hierarchy" utilized in many films, in which the "white woman is desired" and is "made captive and virtually raped."[48]

Barbary villains informed the Muslim characters that become popular in film and other forms of entertainment. Cartoons like "Ali Baba the

Mad Dog of the Desert," "Hassan the Assassin," and "Desert Rat Hordes" feature similar characters, influencing the ways Americans think about Muslims as violent, frightening, foreigners.[49] The Muslim characters from films, cartoons, dime store novels, and television contribute to the archive of Muslim monsters, revealing both a fascination with the exotic as well as a repulsion toward Muslims. Continuing to track that fascination/repulsion, I now turn to film, populated with a wide assortment of Muslim monsters.

Muslims on Film

Film is a voyeuristic project. Historically tied to anthropology, and in particular to the museum, it has often bridged science and entertainment. Like anthropology, movies are often focused on the foreign and the exotic. The "permeability of boundaries" between the anthropological museum and its exhibitions (especially its dioramas) and other cultural spaces reveals the "historical intersection" of the various academies of science and Hollywood.[50] Muslim characters in film are often further alienated—racially, ethnically, sexually, or through gender—due in part to the "exoticism inscribed in the anthropological culture concept," which may partially explain why we find a large number of early Hollywood films focused in Oriental spaces.[51] Exoticism, embedded in the anthropological project and validated by Orientalism, is a reproduction of classical ethnography.[52] Anthropologists have often placed their subjects in a different time through "the *problematic* simultaneity of different, conflicting, and contradictory forms of consciousness."[53] Cinema has done this as well, placing Muslims and others in a pre-modern space, often in a landscape immune to modernity, a strategy that allows the privileged position of the West to be maintained.[54]

In the majority of Hollywood films, Muslim characters are depicted as villains harassing, kidnapping, raping, terrorizing, and killing innocents, often Americans or Europeans. These depictions often reflect two worlds—the world of the West and the world of the East. Beginning with the Valentino films *The Sheik* and *The Son of the Sheik* in the 1920s, Muslim men have been depicted as medieval and have been juxtaposed with white Christian moderns. The Orientalist aesthetic expresses itself in numerous films, from early silent films that take place in wind-swept desert kingdoms to the alien worlds of science fiction films, where aliens, including Muslim monsters, live.

Film is a great communicator. Its use in propaganda campaigns is well supported by the literature. Scholars have also shown how movies, and in particular characters that create fear, have influenced the attitudes toward particular communities. In horror film, a symbiosis exists between the dreams of the filmmaker and the nightmares of the audience—this is the "fusion made by the shared structures of a common ideology."[55] In some cases, monsters are culturally neutral, failing to express a particular identity. In other cases, however, monsters have a pronounced ethnic, religious, or racial identity. Paul Wegener's 1920 film, *The Golem: How He Came into the World*, is an example of the latter, by altering the *golem* legends situated in Jewish folklore to create a monster that threatens German Christians. This Jewish monster is ultimately destroyed by an Aryan hero. "The beautiful blonde child who vanquishes the Jewish menace becomes an innocent defender of her faith as well as her people."[56] The Golem film is one of many movies depicting Jews as monsters. Wegener, whose later films included Nazi propaganda pieces, made a film that mattered to Germans, a movie that had "crucial social and political implications," which we know too well.[57] The Muslim characters examined here also have implications, for they, like the golem, function as powerful celluloid monsters, but they also exist *beyond the limits of the frame*.[58]

Most of the Muslim monsters examined here have, in one way or another, been inspired by Orientalism, which is formulated in a "symbolic world of infinite complexity, surprise, color, manifold variety and richness."[59] The emphasis on difference exists as a "great zero, a place-holder about which is elaborated complex semantic systems and cross-references defying the imagination of even the most far-out science fiction novelist."[60] Time, specifically, the lack of shared time, organizes the manner in which Muslims and other non-whites are portrayed in film. In movies, Oriental exoticism is expressed in numerous tropes—the veiled harem girl, the sword-wielding despot, lavish Oriental decorative accoutrements, turbans, flying carpets, genies, and palace rooms filled with jewels and silks—things of the past. But exotic discourse also has a "darker side of imagery [that exhibits] deviant and even horrifying aspects."[61] Orientalism frequently devolves into horror.

Orientalist imagery is featured in many of Hollywood's classic films, which often include Romanticized images of the East, along with grotesque and frightening material. In Cecil B. DeMille's *Fool's Paradise* (1921), "he conflates bizarre and vulgarized representations of Africa,

the Middle East, and the Far East," an example of his imagination run-
ning "riot."[62] This movie is an Orientalist phantasmagoria, a collection
of horrifying images that symbolize the terrible East: "Siamese architec-
ture and boats in a lagoon [with] shots of a turbaned man leading an ele-
phant," "a mansion with Mediterranean, Spanish colonial, and California
motifs," a "monkey and a Thai doll against a backdrop of leopard skin
draped on a wall," the "throne of the Siamese prince and princess [with]
two women wearing Egyptian costumes," and "scenes of Buddhist priests
with shaven heads preparing to sacrifice a lamb. . . with shots of teeming
alligators below."[63] The fact that Buddhists are shown sacrificing lambs
expresses the film's Orientalist contours. The lamb is a well-known sym-
bol of Christ, and Buddhists are vegetarians. None of this matters, for
Orientalism often focuses less on details and more on exoticism.

> Of all the animals whose death I have observed, the lamb and the
> ewe are the only ones who do not struggle when they are struck: at
> the moment when the knife cuts the jugular, the ewe relaxes and
> does not try to flee or kick. It gives away perfectly. It dies with a sort
> of acceptance. Another animal cannot be found which signifies in
> the same way the acceptance of death. That is why it is the only one
> that corresponds to Jesus: "I lay down my life."[64]

DeMille's movie functions as a narrative about the dangers that
non-Christians pose to "civilized" Westerners. Like other Orientalist
forms, movies provide a space for virtual tourism as the "subject of a voy-
euristic tour that reifies foreigners so that they are reduced to the level of
curios produced in consumer capitalism and, more to the point, assigned
a low rate of exchange favorable to Anglo-Saxon spectators."[65]

Movie-making is, by its nature, a subjective and very personal art
form. Fellini once remarked, "people think of cinema as a camera loaded
with film and a reality out there ready to be photographed. Instead, one
inserts himself between the object and the camera."[66] This is particularly
true in movies that function as civilizational narratives. DeMille's imag-
ery is imitated in numerous later films, including George Lucas's *Indiana
Jones and the Temple of Doom* (1984), directed by Stephen Spielberg.
Like the other films in the *Indiana Jones* series, *Temple of Doom* pres-
ents a wild mixture of exotic elements from the East. The film begins in
Shanghai and quickly moves to India, where Indiana, his sidekick Short
Round (a Chinese orphan who appears to function as Indiana's servant),

and nightclub singer Willie Scott (a blonde who screams at a high pitch throughout the film) arrive at the poor village of Mayapore, whose children have disappeared (kidnapped by bad, brown people who can only be rescued by a white hero), along with a sacred stone (remember, the East is a place of endless mysteries and unimaginable powers). The villagers believe that Indy has been sent by Lord Siva to help them. The trio takes off for Pankot Palace, where an ancient Thuggee cult has been revived with the help of an androgynous boy prince. The cult enslaves children and sacrifices them to Kali in gruesome rituals led by a Hindu priest who wears a helmet with devil's horns.

The banquet at the palace of the child maharajah, whose Muslim-Hindu name is Zalim Singh, is a feast with live baby snakes that emerge from a giant snake when sliced open, giant beetles, and eyeball soup (from what animal one is left to wonder). The chilled monkey brains—the featured dessert—demonstrates a complete ignorance of Hindu dietary restrictions.[67] There is a double irony here: first, regarding the vegetarian diet of Hindus; and second, the Hindu god Hanuman's assumption of the form of a monkey. As Nirej Sekhon writes, "In the second Indiana Jones film, the hero's pseudo-archaeological misadventures land him in an unnamed part of India. After consuming a typical Indian feast of live vermin, eyeball soup, and monkey brains, the decidedly non-Indian Indy discovers a subterranean 'temple of doom,' where he is left to cringe in horror as the natives tear the heart out of a living human."[68] The unmapped village of Mayapore suggests that "civilization" (the West) has not reached it.

In one of the film's climactic segments, Short Round is enslaved in the mines, Willie is captured and earmarked as the next human sacrifice, and Indy is poisoned with the Blood of Kali, temporarily brainwashing him into becoming a follower of the Thuggee cult. In a protracted scene that is both Christological and sadistic, Indy, under the spell of the potion, lowers Willie into a fiery pit, where she will be burned alive in a swirling pool of lava. Willie, dressed in a virginal white dress, her hair adorned with a crown of roses, is shackled in a metal cage that is lowered toward the subterranean fire. Willie's arms and legs are spread apart and held in shackles, to the delight of the cult followers, in a scene that is strongly suggestive of the rape of a white woman by a mob of angry, dark-skinned men. She strongly resembles Christ on the cross; even Willie's headpiece resembles a crown of thorns.

In the final fight scene, Indy battles Mola Ram, the head priest of the Thuggee cult, above a river teeming with alligators, just as in DeMille's

Fool's Paradise. Mola Ram falls in and is eaten alive. The closing scene of the film is a triumphant meditation on white American heroism as Indy and his cohorts return to Mayapore, followed by scores of child slaves freed by the righteous white hero. Only Indy (not an Indian) could have freed these children from the chains of a barbaric and violent religion. These "children indeed prove in dire need of care—of protection from their native elders."[69]

Other films in the *Indiana Jones* series feature stock Muslim characters, including an obnoxious, fat Egyptian that is the comic relief, but *Temple of Doom* and its Oriental horrors say the most about Hollywood's treatment of the East. As a trilogy, the three Indiana Jones films mirror the Arthurian form, "from a knight's interpellation into the Arthurian court, through his demonstration of that interpellation by such actions as rescuing maidens and annexing kingdoms, to his final turning to the spiritual values of the Grail quest," retold "as American history."[70] The *Indiana Jones* films are not the only creations of George Lucas that reflect both Orientalism and medievalism. The theme park is today's equivalent of an eighteenth-century tour down the Nile. Disneyland's Indiana Jones "Adventure" ride features a tour of Oriental horrors, including "caverns of bubbling death, screaming undead mummies, erupting lava, evil wraiths and giant snakes."[71]

The *Star Wars* franchise also relies on a medieval narrative form, functioning collectively as "a neomedieval romance with a futuristic setting."[72] All of the *Star Wars* films are marked by Orientalist imagery. In the first film, the planet Tatooine is a desert wasteland with a single oasis of "civilization"—Mos Eisley. The planet is named after one of the cities in which the film was made, Tataouine, an Amizagh word that translates to "mouth of the springs."[73] Outside the white (human) encampments, Tatooine is populated by all kinds of creatures. According to Star Wars lore, the Jawas and the Tusken Raiders are the only "indigenous" inhabitants of the planet.[74] The Jawas are small, unthreatening, and wily creatures. Known for bargaining skills (just like the Arab merchant), the Jawas dress in the type of robes seen in *Lawrence of Arabia* and other films situated in the Arabian Desert. The set paintings by Ralph McQuarrie include a rendering of a Jawa settlement that looks like a replica of a Persian or Arabian *caravanserai*, fully walled encampments that could be closed at night to protect those staying inside.[75] Princess Leia is shown wearing a full headscarf when she records the message to Obi-Wan Kenobi. The princess, who is spunky and independent in her interactions with all the other men in

the film, is deferential in this segment—not only does she speak quietly and respectfully, she covers her head with a *hijab*.

The Tusken Raiders are also known as the "sand people," a name resembling a common slur for Arabs—"sand niggers."[76] Like the Jawas, sand people dress in Muslim garb, wearing long, sand-covered *jalabiyyas*. Their faces are monstrous, cadaverous, and surrounded by a turban wrapped tightly around the skull, with protruding eyes and a mouth made of metal. In *Star Wars*, these creatures are frightening desert monsters. Sand people are described as "tribal" and "warlike." They also play a crucial role in the transformation of Anakin from a good Jedi to the dark side. In *Attack of the Clones*, Anakin and Padme arrive in Tatooine to find that the sand people have kidnapped Shmi (Anakin's mother). They are described by Anakin's stepfather, Cliegg Lars, as monsters: "Those Tuskens walk like men, but they're vicious, mindless monsters."[77] Anakin finds his mother in a tent of the sand people, described by one scholar as "a brutal, nomadic people," bringing to mind descriptions of roving Arabian barbarians.[78] Unable to save her from the sand people, who have tortured her to death, Anakin massacres their encampment, including all the "women and children."[79] As he breaks down, Anakin admits what he has done: "I killed them. I killed them all. They're dead.. . . Not just the men, but the women and children too. They're like animals, and I slaughtered them like animals."[80] This is the point at which Anakin's transformation to Darth Vader begins.[81] It is not accidental that this race of monsters is called the "sand people," and that they attack travelers through the desert, torture and kill the innocent, and dress in Arab garb:

> Otherness is coded in the presentation of the Tusken Raiders, which serves to normalize the lead human characters and the attributes associated with them. The Tusken Raiders exist as a spectacle of Otherness throughout the Star Wars saga who revel in violence, shooting pod racers across the desert, attacking Luke, torturing Anakin's mother, which position them as villains and bolster Anakin's violent actions against them. When Anakin kills them, it is constructed as greatly out of his character and necessary while simultaneously normalizing the relationship between the Tusken Raiders violence and Otherness. Therefore, the narrative is further constructed for Anakin as the symbol of White hegemonic masculinity to naturally kill the Others, the "Sand People". . .[82]

In a haunting scene from the first *Star Wars* film, Luke expresses his desire to fight the Empire through his training as a pilot, a desire prohibited by his uncle. The young Skywalker walks outside and, in an iconic shot, looks out at the desert at two suns in the distance. In Shi'a thought, the sighting of two moons symbolizes the coming of the Mahdi, the Twelfth Imam, who will restore the world as it should be—a place of justice and peace. Luke is not the Mahdi, but another character holds an uncanny similarity to this religious figure—Ben Kenobi. Like the Mahdi, he disappears, but he materializes again and displays incredible powers. In the end, before disappearing into the air, Kenobi reminds Vader that striking him down will only make his power stronger. Like the Mahdi, he gives messages to his deputies (R2D2, Luke, and others) and sets in motion a series of conflicts that eventually ends in the restoration of justice. Clearly, Lucas incorporated Islamic elements into several of his storylines.[83]

In *Return of the Jedi*, Jabba the Hutt keeps a harem of dancers, including the captive Princess Leia, who is chained like an animal. In 2013, members of Austria's Turkish community were angered by the Orientalist undertones in the *Lego* Jabba the Hut play set, which include a model of Hutt's fortress that bears a strong resemblance to the Hagia Sophia.[84] These are hardly the only examples of Orientalist imagery in the *Star Wars* franchise, but they serve as evidence of the power of the aesthetic, and the many places in which it shows itself. However, the more important point for the purposes of this study is that these films employ Orientalist imagery and present characters that reflect the meta-narrative about Muslims as dangerous, villainous, and in many cases, monstrous.

Films that feature Muslim monsters are the product of a cinematic history that includes Arab, Persian, Turkish, and African Muslim villains in large numbers. A useful way to understand these films is through the classification system developed by John Eisele, who argues that negative Muslim characters are so numerous that they merit their own genre—the "Hollywood Eastern." Eisele identifies 10 characteristics common to these films: transgression, separation, abduction, reduction, induction, seduction, redemption, revelation, reaffirmation, and mutilation.[85] Easterns are classified into subgenres and follow a particular narrative. White slavery films typically feature the kidnapping (abduction) of a white female who is captured or sold to another Arab or "Middle Easterner," usually rescued by a white hero (redemption).[86] There is also a long mythology of Jewish and Muslim white slavery rings. The former is exemplified by the

"Orleans Affair" of 1974, when Jewish merchants in New Orleans were accused of kidnapping and selling pretty young Christian girls into sex slavery rings.[87] In the first season of the Showtime series *Homeland*, an undercover CIA operative poses as an employee of an Arab sheik who collects white women for his traveling harem. In one graphic scene, she physically examines the genitalia of a prospective girl and tells her she needs to be clean-shaven, which is what the sheik prefers.

Sheik films are the original Easterns, established by the Valentino films *The Sheik* (1921) and *Son of the Sheik* (1926). Valentino's status as a sex symbol confuses the characters in the two films. Consider the first film, released in 1921. Valentino plays an Arab sheik—or does he? This charac-ter is more complicated than he appears, as a "sheik" who is a European dressed like an Arab who commits Arab crimes (kidnapping, rape). The sheik is also appealing because he encompasses some aspects of Romantic Orientalism (exotic dress, grand gestures, objectified beauty), but he is not really Arab. If he were a "real" Arab, the film would end with the rescue of Diana by a white hero, who would kill the "sheik" and preserve the Western frontier. The Valentino films are examples of the "sheik-in-drag," similar to the European adventurers who posed as Muslims to "experience" Mecca during the *hajj*.[88] The sheik's true identity is obscured by his dress and behavior, and by his adopted name—Ahmed. When Diana remarks, "His hand is so large for an Arab," Ahmed's French friend replies, "He is not an Arab. His father was an Englishman, his mother, a Spaniard."[89]

In the first sheik film, Ahmed kidnaps and rapes his white captive Diana, who, despite the sexual assault(s), falls in love with him and becomes his wife (or one of his wives). In the second film, the two appear as a happily married couple, with Diana giving some measured advice to her wild husband, still posing as an Arab, when their son—also named Ahmed—rapes the dancing girl Yasmin—an act of revenge for her sus-pected involvement with Ahmed's kidnapping and torture by a band of criminal Arabs. Before Ahmed Junior rapes Yasmin, he exclaims, "I may not be the first victim, by Allah, I shall be the one you remember!" This suggests that Ahmed will be as brutal as possible in the assault. Despite this, in the end, the two ride off into the desert, mirroring the rape-marriage portrayed in the first film. These two films set the standard for how Arab men (and by extension, all Muslim men) are portrayed in movies—as uncontrollably violent individuals.[90]

The violent Arab rapist-murderer is a very different character from the Muslim monster, of course, yet all of these stereotypes inform the

way in which Muslim men are viewed. Other characters in these films aid the stereotype. In *Son of the Sheik*, two characters cross over to the monstrous—Ghabah the Moor and an unnamed Arab dwarf. Ghabah the Moor is a hideous and sinister criminal whose "crimes outnumber the sands." He and the dwarf take great pleasure in threatening to rape Yasmin, as well as in torturing Ahmed by beating him and burning his feet. Ghabah and the dwarf behave like monsters; Ghabah grimaces and makes faces at the camera and the dwarf prances around like a ghoulish troll. These are the *authentic* Muslim monsters of the first Sheik film.

Hollywood Easterns often feature a white victim who is threatened or violated by a Muslim villain and eventually is rescued by a white hero. In addition to the obvious appeal of the rescue narrative, these films are examples of colonial and neo-colonial discourse, communicating the need for white masculinity to save the day. This theme is not limited to Muslim lands. According to the colonial narrative, the entire world needs the West:

> Not only has the Western imaginary metaphorically rendered the colonized land as female to be saved from her environ/mental disorder, it has also given prominence to more literal narratives of rescue specifically of Western and non-Western women—from polygamous Arabs, libidinous Blacks, and macho Italians. Many films—*The Birth of a Nation* (1915), *The Last of the Mohicans* (1920), *Drums Along the Mohawk* (1939), *The Searchers* (1956)—have perpetuated the rape and rescue trope, by which virginal White women, and at times dark women, are rescued from dark men. The figure of the dark rapist, like that of the African cannibal, catalyzes the narrative role of the Western liberator as integral to the colonial rescue fantasy. In the case of the orient, it also carries theological overtones of the inferiority of the polygamous Islamic world to the Christian world as encapsulated by the celibate priest of the monogamous couple.[91]

In cases when a Muslim female appears as a villain, she is often under the control of malevolent men—Nazis, Arabs, or other irredeemable types. One example is found in the 1996 film *The English Patient*, when a Muslim nurse cuts off David Caravaggio's fingers.[92] She wears *hijab*, unlike most of the Arab women in the scene, shows no emotion when performing the amputation, and is immune to David's pleas for mercy. Although she is not a monster, she is inhuman.

Time is a strong organizing concept in films that feature a religious, ethnic, racial, or supernatural Other. As mentioned earlier, the anthropologist Johannes Fabian argues that Western time, which is the present, and the time of the Other, old time, position the subject into a different space. "Beneath their bewildering variety, the distancing devices that we can identify produce a global result. I will call it *denial of coevalness*. By that I mean *a persistent and systematic tendency to place the referent(s) of anthropology in a Time other than the present of the producer of anthropological discourse*."[93] This critique does not apply only to anthropologists, but is seen in numerous spaces outside academia. The explanation of time offered by Fabian is that "Time" represents a world, constructed by the West, where we live in a different time and space than the subject. The manipulation of time has "sanctioned an ideological process by which relations between the West and its Other, between anthropology and its objects, were conceived not only as difference, but as distance in space and Time."[94]

We have seen this before. In Romantic Orientalism, the Oriental despot is an individual trapped in the past. Dracula is a member of an ancient race who lives in a medieval castle in a land that time forgot. Transylvania is a wasteland of superstition, monsters, and curses—the opposite of modern London with its genteel and rational Protestants, salons, gardens, parks, and other signs of progress, civilization, and humanity. The same convention is featured in Hollywood movies, often through the use of a single word (savage, barbarian) or the absence of language (either the lack of English or the inability to speak at all).[95]

In movies, Muslims are often presented as "relics of the past," reflecting a common use of time in Western discourse.[96] Language is a very useful tool in promoting this view:

> Take a word like savagery. As a technical term in evolutionary discourse it denotes a stage in a developmental sequence. But *no degree of nominalist technicality can purge the term of its moral, aesthetic, and political connotations*. Cumulatively, these result in a semantic function that is everything but purely technical. As an indication of relationship between the subject and the object of anthropological discourse, it clearly expresses temporal distancing: Savagery is a marker of the past, and if ethnographic evidence compels the anthropologist to state that savagery exists in contemporary societies then it will be located, by some dint of some sort of horizontal stratigraphy, in their Time, not ours.[97]

Hollywood films often feature Muslim "savages" who are extermi-
nated like flies. In *True Lies* (1994), Arnold Schwarzenegger plays a CIA
agent who fights a legion of Arab terrorists who are killed with impunity.
To be clear, these are not Muslim monsters: they are human characters
(bad humans, but humans nonetheless). Still, the punishment of the Arab
bodies is disturbing. Avi Nesher, a former Israeli commando who works
in Hollywood as a consultant, "incensed by the sick humor of a scene in
which an Uzi tossed down a flight of stairs inadvertently mows down a
roomful of Arabs," had this to say about the scene: "You were supposed
to laugh? I fought Arabs and I had Arab friends, but this was completely
dehumanizing a group."[98] This type of film narrative dehumanizes
Muslims and helps validate the claim that we have a right to be violent
toward the Other. Talal Asad calls this "the right to kill," which is "the
right to behave in violent ways against other people—especially citizens
of foreign states at war and toward the uncivilized, whose very existence
is a threat to the civilized order."[99]

The relationship between terrorist flicks and movies featuring imagi-
nary Muslim monsters is not particularly complicated. Portrayals of
Muslims as killing machines whose lives hold no value belong in the
realm of the imaginary. As Ira Chernus notes, the terrorist is not a mon-
ster; he or she is a human being who commits violence:

> Like all postmodern stories, the war on terrorism rests upon an
> image that is disconnected from reality. Its villain is a fiction of
> imagination, not a real person. To be sure, there are flesh-and-blood
> human beings who really do blow up buildings and kill people.
> They are driven by pressures we cannot understand and do things
> we cannot and should not tolerate, things that are morally abhorrent
> and must be condemned. But they are not the monster America
> fights. The monster is an imaginary being we call "the terrorist."[100]

The trope of the "medieval Muslim" in these portrayals has not gone
unnoticed by scholars. As Khaled Abou el Fadl argues, such symbols help
to divide the world into two camps:

> Several years ago, I remember seeing a picture of Osama bin Laden
> that ominously foretold the tragedy that would come in 9/11. The
> picture showed bin Laden, with his typical slothful and indifferent
> look, sitting while gripping his Kalashnikov with neatly organized

and impressive-looking books filling the background. . . . With very few exceptions, bin Laden's library contained no works by modern writers; nearly all the books were heavy-duty, profound, works on premodern Islamic law and legal theory. . . . With his paltry and rustic furniture, Kalashnikov, and tradition-oriented library, bin Laden symbolized a rebellion against the prevailing paradigms of postcolonialism and the culture of modernity.[101]

In the case of Al Qaeda, the bifurcation of the world is understood in terms of *Dar al Islam* and *Dar al Harb*—the abode of Islam and the abode of war.[102] By following a medieval ideology, Muslims place themselves in the past—the same space in which the West has deemed that all Muslims, American Indians, Africans, and other non-whites live.

In the world of movies, the "pre-modern" Muslim is always presented in stark contrast to the modern and civilized European and American. Muslims are "camel-riding, terroristic, hook-nosed, venal lechers," while the white Christian is "unlike the Oriental, a true human being."[103] The descriptors used for Arab characters in Hollywood films reveal a troubling approach to the representation of Muslims in cinema. These epithets include: " 'assholes,' 'bastards,' 'camel-dicks,' 'pigs,' 'devil-worshippers,' 'jackals,' 'rats,' 'rag-heads,' 'towel-heads,' 'scum-buckets,' 'sons-of-dogs,' 'buzzards of the jungle,' 'sons-of-whores,' 'sons-of-unnamed goats,' and 'sons-of-she-camels.' "[104] In addition to the use of words like "savage," "barbarian," and "sons-of-she-camels," language is used in film in a more coercive way. English is presented as the language of normative humanity, whereas everyone else either speaks nonsense or doesn't speak at all. Eurocentrism is performed through one language: "Hollywood proposed to tell not only its own stories but those of other nations, and not only to Americans but also to the other nations themselves, and always in English. In the Cecil B. DeMille epics, both the ancient Egyptians and the Israelites, not to mention God [speak English]."[105]

The language of normative humanity is English; the language of the Other, the foreigner, and the monster is babble. This is especially true of Arabic, which when included in a film is presented as "an indecipherable murmur."[106] This is a "hallmark of the Orientalist project," seen in the numerous Oriental and Muslim characters that grunt, cannot speak at all, or have an obvious physical deformity.[107] The films of Ray Harryhausen include numerous examples of these conventions. *The Seventh Voyage of Sinbad* (1958) features a Cyclops who lives in the Orient and talks

gibberish. In *Sinbad and the Eye of the Tiger* (1977), Prince Kassim can speak normally but is a baboon. The creature from outer space in *20 Million Miles to Earth* (1957) grunts and growls—his name is the "Ymir," pronounced as "emir."[108]

In film, monsters such as Godzilla or King Kong are seldom capable of speech, instead growling, grunting, or mumbling something undecipherable. Often, non-Westerners are also portrayed this way, "denied a voice in the ordinary sense—not permitted to speak—and in a more radical sense, not recognized as capable of speech."[109] In some cases, Africans, American Indians, Muslims and other non-whites are shown speaking pidgin English. This "inability to master the 'civilized' language" is a convention that symbolizes the Other's inability to become fully civilized/human.[110] Indecipherable languages are not only exotic and uncivilized, they support "the artificial construction of history," where the heroes speak English and the villains mumble and talk gibberish.[111]

Muslim Monsters

The imaginary monsters so familiar to us today, including the vampire, the mummy, the zombie, and the werewolf, are, like the monsters of the past, symbols of racial, ethnic, religious, and political difference:

> One of the ways in particular in which the boundaries between humans and almost-humans have been asserted is through the discourse of 'monstrosity.' Monsters serve to mark the fault-lines but also, subversively, to signal the fragility of such boundaries. They are truly 'monstrous'—as in things shown and displayed—in their simultaneous demonstration and destabilization of the demarcations by which cultures have separated nature from artifice, human from non-human, normal from pathological.[112]

As we have seen, the vampire originated in the anti-Semitic and anti-Turkish/Muslim discourse that was a result of British preoccupation with racial purity. The mummy, a creature that represents the mystery and darkness associated with both Africa and Islam, is a product of Orientalism and Egyptomania. The zombie's genesis was formulated by the fictionalization of African religion and was inspired by the mummies of Egypt.[113] These monsters of modernity, including the Muslim monsters identified in the following pages, express the "social anxiety toward Islam

and Muslim cultures that is largely unexamined by, yet deeply ingrained in, Americans."[114] We find these monsters in the horror film, a genre that emerged from the Gothic horror tales examined in the previous chapter. The horror film is a Gothic enterprise:

> The genre [Gothic] has yet to be defined as clearly having its own raison d'etre and its own place in a theoretical, schematic landscape along with major forms like comedy and tragedy. This despite the macabre's undeniable literary, film, and popular cultural appeal, one that hardly needs elucidation—the undiminished attraction of Poe's work, the cult status of Lovecraft, the astonishing popularity of Stephen King, the rich film world from *Phantom of the Opera*, *Nosferatu*, and *Frankenstein*, to *Rosemary's Baby*, *Night of the Living Dead*, *The Exorcist*, and *The Shining*.[115]

Of course, the transition from Gothic literature to horror film is not without a few hiccups. Eighteenth- and nineteenth-century theatrical productions of Gothic horror tales were radically different from what we find in early films like *Nosferatu*. Rather than maximizing the horror found in novels such as *The Castle of Otranto*, *Dracula*, and *Vathek*, a comedic approach was usually adopted:

> Much in this episode of dramatic history can be designated by the word "Gothic," and when one bears in mind that by 1800 the Gothic novels were in high favor with the reading public, it will be seen that native as well as foreign influences may have operated to produce it. Furthermore, many of these Gothic novels had reached the stage. But an examination of these dramatized versions discloses the curious fact that their authors seem to have taken pains to minimize the horrors of their originals rather than to utilize them for dramatic effect. Nor were they content with even this. They frequently perverted the terrors into comedy, by the way of a concession to a public which was not yet willing to suffer a romanticized theater.[116]

Even in productions that included terrifying episodes, these effects were reduced and were replaced with a campy kind of humor. In the mid-nineteenth century, there was a turn. Theatergoers began to see "ghosts and goblins, bleeding nuns who walk at midnight, wood demons

and other horrors."[117] As the twentieth century approached, the commodification of monsters began, producing myriad economic incentives and material objects related to horror. The emergence of film and, soon after, the establishment of the Hollywood studio system played a huge role in this process. As Peter Lang has observed, "The interest in monsters did not abate in the course of the twentieth century. On the contrary, it grew and reached new dimensions in modern popular culture. Monsters, like mythic images in general, were systematically commoditized and sold on the mass market, as toys, filmic, TV, or literary characters."[118]

Formulas from Gothic literature established the dominant narrative expressed in horror film—the entrapment of the protagonist in a space where the universe contracts. These entrapments, which include "the corridors of uncounted castles, the dark warrens of Victorian slums, sewers, and mines, the fog shrouded streets of Jekyll's or Jack the Ripper's London, and the labyrinth that leads to Dracula's castle," are recycled or re-expressed in countless suspense, horror, and slasher films.[119] In some movies, victims are trapped in underground prisons, as in *Silence of the Lambs* (1991), *The Cell* (2000), and the *Saw* franchise.[120] In *The House of 1,000 Corpses* (2003), the lone survivor is trapped in a house occupied by a deranged group of psychopaths, only to escape to an underground lair filled with corpses and other horrors.

The Gothic convention of the wasteland is often employed in horror films. Think of the deserts, forests, and jungles that serve as the setting for these movies. The 2006 film *The Hills Have Eyes*, which was shot on location in the Moroccan desert, has nuclear mutant monsters.[121] The dark and Jurassic-looking forests of the Pacific Northwest are the setting for *Twin Peaks*, where a blonde teenager is raped and murdered by a demonic spirit named "Bob"; in the *Twilight* franchise, the forests of northern Washington State are occupied by both vampires and werewolves. It is not accidental that movies, whether Western, horror, or science fiction films, feature territories occupied by the enemy. At times in political discourse these are conflated, as in Johnson's comparison of Vietnam to the Alamo and Norman Schwartzkopf's description of Iraq as "Indian territory."[122] As the films examined here show, the wasteland can be anything—a forgotten land called Transylvania, an ancient empire where the sun never shines, a planet in an unknown galaxy, or the American landscape—ravished by an outside, evil force.

The vampire first appeared on the silver screen in *Nosferatu* (1921), a German presentation of Bram Stoker's monster, featuring the rodent-like

Count Orlock. Although considered the first "Dracula film," Orlock is radically different from Stoker's Count; this is because the filmmakers could not secure the rights to Stoker's text. *Nosferatu* is the film that establishes the genre of today's Gothic horror film, followed by numerous studio productions like *Dr. Jekyll and Mr. Hyde*, *Frankenstein*, and *Wuthering Heights*—films that feature monsters, ghosts, and other terrors. The experience of seeing these films was intentionally claustrophobic, mimicking the Gothic castle or the London alley. The "cave-like setting" of the darkened theater made the film even scarier, creating a Gothic atmosphere within the cinema house; these experiences influenced contemporary masters of horror, including Stephen King and Clive Barker.[123]

More than two hundred Dracula and vampire films have been made, but few closely followed Bram Stoker's text. In 1992, Francis Ford Coppola produced *Bram Stoker's Dracula*, a film that exhibits a strong allegiance to the text, emphasizing Stoker's use of medieval imagery, his Gothic aesthetic, and highlighting the more sexually charged elements of the story. Stoker's original text is littered with medieval images, many of which are fiercely Catholic. Literary critics have understood these images as part of an anti-Catholic narrative situated in Stoker's identity as an Irish Protestant:

> Medievalism also meant Catholic imagery, and the tale of terror is replete with monks and nuns, prayers and curses, chapels and tombs, and the perverted spirituality of the Inquisition. Mindless beliefs in the face of overwhelming evil became in many such stories the signature of the Middle Ages. Even Jonathon Harker saw in the desolate Transylvanian wilderness many roadside crosses, evidence of a hopeless search for salvation in a land cursed by war.[124]

Stoker's use of this imagery is complicated, and his use of Catholicism is not solely connected to darkness and evil. Catholic religious accoutrements, most notably holy water and the crucifix, are used in the battle against Dracula. At the same time, when Jonathon enters Transylvania—a Catholic and Muslim territory—he encounters a series of medieval Catholic superstitions and images, many of which are quite frightening. In the film, a Transylvanian girl gives Jonathon a cross and warns him, "The dead travel fast." Shrines from a past era dot the landscape. Wolves and dogs gather around Jonathon as he approaches a castle, where he is greeted by a sculpture of a dragon.

Stoker's Gothic Orientalism is a central part of the text and Coppola, to his credit, expresses it in grand form. In the first 20 minutes of the film, the Turks appear numerous times—savaging Constantinople, fighting with Dracula on the battlefield, causing the Count's wife to kill herself, and ultimately costing both the Count and his beloved their souls. The movie opens with the fall of Constantinople to the Turks in 1462, an event presented as the tragedy that sets in motion the horror that unfolds. The Ottomans shoot an arrow into the Count's castle with a note stating that he has died, driving his wife to throw herself to her death, a sin for which she will suffer eternal damnation. When the Count returns and learns that her soul is lost, he rejects God, goes into a fit of histrionics, and pierces a large cross with his sword out of which blood pours forth, proclaiming, "the blood is the life." At this point the Count, too, loses his soul, becoming a monster and forever damning himself—all of this is the fault of the Turks.

At this point, the film jumps forward to 1897, to an insane asylum at Carfax Abbey in London, a property owned by the Count. Renfeld, who was Dracula's accountant until he was infected and made into a vampire, waits anxiously for his "master" to arrive and free him. Jonathon Harker is asked to take over Renfeld's accounts, and soon heads off for Transylvania, "leaving the West, entering the East." When he enters the East, which is non-Protestant territory, the atmosphere darkens. He has entered a medieval, Gothic Oriental wasteland. After the train journey, Jonathon is met by a coach driver—the Count in disguise—and is taken to the castle. When Dracula greets him at the door, Jonathon is taken aback by the Count's appearance—he wears a bizarre red robe, his hairstyle is something akin to a platinum blonde Minnie Mouse, and he is grossly pale, reflecting the pallid description in the original text.

Dracula holds a Moroccan lantern in his hand, a detail that is not incidental. Transylvania is a former Ottoman territory, and Dracula, as discussed earlier, is a hybrid monster with Turkish blood coursing through his veins. The "Eastern" lantern is a familiar visual trope, appearing in numerous writings, paintings, advertisements, movies, and other forms of cultural production.[125] Oriental lanterns are one of the commodities inspired by the East and fashionable in Europe and North America that gained popularity during Stoker's time. As Naomi Rosenblatt writes:

> In the absence of a widespread ability to travel with ease, everyday
> Victorian Americans could simply open the illustrated catalogue,

Products from the Orient, to easily recreate harems, bazaars, and palaces that they read about in travelogues and saw on display at fairs. Those catalogues offered items such as "embroidered slippers as worn by Turkish ladies in Harems" or lanterns that gave off a glow that was "most suggestive of Arabian Night and Oriental life," allowing buyers to purchase their own piece of the Orient.[126]

Another scene featuring Islamic imagery takes place in London, when Mina and Lucy open up a copy of *1,001 Nights* to find a pornographic painting. Mina is repulsed by the images in the book. Lucy, however, is very intrigued, a foreshadowing of her later copulation with Dracula. Coppola takes the sexual nature of Stoker's text seriously, and this is not the only scene in which *Dracula*'s focus is on the carnal. In a scene between Dracula and Mina that takes place in London, in which the monster is seducing the virgin, a white dog suddenly appears. The two characters pet the animal in a scene of "heavy stroking" that is more than suggestive of their sexual desire for each other.

Several scenes in the film depict sexual acts between humans and monsters. The first of these is the orgy at Dracula's castle between Jonathon and a trio of female vampires, whom Coppola represents as a harem. The vampiresses perform oral sex on Jonathon; they are half-naked, dressed in belly-dancing costumes with head veils in the style of early Hollywood *Arabian Nights* films. Dracula interrupts the sexual act and his three wives express contempt for their master, who orders them to leave Jonathon alone.

The second and more graphic sex scene takes place between Lucy and Dracula at the country house in Hillingham, "an unmistakably Orientalized milieu."[127] At this point in the film, Lucy has been infected by Dracula and is suffering from fevers, night sweats, histrionics, and malaise. The Count calls her to the garden, and Mina follows. When they arrive, the Count has transformed into a *cynocephalus*; after Lucy lies down on a bench and spreads her legs, he performs a bloody act of oral sex. Mina watches in horror, until Dracula looks up at her, breaking "the fourth wall."[128]

This scene, much like Jonathon's orgy scene, links the consumption of drinking human blood with oral sex, something Stoker's text only intimates. In these scenes, Coppola expresses one of the central themes in Bram Stoker's text, that miscegenation is a practice that creates monsters. The possibility of the monstrous race of human-vampire hybrids

is intimated at the end of the film, with Mina's pregnancy. If Mina isn't carrying Jonathon's child, British racial purity is, once again, under threat from a race of monsters.

Coppola's meditation on Dracula is one of many films that present Islam as a danger to the West. Hollywood productions tend to focus on Muslim characters that stand in direct opposition to the West—oppressed women, abusive men, and pan-Islamic backwardness. Muslim monsters are a bit more rare in the movies. When they are featured, a bit of genealogical work is required to reveal their identity. Such is the case of *300*, Zach Snyder's 2007 film adaptation of Frank Miller's graphic novel. To create a movie that visually represents the text, actors performed "against blank screens on which backgrounds [were] drawn to represent the panels Miller created."[129] The computer-generated terrors include a nine-foot-tall King Xerxes, an army of Persians, including giant elephants and rhinos, and a hunchback with filed teeth—monsters that are made larger and more frightening through the use of this technology.

While the film is purportedly about an ancient battle, in fact it is a virulently hateful film, targeting Muslims (specifically, Persians), Africans, and the disabled. *300* displays a wild mixture of pre-modern fantasies about Muslims, existing as a kind of filmic expression of the Saracen doxology:

> Yet however one chooses to judge the persisting of Crusading ideology, it is essential to consider as well a discourse that is inextricably bound up with it, one remarkably uniform throughout the centuries, an ideology we might dub the Saracen doxology to emphasize its descent from medieval ways of constructing the Saracen other as well as its perdurable, almost catechistic character.[130]

The film grossed over $500 million at the box office, reaching a wide audience domestically and internationally. An almost frame-by-frame movie version of Miller's text, the movie fictionalizes a battle that took place in 480 BCE between an alliance of Greek city-states, including the Spartans, against the Persians. In *300*, this battle is transformed into a civilizational war between the West and Islam. The Persians represent Muslims and the existential threat of Islam, a threat Miller has commented on publicly—he has identified Islam with terrorism and violence, without exception.

Miller's graphic comic *Holy Terror*, which imagines another battle against Muslim monsters, has been described by one critic as, "one of the

most appalling, offensive and vindictive comics of all time."[131] Thus far, press reports have not indicated that it will be made into a film. However, there is a larger discourse at play that involves anxieties about race, politics, and religion. Hamid Dabashi expresses this in his polemical critique of the film:

> Snyder's "Persians" are the nightmares of the White Christian America, the semiotic summations of all their undesirable elements—all the racialized minorities, all the vilified foreigners, all demonized in the interest of a white gang of patriarchal warriors who do not hesitate even to kill their own children if they fail the military standard of thuggish buffoonery. Look at the graphics of Miller and the cinematography of Snyder. The Spartans are not just that. There is a blatant Christological disposition about King Leonidas and his soldiers. In one final frame where King Leonidas and his Spartan soldiers are lying dead after the battle is over there is a powerful portrayal of a Crucifix that unmistakably invokes the European tradition from Michelangelo to Titian, Tintoretto and El Greco. Miller and Snyder's King Leonidas is the alter ego of Christ running amuck. There is a Dantean demonology about the manner in which Miller and Snyder depict the entirety of the world they hate for being other than white, male, Christian, and heterosexual (the only woman in 300, Queen Gorgo, is a cut in her warmongering between Margaret Thatcher, Maryam Rajavi and Condoleeza Rice—all coming together to provide the German Gestapo ideal of womanhood).[132]

The opening scene of 300 shows a young boy training to be a Spartan warrior. When he goes to battle against a giant wolf, the narrator introduces the threat against "sacred" Sparta: the Persian "beast. . . awaiting the meal to come." The Persian Empire is literally a monster, and Sparta, playing the role of the hero, is "the world's one hope" for "justice," an oppositional relationship portrayed through the presentation of the normative, human Spartans and the monstrous Persians, whose alterity is represented through deformed physiognomy, racial difference, and deviant sexual practices.

The presentation of the Spartans as white, democratic heroes and the Persians as perverted barbarians uses time as a strategy to place the Other in another space, a space that is both medieval and otherworldly. The

Spartans are ahead of their time, whereas the Persians, like all Orientals, are stuck. They are pre-modern. Remember, *300* is not about an ancient battle—it's about the victory of the West's advanced and modern civilization over Islam's backward and brutal culture: "The Saidian (and post-Saidian) historical relationship between the West and the East can be productively recast in the temporal terms that Fabian describes: The West is always 'here and now,' and the East 'there and then.' And the *there* and *then* is, predictably, medieval."[133] In *300*, this is demonstrated in several medieval tropes, but it is also expressed in the idea that Persians are located in a time and place occupied by all kinds of monsters:

> While the graphic novel portrayed the Persians as effeminate (in contrast to the overly masculine Spartans), and in the case of the Immortals, sinister, the film presents them as demonic, monstrous and mutant-like. The narrator further brings fantasy-like beasts into his account: the mammoth elephants of the graphic novel are even bigger and are joined by a giant rhinoceros in the film. The film further supplies Persian magicians that hurl sparkly grenades, the Immortals let loose the savage and gigantic Uber Immortal (as he is generally referred to by fans), and the axe-man, with whom a displeased Xerxes executes his generals, turns in the film into a mutant-like creature with Paleolithic-like axe appendages for hands.[134]

The monstrosity of the Persians is primarily based on racial difference, although hideous sexual behaviors also come into play. They are monsters that deviate from bodily normativity. Ephialtes's monstrosity is predicated on his physical disability, but he is only one of many deformed and punished bodies. In B. J. Chaplin's excellent study of the film, he argues that disability is used in *300* to represent " 'particular bodies in particular societies' and 'moral deficiency.' "[135] King Xerxes wins Ephialtes over (to the dark side) when the two meet at the king's harem, in a carnivalesque scene of disfigured lesbians, disfigured Persians (including Persians missing limbs), a human with a goat's head, lots of moaning, and a good dose of Orientalist costumes and nudity. Xerxes promises "all the pleasures of the world" to Ephialtes, who agrees, kneels before him in a suggestive pose and then issues a series of grunts before he sets off to betray the Spartans. This scene is one of the reasons the film has been described as a phantasmagoria.[136] It also plays out a long list of Western

fantasies of the harem—homosexuality, lesbianism, orgasmic delights, and monsters.

The Persians are also racial monsters. In an early scene, an African messenger from the Persian court, reminiscent of a cross between a giant and a Black Saracen or Black Turk, arrives at the Spartan court. Wearing a human garland of skulls, he is accompanied by other Persians wearing turbans and face veils. He has a vile hatred for women that is expressed in his behavior toward Queen Gorgo, played as an emancipated Western woman. King Leonidas refers to the Persians as "philosophers and boy lovers" (an ironic charge given the sexual history of Sparta) before the Black Persian and his companions are killed, pushed into a bottomless pit.[137] 300 is full of Persian characters like the Black Persian, brutal and monstrous figures exterminated throughout the film in a series of bloody and violent encounters. Perhaps the most visible and outrageous monster, however, is the king of the Persians, portrayed as a sexed-up giant pervert. This portrayal of Xerxes sent Iranians over the edge, protesting at the individual and even governmental level at what was viewed as a defaming of one of the Persian Empire's most famous leaders.

King Xerxes towers over King Leonidas, much like the giants of medieval lore who terrified Christian knights. Other giants in the film include the 10-foot tall Persians with lobster claws and filed teeth who show up at the final battle, and the giants with missing arms and metal prosthetics carrying dwarfs (who serve as archers) on their backs. Xerxes represents a long list of medieval tropes about Muslims: they are giants; they have black or brown skin; they are bisexual; they like men, they have sex with boys; and they are generally creepy. As one reviewer put it, "The Persian commander, the god-king Xerxes [Rodrigo Santoro] is a towering, bald club fag with facial piercings, kohl-rimmed eyes, and a disturbing predilection for making people kneel before him."[138]

Xerxes is identified with a deviant sexuality, signified by his preference for boys and men, his fondness for Leonidas, and the harem scene. In Kyle Smith's review of the film, he writes, "The crack about boy-love becomes central when we meet Xerxes: He's modeling the latest in earrings, dog collars, lipstick and eyeliner, like an 8-foot Rupaul. It's hard to escape the idea that Leonidas is a king who just doesn't like queens."[139] Xerxes is not deformed like Ephialtes, but his size and preference for men and boys, in the words of Ephraim Lytle, "qualifies him for special freakhood."[140] The fact that he is a giant also suggests an element of sexual monstrosity that is quite evident—Xerxes possesses monstrous sexual

organs. Xerxes reflects the medieval tale of Muslims with penises as large as trees entering heaven, requiring a small army of Jews and Christians to assist them.[141]

The fact that racial difference is connected to monstrosity in *300* is not that surprising, given the history of race in American cinema. The epidermis is often the location on which difference (racial, religious, human) is mapped:

> [Cinema] constructs the imaginative space of the other in the Western spectator's mind. Furthermore, questions raised by "colonial discourse" assume a greater urgency when discussed in relation to filmic representations of the other. The "perverse pleasures" of cinema and its potential for pornographic exploitation have been studied exhaustively by feminist film theory. Issues of colour, "the epidermic schema," to use Frantz Fanon's (1986) suggestive phrase become all the more "visible" in a visually oriented medium based on a creative play of light and darkness, the two binary elements which constitute, according to some postcolonial critics, the Manichean allegory of colonial discourse.[142]

The Persians are all monsters, a collection of deformed hunchbacks, giants, sexual deviants, and other weirdos. Persians are all bad: "Black people. Brown people. Disfigured people. Gay men (not gay in the buff, homoerotic Spartan fashion, but in the effeminate Persian style). Lesbians. Disfigured lesbians. Ten-foot-tall giants with filed teeth and lobster claws. Elephants and rhinos (filthy creatures both)."[143] The prequel to *300*, titled *300: Rise of an Empire*, focuses in part on the life of Xerxes, and given that it is based on Frank Miller's unpublished graphic novel *Xerxes*, one can guess that it will include more Muslim monsters.

Bram Stoker's Dracula and *300* express a particularly Gothic style. Transylvania and the Persian Empire are depicted as dark, foreboding landscapes, full of monsters. They follow the crusader narrative, in which gallant knights (Van Helsing and his assistants, Leonidas and his army of valiant soldiers) do battle with monsters—vampires in one case, an array of giants, dwarfs, and other creatures in the other. Medieval imagery dominates these two films, in costumes, sets, and accoutrements. Dracula's home is filled with Eastern delights and horrors. The count greets Jonathon with a Moroccan lantern, and veiled female vampires eat a human baby. *300's* monsters congregate around a perverted sultan of

ancient Persia, a "god King" who lords over a harem of terror and demands submission [code for "Islam"] from all those who cross his path.

Science fiction offers something quite different. It is often less Gothic but still pushes a civilizational polemic in narratives that are focused on the struggle to preserve "our" way of life against an "alien" force attacking civilization. Alien/foreign/monster are symbols for the current anxiety of the time. Since 9/11, the focus of these anxieties has been the Muslim, generating a universe of non-human creatures, often cast in the language of a post–September 11 world.

6

The Monsters of September 11

Aliens and Other Muslims

"Alien" is often code for non-white Christians. Science fiction is a political genre:

Once clearly identified as aggressive, or implacable, or too "different" to coexist peacefully with an enlightened humanity, then the Other becomes a legitimate target. It is at this point that the process of stereotypical manipulation in SF, when faced with the Other, often defeats its own attempts at heroism. To create a resourceful enemy, the alien is endowed with a varied and heterogeneous degree of intelligence. However, it is rarely an intelligence that humans would find incomprehensible and, most significantly, it is hardly ever an intelligence superior to humankind's. From a postcolonial perspective, the misrepresentation of the Other is almost complete. The alien first exoticized and distant, then identifiably different, has now become a quantifiable and dangerous known, sufficiently intelligent to pose a danger but never sufficiently superior to overcome the wiles of Homo sapiens.[1]

In the 1950s, movies about "aliens" were cautionary tales about the Communist/atheist threat, but with the end of Soviet power, a new danger emerged—Islam.

Stephen King once remarked that we create horrors to deal with the anxieties that exist in the real world, and chief among these is our fear of mortality, which is heightened during times of conflict or fear of conflict.[2] The idea that "[w]e should fight for our humanity, and 'not go gentle into

that good night'" has political implications.[3] This is precisely why the history of movies is tied to political events, something seen in the increased production of science fiction films during the Cold War and the precipitous rise in apocalyptic films since 2001.

It is not accidental that in science fiction movies, imaginary planets often take the appearance of Arabian deserts. The Gothic formula of the desert wasteland has continued to be a popular motif in the twentieth century—expressed here in Yeats's famous poem "The Second Coming":

> *Surely some revelation is at hand:*
> *Surely the Second Coming is at hand.*
> *The Second Coming! Hardly are those words out*
> *When a vast image out of Spiritus Mundi*
> *Troubles my sight: a waste of desert sand;*
> *A shape with lion body and the head of a man,*
> *A gaze blank and pitiless as the sun,*
> *Is moving its slow thighs, while all about it*
> *Wind shadows of the indignant desert birds.*
> *The darkness drops again but now I know*
> *That twenty centuries of stony sleep*
> *Were vexed to nightmare by a rocking cradle,*
> *And what rough beast, its hour come round at last,*
> *Slouches towards Bethlehem to be born?[4]*

The trauma of World War I and the Age of Anxiety influenced this poem, but there is something else—the evil that has always been associated with the desert. "The desert yields not the Son of Man but the horror, the heart of darkness; a place not of indifference, but of malign terror."[5] This vision of the desert is found in several genres of fiction outside fantasy and science fiction, most notably the Western. In Cormac McCarthy's *Blood Meridian* (1985), we find "a chilling, raw restatement of the American West" that is "amoral, apocalyptic—steeped in the surrealism and nightmare of Dante, de Sade, and the art of Hieronymus Bosch."[6]

The desert island typically functions as a landscape of horrors in several science fiction films. In the first *Star Wars* film, a giant skeleton of a dinosaur-like creature lies on the sands of Tatooine while C3PO and R2D2 wander in the desert. They encounter all manner of horrible creatures, from the sand people to the array of grotesque monsters in the cantina at Mos Eisley, including a number of human-animal/reptile hybrids. *Dune*

(1984), based on the science fiction novels of Frank Herbert, takes place on a planet covered with deserts and occupied by giant carnivorous sandworms. The name of this planet is Arrakis, taken from the Arabic *ar-rakis* ("the dancer"). The conflict in the story surrounds the struggle for spices, historically referencing the competition for spices between Europe and Islamic states. Arrakis is but one planet controlled by Padishah Emperor Shaddam, whose honorific title *padishah* is a Persian word that means "king."

The Riddick films also feature an interesting array of Muslim images and characters, both positive and negative. Most of the first film, titled *Pitch Black* (2000), takes place on a desert island with deadly sandstorms, where Riddick leads a group of humans through the desert, including characters named Imam and Zeza, who wear Muslim clothing, perform *salat*, and pepper their speech with Arabic phrases such as "Salam Alaikum" and "Rahman." The sequel, *Chronicles of Riddick* (2004), appears to have been made in response to 9/11. It opens with the following narration:

> Not since the crusades on earth has such damage been done by theological dogma. Known as lovers of death, Necromongers perpetrate their own unholy war with a viciousness and finality never seen before on any world at any time. To each civilization driven to its knees, they offer a simple choice—convert or die. Unfortunately for the converts, those who choose death may meet the gentler fate.

In *Chronicles of Riddick*, the monsters kill humans who do not agree to "convert" to the Necromonger religion; when they do convert, the humans kneel down in the Muslim stage of prayer known as *sujud*. The Grand Marshal of the Necromongers goes on a pilgrimage and returns as a monster. He lives in a Moorish-style palace where Riddick is repeatedly tortured. The Grand Marshal constantly orders captives to "convert," "convert or fight," or "convert or die"—some of the language in which this film reflects contemporary political discourse surrounding Islam.

In addition to the Moorish-style palace in Riddick, many other science fiction films feature Orientalist architecture. For example, in *Star Wars, Episode I: The Phantom Menace*, Naboo's capital Theed is fashioned along "Orientalist contours."[7] Theed bears an uncanny resemblance to Istanbul's skyline. The domain of monsters is not necessarily a desert or an Orientalist skyline, but often an "empty landscape, ranging from waste lands to underexploited resources, punctuated by crowded and decayed cities, faint echoes of an earlier glory."[8] Such is the case of apocalyptic

films following 9/11—movies that often use imagery from September 11 with stunning accuracy.

Some of these films are fiercely political. Since September 11, 2001, there has been a marked increase in the production of zombie films, a phenomenon noted by scholars.[9] Peter Dendle argues that this genre offers the same millenarian aesthetic as 9/11. "The possibility of wide-scale destruction and devastation which 9/11 brought once again into the communal consciousness found a ready narrative in the zombie apocalypses which over thirty years had honed images of desperation, subsistence and amoral survivalism to a fine edge."[10] Descriptions of zombies mimic those of Muslim terrorists, as in this description of zombification as "the logical conclusion of human reductionism: it is to reduce a person to a body, to reduce behavior to basic motor functions, and to reduce social utility to raw labor."[11] Like the suicide bomber who follows orders from his superior, the zombie has no individual identity and "cannot retain a sense of self— a unique, human consciousness."[12] And like the terrorist, the zombie is focused solely on exterminating humans, acting out of a "psychic imperialism: the displacement of one person's right to experience life, spirit, passion, autonomy, and creativity for another person's exploitative gain."[13]

This image of the zombie as an automaton with no feelings of guilt or remorse, on a mission to kill and kill again, has a political correlate. In addition to the post-9/11 spike in zombie films, there are countless disaster, millenarian, and apocalyptic movies that do not feature these monsters but exploit the fear and anxiety that the attacks created. These movies all focus on a post-2001 sense of dread that we are never safe, amplifying the anxiety Americans feel: "It does not take much of a stretch to see the parallel between zombies and anonymous terrorists who seek to convert others within society to their deadly cause. The fear that anyone could be a suicide bomber or a hijacker parallels a common trope in zombie films, in which healthy people are zombified by contact with other bodies and become infected."[14]

What is the zombie's anthropology? It turns out that the zombie has an antecedent Oriental monster—the Egyptian mummy—that predates the zombie by a few decades. The first part of this story begins in the early twentieth century, when America, following Europe, was strongly fixated on Orientalism and in particular, on Egyptology. As we saw in Chapter 4, alongside *objets d'art*, advertising, and architecture, the fascination with all things Oriental was expressed in various forms of entertainment. Magic shows, which were recorded and shown in theaters, predate the

Egyptian mummy movie craze by only a few years and often included a mummy, Orientalist imagery, and in some cases, strong racial overtones. One example is the 1909 production titled *The Haunted Curiosity Shop*:

> The setting is an interior, with a pedestal, cupboard doors, and a painted backcloth decorated with a mummy case, statues, canopic jars, plinths, busts, and figurines—a veritable Victorian fantasy of the Egyptian burial chamber. An old curio dealer, leafing through his catalog, is startled by the sudden appearance of a disembodied hand with a wand (or a sword), and then of a skull wearing an Egyptian headdress. Cupboard doors fly open, and the skull flies off the table and leftward to a shelf, where it turns into a woman's upper body and head. While the shopkeeper closes the cupboard, the woman's lower body enters from the left and attaches itself to her waiting upper half. The woman dances, and as she turns she turns she becomes a black woman—or rather; a white woman in blackface—with black gloves. Horrified, the dealer shuts her in the cupboard, but as she closes it she turns white again, and then she appears as a ghost outside the cupboard. He opens the cupboard again to discover a mummy, which changes into a man in ancient Egyptian tunic and headdress.[15]

Soon came the Egyptian mummy movies, one after another, featuring an Egyptian monster stalking and often killing Europeans or Americans. The early twentieth century saw an explosion of these films—so many, in fact, that the mummy was paired with every imaginable object, as titles like *The Mummy and the Cowpunchers* (1912) and *The Mummy and the Hummingbird* (1915) attest.[16]

Two early versions of *The Mummy* were produced in 1913 and 1914, and 85 years later, a new film, also titled *The Mummy*, was released that recreated these films in a campy but violent way. The mummy in this film is a terrifying monster, disfigured by being eaten alive thousands of years earlier by an army of scarab beetles. Equally frightening are the Arab masses that follow the monster's every order, portrayed as "mindless, murderous zombies who chant the name Imhotep [the mummy]."[17] Essentially, this is an army of mummies (very much like zombies) who follow the King Mummy. The film is filled with negative depictions of Muslims. According to one review, "If someone complains of a foul odor, you can be sure an Arab stooge is about to enter a scene."[18]

Unlike the vampire, there is no Gothic inspiration for the zombie, although Shelley's monster features zombification in the sense that he is resurrected from the dead. However, when we look at the text that started the zombie craze, there is an interesting link. William Seabrook wrote *The Magic Island* in 1929, describing how "voodoo priests, command-ing the knowledge of African mysticism and ritual, were able to kill their enemies and bring them back from the dead as mindless servants."[19] As Colin Dayan has pointed out, *Magic Island* exoticized the Haitians, and the book functioned "for the delectation of readers in the United States who sought justification for the occupation of Haiti."[20] Seabrook traveled extensively in Arabia before heading to Haiti.[21] Furthermore, he wrote a book titled *Adventures in Arabia: Among the Bedouins, Druses, Whirling Dervishes and Yezidee Devil Worshipers* (1927). This is not the only evidence to suggest that the zombie is inspired in part by the Egyptian mummy. In observing the bodily movements of these monsters in cinema, there is a striking similarity: "[The zombie's] actions are like those of the black mummy, but he doesn't have behind him the thrill of Egyptian romance, nor is he obsessed by the urge to kill or the love of a departed one. He merely does what he is told."[22]

The zombie film based on Seabrook's 1929 book is *White Zombie* (1932), in which the blackness of the Haitians and the threat of zombifica-tion are used to establish the fear of racial mixing. Much like the monster in Frankenstein and Dracula, the zombie has the potential to pollute and destroy the "white race." In the tradition of texts like *Othello*, *Frankenstein*, *Zofloya*, and *Dracula*, the monstrous Other poses a special threat to the virginal white Christian woman. Here, she is attacked and infected by the black Haitian zombie—once again, the threat of racial pollution is at the center of the narrative: "The image of the white woman who becomes a zombie puts whiteness right back into the frame of voodoo, and yet also makes it strikingly aberrant: the white zombie is an unnatural figure because she is both white and has surrendered to voodoo to the extent that it seems to possess her completely."[23] The idea that the racial or political subaltern poses a threat to white hegemony is central to the zombie story, and while not all zombies are dead—sometimes they are killing machines driven by an external force—zombies are always infected.[24]

Zombies have been related to the vampire on more than one occa-sion. "The zombie is an utter cretin, a vampire with a lobotomy."[25] H. P. Lovecraft is one of many writers who used the theme of vampire pollu-tion in his tales about the zombie. In the short story titled *In the Vault*,

the zombie infects a victim with a vampire bite.[26] This is not the only vampiric zombie. In 1954, Richard Matheson's novel *I Am Legend*, a Cold War–era apocalyptic horror tale about the last man on earth, was published. The monsters in this story are preceded by a number of other plagues: "Between the storms and the mosquitoes and everyone being sick, life is rapidly becoming a pain."[27] The monsters smell bad because they cannot excrete waste, "[b]ut the vampires didn't breathe; not the dead ones, anyway. That meant, roughly, that half their blood flow was cut off. This means, further, that a considerable amount of waste products would be left in the vampire's system."[28] The monsters are also described as "the plague."[29] These references to the vampire-zombie "odor" and the "plague" of the creatures are situated in racial discourse, where smell and disease play a prominent role. Like the anti-Semitic discourse surrounding the diseased and smelly bodies of Jews, a similar language surrounding African-Americans was popular during the writing of Matheson's book. For example, an African-American woman is depicted as "ugly," with "an unbearable odor and an oily skin."[30] Matheson's creatures are but one example of the zombie's ability to stand in for a variety of social, religious, and political enemies, and in many of these cases the zombie functions as the "catch-all monster"—the Communist, the African-American, the Jew, the Muslim. As film critic Maitland McDonagh has stated, zombie films reflect "a cultural subtext" of "the world at that time."[31]

The most obvious similarity between the vampire and zombie is that both creatures extinguish vitality and introduce a state of zombification, at times through biting their victim, and at other times by attacking the body in another way. We might think of vampires and mummies/zombies as "psychic vampires," creatures who "flourish not by sucking blood but by draining vitality, will, and even experience from their victims."[32] The standard zombie narrative introduces a monster, or monsters, who steal life from the innocent, much like the Muslim terrorist who is the neo-dead, asleep to the vitality of the living, who takes life in an intimate, "deadly embrace."[33]

In 1968, George Romero challenged this structure and turned the zombie narrative on its head, so to speak. In *Night of the Living Dead*, the zombies are not Haitians or African-Americans, but white Southerners who rove the countryside looking for victims. The hero is an African-American who fights the (white) zombies in a radical shift from the Gothic formula, "unhinging the gothic's usual association of blackness/evil and whiteness/good, the movie critiques 'whiteness' as

rapacious and horrifying."[34] Romero's film is a commentary on race in the United States. In the end, the hero is killed by Southern white police officers. The final scenes of the film are close replicas of still shots from the lynching of African-American men in the South.[35] This movie, and the countless other zombie and zombie-inspired films, are not about the dead—they are about the living.

Many zombie films follow the formula that Romero established of flesh-eating un-dead wandering the landscape in a search for more victims. However, as more zombie films were produced, the notion of what a zombie "is" changed dramatically. By the mid-1970s, the zombie had transformed into a creature that could be un-dead, but was, importantly, characterized by his or her behavior—creatures controlled by a master with no "capability to think or act for themselves."[36] One subgenre that deserves attention here is films featuring body snatchers—living humans who are infected or brainwashed, taken over by an outside force that makes them killers. These movies focus on "the depiction of our paranoia and the fear of other bodies," and in the post-9/11 milieu, these other bodies are Muslim.[37] The 2007 film *The Invasion* was marketed as a remake of the original *The Invasion of the Body Snatchers* (1978). It clearly falls under the subgenre of the "post-9/11 zombie invasion film," featuring a host of external threats including "infectious disease, biological warfare, euthanasia, terrorism."[38]

Contamination is a popular theme in post-9/11 zombie horror films, and in the body snatchers subgenre, the carriers of the germ, or disease, are humans. Obviously, this contamination is not simply biological but cultural, similar to the concept of zombies as a metaphor for terrorists. You never know who has the disease, and they may even appear as normal, healthy, and American—but something else lives inside, which may emerge at any moment. Popular discourse about Islam utilizes the language of pathology. In the United States, *shari'ah* is "creeping" across the country like an unstoppable mold, the Ground Zero Mosque is a pockmark on the New York cityscape, and real Americans are "sick" of Muslims.[39] In Europe, academic discourse is focused on the affliction of Islam; the title of one article reads, "Paving the Way for Extremism: How Preventing the Symptoms Does Not Cure the Disease of Terrorism."[40]

The Invasion, like many zombie films, focuses on the fears of contamination and infection, both strong Gothic sensibilities. The idea that disease and bodily corruption originate from someplace else is often expressed on foreign and alien bodes that threaten our civilization, so "[t]he Gothic

underscores the multifold miasmas, poisons, fungi, plagues, viruses, that are out there and able to destroy our individual or collective systemic order."[41] Placing these disruptions, germs, and corruptions into a strange body is one way that monsters are created, and in films like this, "[h]orror focuses upon the terror of that which is bio-antithetical, bio-illogical, a fear as viable today as it was in the middle-ages or in the imagined Middle Ages of 18th century Gothic literature."[42] In *The Invasion*, a virus comes from elsewhere, infects normal people, and can only be stopped by the mass mobilization of the military across the homeland. In the opening scene, the heroine, a psychologist named Carol, played by Nicole Kidman, is shown ingesting sugary soda and handfuls of pills in an effort to stay awake. Sitting on the floor in an abandoned drugstore, Carol stares up at flickering lights while the world around her appears to tip side to side, like an airplane in trouble. As she struggles to stay awake, yells and screams are heard from a group of people trapped in a closet, unable to get out and begging for her help. In the flashing lights, the hysteria among the face-less people who pound on the door, and Carol's apparent vertigo, we have a scene reminiscent of a plane going down—the first of numerous scenes reflecting anxieties surrounding 9/11.

The movie then flashes back to the origin of this nightmare, which occurred when the space shuttle *Patriot* crashed to earth and released a virus of unknown origin. Framed as an attack on America, the virus immediately starts infecting people without warning. Carol, in her work as a psychologist, begins to notice that people are changing—behaving differently than their "normal" selves. After a series of desperate phone calls from a patient whose husband has apparently been infected with the virus, Carol goes online and conducts a search based on the patient's description of her husband, who has exhibited increasingly bizarre and frightening behavior, much of which focuses on controlling his wife. She finds that millions of people have posted statements like, "My husband is not my husband," and "My son is not my son." The virus appears to make men aggressive and violent and women silent and subservient—curiously, exhibiting the exact qualities with which Muslims are usually portrayed.

Shortly after Carol makes this discovery, she finds that her ex-husband Tucker, who had shown signs of the virus, has taken their son, Oliver. When she goes to find Oliver at Tucker's home, she is detected, and before she can escape, her ex-husband, helped by three other contaminated men—now zombies—infect her with the virus. In addition to the manner

in which they spread the virus to her, by spitting in her mouth, the scene is disturbing on another level—this is a gang rape.[43] The zombies force Carol to the ground and hold her down. She protests and fights and then is violated with a forced ingestion of bodily fluid. With this scene, *The Invasion* becomes a "rape film," one of the countless movies that feature "a rape, an attempted rape, a threat of rape, an implied rape, and even violent or implicitly coercive sexuality."[44] This assault mimics the gang rape scene from *The Accused* (1998); in fact, once it is "over," Carol flees the scene, just as Jodie Foster's character did after she was pinned down and assaulted in *The Accused*. Like Foster's scantily dressed, inebriated character, Carol, who is strong and completely independent from her ex-husband, is also presented as "asking for it." The assault is in the tradition of other rape narratives in which a female is victimized due to her flirtatious behavior, independence, or other characteristic. In Hollywood cinema, "the number of films that associate women's independence and sexuality with sexual violence is overwhelming."[45]

Once Carol escapes, she finds Oliver at his grandmother's house. She poses as infected by acting non-emotional and almost catatonic. Here, it is revealed that the virus renders one emotionless; the infected are zombie-terrorists with no emotions, no morality—beings solely focused on the destruction of human life. Carol flees with Oliver and finds refuge in the pharmacy, returning us to the opening scene of the movie. When her boyfriend Ben shows up, purportedly to help them, it is clear he has been infected as well. This is where the film gets really interesting. Ben tells Carol that it is no use to resist, that "they" offer a new world absent of pain, war, and suffering. "We were wrong to fight them," Ben argues, insisting they offer "a world without war, poverty, hate. . . rape," then suggesting, "You know it's true. Our world [that is, *their* world] is a better world." This vision of the world is very millenarian—the old will be wiped out and a new order will take place. Like the vision of Islamicate Universalism, everything will be just and peaceful. In one of bin Laden's manifestos, he offered this explanation to "the Americans," a plea to join him in creating a new world:

> It is to this religion that we call you—the seal of all the previous religions. It is the religion of the *tawhid* of Allah, sincerity, the best of manners, righteousness, mercy, honor, purity, and piety. It is the religion of showing kindness to others, establishing justice between them, granting them their rights, and defending the

oppressed and the persecuted. It is the religion of enjoining the good and forbidding the evil with the hand, tongue, and heart. It is the religion of *jihad* in the way of Allah, so that Allah's word [Koran] and the religion [*shariah* law] reign supreme. And it is the religion of *tawhid* and agreement in obedience to Allah, and total equality between all people, without regard to their color, sex, or language.[46]

Carol resists the urge to fall asleep and become one of "them," shoots Ben in the leg, and makes a run for it with Oliver. They are rescued on a rooftop by a military helicopter, barely escaping the throngs of zombies below. In the end, the mass mobilization of the US military and its government agencies—including its most brilliant scientists—save the day. The helicopter heads to a military base, where Oliver's blood is used to create a vaccine that will cure the infected and restore America to what it once was. The homeland has been restored by the military, just as it was after 9/11.

After September 11, 2001, end-of-the-world scenarios also dominated the Cineplex, from vampire-zombie and plague movies like *I Am Legend* (2007) and *28 Weeks Later* (2007) to alien invasion films like *War of the Worlds* (2005), which incorporates a stunning number of 9/11 references and images, and environmental disaster films like *The Day after Tomorrow* (2004). These films all reflect the sense that we are living in a world where anything could happen—a notion situated in the belief that 9/11 changed everything. 9/11 is an apocalyptic event, something seen in the naming of Ground Zero, which was rooted in the "Day Zero" stories from the Cold War, which imagined a man-made apocalypse followed by the rebuilding of earth by a few survivors. These tales, with titles like *The Gas War of 1940*, *The Collapse of Homo Sapiens*, and *Unthinkable*, represent the "imminent peril of sudden extinction."[47]

There is an eerie intersection between the events of September 11, 2001 and the world of films. For one, the images of the Twin Towers that were played on a continuous cycle to the world didn't seem real, something expressed in Zizek's description of the second plane hitting the World Trade Center as "the ultimate Hitchcockian blot." These images—the planes, the fiery explosions, the crumbling and then total collapse of the Twin Towers, the people running for their lives, the remains of the plane in Pennsylvania, the hole in the Pentagon—were broadcast in real time and replayed on a continuous cycle for hours, then days, and then weeks. The questions this raised surrounding the entertainment of real horror

was noted by Zizek: "We wanted to see it again and again; the same shots were repeated *ad nauseam*, and the uncanny satisfaction we got from it was *jouisaance* at its purest."[48] The public sought other ways to experience the terror, including movies. "Even while industry leaders were eager to censor out trauma-inducing images of any kind, video outlets reported that when left to their own discretion consumers were eagerly purchasing terrifying flicks like *The Siege* and *The Towering Inferno*."[49] There was something about the spectacle in the "visceral immediacy of the images" that, for some, created an "altered state of consciousness [effecting a] haptic or pathic effect."[50] The spectacle of 9/11 became, for some, a form of entertainment, for in many ways it was the culmination of every horror film ever made, every war and disaster in American history, all rolled into one terrible day. September 11 was not a "processable" moment:

> These historical frames of acceptance had immediate resonance in the wake of September 11. The memory of Pearl Harbor evoked the surprise attack that caused massive death and destruction and drew the United States into World War II. The references to "ground zero" recalled the apocalyptic nightmares of the atomic age, long dormant but now revived, complete with visions of civilians going about their daily business snuffed out in an instant. . . . But September 11 was not an atomic attack. Nor was it another Pearl Harbor, where an identifiable nation attacked a military base. September 11 was something new. As Americans struggled to make sense of what happened, they reached into their collective historical memories.[51]

Much of this collective memory was filled with images from horror films. Lacanian analyses of these films suggest that the violent fantasies portrayed on the screen amount to "the '*mise-en-scene* of desire' for the spectator."[52] If we accept that it is "the experience of the ecstatic, often horrific Real that manifests itself in so many contemporary films," then perhaps the spectacle of 9/11 is a reversal, or blurring, of this.[53]

In the days following the attacks, networks adopted the language of Hollywood from science fiction, horror, and apocalyptic films and television shows. Just one day after the attacks, CNN titled its coverage, "The Day After" (also the title of a well-known 1980s made-for-TV nuclear disaster movie). Fox sported the slogan, "America Strikes Back"—based, of course, on the *Star Wars* trilogy."[54] Several news reports of the day utilized the language of horror, as in this case: "The World will never be the

same again. . . . Who is doing this to us?. . . There is no safe place from the bedlam of madness and mania."[55]

9/11 quickly became a form of entertainment. The images from 9/11 so familiar to us created "stock footage" for Hollywood. In Steven Spielberg's *War of the Worlds* (2005), both the language of the War on Terror and several iconic likenesses from the attacks are used. "Startling for its vivid portrayal of suspenseful urban carnage, the film's imagery includes several set pieces that specifically recall the destruction of the World Trade Center, including the clouds of clothing that float to the ground after the death rays of aliens vaporize fleeing humans. In response to an electromagnetic pulse sent out by the alien craft, airplanes fall from the sky."[56] The film's tagline ("They're already here") as well as references to "sleeper cells" evoked the political discourse of the time, the fear surrounding terrorist cells, the idea that another attack would be launched from inside the country.[57] The sense that horror was lurking everywhere was reinforced in political discourse that was Gothic in character:

> The gothic scenes evoked by Bush as much as Poe involve monsters and ghosts in tenebrous atmospheres that generate fear and anxiety, where terror is a pervasive tormentor of the senses. Poe's narratives, for example, turn on encounters with dark, perverse, seemingly indomitable forces often entombed in haunted houses. Similarly, Bush's post-September 11 narratives play upon fears of terrorists and rogue states who are equally dark, perverse and indomitable forces. In both cases, ineffable and potently violent and cruel forces haunt and terrorize the civilized, human world.[58]

In 2002, following the scape of bin Laden from his hiding place in a cave, Bush evoked images of a "terrorist underworld" that dwelled "in caves."[59] Soon, Hollywood produced a number of films featuring monsters lurking in caves and other subterranean chambers, including *The Cavern* (2005), *The Cave* (2005), *The Descent* (2005), *The Descent 2* (2009), and *Catacombs* (2007). Horror films, with their element of surprise and narratives of destruction, offered a space for people to release their anxieties. Horror is a genre that, as Lacan and others have shown, offers a way to experience horror:

> [There exists a] delight in thwarting the audience's expectations of closure. The most famous example of this tendency are the surprise

codas of Brain de Palma's films—for instance, the hand reaching
out from the grave in *Carrie*. . . . At the end of *The Evil Dead*, the
monsters, after defying myriad attempts to destroy them, appear
finally to be annihilated as they are burned to death in an amazing
lengthy sequence. But in the last shot of the film, when the hero
steps outside into the light of day, the camera rushes toward him,
and he turns and faces it with an expression of horror.[60]

This sense of doom, the milieu of fear, anxiety, and terror that over-
whelmed Americans, expressed itself in numerous ways, contributing to
the rise in zombie films, horror films (including torture porn), and those
movies that crossed genres, as well as in other spaces, including a deten-
tion center called Abu Ghraib.

The Post-Humans of Abu Ghraib

We arrive, then, at the answer to the question posed at the beginning of
this book: How did we get here? The Muslim monster, unfortunately, has
a long and storied pedigree, and we see the results in the heinous and
inhumane atrocities performed on Muslim bodies at Abu Ghraib, GTMO,
and other sites we have not thus far been able to witness (called "Black
Sites"). It is to these crimes, and the ideologies that have inspired them,
that I now turn.

The crimes of war are often gruesome, told on the bodies of its vic-
tims. Anyone who watched television during the unraveling of Yugoslavia
in the 1990s remembers the images of starving Bosnians with hollow and
empty eyes, staring at the cameras through the fences that imprisoned
them. The same defeated and empty expressions are seen in photographs
from Andersonville—like Germany, Poland, Bosnia, and other places that
have seen war, genocide, and cruelty beyond imagination in recent centu-
ries. At Abu Ghraib, we have very different images, of the hooded figure
connected to electrical wires, the naked man on a dog leash held by a
female soldier who smiles for the camera, the naked piles of bodies, and
the other bodies, some alive, some dead. These are the images that haunt
us today, a decade later.

The crimes of Abu Ghraib show us how powerful the discourse of
Muslim monsters is. One interrogator at Abu Ghraib commented, "We
thought they [the Iraqis] were animals," revealing that soldiers thought

Muslims were something only human-*like*.[61] Some US soldiers likened Iraqis to animals, referring to them as "beasts."[62] There were "striking similarities between the lives of animals and the lives of prisoners captured on film at Abu Ghraib," except the dogs used to torture the prisoners were treated better.[63] Survivors of Abu Ghraib testified to the inhumane treatment they were subjected to. Haider Al-Aboodi recalled how he and others were "forced to walk like dogs on our hands and knees. And we had to bark like a dog," Kasim Hilas told of the rape of an Iraqi boy by a male soldier that was filmed by a female soldier, and as Nori Al-Yasseri testified, "They treated us like animals not humans."[64]

Abu Ghraib is the site most readily identified with crimes against Muslim men in US captivity. The gross abuse of Iraqis is documented in photographs that have become familiar to us—the pyramids of naked bodies, the hooded figure attached to electrical wires; the soldiers grinning for the camera, giving the thumbs up, at times pointing to the object of their entertainment; the simulated fellatio, and so on. All of this happened under US military command, what some may call a result of "technocratic futurism," a fact that is neither surprising nor debatable.[65] As one study notes, "While the proverbial road to hell is paved with good intentions, the internal government memos [collected in that publication] demonstrate that the path to the purgatory that is Guantanamo Bay, or Abu Ghraib, has been paved with decidedly bad intentions."[66]

The policies that led to Abu Ghraib's house of horrors came from the highest authority, orchestrated by Americans who believed wholeheartedly in the inhumanity—the monstrosity—of Muslims, and who counted on an apathetic public, should the crimes ever be discovered. According to a January 19, 2002, memo from the office of the Secretary of Defense, "Al Qaeda and Taliban individuals under the control of the Department of Defense are not entitled to prisoner of war status."[67] Prisoner of war status, part of the Third Hague Convention, was intended to ensure that prisoners of war not be tortured. The removal of such protection gave the green light to torture. In October 2002, the DOD Joint Task Force 170 at GTMO issued a memorandum specifying what "counter-resistance strategies" could be employed, a list that includes hooding detainees, 20-hour-long interrogations, forced nudity, and the use of "individual phobias (such as fear of dogs) to induce stress."[68] Things quickly got out of hand, something anyone might have predicted. Once torture was sanctioned, the gruesome scene at Abu Ghraib unfolded—crimes that read

like a script of a horror movie: anal rape with a phosphorus light, torture through the beating of sexual members, and other sadistic acts.[69]

The crimes of Abu Ghraib are not the sole result of its architects, however. Through the archive of monsters presented here, we know that Muslim men have often been the subject of a kind of imaginary dehumanization. But what exactly is the link between these phantasms and real Muslim bodies? This is a question I hope to answer here.

In the Middle Ages, there was an identification between the page (or canvas) and the body, inscribing human bodies with meaning. As one fellow scholar puts it, "[l]iterary production takes place on bodies."[70] This made human subjects the "conveyors of words or, more generally, signs."[71] During the medieval period, Jewish, Muslim, and African bodies functioned as signs of Satan, demons, monsters, sin, and monstrosity within a system of meaning that continued to be in force in the Renaissance and later centuries. We see these signs in medieval texts and drawings, dramas such as *Othello*, great works of art, and later in the fiction of Romanticism and Gothic horror, the travel journals of explorers, board games, dime-store novels, and the movies.

Why would the same not be true today? Television and movies occupy an important place in American culture, serving as dominant influences on the way people think and behave, determining the *habitus*. Even excluding the 1,300-year archive of Muslim monsters exposed on the pages of this book, when we focus only on contemporary representations, a bleak picture emerges. Since 9/11, Muslim men, a group historically maligned in American cinema, became even more vilified. Showtime's *Homeland* series, a critical and popular success that has garnered numerous accolades and awards, features Muslim characters so sinister and cruel that they are almost ridiculous. Brody, the main character, is a rescued American soldier, a red-headed, good American boy gone bad. Transformed into a Muslim during his captivity, Brody is a brainwashed terrorist killer who, even if he is deprogrammed from his zombie-like Muslim-killer state at some point, exhibits the kind of perverse and violent behaviors long associated with Muslim men and Muslim men as monsters. On his return home, he initially refuses sex with his wife, instead masturbating in front of her naked body while she watches in shock and discomfort. Later, he consummates sex with her. It is rough sex, perhaps rape, and as the camera focuses on her face, there is an uncomfortable thought expressed in her countenance—part disbelief, part disgust. In one of the numerous sex scenes with the other main character in the series, Carrie (the CIA

agent so neurotic and anxiety-ridden that she is hospitalized at the end of the first season), Brody grunts like an animal, appearing as more beast than man. The other Muslim villains are caricatures of the fantasies long held by the West about men from the Orient—they are sinister, wily, and murderous.

It doesn't matter that *Homeland* is a meditation on fear, anxiety, and hate. Millions of Americans watch the program, and it is a favorite of President Obama's. *Homeland* is not alone in its horrid depiction of Muslims, and if it was not accompanied by dozens of other television productions, movies, books, and other media, perhaps it wouldn't be lauded, showered with praise and awards. It is not the exception to the rule—it *is* the rule. This is what makes *Homeland* and other shows and movies that feature atrocious representations of Muslims acceptable and loved. They are familiar, retelling stories familiar to us from a childhood and a history filled with such characters.

However, the existence of the Muslim monsters documented in this study only partially explains Abu Ghraib. The United States of America has a long history of brutality and violence toward its enemies. One only needs to look at the annals of American Indian history, or at slavery, to know this. This is a violent country that has done, and continues to do, very bad things. Add to this the policies established under Bush and Rumsfeld, a military culture that counts on the dehumanization of the enemy in order to be successful, and the popularity of books like Ralph Patai's *The Arab Mind*, a "study" of "the Arab" and their sexual neuroses that had widespread readership among US policymakers, military brass, and soldiers during the early 2000s.[72]

The photographs that emerged from Abu Ghraib were orchestrated, designed, and thoughtful. They were not spontaneous, or, in the words of many commentators, the result of a few bad apples. The soldiers who set up the pyramids of naked bodies, for example, took extra care to make sure that "each man had his penis touching the buttocks of the man below."[73] Great care was taken in the abuse of Iraqis at Abu Ghraib. Much like the lynchings of African-Americans, the crimes of Abu Ghraib became a public and visible event.[74] Nearly two thousand photographs were taken, suggesting that in some way, the perpetrators wanted to memorialize the crimes. There is a precedent in US history for such a horrible subject of photographic documentation. At one time, the photographs of lynchings were popularized, made into postcards, while special trains ran by the sites of the crimes—making the death of black men a

kind of entertainment that lived on far beyond the original crime and its viewing.[75] The photos of Abu Ghraib are also permanent mementos of the cruelty and depravity of American power and the helplessness of those who find themselves subjected to it. Abu Ghraib has not yet become a tourist site. It is now called Baghdad Central Prison. Re-opened in 2009 to ease overcrowding at other prisons, it got a fresh coat of paint in lavender, cream, and baby blue, the walls decorated with slogans in Arabic and posters that say, "No to torture."[76]

Abu Ghraib is part of the archive of Muslim monsters. Like the spectacle of foreign bodies formulated in the Middle Ages and the Renaissance, which continued to be seen during the colonial age, the images of Muslim bodies that emerged from the prison are situated in a mixed-up milieu of sexual desire and repulsion. The fact that so many of the photographs are fixated on sodomy is not lost on scholars. As Nicholas Mirzeoff writes, "[that] the whole indigenous population was composed of sodomites served as a means of justifying and necessitating early colonial expansion in the Atlantic world," which in discourse about the goods of slavery represented Jews and Africans as "sodomitical."[77] Muslims have often been viewed this way, as having a bizarre sexuality, or even being sexual monsters, what used to be described as *sodomia*.

The relationship of the crimes detailed at Abu Ghraib in photographs—1,800 or so images of naked, tortured, sodomized, bloody, and dead Iraqis—were interspersed with "selfies" of the soldiers performing sex acts on themselves and others. Abu Ghraib was essentially a set for snuff films, pornographic movies in which real people are murdered. Even those advocating torture recognized the pornographic aesthetic. Rush Limbaugh described the images as "[s]tandard good old American pornography."[78] A more apt description might be torture porn, the name given to a genre of films that was inspired in part by Abu Ghraib. These are movies that portray the gruesome and extended torture of human beings trapped in a prison-like cellar, room, or other setting.[79] At Abu Ghraib, the difference was, it was real.

Like other colonial spaces examined in this study, Abu Ghraib displays desires about others, as well as revealing the fantasies of torture that ran riot after September 11. The popularity of torture in television and film has gone largely unnoticed by scholars, but as Ziauddin Sardar has written, "There is a seamless connection between what happens in American society, the way society is represented by Hollywood, and the torture meted out by US soldiers abroad. In movies, torture is an everyday activity."[80]

Abu Ghraib also perpetuates the idea that, for some, torturing Muslims is an acceptable pastime, a hobby for good old boys, what Rush Limbaugh described as, "a good time. . . sort of like hazing, a fraternity prank. Sort of like that kind of fun."[81] The idea that soldiers had a right to torture and have *fun*, after having to put up with Muslims all day long, reveals the power of the imaginary monsters documented in this book.

What lies behind these crimes? This question has received considerably less attention than the crimes (and their aesthetic resonances) themselves. The answer is found in the belief that Muslims are less-than-zero—post-human.[82] The horrors of Abu Ghraib, which continue in some form at GTMO in the forced feedings and other governmental policies still underway, are acts that reveal that Muslims are not considered human. This is, I believe, what makes the existence of imaginary Muslim monsters in Europe and the United States such a serious problem. Something led the architects of the War on Terror to think that the indefinite detention, torture, rape, and murder of Muslims—no matter how "bad" these Muslims are—would be acceptable. Muslims are so dehumanized in public discourse that treating them as just bodies, Agamben's "bare life," has become, in fact, acceptable. Muslims are not just represented as monsters—they *are* monsters.

The post-human condition of Muslims is something that has yet to be undone. At the writing of this book, GTMO was still open; and lest we forget, the commander who came to "Gitmo-ize" Abu Ghraib, Major General Geoffrey Miller, was transferred from Guantánamo Bay, suggesting that what we know of Abu Ghraib has happened before and will happen again.[83] Abu Ghraib and GTMO are but two cogs in the large and complex machinery of hate and dehumanization. In these spaces, the obliteration of Muslim humanity is complete.

Notes

INTRODUCTION

1. Susan Sontag, "Regarding the Torture of Others," *New York Times Magazine*, May 23, 2004: 26.
2. Stephen C. Caton, "Coetzee, Agamben, and the Passion of Abu Ghraib," *American Anthropologist* 108, no. 1 (2005): 121.
3. Peter Gottschalk and Gabriel Greenberg, *Islamophobia: Making Muslims the Enemy* (Lanham, MD: Rowman and Littlefield Publishers, 2008), 5.
4. Bush and bin Laden provided similar visions of a world bifurcated by modernity and medievalism. Both utilized religious language and outlined who the enemy was (for Bush, radical Islamicists; for bin Laden, anyone but radical Islamicists). See Bruce Lincoln, *Holy Terrors: Thinking about Religion after September 11* (Chicago: University of Chicago, 2003), 29.
5. Edward Said, *Orientalism* (New York: Vintage, 1978), 108.
6. Sherene H. Razack, "How Is White Supremacy Embodied? Sexualized Racial Violence at Abu Ghraib," *Canadian Journal of Women and Law* 17 (2005): 356.
7. Talal Asad, *On Suicide Bombing* (New York: Columbia University Press, 2007), 91.
8. Anna Czarnowus, *Inscription on the Body: Monstrous Children in Middle English Literature* (Katowice: Wydawnictwo Uniwersytetu Śląskiego), 2009, 77.
9. Anne McClintock, "Paranoid Empire: Specters from Guantanamo and Abu Ghraib," *Small Axe* 13, no. 1 (2009): 54.
10. See McClintock 2009, 64, on the use of torture against non-whites in US history.
11. Salahuddin is more commonly known as Saladin in the West. An individual cited in Christian texts for his bravery and chivalry, he was often compared to his contemporary Richard the Lionheart for his chivalry and bravery. See G.

J. ten Hoor's article, "Legends of Saladin in Medieval Dutch." *Monatschefte* 44, no. 6 (October 1952): 253–256.

12. Zan Strabac and Ola Listhaung, "Anti-Muslim Prejudice in Europe: A Multilevel Analysis of Survey Data from 30 Countries," *Social Science Research* 37 (2008): 283. According to this research, the Czech Republic is the exception to this trend, in that general anti-immigrant sentiments are stronger than anti-Muslim attitudes (p. 279).

CHAPTER 1

1. On French renderings of the Prophet, see Jane Smith's article, "French Christian Narratives Concerning Muhammad and the Religion of Islam from the Fifteenth to the Eighteenth Centuries," *Islam and Christian-Muslim Relations* 7, no. 1 (1996): 47–61.

2. Rebecca Joubin, "Islam and Arabs Through the Eyes of the *Encylopedie*: The 'Other As a Case of French Cultural Self-Criticism," *International Journal of Middle East Studies* 32, no. 2 (2000): 197–217.

3. Said, *Orientalism*, 70.

4. Zachary Lockman, *Contending Visions of the Middle East: The History and Politics of Orientalism* (New York: Cambridge University Press, 2004), 77.

5. Said, *Orientalism*, 207.

6. Ghassan Salamé, "Islam and the West," *Foreign Policy* 90 (Spring 1993): 22.

7. For discourse about Africa as the perennial Other against which the West defines itself, see Achille Mbembe, *On the Postcolony* (Berkeley: University of California Press, 2001).

8. Richard King, *Orientalism and Religion: Postcolonial Theory, India and "The Mythic East"* (New York: Routledge, 1999), 7.

9. John Lloyd Stephens, *Incidents of Travel in Egypt, Arabia Petraea, and the Holy Land* (Norman: University of Oklahoma Press, 1970), 318. Stephens traveled to the region to "cure" his poor health. Wealthy European and Americans often traveled to the East, a region viewed as a place with magic and power, in search of cures for physical and spiritual ailments.

10. Imazighen are more commonly known as Berbers, a term that in both Arabic and English denotes a barbarian character. See R. A. Skelton, *Explorer's Maps* (West Sussex, UK: Littlehampton Book Services, 1970) for maps depicting the regions where barbarians could be found, including North Africa.

11. James W. Messerschmidt, *Hegemonic Masculinities and Camouflaged Politics: Unmasking the Bush Dynasty and Its War Against Iraq* (Boulder, CO: Paradigm Publishers, 2010), 116–117.

12. The innate violence among Muslim men is a common Islamophobic myth, one found in a number of cultural spaces, including entertainment. In the March 19, 2004, episode of HBO's *Real Time with Bill Maher*, the host theorized

that terrorism was caused by the celibacy inherent in Muslim culture, once again equating sex with violence in constructing a Muslim "identity." In his words, "Have you ever wondered why the word from the Arab street is always so angry? It's because it's a bunch of guys standing in the street! Which is what guys do when they don't have girlfriends, when they're not allowed to even talk to a girl. Of course they want to commit suicide! Unlike this country where it's the married guys who want to kill themselves. . . . But here we always have hope. You can at least talk to a girl. And one might be crazy enough to go for you. Or you could get rich and buy one, like people do in Beverly Hills. But the connection between no sex and anger is real. It's why prizefighters stay celibate when they're in training, so that on fight night, they're pissed off and ready to kill." Maher regularly singles out Islam in his monologues.

13. Slavoj Zizek, *Welcome to the Desert of the Real* (New York: Verso, 2002), 72.

14. See William T. Cavanaugh, *The Myth of Religious Violence: Secular Ideology and the Roots of Religious Conflict* (New York: Oxford University Press, 2009).

15. Frantz Fanon, "Algeria Unveiled," in *The New Left Reader*, ed. Carl Oglesby (New York: Grove Press, 1979): 170–171.

16. Although less focused upon, the Oriental Jewess has also been a subject of desire.

17. For a study of the harem as fictive space for the West, see Ali Behdad, "The Eroticized Orient: Images of the Harem in Montesquieu and his Precursors," *Stanford French Review* 13, no. 2–3 (1989): 109–126.

18. Joseph A. Massad, *Desiring Arabs* (Chicago: University of Chicago Press, 2007), 38.

19. See Joseph A. Boone, "Vacation Cruises; Or, the Homoerotics of Orientalism," *PMLA* 110 [Special Topic: Colonialism and the Postcolonial Condition], no. 1 (1995): 89–107.

20. Elaine Graham, "Post/Human Conditions," *Theology & Sexuality* 10, no. 2 (2004): 20.

21. Pierpaolo Atonell and João Cezar de Castra Rocha, "Introduction," in *Evolution and Conversion: Dialogues on the Origins of Culture*, by René Girard (New York: Continuum Books, 2007), viii.

22. European Jews were not foreign, but were constructed as outsiders, what some scholars have described as internal Others.

23. Charles Taylor, *A Secular Age* (Cambridge, MA: Harvard University Press, 2007), 99. In Taylor's reading of history, the Middle Ages is predominantly an age of anxiety and fear, which become heightened after the fourteenth century and its famines, wars, and plague (p. 88).

24. Gothic mobility is raised by Teresa Goddu in her article "Vampire Gothic," *American Literary History* 11, no. 1 (1999): 26–27.

25. Goddu, 127.

26. Le Fanu's *Carmilla* is not examined in this book. However, as one of the formative texts on the vampire, it should be pointed out that Carmilla has racial characteristics that mark her as a racial Other. Like Dracula, her ancestry is likely mixed and somewhat mysterious. See Marilyn Brock's article "The Vamp and the Good English Mother: Female Roles in Le Fanu's *Carmilla* and Stoker's *Dracula*," in *From Wollstonecraft to Stoker: Essays on Gothic and Victorian Sensation Fiction*, ed. Marilyn Brock (Jefferson, NC: McFarland, 2009), 123.

27. Cannon Schmitt, *Alien Nation: Nineteenth-Century Gothic Fictions and English Nationality* (Philadelphia: University of Pennsylvania Press, 1997), 10. The focus on decay reflects concerns about racial purity, which could be destroyed by the Irish, Jews, Muslims, and other undesirables.

28. Robin Wood, *Hollywood from Vietnam to Reagan* (New York: Columbia University Press, 1986), 79, quoted in Steven Schneider, "Monsters as (Uncanny) Metaphors: Freud, Lakoff, and the Representation of Monstrosity in Cinematic Horror," *Other Voices* 1, no. 3 (2005).

29. Benson Saler and Charles A. Ziegler, "Dracula and Carmilla: Monsters and the Mind," *Philosophy and Literature* 20, no. 1 (2005): 220. See David D. Gilmore, *Monsters: Evil Beings, Mythical Beasts, and All Manner of Imaginary Terrors* (Philadelphia: University of Pennsylvania Press, 2003), 174–189.

30. Suzanne Lewis, *The Art of Matthew Paris in the Chronica Majorca* (Berkeley: University of California Press, 1987), 272.

31. George Wells Ferguson, *Signs and Symbols in Christian Art* (New York: Oxford University Press, 1966), 13.

32. Some examples of how the language surrounding monsters is also applied to real Muslims are included in this study. For example, the Muslim terrorists examined in later chapters are often described in language similar to that used for the zombie, the un-dead.

33. I plan to write a sequel to this volume that examines female Muslim monsters.

34. Judith Halberstam, *Skin Shows: Gothic Horror and the Technology of Monsters* (Durham, NC: Duke University Press, 1995), 8.

35. Jeffrey Jerome Cohen, "Monster Culture," in *Monster Theory: Reading Culture*, ed. Jeffrey Jerome Cohen (Minneapolis: University of Minnesota Press, 1996), 2.

36. Graham, "Post/Human Conditions," 20.

37. Mark Bevir, "Foucault, Power, and Institutions," *Political Studies* 47, no. 2 (1999): 356.

38. Michel Foucault, "Nietzsche, Genealogy and History," in *Language, Counter-Memory and Practice" Selected Essays and Interviews by Michel Foucault*, ed. Donald Bouchard (Ithaca, NY: Cornell University Press, 1977), 148.

39. Pierre Bourdieu, *The Logic of Practice*, ed. Richard Nice (Stanford, CA: Stanford University Press, 1990), 53.

40. Ciarin Cronin, "Bourdieu and Foucault on Power and Modernity," *Philosophy & Social Criticism* 22 (1996): 56.

41. Cronin, 66. My emphasis added.

42. Pierre Bourdieu, *The Field of Cultural Production: Essays on Art and Literature* (New York: Columbia University Press, 1993), 30.

43. Bevir, 347.

CHAPTER 2

1. The periods following the Middle Ages that are examined in this study are the Renaissance and the Elizabethan era, and the age of colonialism, including Orientalism. Then I shift away from Europe and look at the Muslim monsters that occupy the *imaginaire* of European explorers and the early North Americans.

2. Fred C. Robinson, "Medieval, the Middle Ages," *Speculum* 59, no. 4 (1984): 749.

3. Ibid.

4. For an etymology of "Middle Ages," including its earliest appearance in England (1531 for *media tempora* and 1625 for *media secula*), see Robinson, "Medieval, the Middle Ages," 748.

5. Catherine Brown, "In the Middle," *Journal of Medieval and Early Modern Studies* 30, no. 3 (2000): 547. Brown includes a very useful discussion of the similarities between Orientalism and medieval studies in her article, the latter seeing medieval objects in the same distanced way as Orientalists see the Orient.

6. Paul Freedman and Gabrielle M. Spiegel, "Medievalisms Old and New: The Rediscovery of Alterity in North American Medieval Studies," *The American Historical Review* 103, no. 3 (1998): 678.

7. Freedman and Spiegel, "Medievalisms," 677. Also, see John Ganim's article on Mikhail Bakhtin's influence on the notion of the grotesque in medieval studies in "Medieval Literature as Monster: The Grotesque before and after Bakhtin," *Exemplaria* 7, no. 1: 27–40. Also, see Mikhail Bakhtin, *Rabelais and His World*, trans. Helene Iswolsky (Boston: MIT Press, 1968).

8. Ibid.

9. Nickolas Haydock, "'The Unseen Cross Upon the Breast': Medievalism, Orientalism, and Discontent," in *Hollywood in the Holy Land: Essays on Film Depictions of the crusades and Christian-Muslim Clashes*, edited by Nickolas Haydock and E.L. Risden (Jefferson, NC: McFarland & Company, 2009), 19.

10. Patrick J. Geary, *The Myth of Nations: The Medieval Origins of Europe* (Princeton, NJ: Princeton University Press, 2003), 13.

11. Non-horror films also use this theme, such as the 1972 movie *Deliverance*, in which US rural Southerners hunt and terrorize Northerners on a camping trip. See Gael Sweeney, "The Trashing of White Trash: Natural Born Killers

and the Appropriation of the White Trash Aesthetic," *Quarterly Review of Film and Video* 18, no. 2: 143–155.

12. Michael Uebel, "Unthinking the Monster: Twelfth-Century Responses to Saracen Alterity," in *Monster Theory: Reading Culture*, ed. Jeffrey Jerome Cohen (Minneapolis: University of Minnesota Press, 1996), 267.

13. Sheila Delany, "Chaucer's Prioress, the Jews, and the Muslims," *Medieval Encounters* 3, no. 2 (1999): 202. Emphasis added is mine.

14. Peter Brown, *The Cult of the Saints: Its Rise and Function in Latin Christianity* (Chicago: University of Chicago Press, 1981), 110.

15. Talal Asad, *Genealogies of Religion: Discipline and Reasons of Power in Christianity and Islam* (Baltimore, MD: The Johns Hopkins University Press, 1993), 35.

16. Freedman and Spiegel, "Medievalisms," 698. Also see R. I. Moore, *The Formation of a Persecuting Society* (Hoboken, NJ: Wiley-Blackwell, 2007).

17. W. R. Jones, "The Image of the Barbarian of Medieval Europe," *Comparative Studies in Society and History* 13, no. 4 (1971): 392.

18. Bruce W. Holsinger, "Medieval Studies, Postcolonial Studies, and the Genealogies of Critique." *Speculum* 77, no. 4 (October 2002): 1205. Also, see Benedict Anderson, *Imagined Communities: Reflections on the Origin and Spread of Nationalism* (New York: Verso, 2006).

19. Stephen J. Harris, *Race and Ethnicity in Anglo-Saxon Literature* (New York: Routledge, 2003), 1.

20. Ibid., 14.

21. Ibid., 42.

22. Talal Asad, *Genealogies of Religion: Discipline and Reasons of Power in Christianity and Islam* (Baltimore, MD: John Hopkins University Press, 1993), 125.

23. Charles Taylor, *A Secular Age* (Cambridge, MA: Harvard University Press, 2007), 171–172.

24. Rudolf Wittkower, "Marvels of the East. A Study in the History of Monsters," *Journal of the Warburg and Courtald Institutes* 5 (1942): 159.

25. J. A. McCullouch, *Medieval Faith and Fable* (Boston: Marshall Jones, 1932), 64.

26. *Richard Couer de Lion*, lines 4352–4355. The translation is, "Alas, Mahomet! What has he meant, this English dog that is called Fouke? He is no man, he is an evil spirit, that is stolen out of hell!" My gratitude to Dr. Ann Dobyns at the University of Denver for her translation of these lines.

27. Malcolm Hebron, *The Medieval Siege: Theme and Image in Middle English Romance* (Oxford: Clarendon Press, 1997), 44.

28. See Origen, *Contra Celsum*, 7:68, quoted in Elaine Pagels, *The Origin of Satan* (New York: Random House, 1995), 141.

29. Steven F. Kruger, "Medieval Christian (Dis)identifications: Muslims and Jews in Guibert of Nogent," *New Literary History* 28, no. 2 (1997): 186.

30. Jonathon B. Riess, *The Renaissance Antichrist: Luca Signorella's Orvieto Frescoes* (Princeton, NJ: Princeton University Press, 1995), 119–120. Also, see Norman

Cohn, *The Pursuit of the Millenium: Revolutionary Millenarians and Mystical Anarchists of the Middle Ages* (New York: Oxford University Press, 1970), 76.

31. Jeffrey Jerome Cohen, "The Muslim Connection, Or on the Changing Role of the Jew in High Medieval Thought," in *From Witness to Witchcraft: Jews and Judaism in Medieval Christian Thought*, Wolfenbutteler Mittelalter-Studen 11 (Wiesbaden: Harrassowitz, 1996), 141–162.

32. Kruger, "Medieval Christian (Dis)identifications," 193.

33. Dana Carleton Munro, "The Western Attitude Toward Islam During the Period of the Crusades," *Speculum: A Journal of Mediaeval Studies* 6, no. 3 (1931): 334.

34. Asad, *Genealogies of Religion*, 29.

35. Jeffrey Jerome Cohen, "On Saracen Enjoyment: Some Fantasies of Race in Late Medieval France and England," *Journal of Medieval and Early Modern Studies* 31, no. 1 (2001): 16.

36. Michel Foucault, *Power/Knowledge: Selected Interviews and Other Writings*, ed. and trans. by Colin Gordon (New York: Pantheon, 1980), 98, quoted in Beatrice Han, *Foucault's Critical Project: Between the Transcendental and the Historical*, trans. Edward Pile (Stanford, CA: Stanford University Press, 2002), 118.

37. Tamburlaine has a lame leg. Dracula cannot bear the sunlight. Mummies cannot move freely. Zombies never rest. Medieval monsters are also punished, often marked on the skin, such as the hairy, black giant Saracens that are often found in the medieval romance, attacking, harassing, killing, and eating Christian knights. *Cynocephalie* can only howl, not talk. Black Saracens are also punished, their black skin a sign of God's rejection.

38. Cohen, "On Saracen Enjoyment," 118.

39. Jeffrey Jerome Cohen, *Medieval Identity Machines* (Minneapolis: University of Minnesota Press, 2003), 195.

40. Michael Camille, *The Gothic Idol: Ideology and Image-Making in Medieval Art* (Cambridge: Cambridge University Press, 1989), 140–141.

41. Michael Camille, *Master of Death: The Lifeless Art of Pierre Remiet, Illuminator* (New Haven, CT: Yale University Press, 1996), 108.

42. *Cursor Mundi*, ed. Richard Morris, lines 8072–8122 (London: 1875), quoted in Thomas G. Hahn, "The Difference the Middle Ages Makes: Color and Race before the Modern World," *Journal of Medieval and Early Modern Studies* 31, no. 1 (2001): 14.

43. *The King of Tars*, ed. Judith Perryman (Heidelberg: Carl Winter, 1980), quoted in Hahn, "The Difference," 115.

44. Michael Camille, *Image on the Edge: The Margins of Medieval Art* (Cambridge, MA: Harvard University Press, 1992), 16.

45. Paul Binski, *Medieval Death: Ritual and Representation* (Ithaca, NY: Cornell University Press, 1996), 172.

46. Halberstam, *Skin Shows*, 13.

47. John Block Friedman, *The Monstrous Races in Medieval Art and Thought* (Syracuse, NY: Syracuse University Press, 2000), 37.

48. Munro, "The Western Attitude," 330.

49. Thomas E. A. Dale, "The Monstrous," in *A Companion to Medieval Art: Romanesque and Gothic in Northern Europe*, ed. Conrad Rudolph (Malden: Blackwell Publishing, 2006), 265.

50. See M. R. James, *The Canterbury Psalter* (London: Percy Lund, Humphries, 1935), Folio 263.

51. William Wistar Comfort, "The Literary Role of the Saracens in the French Epic," *PMLA* 55, no. 3 (1940): 650.

52. Jacqueline de Weever, *Sheba's Daughters: Whitening and Demonizing the Saracen Woman in Medieval French Epic* (New York: Garland Publishing, 1998), 66.

53. *Aliscans*, lines 6673–6677. For the French, see Claude Regnier, ed., *Aliscans* (Paris: Honore Champion, 1992), 245. Translation is found in Jacqueline de Weever, *Sheba's Daughters: Whitening and Demonizing the Saracen Woman in Medieval French Epic* (New York: Garland Publishing, 1998), 66.

54. John V. Tolan, *Saracens: Islam in the Medieval European Imagination* (New York: Columbia University Press, 2002), 367.

55. Michael Paull, "The Figure of Mahomet in the Towneley Cycle," *Comparative Drama* 6, no. 3 (Fall 1972): 190.

56. Bernard McGinn, *Antichrist: Two Thousand Years of the Human Fascination with Evil* (New York: Harper Collins Publishers, 1994), 86.

57. Tolan, *Saracens*, 194.

58. Thomas E. Burman, *Religious Polemic and the Intellectual History of the Mozarebs, c. 1050–1200* (New York: E. J. Brill, 1994), 283.

59. Comfort, "The Literary Role," 634, 636.

60. Cyril Mango and Roger Scott, trans., *The Chronicles of Theophanes Confessor* (Oxford: Clarendon Press, 1997), 464.

61. Ibid., 464–465.

62. Hoyland, *Seeing Islam*, 229.

63. See Nerina Rustomji, "American Visions of the Houri," *The Muslim World* 97, no. 1 (2007): 79–92.

64. Tolan, *Saracens*, 92.

65. Ibid., 93.

66. See Dibyesh Anand, "The Violence of Security: Hindu Nationalism and the Politics of Representing 'the Muslim' as a Danger." *The Round Table: The Commonwealth Journal of International Affairs* 94, no. 379 (2005): 203–215, and Arthur Saniotis, "Embodying Ambivalence: Muslim Australians as 'Other.'" *Journal of Australian Studies* 28, no. 82 (2004): 49–59. Also see Sheila Musaji's work on rape fantasies in the Islamophobic industry, "Geller and Spencer Fantasize about 'Muslim Rapists' in Norway & Beyond," The American

Muslim 7/13/13, http://theamericanmuslim.org/tam.php/features/articles/geller_and_spencer/0018681.

67. Hrotsvitha (Hrotsvit), a nun who lived in Saxony (c. 10th century), penned the most popular version of this story.

68. Lisa Weston, "'The Saracen' and the Martyr: Embracing the Foreign in Hrotsvit's Pelagius," in *Meeting the Foreign in the Middle Ages*, ed. Albrecht Classen (New York: Routledge, 2002), 5.

69. Tolan, *Saracens*, 106.

70. Ibid., 107.

71. Weston, "'The Saracen,'" 3.

72. John V. Tolan, *Saracens: Islam in the Medieval European Imagination* (New York: Columbia University Press, 2002), 152.

73. Gerald MacLean, *Looking East: English Writing and the Ottoman Empire before 1800* (New York: Palgrave Macmillan, 2007), 157.

74. Kenneth Baxter Wolf, *Christian Martyrs in Medieval Spain: Cambridge Iberian and Latin American Studies* (Cambridge: Cambridge University Press, 1988), 9.

75. Ibid., 11.

76. Katharine Scarfe Beckett, *Anglo-Saxon Perceptions of the Islamic World* (Cambridge: Cambridge University Press, 2003), 134.

77. Beckett, *Anglo-Saxon Perceptions*, 108.

78. Harris, *Race and Ethnicity*, 6.

79. Beckett, *Anglo-Saxon Perceptions*, 229.

80. Comfort, "The Literary Role," 649.

81. Bertram Colgrave and R. A. B. Mynors, eds., *Bede's Ecclesiastical History of the English People* (Oxford: The Clarendon Press, 1969), 557.

82. Robert G. Hoyland, *Seeing Islam as Others Saw It: A Survey and Evaluation of Christian, Jewish and Zoroastrian Writings on Early Islam* (Princeton, NJ: The Darwin Press, 1997), 535.

83. Andrew Wheatcroft, *Infidels: A History of the Conflict Between Christendom and Islam* (Westminster: Random House, 2005), 49.

84. Svetlana Luchitskaja, "The Image of Muhammad in Latin Chronography of the Twelfth and Thirteenth Centuries, " *Journal of Medieval History* 26, no. 2 (2000): 115.

85. *Mozareb*, used to refer to Christians living in Islamic Spain, is taken from the Arabic word *musta'rib*, meaning "one who adopts Arab customs."

86. Kenneth Baxter Wolf, *Conquerors and Chroniclers of Early Medieval Spain* (Liverpool: Liverpool University Press, 1990), 39.

87. Norman Roth, *Jews, Visigoths and Muslims in Medieval Spain* (Leiden: E. J. Brill, 1994), 51.

88. John Victor Tolan, "Mirror in Chivalry: Salah al-Din in the Medieval European Imagination," in *Images of the Other: Europe and the Muslim World Before 1700*, ed. David Blanks (Cairo: The American University of Cairo Press, 1997), 20.

89. Peter S. Noble, "Saracen Heroes in Adenet le Roi," in *Romance Epic: Essays On A Medieval Literary Genre*, ed. Hans-Erich Keller (Kalamazoo: Medieval Institute Publications, 1987), 209.

90. Irfan Shahid, *Rome and the Arabs: A Prolegomenon to the Study of Byzantium and the Arabs* (Washington, DC: Dumbarton Oaks, 1984), 124, 123.

91. Ibid., 125–126.

92. Comfort, "The Literary Role," 649.

93. Paull, "The Figure of Mahomet," 190.

94. Daniel Sahas, *John of Damascus on Islam: The "Heresy of the Ishmaelites"* (Leiden: E. J. Brill, 1972), 88–89.

95. Luchitskaja, "The Image of Muhammad," 117.

96. Tolan, *Saracens*, 11.

97. This classification was broadly used by Europeans and later Americans to legitimize slavery.

98. Edith R. Sanders, "The Hamitic Hypothesis: Its Origins and Functions in Time Perspective," *The Journal of African History* 10, no. 4 (1969): 527.

99. Harris, *Race and Ethnicity*, 148.

100. Suzanne Conklin Akbari, "Placing the Jews in Late Medieval English Literature," in *Orientalism and the Jews*, ed. Ivan Davidson Kalmar and Derek J. Penslar (Waltham, MA: Brandeis University Press, 2005), 34.

101. Harris, *Race and Ethnicity*, 148.

102. Suzanne Lewis, *Reading Images: Narrative Discourse and Reception in the Thirteenth-Century Illuminated Apocalypse* (Cambridge: Cambridge University Press, 1995), 232.

103. Cohen, "On Saracen Enjoyment," 114, 119.

104. Rebecca Wilcox, "Romancing the East: Greeks and Saracens in Guy of Warwick," in *Pulp Fictions of Medieval England: Essays in Popular Romance*, ed. Nicola McDonald (Manchester: Manchester University Press, 2004), 204.

105. Allan Harris Cutler and Helen Elmquist Cutler, *The Jew as Ally of the Muslim* (Notre Dame, IN: University of Notre Dame Press, 1986), 90.

106. Debra Higgs Strickland, *Saracens, Demons, and Jews: Making Monsters in Medieval Art* (Princeton, NJ: Princeton University Press, 2003), 165.

107. Hoyland, *Seeing Islam*, 106.

108. Camille, *The Gothic Idol*, 130.

109. Akbari, "Placing the Jews," 34.

110. Ibid., 46.

111. Gil Anidjar, *The Jew, The Arab: A History of the Enemy* (Stanford, CA: Stanford University Press, 2003), 34.

112. Paull, "The Figure of Mahomet," 192.

113. J. W. Robinson, "The Late Medieval Cult of Jesus and the Mystery Plays," *PMLA* 80, no. 5 (December 1965): 513.

114. Brenda Deen Schildgen, *Pagans, Tartars, Moslems, and Jews in Chaucer's Canterbury Tales* (Gainesville: University Press of Florida, 2001), 51.

115. Margaret Mary Raftery, "(Type)Casting the Other: Representation of Jews and Devils in Two Plays of the Assumption," *European Medieval Drama: Papers from the International Conference on European Medieval Drama* 9 (2005): 41.

116. See the aforementioned Raftery article, where she addresses the identification of Jews with Satan and other evil characters.

117. Kruger, "Medieval (Dis)identifications," 187–189.

118. Ibid., 193.

119. Delany, "Chaucer's Prioress," 208.

120. Ruth Melinkoff, *Outcasts: Signs of Otherness in Northern European Art of the Late Middle Ages, Volume One: Text* (Berkeley: University of California Press, 1993), 127.

121. The Holkham Bible also contains an image of Saracens identified as Greeks, titled "The Pharisee and the Publican." See F. P. Pickering, ed., *The Anglo-Norman Text of the Holkham Bible Picture Book* (Cambridge: Oxford University Press, 1971), 103, 105.

122. Delany, "Chaucer's Prioress," 206.

123. See Raymond J. Rice, "Cannibalism and the Act of Revenge in Tudor-Stuart Drama," *Studies in English Literature 1500–1900* 44, no. 2 (2004): 297–316, and James L. Calderwood, *Shakespeare and the Denial of Death* (Amherst: University of Massachusetts Press, 1987).

124. Cannibalism is a feature of many of the monsters examined in this study.

125. Peter Hulme, *Colonial Encounters: Europe and the Native Caribbean 1492–1797* (London: Routledge, 1992), 86, quoted in Alan Rice, "'Who's Eating Whom': The Discourse of Cannibalism in the Literature of the Black Atlantic from Equiano's *Travels* to Toni Morrison's *Beloved*," *Research in African Literatures* 29, no. 4 (1998): 110.

126. Brown, *The Cult of the Saints*, 80.

127. Uebel, "Unthinking the Monster," 280.

128. Carolyn Walker Bynum, *The Resurrection of the Body in Western Christianity, 200–1336* (New York: Columbia University Press, 1995).

129. Richard M. Gottlieb, "The Reassembly of the Body from Parts: Psychoanalytic Reflections on Death, Resurrection, and Cannibalism," *Journal of the American Psychoanalytic Association* 55, no. 4 (2007): 1227.

130. Ibid., 1228.

131. Roger Dalrymple, "*Torrent of Portyngale* and the Literary Giants," in *Cultural Encounters in the Romance of Medieval England*, ed. Corrine Saunders (Cambridge: D. S. Brewer, 2005), 168.

132. Ibid., 160.

133. Ibid.

134. *Guy of Warwick*, lines 76.7–11, quoted in Jeffrey Jerome Cohen, *Of Giants: Sex, Monsters and the Middle Ages* (Minneapolis: University of Minnesota Press, 1999), 87–88.

135. Comfort, "The Literary Role," 650.

136. In *King Kong*, Ferracutus is the grotesque monster that lives on Skull Island, which exists in a kind of time warp far removed from modernity. King Kong is a monster likened to an African, as indicated by his "large size." For a discussion of how the character functions in contemporary racism, see Gail Dines, "King Kong and the White Woman: Hustler Magazine and the Demonization of Black Masculinity." *Violence Against Women* 4, no. 3 (June 1998): 291–307.

137. Originally believed to be an account of Charlemagne's military campaigns, it was later discovered to be a forgery based on the *Chanson de Roland*.

138. Munro, "The Western Attitude," 331.

139. Cohen, "On Saracen Enjoyment," 126.

140. Ibid., 121.

141. De Weever, *Sheba's Daughters*, 8.

142. *Aliscans*, lines 6721–6722, in Ramey, *Christian, Saracen and Genre*, 47.

143. Ibid., lines 6731–6732.

144. Ibid., lines 6767–6769.

145. Sharon Kinoshita, *Medieval Boundaries: Rethinking Difference in Old French Literature* (Philadelphia: University of Pennsylvania Press, 2006), 103.

146. Ramey, *Christian, Saracen and Genre*, 46.

147. Robert Young, *Colonial Desire: Hybridity in Theory, Culture and Race* (New York: Routledge, 1995), 26.

148. McCullouch, *Medieval Faith and Fable*, 61.

149. Ibid., 66.

150. Wilcox, "Romancing the East," 233.

151. *Guy of Warwick*, lines 62.11–12.

152. Jacob Kinnard, "Wisdom Divine: The Visual Representation of Prajna in Pala-Period Buddhism," PhD dissertation, (University of Chicago, 1996), 32.

153. Lisa Verner, *The Epistemology of the Monstrous in the Middle Ages* (New York: Routledge, 2005), 5.

154. Ibid., 4.

155. Ruth Melinkoff, *Antisemitic Hate Signs in Hebrew Illuminated Manuscripts from Medieval Germany* (Jerusalem: Hamakor Press, 1999), 41.

156. Debra Hassig, *Medieval Bestiaries: Text, Image, Ideology* (Cambridge: Cambridge University Press, 1995), 63.

157. Hassig, *Medieval Bestiaries*, 145.

158. Ibid.

159. Arnold I. Davidson, "The Horror of Monsters," in *The Boundaries of Humanity: Humans, Animals, Machines*, ed. James J. Sheehan and Morton Sosna (Berkeley: University of California Press, 1991), 36, quoted in Joyce

Tally Lionarons, "The Old English Legend of St. Christopher," in *Marvels, Monsters and Miracles: Studies in the Medieval and Early Modern Imaginations*, ed. Timothy S. Jones and David A. Sprunger (Kalamazoo: Western Michigan University, 2002), 172.

160. Kathleen Corrigan, *Visual Polemics in Ninth-Century Byzantine Psalters* (Cambridge: Cambridge University Press, 1992), 82.

161. Camille, *The Gothic Idol*, 138.

162. David Gordon White, *Myths of the Dog-Man* (Chicago: University of Chicago Press, 1991), 67.

163. Gerard J. Brault, *The Song of Roland: An Analytical Edition* (University Park: The Pennsylvania State University Press, 1978), 304, 432, 157.

164. Cohen, "On Saracen Enjoyment," 120.

165. Naomi Reed Kline, "The World of Strange Races," in *Monsters, Marvels and Miracles: Imaginary Journeys and Landscapes in the Middle Ages*, ed. Leif Sondergaard and Rasmus Thorning Hansen (Odense: University of Southern Denmark Press, 2005), 31–32.

166. Ibid.

167. Brault, *The Song of Roland*, 355.

168. Strickland, *Saracens, Demons, and Jews*, 159–160.

169. Melinkoff, *Antisemitic Hate Signs*, 38.

170. Kenneth Stow, *Jewish Dogs: An Image and Its Interpreters: Continuity in the Catholic-Jewish Encounter* (Stanford, CA: Stanford University Press, 2006), 4.

171. Ibid., 14.

172. James Marrow, *Passion Iconography in Northern European Art of the Late Middle Ages and Early Renaissance* (Brussels: Van Ghemmert, 1979), 40.

CHAPTER 3

1. W. R. Jones, "Image of the Barbarian," 393.

2. Robert Schwoebel, *The Shadow of the Crescent: The Renaissance Image of the Turk (1453–1517)* (New York: St. Martin's Press, 1967), 8.

3. Richard G. Cole, "Sixteenth-Century Travel Books as a Source of European Attitudes toward Non-White and Non-Western Culture," *Proceedings of the American Philosophical Society* 116, no. 1 (1972): 61.

4. Samuel Chew, *The Crescent and the Rose: Islam and England during the Renaissance* (New York: Oxford University Press, 1937), 133.

5. Ibid., 141.

6. Michael J. Heath, "Renaissance Scholars and the Origins of the Turks," *Biblioteque d'Humanisme et Renaissance* 41, no. 3 (1979): 458–461.

7. Philip Mansel, "The French Renaissance in Search of the Ottoman Empire," in *Re-Orienting the Renaissance: Cultural Exchanges with the East*, ed. Gerald MacClean (New York: Palgrave MacMillan, 2005), 98.

8. Frances K. Barasch, *The Grotesque: A Study in Meanings* (The Hague: Mouton, 1971), 33.

9. Ibid., 102.

10. Brault, *The Song of Roland*, 208.

11. Ibid., 195, 410.

12. Delany, 210.

13. Antonio Ballesteros Gonzales and Ana Manzanas Calvo, "Monsters on the Island: Caliban's and Prospero's Hideous Progeny," *Atlantis* 19, no. 1 (1997): 16.

14. Anne Lake Prescott, "Rabelasian (Non) Wonders and Renaissance Polemics," in *Wonders, Marvels, and Monsters in Early Modern Culture*, ed. Peter G. Platt (Newark: University of Delaware Press, 1999), 133.

15. Wittkower, "Marvels of the East," 183.

16. William Rossky, "Imagination in the English Renaissance: Psychology and Poetic," *Studies in the Renaissance* 5 (1958): 50–51.

17. Ibid., 51.

18. See Ross Hagen, "A Warning to England: Monstrous Births, Teratology and Feminine Power in Elizabethan 'Broadside Ballads," *Horror Studies* 4, no. 1 (April 2013): 21–41.

19. William E. Burns, "The King's Two Monstrous Bodies: John Bulwer and the English Revolution," in *Wonders, Marvels, and Monsters in Early Modern Culture*, ed. Peter G. Platt (Newark: University of Delaware Press, 1999), 189.

20. See Johan Winsser, "Mary Dyer and the 'Monster' Story," *Quaker History* 79, no. 1 (1990): 20–34.

21. Leonardo Olschki, "Asiatic Exoticism in Italian Art of the Early Renaissance," *The Art Bulletin* 26, no. 2 (1944): 99.

22. D. H. Cohen, "The Jew and Shylock," *Shakespeare Quarterly* 31, no. 1 (1980): 57. See also *The Merchant of Venice*, Part IV.i: lines 70–80. The following chapter examines Muslim monsters in Shakespearean drama in detail.

23. Nabil I. Matar, "Renaissance England and the Turban," in *Images of the Other: Europe and the Muslim World before 1700*, ed. David Blanks (Cairo: The American University of Cairo Press, 1997), 40–41.

24. Ivan Davidson Kalmar, "Jesus Did Not Wear a Turban: Orientalism, Jews, and Christian Art," in *Orientalism and the Jews*, eds. Ivan Davidson Kalmar and Derek J. Penslar (Waltham, MA: Brandeis University Press, 2005), 123.

25. Ibid., 3.

26. Ibid.

27. James Marrow, "*Circumdederunt me canes multi*: Christ's Tormentors in Northern European Art of the Late Middle Ages and Early Renaissance," *The Art Bulletin* 59, no. 2 (1977): 168.

28. Gil Anidjar, *The Jew, The Arab: A History of the Enemy* (Palo Alto, CA: Stanford University Press, 2003), x.

29. Deborah Howard, *Venice and the East: The Impact of the Islamic World on Venetian Architecture 1100–1500* (New Haven, CT: Yale University Press, 2000), 15.

30. Hermann Goetz, "Oriental Types and Scenes in Renaissance and Baroque Painting," *The Burlington Magazine for Connoisseurs* 73, no. 425 (1938): 55–56. Other cases of positive cross-pollination include the influences of Eastern fashion on European dress and the residence of European artists in Islamic courts. Islamic rulers employed Italian artists, such as Bellini's service to the Sultan in 1479–1480. See Goetz, "Oriental Types," 62.

31. Dana E. Katz, "Painting and the Politics of Persecution: Representing the Jew in Fifteenth-Century Mantua," *Art History* 23, no. 4 (2000): 489.

32. Katz, "Painting and the Politics of Persecution," 490.

33. See James Marrow, *"Circumdederunt me canes multi:* Christ's Tormentors in Northern European Art of the Late Middle Ages and Early Renaissance," *The Art Bulletin* 59, no. 2 (1977): 167–181.

34. Dana E. Katz, *The Jew in the Art of the Italian Renaissance* (Philadelphia: University of Pennsylvania Press, 2008), 65.

35. Paula Sutter Fichtner, *Terror and Toleration: The Habsburg Empire Confronts Islam, 1526–1850* (London: Reaktion Books, 2008), 52.

36. Cutler and Cutler, *The Jew as Ally of the Muslim,* 103. See pages 101–108 in the same study for numerous examples of Renaissance paintings displaying Jewish/Muslim imagery.

37. See Chapter 2 for a discussion of these cannibalistic monsters, which range from Black Saracens to giants with hairy skin and other afflictions.

38. Katharine Park, "The Criminal and the Saintly Body: Autopsy and Dissection in Renaissance Italy," *Renaissance Quarterly* 47, no. 1 (Spring 1994): 1.

39. Piero Camporesi, *The Incorruptible Flesh: Bodily Mutilation and Mortification in Religion and Folklore* (New York: Cambridge University Press, 2009), 3–7, quoted in Park, "The Criminal and the Saintly Body," 1–2.

40. Park, "The Criminal and the Saintly Body," 22.

41. Carolyn Walker Bynum, "The Female Body and Religious Practice in the Later Middle Ages," in *Zone: Fragments for a History of the Body, Part I,* ed. Michel Feher et al. (New York: Zone Books, 1989), 161–162, quoted in Katharine Park, "The Criminal and the Saintly Body: Autopsy and Dissection in Renaissance Italy," *Renaissance Quarterly* 47, no. 1 (Spring 1994): 21, http://www.jstor.stable/2863109 [accessed February 1, 2012].

42. Paul Kaplan, "Black Turks: Venetian Artists and Perceptions of Ottoman Ethnicity," in *The Turk and Islam in the Western Eye, 1450–1750: Visual Imagery before Orientalism,* ed. James G. Harper (Burlington, VT: Ashgate, 2011), 53–54.

43. Kaplan, "Black Turks," 55.

44. The Black Saracen appears in future centuries in Gothic horror and in early US political culture in the form of the "monsters of Africa," also known as

Moors. As recently as 2006, the hyper-racist civilizational gore-fest film *300* features a "Black Persian," a giant, grunting monster who wears a necklace of human skulls around his neck. These characters are discussed in following chapters.

45. Jean Devisse and Michael Mollat, "The Appeal to the Ethiopian," in *The Image of the Black in Western Art: From the Early Christian Era to the "Age of Discovery," Africans in the Christian Ordinance of the World*, eds. David Bindman and Henry Louis Gates, Jr. (Cambridge, MA: Harvard University Press, 2010), 83.

46. C. A. Patrides, "'The Bloody and Cruell Turke'": The Background of a Renaissance Commonplace," *Studies in the Renaissance* 10 (1963): 130.

47. Silke R. Falkner, "'Having It Off' with Fish, Camels, and Lads: Sodomitic Pleasures in German-Language Turcica," *Journal of the History of Sexuality* 13, no. 4 (2004): 402.

48. Ibid., 408.

49. Ibid., 415.

50. Daniel J. Vitkus, "Introduction," in *Three Turks Plays from Early Modern England: Selimus, A Christian Turned Turk, and The Renegado*, ed. Daniel J. Vitkus (New York: Columbia University Press, 2000), 9.

51. Naji B. Oueijan, *Progress of an Image: The East in English Literature* (New York: Peter Lang, 1996), 16.

52. Nabil I. Matar, "Muslims in Seventeenth-Century England," *Journal of Islamic Studies* 8, no. 1 (1997): 74.

53. Elie Salem, "The Elizabethan Image of Islam," *Studia Islamica* 22 (1965): 43, 54.

54. *The Palace of Pleasure*, lines 250–251, quoted in Linda McJannet, *The Sultan Speaks: Dialogue in English Plays and Histories about the Ottoman Turks* (New York: Palgrave MacMillan, 2006), 149–150.

55. McJannet, *The Sultan Speaks*, 63.

56. Matthew Dimmock, *New Turkes: Dramatizing Islam and the Ottomans in Early Modern England* (Burlington, VT: Ashgate, 2005). Also, see *Tamburlaine*, Part I, III.iii, line 269, and Part I, IV.iii, lines 2–4.

57. *Tamburlaine*, Part I, III.iii, lines 75–76.

58. *Tamburlaine*, Part I, III.iii, line 82.

59. William J. Brown, "Marlowe's *Debasement of Bajazet: Foxe's Actes and Monuments and Tamburlaine*, Part I," *Renaissance Quarterly* 24, no. 1 (Spring 1971): 40.

60. William J. Brown, "Marlowe's *Debasement*," 41.

61. Dimmock, *New Turkes*, 154.

62. Ibid.

63. McJannet, *The Sultan Speaks*, 81. The Grand Turk at the Siege of Rhodes was also accused of drinking blood, a charge made against numerous Turks during the fifteenth and sixteenth centuries.

64. Burnett, 46.

65. *Tamburlaine*, I:IV, iii, lines 7–12.

66. *Tamburlaine*, I.iii.

67. James William Johnson, "The Scythian: His Rise and Fall," *Journal of the History of Ideas* 20, no. 2 (April 1959): 250, http://www.jstor.org/stable/2707822 [accessed February 1, 2012].

68. Burnett, *Constructing 'Monsters,'* 42.

69. Johnson, "The Scythian," 254. Also, see Tertullian, *Apology*, IX, trans. T. R. Glover (London: Loeb Classics, 1931), Paulus Orosius, *Seven Books of History*, trans. Irving Raymond (New York: Columbia University Press, 1936), 49, and George Boas, *Essays on Primitivism and Related Ideas in the Middle Ages* (Baltimore, MD: Johns Hopkins University Press, 1948), f.n. 136.

70. Johnson, "The Scythian," 255.

71. *King Lear* I.i., lines 95–107.

72. Chet Van Duzer, "A Northern Refuge of the Monstrous Races: Asia on Waldeesmüller's 1516 *Carta Marina*," *Imago Mundi* 62, no. 2 (2010): 223–224.

73. Ibid., 225.

74. Kaplan, "Black Turks," 56.

75. Stephen Bateman, *The Doome Warning All Men to the Judgment* (London, 1581), 6–7, quoted in James R. Aubrey, "Race and Spectacle of the Monstrous in Othello," *CLIO* 22, no. 3 (1993): 229.

76. In 1930, Paul Robeson became the first African-American actor to portray Othello on the stage in a century since Ira Aldridge appeared on European stages as the Moor. Mekhi Phifer played Othello in the well-received 2001 film adaptation of the play called "O."

77. Aubrey, "Race and Spectacle," 221–222.

78. Chew, *The Crescent and the Rose*, 225.

79. See Chew, *The Crescent and the Rose*, 225.

80. Pierre Boiastuau, *Certain Secret Wonders of Nature* (London, 1589), 13–14, quoted in Aubrey, "Race and Spectacle," 224.

81. Maurizio Calbi, "'Civil Monsters': Race, Eroticism and the Body in Early Modern Literature and Culture," *Sederi* 13 (2003): 18.

82. Ibid., 19.

83. Katherine Park and Lorraine Daston, "Unnatural Conceptions: The Study of Monsters in Sixteenth-and Seventeenth-Century France and England," *Past and Present* 92 (1981): 37.

84. *Othello* I.i., lines 88–89, I.i., line 116.

85. *Othello* I.i., lines 112–113.

86. *Othello* I.iii., lines 402–403.

87. Michael Neill, "Unproper Beds: Race, Adultery, and the Hideous in Othello," *Shakespeare Quarterly* 40, no. 4 (1989): 391, quoted in Herbert Marshall and Mildred Stock, *Ira Aldridge: The Negro Tragedian* (London: Rockcliff, 1958), 265–266.

88. Vitkus, *Turning Turk*, 91.

89. *Othello* V.ii., line 210.

90. *Othello*, I.iii., lines 146–147.

91. Newman, Karen Newman, "'And Wash the Ethiop White': Femininity and the Monstrous in Othello," in *Shakespeare Reproduced: The Text in History and Ideology*, eds. Jean E. Howard and Marion F. O'Connor (New York: Methuen, 1987), 148.

92. Bryan S. Turner, "A Note on Rodinson's *Mohammed*," *Religion* 3, issue 1 (1973): 79.

93. Vitkus, *Turning Turk*, 85.

94. Vitkus, *Turning Turk*, 77.

95. *Othello* I.i., lines 136–137.

96. Vitkus, *Turning Turk*, 106.

97. Jacob Larwood and John Camden Hotten, *English Inn Signs: Being a Revised and Modernized Version of History of Signboards* (London: Chatto and Windus, 1951), 40.

98. Brault, *The Song of Roland*, 147.

99. Bryant Lillywhite, *London Signs: A Reference Book of London Signs from Earliest Times to about the Mid-Nineteenth Century* (London: George Allen and Unwin Ltd., 1972), 481.

100. Brault, *The Song of Roland*, 145.

101. Larwood and Hotten, *English Inn Signs*, 40.

102. Lillywhite, *London Signs*, 597.

103. Viennese coffee came into existence after the Battle of Vienna, when Austrians discovered a bag of coffee left by the Ottoman forces after their retreat in 1529. See Jack Goody, *Islam in Europe* (Malden, MA: Polity Press, 2007), 78.

104. Antony Clayton, *London's Coffee Houses: A Stimulating Story* (London: Historical Publications, 2003), 11.

105. Ibid., 252.

106. Larwood and Hotten, *English Inn Signs*, 209.

107. Nicola McDonald, "Eating People and the Alimentary Logic of Richard Couer de Lion," in *Pulp Fictions of Medieval England: Essays in Popular Romance*, ed. Nicola McDonald (Manchester: Manchester University Press, 2004), 125.

108. Constance B. Hieatt and Robin F. Jones, "Two Anglo-Norman Culinary Collections Edited from British Library Manuscripts Additional 32085 and Royal 12.C.xii," *Speculum* 61, no. 4 (1986): 876–877.

109. McDonald, "Eating People," 127.

110. Hieatt and Jones, "Two Anglo-Norman Culinary Collections," 876–877.

111. Barbara Santich, "The Evolution of Culinary Techniques in the Medieval Era," in *Food in the Middle Ages: A Book of Essays*, ed. Melitta Weiss Adamson (New York: Garland Publishing, 1995), 68.

112. McDonald, "Eating People," 125.

113. Susan E. Farrier, "Hungry Heroes in Medieval Literature," in *Food in the Middle Ages: A Book of Essays*, ed. Melitta Weiss Adamson (New York: Garland Publishing, 1995), 156.

114. Blurton, *Cannibalism*, 126.

115. Farrier, "Hungry Heroes," 136.

116. According to Charles II's chemist, Libyan corpses were the best because of the cause of death—suffocation, which "doth concentrate the spirits in all the parts by reason of the fear and sudden surprisal which seizes on the travellers." See Karen Gordon-Grube, "Anthropophagy in Post-Renaissance Europe: The Tradition of Medicinal Cannibalism," *American Anthropologist* 90, no. 2 (1988): 406, http://www.jstor.org/stable/677961 [accessed January 6, 2012].

117. Gunilla Dahlberg, "The Theatre Around Queen Christina," *Renaissance Studies* 23, no. 2 (2009): 176.

118. Ibid.

119. Simon McKeown, "Reading and Writing the Swedish Renaissance," *Renaissance Studies* 23, no. 2 (2009): 141.

120. Dahlberg, "The Theatre Around Queen Christina," 177.

121. Ibid., 178.

122. Ibid.

123. Elfriede Iby, "The Ladies' Carousel," unpublished research article (via e-mail on June 14, 2010). Dr. Iby, a scholar in residence at Schönbrunn Palace, graciously sent me her research article.

124. Fichtner, *Terror and Toleration*, 42.

125. Philip K. Wilson, "Eighteenth-Century 'Monsters,'" 7.

126. Ibid.

127. Taylor, *A Secular Age*, 12.

128. H. L. Malchow, "Frankenstein's Monster and Images of Race in Nineteenth-Century Britain," *Past & Present* 139 (May 1993): 93.

CHAPTER 4

1. Taylor, *A Secular Age*, 88.

2. Gilmore, *Monsters*, 62.

3. Park and Daston, "Unnatural Conceptions," 20.

4. Gilmore, *Monsters*, 62.

5. Kirkpatrick Sale, *The Conquest of Paradise: Christopher Columbus and the Columbian Legacy* (New York: Alfred A. Knopf, 1990), 78.

6. Claire Kahane, "The Gothic Mirror," in *The (M)other Tongue: Essays in Feminist Psychoanalytic Interpretation*, eds. Shirley Nelson Garner, Claire Kahane, and Madelon Sprengnether (Ithaca, NY: Cornell University Press, 1985), 334.

7. Kahane, "The Gothic Mirror," 335. Also, see Judith Halberstam's feminist/queered study of Gothic horror in *Shows: Gothic Horror and the Technology of*

Monsters (Durham, NC: Duke University Press, 1995). In addition, there is a large corpus of material on the Gothic treatment of the feminine by scholars, including Camille Paglia.

8. Jay M. Smith, *Monsters of the Gévaudan: The Making of a Beast* (Cambridge, MA: Harvard University Press, 2011), 3.

9. Ibid., 20, 37. Reports of human-animal hybrids were common in Europe during this time, and included a girl with the head and feet of a monkey, a porcupine man, and a wolf-child (p. 37).

10. Ibid., 43.

11. Ibid., 44–45. The monster was also thought to be a witch, an identity strongly situated in gender.

12. Gilmore, *Monsters*, 61.

13. Sale, *The Conquest of Paradise*, 78.

14. Matt Kaplan, *Medusa's Gaze and Vampire's Bite: The Science of Monsters* (New York: Scribner, 2012), 116.

15. Arlo H. Nimmo, "The Cult of Pele in Traditional Hawai'i." *Bishop Museum Occasional Papers* 30 (June 1990): 47.

16. For a discussion of the Romantic-Gothic genre as seen in the character of Victor Frankenstein, see Kim Hammond, "Monsters of Modernity: Frankenstein and Modern Environmentalism," *Cultural Geographies* 11 (2004): 181–198.

17. Jerome McGann, "Rethinking Romanticism." *ELH* 59, no. 3 (Autumn 1992): 741.

18. W. Scott Poole, "Confederates and Vampires: Manly Wade Wellman and the Gothic Sublime," *Studies in Popular Culture* 26, no. 3 (2004): 91.

19. Benedict Robinson, *Islam and Early Modern English Literature: The Politics of Romance from Spenser to Milton* (New York: Palgrave MacMillan, 2007), 27.

20. Ian Almond, "Leibniz, Historicism, and the 'Plague of Islam,'" *Eighteenth-Century Studies* 39, no. 4 (2006): 463.

21. Taylor, *A Secular Age*, 222.

22. Rebecca Joubin, "Islam and Arabs Through the Eyes of the Encyclopedie: The 'Other' as a Case of French Cultural Criticism," *International Journal of Middle East Studies* 32, no. 2 (May 2000): 197.

23. Almond, "Leibniz," 463–464.

24. Ibid., 470.

25. Joubin, "Islam and Arabs," 204–205.

26. Joubin, "Islam and Arabs," 206.

27. Leibniz, *Theodicy*, trans. E.M. Huggard (Open Court, 1985), 51.

28. Almond, "Leibniz," 483.

29. Voltaire, *Philosophical Dictionary* (New York: Penguin Books, 1972), 359.

30. Ibid., 251.

31. Joubin, "Islam and Arabs," 201.

32. Voltaire, *Philosophical Dictionary*, 145.

33. Australia, although a large landmass, is no longer believed to balance the earth. However, this myth was only dispelled some two hundred years ago.

34. Otaheite was renamed Tahiti, an island that remains under colonial rule hundreds of years later. The Fijians are often described as cannibalistic giants in colonial-era literature. See Jeff Berglund, *Cannibal Fictions: American Explorations of Colonialism, Race, Gender and Sexuality* (Madison: University of Wisconsin Press, 2006). Chapter 2, entitled "P. T. Barnum's American Exhibition of Fiji Cannibals, *1871–1873*," details the display of Fijians as a circus act. Also, see the October 17, 1995, article in *The Independent*, "Wales Braces Themselves for the Giants of Fiji." The language and imagery surrounding the South Pacific, from Tahiti's beautiful maidens to Fiji's giants, remain features in popular journalism and advertising.

35. Rod Edmond, *Representing the South Pacific: Colonial Discourse from Cook to Gauguin* (New York: Cambridge University Press, 1997), 6.

36. Cole, "Sixteenth-Century Travel Books," 59.

37. Ruth Vasey, "Foreign Parts: Hollywood's Global Distribution and the Representation of Ethnicity." *American Quarterly* 44, no. 4 [Special Issue: Hollywood, Censorship, and American Culture] (December 1992): 629.

38. Pierre Loti, *The Marriage of Loti* (Honolulu: University of Hawaii Press, 1976), 12.

39. Pierre Loti, *Aziyade* (New York: Paul Kegan International, 1989), 9.

40. Kitty Scoular Datta, "Iskandar, Alexander: Oriental Geography and Romantic Poetry," in *Reorienting Orientalism*, ed. Chandreyee Niyogi (New Delhi: Sage Publications, 2006), 50.

41. Mohammed Sharafuddin, *Islam and Romantic Orientalism* (New York: I. B. Tauris, 1994), 107, 105.

42. Greg Dening, "Possessing Tahiti," *Archaeology in Oceania* 21, no. 1 (1986): 112–3.

43. James Bruce, *Travels to Discover the Source of the Nile: Volume One* (Dublin: G. G. J. and J. Robinson, 1790–1791), 89, quoted in Sharafuddin, 15–16.

44. John Daniel, *A Narrative of the Life and Astonishing Adventures of John Daniel* (London: M. Cooper, 1751), quoted in Rebecca Weaver-Hightower, *Empire Islands: Castaways, Cannibals, and Fantasies of Conquest* (Minneapolis: University of Minnesota Press, 2007), 153.

45. Avramescu, *An Intellectual History*, 87.

46. Kalman, "Sensuality, Depravity, and Ritual Murder," 37–38.

47. John Michael, "Beyond Us and Them: Identity and Terror from an Arab American's Perspective," *The South Atlantic Quarterly* 102 (2003): 701.

48. Robert Stam and Ella Shohat, *Race in Translation: Culture Wars and the Postcolonial Atlantic* (New York: New York University Press, 2012), 150.

49. Said, *Orientalism*, 40.

50. Oueijan, *The Progress of an Image*, 44.

51. Sharafuddin, *Islam and Romantic Orientalism* 67.

52. Filiz Turhan, *The Other Empire: British Romantic Writings about the Ottoman Empire* (New York: Routledge, 2003), 95.

53. Percy Bysshe Shelley, *Hellas: A Lyrical drama. A Reprint of the original edition published in 1822, with the author's prologue and notes by various hands*, ed. Thomas J. Wise (New York: Phaeton Press, 1970), Act II, lines 241–249.

54. *Turkish Tales*, lines 747–754, quoted in Mohammed Sharafuddin, *Islam and Romantic Orientalism* (New York: I. B. Tauris, 1994), 241.

55. Edward Said, *Orientalism*, 207.

56. Aamir Mufti, "Critical Secularism: A Reintroduction for Perilous Times," *Boundary 2* 31, no. 2 (2004): 3. Here, Mufti quotes Edward Said, *Orientalism* (New York: Vintage Books, 1994), 120–121.

57. Said, *Orientalism*, 28. Also, see Stam and Shohat's discussion of the "Muslim-Jewish affinity," *Race in Translation*, 156–157.

58. Said, *Orientalism*, 27–28.

59. James Pasto, "Islam's 'Strange Secret Sharer': Orientalism, Judaism, and the Jewish Question," *Comparative Studies in Society and History* 40, no. 3 (1998): 438.

60. Bryan S. Turner, *Religion and Social Theory* (London: SAGE Publications, 1983), 29.

61. Fouad M. Moughrabi, "The Arab Basic Personality: A Critical Survey of the Literature," *International Journal of Middle Eastern Studies* 9 (1978): 103.

62. Anidjar, *The Jew, the Arab*, 35.

63. Ibid., 234.

64. Jonathon Hess, "Johann David Michaelis and the Colonial Imaginary: Orientalism and the Emergence of Racial Antisemitism in Eighteenth-Century Germany," *Jewish Social Studies* 6 (2000): 65.

65. Hess, "Johann David Michaelis," 56.

66. Hess, "Johann David Michaelis," 86. Michaelis suggested that Haiti or Jamaica were good candidates for this Jewish colony; conveniently they are both far away from Germany.

67. Ibid.

68. Robert Casillo, "The Desert and the Swamp: Enlightenment, Orientalism, and the Jews in Ezra Pound," *Modern Language Quarterly* 45, no. 3 (1984): 268, 270, 273.

69. Reina Lewis, *Gendering Orientalism: Race, Femininity and Representation* (New York: Routledge, 1996), 216.

70. Thomas W. Knox, *Backsheesh! Or the Adventures in the Orient with Descriptive and Humorous Sketches of Sighs and Scenes over the Atlantic, down the Danube, Through the Crimea; in Turkey, Greece, Asia-Minor, Syria, Palestine, and Egypt; Up the Nile, in Nubia, and Equatorial Africa, Etc., Etc.* (Hartford: A. D. Worthington, Publishers, 1875), 178.

71. Vitkus, *Three Turk Plays*, 37–38.

72. Said, *Orientalism*, 231.

73. Hess, "Johann David Michaelis," 68.

74. Ibid.

75. W. M. L. de Wette, *Biblische Dogmatik Alten und Neuen Testaments (1813)*, 114, quoted in Pasto, 443.

76. Irfan Shahid, *Byzantium and the Semitic Orient before the Rise of Islam* (London: Valorium Reprints, 1988), 75.

77. Moughrabi, "The Arab Basic Personality," 99, 103.

78. Ralph Waldo Emerson, *Works*, VIII: 237, quoted in Muhammad al-Dami, *Arabian Mirrors and Western Soothsayers: Nineteenth Century Literary Approaches to Arab-Islamic History* (New York: Peter Lang, 2002), 46.

79. Kalmar, "Jesus Did Not Wear a Turban," 17.

80. Ella Shohat, "Gender in Hollywood's Orient," *Middle East Report* no. 162 (1990): 40.

81. Leila Ahmed, *Edward W. Lane: A Study of His Life and Works and of British Ideas of the Middle East in the Nineteenth Century* (London: Longman Group, 1978), 14.

82. Graham-Browne, *The Portrayal of Women*, 7.

83. James S. Duncan, *Writes of Passage: Reading Travel Writing* (London: Routledge, 1998), 143.

84. Ibid.

85. Julie Cupples, "The Field as a Landscape of Desire: Sex and Sexuality in Geographical Fieldwork," *Area 34*, no. 4 (2002): 384.

86. Gerard de Nerval, *The Women of Cairo: Scenes of Life in the Orient (Voyage en Orient)*, 2 vols. (London: George Routledge & Sons, 1929), Vol. II, 36, quoted in Sarah Graham-Brown, *The Portrayal of Women in Photography of the Middle East 1860–1950: Images of Women* (New York: Columbia University Press, 1988), 11.

87. Ibid., 385.

88. Charles Didier, "Le Maroc," *La Revue des Deux Mons*, Nov. 1, 1835, 259–260, quoted in Kalman, 40–41.

89. Julie Kalman, "Sensuality, Depravity, and Ritual Murder: The Damascus Blood Libel and the Jews in France," *Jewish Social Studies: History, Culture, Society 13*, no. 3 (2007): 38.

90. These monsters are examined later in this chapter, in the section on Gothic female monsters.

91. Anne McClintock, *Imperial Leather: Race, Gender and Sexuality in the Colonial Contest* (New York: Routledge, 1995), 124.

92. Casillo, "The Desert and the Swamp," 280.

93. Paul Goetsch, *Monsters in English Literature: From the Romantic Age to the First World War* (New York: Peter Lang, 2002), 301.

94. Henry Rider Haggard, *Rider Haggard: The Great Adventures* (Lindley, UK: Jerry Mills Publishing, 2005), 549.

95. In at least one medieval account of the Prophet's death, he dies with his face buried in Aisha's breasts.

96. Quoted in Zohreh T. Sullivan, "Race, Gender and Imperial Ideology in the Nineteenth Century," *Nineteenth-Century Contexts 13* (1989): 27.

97. Gerald MacLean, *Looking East: English Writing and the Ottoman Empire Before 1800* (New York: Palgrave MacMillan, 2007), 157.

98. See Ephraim Nissan, "Ghastly Representations of the Denominational Other in Folklore, II, Thomas Nast's Crocodiles in the American River Ganges (New York, 1871)," *La Ricerca Folklorica 57, Visioni in movimento: Pratiche dello sguardo antropologico* (April 2008): 148–154.

99. Ibid.

100. Diego Saglia, "William Beckford's 'Sparks of Orientalism' and the Material-Discursive Orient of British Romanticism," *Textual Practice 16*, no. 1 (2002): 75.

101. Saglia, "William Beckford's 'Sparks of Orientalism,'" 75.

102. David Punter, *The Literature of Terror: A History of Gothic Fictions from 1765 to the Present Day* (London: Longman Group, 1980), 6, quoted in Lee Kovacs, *The Haunted Screen: Ghosts in Literature and Film* (Jefferson, NC: McFarland, 1999), 9.

103. Poole, "Confederates and Vampires," 92–93.

104. John Paul Riquelme, "Toward a History of Gothic and Modernism: Dark Modernity from Bram Stoker to Samuel Beckett," *Modern Fiction Studies 46*, no. 3 (2000): 586.

105. Morgan, "Toward an Organic Theory," 100.

106. Timothy K. Beal, *Religion and Its Monsters* (New York: Routledge, 2002), 143.

107. Martin Tropp, *Images of Fear: How Horror Stories Helped to Shape Modern Culture: 1818–1918* (Jefferson, NC: McFarland, 1990), 181.

108. Ibid.

109. On the theme of reverse-colonization, see Stephen D. Arata, "The Occidental Tourist: 'Dracula' and the Anxiety of Reverse Colonization," *Victorian Studies 33*, no. 4 (Summer 1990): 621–645.

110. Camille Paglia, *Sexual Personae: Art and Decadence from Nefertiti to Emily Dickinson* (New York: Vintage, 1991), 265, quoted in Jack Morgan, "Toward an Organic Theory of the Gothic: Conceptualizing Horror," *Journal of Popular Culture 32*, no. 3 (1998): 61. Emphasis added is mine.

111. William Beckford, "Vathek," in Alan Richardson, ed. *Three Oriental Tales* (Boston: Houghton Mifflin, 2002), 119–20.

112. George E. Haggerty, "Literature and Homosexuality in the Late Eighteenth Century: Walpole, Beckford, and Lewis," *Studies in the Novel 18*, no. 4 (Winter 1986): 342.

113. Peter Raedts, "Remembering and Forgetting: Images of the Classical and Medieval Past in the Era of Revolution and Restoration," in *The Revival of*

Medieval Illumination, ed. Thomas Coomans and Jan de Mayer (Leuven: Leuven University Press, 2007), 27.

114. John Milton, *Paradise Lost*, ed. Alastair Fowler (New York: Longman, 1998), Act I, lines 579–587.

115. Raedts, "Remembering and Forgetting," 30.

116. Benedict S. Robinson, *Islam and Early Modern English Literature*, 159. Also, see Patrides, " 'The Bloody and Cruell Turke,' " 134.

117. John W. Willoughby, "Childe Roland to the Dark Tower Came," *Victorian Poetry 1*, no. 4 (1963): 160.

118. Gilmore, *Monsters*, 62.

119. Tropp, *Images of Fear*, 19.

120. Ibid.

121. Guy Chapman, *Beckford* (New York: Charles Scribner's Sons, 1937), 291.

122. Max Fincher, *Queering Gothic in the Romantic Age: The Penetrating Eye* (New York: Palgrave MacMillan, 2007), 65.

123. Goetsch, *Monsters in English Literature*, 26.

124. Victor Turner's concept of liminality was first discussed in his 1967 essay titled "Betwixt and Between: The Liminal Period in Rites of Passage."

125. Paul Elmer, ed., *The Complete Works of Lord Byron* (Cambridge: The Riverside Press, 1905), 213–214.

126. De Quincey, *Confessions*, 73, quoted in Goetsch, *Monsters in English Literature*, 52.

127. Richard Carter, "Mary Shelley's Nightmare (1797–1851): *Frankenstein*; Her Life, Literary Legacy, and Last Illness," *World Journal of Surgery 23*, no. 11 (1999): 1200.

128. Ibid., 1198.

129. It was more common for British opium users to ingest the drug rather than smoke it.

130. Carter, "Mary Shelley's Nightmare," 1197.

131. Mary Shelley, *Frankenstein*, 66–67, quoted in Gayatri Chakravorty Spivak, "Three Women's Texts and a Critique of Orientalism," *Critical Inquiry 12*, no. 1 (1985): 256.

132. Mary Shelley, *Frankenstein or The Modern Prometheus: The 1818 Text* (New York: Oxford University Press, 2009), 17, quoted in Anne K. Mellor, "Frankenstein, Racial Science, and the Yellow Peril," *Nineteenth-Century Contexts 23*, no. 1 (2001): 2.

133. Mary Shelley, *Frankenstein*, 53, 216, quoted in Mellor, "*Frankenstein*, Racial Science," 2.

134. Shelley, *Frankenstein*, 200, quoted in Mellor, "*Frankenstein*, Racial Science," 2.

135. Frankenstein's creature is yet another example supporting Halberstam's claim that skin is the organ that most commonly represents monstrosity. Here, the monster's skin is yellow, while in other cases, such as the Black Saracen, as mentioned earlier, it is blue, purple, or black.

136. Sullivan, "Race, Gender and Imperial Ideology," 19.

137. Malchow, "Frankenstein's Monster," 99. Shelley kept a meticulous record of the books she read in her journals. During 1814–1815, she and Percy also read a history of the West Indies. See Malchow, "Frankenstein's Monster," 99–100.

138. Shelley, *Frankenstein*, 31, quoted in Malchow, "Frankenstein's Monster," 112.

139. Malchow, "Frankenstein's Monster," 112.

140. Ibid., 113.

141. Shelley, *Frankenstein* 158, quoted in Spivak, "Three Women's Texts," 256.

142. This is also true in horror cinema, where monsters often wait for humans venturing into the desert. Examples include the Sand People in *Star Wars* (1977) and, more recently, the giant man-eating worms in *Tremors* (1990) and the mutants in *The Hills Have Eyes* (2006). The desert as a setting for monsters in film is discussed in detail in the following chapter.

143. David Jasper, *The Sacred Desert: Religion, Literature, Art and Culture* (Malden, MA: Wiley-Blackwell, 2004), 71.

144. Robert Browning, "Childe Roland to the Dark Tower Came": Part II, 69–71, 73–75, and 151–154, quoted in Joyce S. Meyers, " 'Childe Roland to the Dark Tower Came' ": A Nightmare Confrontation with Death," *Victorian Poetry 8*, no. 4 (1970): 336.

145. Willoughby, "Childe Roland to the Dark Tower Came," 293.

146. Harold Golder, "Browning's Childe Roland," *PMLA 39*, no. 4 (1924): 969.

147. Curtis Dahl, "The Victorian Wasteland," *College English 16*, no. 6 (1955): 347.

148. Ahmed, *Edward W. Lane*, 16.

149. Goetsch, *Monsters in English Literature*, 265.

150. H. J. B. Philby, *The Empty Quarter: Being a Description of the Great South Desert of Arabia Known As Rub' Al Khali* (New York: Henry Holt, 1933), 164.

151. Rana Kabbani, *Europe's Myths of Orient* (Bloomington: Indiana University Press, 1986), 31.

152. Golder, "Browning's Childe Roland," 969.

153. Goetsch, *Monsters in English Literature*, 182.

154. Goetsch, *Monsters in English Literature*, 40.

155. Charlotte Dacre, *Zofloya, or The Moor* (New York: Oxford University Press, 2008), 135–136.

156. Quoted in Stephanie Burley, "The Death of Zofloya; or, The Moor as Epistemological Limit," in *The Gothic Other: Racial and Social Constructions in the Literary Imagination*, eds. Ruth Bienstock Anolik and Douglas L. Howard (Jefferson, NC: McFarland, 2004), 202.

157. Dacre, *Zofloya*, 136.

158. Eugenia Delamotte, "White Terror, Black Dreams: Gothic Constructions of Race in the Nineteenth Century," in *The Gothic Other: Racial and Social Constructions in the Literary Imagination*, eds. Ruth Bienstock Anolik and Douglas L. Howard (Jefferson, NC: McFarland, 2004), 24.

159. Burley, "The Death of Zofloya," 205.

160. Dacre, *Zofloya*, 164.

161. Dacre, *Zofloya*, 190, 191, and 229.

162. Dacre, *Zofloya*, 151.

163. Dacre, *Zofloya*, 142.

164. Dacre, *Zofloya*, 178.

165. Dacre, *Zofloya*, 213.

166. Dacre, *Zofloya*, 267.

167. Dacre, *Zofloya*, 266–267.

168. Dacre, *Zofloya*, 267.

169. Ibid.

170. Fincher, 65.

171. Quoted in Alan Richardson, ed. *Three Oriental Tales* (New York: Houghton Mifflin, 2002), 141.

172. Ibid., 94.

173. Andrew J. Green, "Essays in Miniature," *College English 3*, no. 8 (May 1942): 723.

174. Vathek's mother encourages him to commit evil acts, but is not portrayed as a demon or other creature, which is why I limit my analysis of monsters to the Indian and the title character.

175. Eric Meyer, "'I Know Thee Not, I Loathe Thy Race': Romantic Orientalism in the Eye of the Other, " *English Literary History 58*, no. 3 (1991): 666.

176. Adam Roberts and Eric Robertson, "The Giaour's Sabre: A Reading of Beckford's *Vathek*," *Studies in Romanticism 35*, no. 2 (Summer 1996): 208.

177. Ibid., 205.

178. Richardson, *Three Oriental Tales*, 81–82.

179. Richardson, *Three Oriental Tales*, 9.

180. Richardson, *Three Oriental Tales*, 69.

181. Richardson, *Three Oriental Tales*, 89–90.

182. Richardon, *Three Oriental Tales*, 84.

183. *Vathek*, 9:5.

184. Roberts and Robertson, "The Giaour's Sabre," 206.

185. Richardson, *Three Oriental Tales*, 83.

186. Dani Cavallaro, *The Gothic Vision: Three Centuries of Horror, Terror and Fear* (New York: Continuum, 2002), 163.

187. Richardson, *Three Oriental Tales*, 97.

188. Cavallaro, *The Gothic Vision*, 163.

189. Hulme, *Colonial Encounters*, 86, quoted in Alan Rice, "Who's Eating Whom," 110.

190. Louis S. Warren, "Buffalo Bill Meets Dracula: William F. Cody, Bram Stoker, and the Frontiers of Racial Decay," *The American Historical Review 107*, no. 4 (October 2002): 1141.

191. Ibid., 1148–1149.

192. Ibid., 1129.

193. Sullivan, "Race, Gender and Imperial Ideology," 20.

194. Stephen D. Arata, "The Occidental Tourist: 'Dracula' and the Anxiety of Reverse Colonization," *Victorian Studies 33*, no. 4 (1990): 629.

195. Dale Hudson, "Vampires of Color and the Performance of Multicultural Whiteness," in *The Persistence of Whiteness: Race and Contemporary Hollywood Cinema*, ed. Daniel Bernardi (New York: Routledge, 2008), 129.

196. Lisa Hopkins, *Screening the Gothic* (Austin: University of Texas Press, 2005), 120.

197. Halberstam, *Skin Shows*, 92–93.

198. Halberstam, *Skin Shows*, 105.

199. Stoker, *Dracula*, 51.

200. George Du Maurier, *Trilby* (New York: Oxford University Press, 1995), 234.

201. Ruth Bientsock Anolik, "The Infamous Svengali: George Du Maurier's Satanic Jew," in *The Gothic Other: Racial and Social Constructions in the Literary Imagination*, eds. Ruth Bienstock Anolik and Douglas L. Howard (Jefferson, NC: McFarland, 2004), 164.

202. Anthony S. Wohl, "'Ben Ju Ju'": Representations of Disraeli's Jewishness in the Victorian Political Cartoon," *Jewish History 10*, no. 2 (1996): 115.

203. Stoker, *Dracula*, 18.

204. Quoted in Johnson, "The Myth of Jewish Male Menses," 281.

205. For an explanation of how this myth was used in the punishment of Jews in the Middle Ages, see Miri Rubin, *Gentile Tales: The Narrative Assault on Late Medieval Jews* (New Haven, CT: Yale University Press, 1999), 139–140.

206. Johnson, "The Myth of Jewish Male Menses," 286.

207. Andrew Smith, *Victorian Demons: Medicine, Masculinity, and the Gothic at the "Fin-de-siecle"* (Manchester: Manchester University Press, 2004), 35, quoted in Saverio Tomaiuolo, "Reading Between the (Blood)lines of Victorian Vampires: Mary Elizabeth Braddon's 'Good Lady Ducayne,'" in *From Wollstonecraft to Stoker: Essays on Gothic and Victorian Sensation Fiction*, ed. Marilyn Brock (Jefferson, NC: McFarland, 2009), 111.

208. Tomaiuolo, "Reading Between the (Blood)lines," 103.

209. Stoker, *Dracula*, 1.

210. Baron De La Motte Fouque, *The Magic Ring, or, The Castle of Montfaucon*, tr. Robert Pearse Gillies (Chicago: Valancourt Books, 2006), 5. This work was the inspiration for many tales featuring the themes of chivalry and knighthood, including *The Lord of the Rings* series.

211. Goetsch, *Monsters in English Literature*, 286.

212. Ibid.

213. Cannon Shmitt, *Alien Nation: Nineteenth-Century Gothic Fictions and English Nationality* (Philadelphia: University of Pennsylvania Press, 1997), 139.

214. Stoker, *Dracula*, 31.

215. Robert Tracy, "Loving You All Ways: Vamps, Vampires, Necrophiles and Necrophilles in Nineteenth-Century Fiction," in *Sex and Death in Victorian Literature*, ed. Regina Barecca (Bloomington: Indiana University Press, 1990),

38, quoted in Carol A. Senf, *Science and Social Science in Bram Stoker's Fiction* (Westport, CT: Greenwood Press, 2002), 89.

216. Nandris, "The Historical Dracula," 392.

217. Eleni Coundouriotis, "*Dracula* and the Idea of Europe," *Connotations* 9, no. 2 (1999–2000): 154.

218. Stoker, *Dracula*, 31.

219. Coundouriotis, "*Dracula* and the Idea of Europe," 155.

220. David Glover, *Vampires, Mummies, and Liberals: Bram Stoker and the Politics of Popular Fiction* (Durham, NC: Duke University Press, 1996), 40.

221. Arata, "The Occidental Tourist," 629.

222. Ibid., 626.

223. Charles Boner, *Transylvania* (1865), 1–2, quoted in Arata, "The Occidental Tourist," 629.

224. Bram Stoker, *The Mystery of the Sea*, 204, quoted in Carol A. Senf, *Bram Stoker* (Cardiff: University of Wales Press, 2010), 98.

225. Stoker, *Mystery of the Sea*, 247, quoted in Senf, *Bram Stoker*, 98.

226. Stoker, *Dracula*, 40.

227. David Glover, "Travels in Romania: Myths of Origin, Myths of Blood," *Discourse* 16 (1993): 132–3.

228. On Western fantasies, see Ali Behdad's article, "The Eroticized Orient: Images of the Harem in Montesquieu and his Precursors," *Stanford French Review* 13, no. 2–3 (1989): 109–126.

229. Stoker, *Dracula*, 40–41.

230. Ibid., 41.

231. Stoker, *Dracula*, 332–3, quoted in Grigore Nandris, "The Historical Dracula: The Theme of His Legend in the Western and in the Eastern Literatures of Europe," *Comparative Literature Series* 3, no. 4 (1966): 368.

232. Stoker, *Dracula*, 12.

233. Ibid., 13–14.

234. In Francis Ford Coppola's film adaptation of Bram Stoker's text, Dracula transforms into a *cynocephalus* and gives Lucy oral sex. This disturbing scene is discussed in Chapter 6.

235. As Cannon Schmitt argues, Lucy's last name of "Westerna" serves as another marker of the time and space in which occidental identity is marked. Schmitt, *Alien Nation*, 143.

236. Ibid., 153.

237. Stoker, *Dracula*, 27, quoted in Richard Wasson, "The Politics of Dracula," *English Literature in Transition, 1880–1920*, vol. 9, no. 1 (1966): 24.

238. Nandris, "The Historical Dracula," 369.

239. Coundouriotis, "*Dracula* and the Idea of Europe," 145.

240. Most recently, the human-vampire that Bella Swan gives birth to in the *Twilight* series is so monstrous it breaks her bones from the inside and kills her when she finally gives birth.

241. Riquelme, "Toward a History," 591.

242. Arata, "The Occidental Tourist," 625.

243. Suzanna Nyberg, "Men in Love: The Fantasizing of Bram Stoker and Edvard Munch," in *The Fantastic Vampire: Studies in the Children of the Night. Selected Essays from the Eighteenth International Conference on the Fantastic in the Arts*, ed. James Craig Holte (Westport, CT: Greenwood Press, 2002) 48.

244. Kate Holterhoff, "Liminality and Power in Bram Stoker's Jewel of the Seven Stars," in *From Wollstonecraft to Stoker: Essays on Gothic and Victorian Sensation Fiction*, ed. Marilyn Brock (Jefferson, NC: McFarland, 2009), 133.

245. Senf, *Bram Stoker*, 101.

246. Glover, *Vampires, Mummies, and Liberals*, 82.

247. Bram Stoker, *Jewel of Seven Stars*, 337, quoted in Glover, *Vampires, Mummies, and Liberals*, 82.

248. Richard Marsh, *The Beetle*, ed. Julian Wolfreys (Buffalo, NY: Broadview Press, 2004), 18.

249. Antonia Lant, "The Curse of the Pharaoh, or How Cinema Contracted Egyptomania," in *Visions of the East: Orientalism in Film*, eds. Matthew Bernstein and Gaylyn Strudlar (New Brunswick, NJ: Rutgers University Press, 1997), 75.

CHAPTER 5

1. Luis Weckmann, "The Middle Ages in the Conquest of America," *Speculum* 26, no. 1 (1951): 130.

2. Barbara Fuchs, "Virtual Spaniards: The Moriscos and the Fictions of Spanish Identity," *Journal of Spanish Cultural Studies* 2, no. 1 (2001): 15.

3. Weckmann, "The Middle Ages," 130.

4. Weckmann, "The Middle Ages," 131.

5. Tink Tinker and Mark Freeland, "Thief, Slave Trader, Murderer: Christopher Columbus and Caribbean Population Decline," *Wicazo Sa Review* 23, no. 1 (2008): 37.

6. Robert N. Bellah, "Civil Religion in America," *Daedalus* 96, no. 1 (1967): 7–8.

7. Bellah, "Civil Religion," 18.

8. Steven T. Newcomb, *Pagans in the Promised Land: Decoding the Doctrine of Christian Discovery* (Golden, CO: Fulcrum Publishing, 2008), 128.

9. Tinker and Freeland, "Thief, Slave Trader, Murderer," 43.

10. Eliza Cushing, *Saratoga: A Tale of the Revolution*, 2 vols. (Boston: Cummings, Hollard, 1824), I.37, quoted in Leland S. Person, Jr., "The American Eve: Miscegenation and a Feminist Frontier Fiction," *American Quarterly* 37, no. 5 (1985): 678.

11. Charles F. Adams, ed., *Familiar Letters of John Adams and His Wife, Abigail Adams, during the Revolution* (New York, 1876), 211, quoted in Geary, 7. Also, see

Allen J. Frantzen, *Desire for Origins: New Language, Old English and Teaching the Tradition* (New Brunswick, NJ: Rutgers University Press, 1990), 16.

12. Frantzen, *Desire for Origins*, 16.

13. Charles Homer Haskins, "European History and American Scholarship," *The American Historical Review* 28, no. 2 (1923): 218, quoted in Freedman and Spiegel, "Medievalisms Old and New," 683.

14. John Matthews Manly, "Humanistic Studies and Science," *Speculum* 5 (1930): 250, italics added, quoted in Freedman and Spiegel, "Medievalisms Old and New," 683.

15. Mark Edmundson, *Nightmare on Main Street: Angels, Sadomasochism, and the Culture of Gothic* (Cambridge, MA: Harvard University Press, 1997), 4–5, quoted in Freedman and Spiegel, "Medievalisms Old and New," 703.

16. Jeffrey Jerome Cohen, "Preface," in *Monster Theory: Reading Culture*, ed. Jeffrey Jerome Cohen (Minneapolis: University of Minnesota Press, 1996), vii.

17. Ibid., viii.

18. See Anouar Majid, *Freedom and Orthodoxy: Islam and Difference in the Post-Andalusian Age* (Stanford, CA: Stanford University Press, 2004).

19. Barbara Fuchs, *Exotic Nation: Maurophilia and the Construction of Early Modern Spain* (Philadelphia: University of Pennsylvania Press, 2009), 118.

20. Ibid.

21. The first account is from Stephen Clissold, *Conquistador* (London: Derek Verschoyle, 1954), 64, and the second account is found in Chew, *The Crescent and the Rose*, 462. Both are quoted in Barbara Fuchs, *Mimesis and Empire: The New World, Islam, and European Identities* (New York: Cambridge University Press, 2001), 1.

22. Catalan Avramescu, *An Intellectual History of Cannibalism*, trans. Alistair Ian Blyth (Princeton, NJ: Princeton University Press, 2009), 86.

23. Christopher Columbus, *Journal of the First Voyage to America 1492–1493. Heath Anthology of American Literature Volume One*, eds. Paul Latner et al. (Lexington, MA: Heath, 1994), 122–123, quoted in Alan Rice, "Who's Eating Whom," 111.

24. Weckmann, "The Middle Ages," 133.

25. Ibid.

26. Bernard Sheehan, *Savagism and Civility: Indians and Englishmen in Colonial Virginia* (Cambridge: Cambridge University Press, 1980), 73.

27. Vitkus, *Three Turk Plays*, 6.

28. Peter Mason, *Deconstructing America: Representations of the Other* (New York: Routledge, 1990), 53.

29. Mason, *Deconstructing America*, 103.

30. Weckmann, "The Middle Ages," 132.

31. Majid, *Freedom and Orthodoxy*, 49.

32. Majid, *Freedom and Orthodoxy*, 74–75.

33. Fuchs, "Virtual Spaniards," 3. "America" was depicted with positive American Indian attributes by some European artists, such as the images of female figures partnered with a headdress or animal indigenous to the Americas. See *Ellwood Parry, The Image of the Indian and the Black Man: 1590–1900* (New York: George Braziller, New York), 1.

34. Anne Jacobson Schutte, "'Such Monstrous Births': A Neglected Aspect of the Antinomian Controversy," *Renaissance Quarterly* 38, no. 1 (1985): 91.

35. W. Scott Poole, *Monsters in America: Our Historical Obsession with the Hideous and Haunting* (Waco, TX: Baylor University Press, 2011), 29.

36. Schutte, "'Such Monstrous Births," 95.

37. Lindal Buchanan, "A Study of Maternal Rhetoric: Anne Hutchinson, Monsters, and the Antinomian Controversy," *Rhetoric Review* 25, no. 3 (2006): 242. One example is the use of the monk-cow in anti-Catholic rhetoric. See Park and Daston, "Unnatural Conceptions," 26.

38. W. Scott Poole, *Monsters in America*, 43.

39. Sheehan, *Savagism and Civility*, 5.

40. Ann Japenga, "Bigfoot on the Mojave," originally published as "Yucca Man" in *Palm Springs Life*, in *True Tales of the Mojave Desert: From Talking Rocks to Yucca Man*, ed. Peter Wild (Santa Fe, NM: The Center for American Places, 2004), 211.

41. W. Scott Poole, *Monsters in America*, 30.

42. Paul Baepler, "The Barbary Captivity Narrative in American Culture," *Early American Literature* 39, no. 2 (1994): 220.

43. Ibid., 229, 220.

44. Ibid., 221–222.

45. L. Carl Brown, "The United States and the Maghrib," *The Middle East Journal* 30, no. 3 (1976): 282.

46. Ibid.

47. Ibid., 273.

48. Shohat, "Gender in Hollywood's Orient," 41. In many Hollywood films of this type, the female is raped. Such is the case in Rudolph Valentino's film *The Sheik* (1921), where an Arab kidnaps a white woman, rapes her, she falls in love with him, and they live happily ever after. In the sequel to this film, *Son of the Sheik* (1926), where Valentino plays the roles of both father and son, a similar scenario plays out.

49. Jack Shaheen, "Hollywood's Muslim Arabs," *The Muslim World* 90, no. 1–2 (2000): 34.

50. Gregg Mitman, "Cinematic Nature: Hollywood Technology, Popular Culture, and the American Museum of Natural History," *Isis* 84, no. 4 (December 1993): 638–639. See Mitman's article for numerous examples of the relationship between anthropology and popular cinema, such as Walt Disney's reliance on scientific films (p. 661).

51. Elizabeth G. Traube, "'The Popular' in American Culture." *Annual Review of Anthropology* 25 (1996): 128.

52. Traube argues that the pull of exoticism explains, at least in part, why American anthropologists have had so little interest in "popular culture," which is seen as mundane and boring. The same has not been true for academic disciplines such as religious studies, where numerous scholars have studied American religious movements. One example is Robert Orsi's study of mid-twentieth-century American Catholicism, in which he argues for an understanding of religion as a set of relationships, rather than as a theoretical model. See *Between Heaven and Earth: The Religious Worlds People Make and the Scholars Who Study Them* (Princeton, NJ: Princeton University Press, 2006).

53. Johannes Fabian, *Time and the Other: How Anthropology Makes Its Object* (New York: Columbia University Press, 2002), 31. Emphasis is Fabian's.

54. Fabian, *Time and the Other*, 144–145.

55. Lester D. Friedman, "The Edge of Knowledge: Jews as Monsters/Jews as Victims," *MELUS* 11, no. 3, *Ethnic Images in Popular Genres and Media* (Autumn 1984): 49.

56. Friedman, "The Edge of Knowledge," 54.

57. Ibid., 55.

58. Ibid.

59. Stephen William Foster, "The Exotic as a Symbolic System," *Dialectical Anthropology* 7, no. 1 (1982): 21.

60. Foster, "The Exotic," 21.

61. Foster, "The Exotic," 24.

62. Sumiko Hagashi, "Touring the Orient with Lafcadio Hearn and Cecil B. DeMille," in *The Birth of Whiteness: Race and the Emergence of U.S. Cinema*, ed. Daniel Bernardi (New Brunswick, NJ: Rutgers University Press, 1996), 343.

63. Ibid., 343–345.

64. Jacques Ellul, *Apocalypse* (New York: Seabury, 1977), 267, quoted in J. Daryl Charles, "An Apocalyptic Tribute to the Lamb," *Journal of the Evangelical Theological Society* 34, no. 4 (December 1991): 467.

65. Higashi, "Touring the Orient," 356.

66. Lester D. Friedman, "Celluloid Palimpsests: An Overview of Ethnicity and the American Film," in *Unspeakable Images: Ethnicity and the American Cinema*, ed. Lester D. Friedman (Chicago: University of Illinois Press, 1991), 30.

67. One assumes that the Indian characters in this film are Hindu, but due to the Muslim quality of some of the imagery, it is worth mentioning that Muslims have strict dietary rules that preclude them from eating live baby snakes and monkey brains.

68. Nirej Sekhon, "Beefeaters," *Transition* 94, no. 4 (2003): 61.

69. Susan Aronstein, "'Not Exactly a Night': Arthurian Narrative and Recuperative Politics in the *Indiana Jones* Trilogy," *Cinema Journal* 34, no. 4 (1995): 10.

70. Aronstein, "'Not Exactly a Night,'" 4.

71. http://disneyland.disney.go.com/disneyland/indian-jones-adventure/ [accessed April 16, 2011]. The Jungle Cruise ride is one I remembered well from my childhood—in particular, the African headhunter that held up a shrunken head. When I returned to Disneyland in 2011, I assumed this image would be long gone. As we approached the headhunter, the "guide" instructed everyone to duck so that our heads wouldn't end up on a necklace.

72. Tom Henthorne, "Boys to Men: Medievalism and Masculinity in Star Wars and E. T.: The Extra Terrestrial," in *The Medieval Hero on Screen: Representations from Beowulf to Buffy*, eds. Martha W. Driver and Sid Ray (Jefferson, NC: McFarland, 2004), 77.

73. The Amizagh people and language are more commonly known by the name "Berber," a derogatory name referring to their "barbarian" culture. The translation of Tataouine is found in Brian T. Edwards, "Kiddie Orientalism: A Cultural Critic's Struggle to Teach Post-9/11, *Star Wars*-Obsessed Youth about Tatooine and the 'Imagined Look of Evil,'" *The Believer* [June 2008].

74. Tony M. Vinci, "The Fall of the Rebellion; or, Defiant and Obedient Heroes in a Galaxy Far, Far Away: Individualism and Intertextuality in the Star Wars Trilogy," in *Culture, Identities and Technology in the Star Wars Films: Essays on Two Trilogies*, eds. Carl Silvio and Tony M. Vinci (Jefferson, NC: McFarland, 2007), 32.

75. Ralph McQuarrie is the chief conceptual artist of the *Star Wars* franchise, and worked on the concept illustrations for *Raiders of the Lost Ark* (1981) as well.

76. Randall L. Kennedy, "Who Can Say 'Nigger'? and Other Considerations," *The Journal of Blacks in Higher Education* 26 (1999–2000): 87. The name "Tusken Raiders" is an allusion to the sand people's attack on the human settlement called Fort Tusken.

77. *Star Wars: Episode III—Revenge of the Sith*. Directed by George Lucas. DVD. 20th Century Fox, 2005.

78. Joshua Atkinson and Bernadette Calafell, "Darth Vader Made Me Do It! Anakin Skywalker's Avoidance of Responsibility and the Gray Areas of Hegemonic Masculinity in the Star Wars Universe," *Communication, Culture & Critique* 2 (2009): 8.

79. Veronica A. Wilson, "Seduced by the Dark Side of the Force: Gender, Sexuality, and Moral Agency in George Lucas's Star Wars Universe," in *Culture, Identities and Technology in the Star Wars Films: Essays on Two Trilogies*, eds. Carl Silvio and Tony M. Vinci (Jefferson: McFarland, 2007), 139.

80. *Star Wars: Episode III—Revenge of the Sith*. Directed by George Lucas. DVD. 20th Century Fox, 2005.

81. It is difficult not to see the similarity to Dracula's transformation in Coppola's film here, where the catalyst for his transformation into a monster is due to the Ottomans.

82. Atkinson and Calafell, "Darth Vader Made Me Do It!" 9.

83. George Lucas is familiar with Joseph Campbell and the approach to religious study known as perennialsim.

84. Doktor Zoom, "Tatooine Not Constantinople: Austrian Turks Go To 'Red Alert' over Star Wars Lego Set." *Wonkette*, January 26, 2013. http://wonkette.com/498528/austrian-turks-go-to-red-alert-over-star-wars-lego-set.

85. John Eisele, "The Wild East: Deconstructing the Language of Genre in the Hollywood Eastern," *Cinema Journal* 41, no. 4 (Summer 2002): 73.

86. Ibid.

87. Cutler and Cutler, *The Jew as Ally*, 85.

88. Thomas F. McDow, "Trafficking in Persianness: Richard Burton between Mimicry and Similitude in the Indian Ocean and Persianate Worlds," *Comparative Studies of South Asia, Africa and Middle East* (2010): 491–2.

89. Jack Sheehan, *Reel Bad Arabs: How Hollywood Vilifies a People* (New York: Olive Branch Press), 20.

90. See Eisele, "The Wild East," 73–75 for a fuller discussion of this problem.

91. Ella Shohat and Robert Stam, *Unthinking Eurocentrism: Multiculturalism and the Media* (New York: Routledge, 1994), 156.

92. Caravaggio is played by Willem Dafoe. Like his namesake, he is a scoundrel and womanizer.

93. Fabian,*Time and the Other*, 31.

94. Fabian, *Time and the Other*, 147.

95. Much like medieval monsters, who were often described as incapable of human speech, Muslim characters in films often speak a non-language, such as jibberish.

96. Majid, *Freedom and Orthodoxy*, 154.

97. Fabian, *Time and the Other*, 75. Emphasis added in mine.

98. *Jerusalem Report*, October 17, 1996, quoted in Shaheen, "Hollywood's Muslim Arabs," 28.

99. Talal Asad, *On Suicide Bombing* (New York: Columbia University Press, 2007), 59.

100. Ira Chernus, *Monsters to Destroy: The Neoconservative War on Terror and Sin* (Boulder, CO: Paradigm Publishers, 2006), 213–214.

101. Khaled Abou el Fadl, "9/11 and the Muslim Transformation," in *September 11 in History: A Watershed Moment?* ed. Mary L. Dudziak (Durham, NC: Duke University Press, 2003), 70–71.

102. See Tariq Ramadan's critique of this binary structure in the context of modernity in *Western Muslims and the Future of Islam* (New York: Oxford University Press, 2004), 62–79.

103. Said, *Orientalism*, 108.

104. Jack Shaheen, *Reel Bad Arabs: How Hollywood Vilifies a People* (New York: Interlink Books, 2011), 11.

105. Shohat and Stam, *Unthinking Eurocentrism*, 191.

106. Ibid., 192.

107. Bellin, *Framing Monsters*, 85.

108. According to one published report, Harryhausen was concerned about the name of the monster; still, the space monster is listed as "Ymir" in the ending credits.

109. David Spurr, *The Rhetoric of Empire: Colonial Discourse in Journalism, Travel Writing, and Imperial Administration* (Durham, NC: Duke University Press, 1993), 104, quoted in Bellin, 85–86.

110. Shohat and Stam, *Unthinking Eurocentrism*, 192.

111. Srivastava, " 'The Empire Writes Back,' " 73.

112. Elaine L. Graham, *Representations of the Post/Human: Monsters, Aliens and Others in Popular Culture* (New Brunswick, NJ: Rutgers University Press, 2002), 12.

113. The werewolf, although not examined here, is a monster representing the uncivilized country folk of Europe—a symbol of primitivism, illiteracy, racial impurity, and the importance of social class.

114. Peter Gottschalk and Gabriel Greenberg, *Islamophobia: Making Muslims the Enemy* (Lanham, MD: Rowman & Littlefield, 2008), 5.

115. Morgan, "Toward an Organic Theory," 59.

116. William Thorp, "The Stage Misadventures of Some Gothic Novels," *PMLA* 43, no. 2 (1928): 476.

117. Thorp, "The Stage Misadventures," 486.

118. Quoted in Goetsch, *Monsters in English Literature*, 329.

119. Tropp, *Images of Fear*, 187–188.

120. The first movie in the *Saw* franchise was released in 2004.

121. *The Hills Have Eyes* was shot near Ourzazate, which has become a popular locale for filming scary films located in the desert, including *The Mummy* (1999).

122. Shohat and Stam, *Unthinking Eurocentrism*, 121.

123. Jack Morgan, *The Biology of Horror: Gothic Literature and Film* (Carbondale: Southern Illinois University Press, 2002), 43.

124. Tropp, *Images of Fear*, 183.

125. Foster, "The Exotic as a Symbolic System," 25.

126. Holly Edwards, "A Million and One Nights: Orientalism in America, 1870–1930," in *Noble Dreams, Wicked Pleasures*, ed. Holly Edwards (Princeton, NJ: Princeton University Press, 2000), 32, quoted in Naomi Rosenblatt, "Orientalism in American Popular Culture," *Penn History Review* 16, no. 2 (2009): 59–60.

127. David Glover, *Vampires, Mummies, and Liberals: Bram Stoker and the Politics of Popular Fiction* (Durham, NC: Duke University Press, 1996), 143.

128. This term usually refers to the moment when an actor in a play or movie looks directly at the audience. In this case, when Dracula catches Mina looking at him, it is unclear whether Mina is hallucinating the entire scene, thus implicating the viewer as well.

129. Peter Travers, "300," *Rolling Stone*, March 9, 2001.

130. Nickolas Haydock, "'The Unseen Cross Upon the Breast': Medievalism, Orientalism, and Discontent," in *Hollywood and the Holy Land: Essays on Film Depictions of the Crusades and Christian-Muslim Clashes*, eds. Nickolas Haydock and E. L. Risden (Jefferson, NC: McFarland, 2009), 19.

131. Spencer Ackerman, "Frank Miller's *Holy Terror* Is Fodder for Anti-Islam Set," *Wired*, September 28, 2011.

132. Hamid Dabashi, "The '300' Stroke," *Al-Ahram Weekly*, August 2–8, 2007, http://weekly.ahram.org.eg/2007/856/cu1.htm [accessed March 22, 2011].

133. Kathleen Coyne Kelly, "Medieval Times: Bodily Temporalities in *The Thief of Baghdad* (1924), *The Thief of Baghdad* (1924), and *Aladdin* (1992)," in *Hollywood and the Holy Land: Essays on Film Depictions of the Crusades and Christian-Muslim Clashes*, eds. Nickolas Haydock and E. L. Risden (Jefferson, NC: McFarland, 2009), 203.

134. G. N. Murray, "Zach Snyder, Frank Miller and Herodotus: Three Takes on the 300 Spartans," *Akterion* 52 (2007): 26.

135. B. J. Chaplin, "(Mis) Representation of Disability in the Film 300," Master's thesis, University of Georgia, May 2008, 20–21.

136. Hamid Dabashi, "The American Empire: Triumph or Triumphalism," *Unbound: Harvard Journal of the Legal Left* 4 (2008): 83.

137. Chaplin, "(Mis) Representation," 34.

138. Dana Stephens, "A Movie Only a Spartan Could Love," *Slate*, March 8, 2007.

139. Kyle Smith, "Persian Shrug," *New York Post*, March 9, 2007.

140. Ephraim Lytle, "Sparta? No. This Is Madness," *The Toronto Star*, March 11, 2007.

141. We may see the Persian giant king again soon. According to the *Los Angeles Times*, Frank Miller is planning a prequel to *300* called *Xerxes* that will also feature Ephialtes. Other reports claim the prequel will focus on Darius, the Persian king who ruled before Xerxes. Zach Snyder is slated to direct the film version of Miller's upcoming project.

142. Yosefa Loshitsky, "Orientalist Representations: Palestinians and Arabs in Some Postcolonial Film and Literature," in *Cultural Encounters: Representing "Otherness,"* ed. Elizabeth Halam and Brian V. Street (New York: Routledge, 2000), 51.

143. Stephens, *Incidents of Travel*.

CHAPTER 6

1. Patricia Kerslake, *Science Fiction and Empire* (Liverpool: Liverpool University Press, 1007), 19.

2. Juneko Robinson, "Immanent Attack: An Existential Take on The Invasion of the Body Snatchers Films," in *Fear, Cultural Anxiety, and Transformation: Horror, Science Fiction, and Fantasy Films Remade* (Lanham, MD: Lexington Books, 2009), 24.

3. Ibid., 43.

4. Quoted in Jasper, 70–71.

5. Jasper, *The Sacred Desert*, 71.

6. Ibid., 104.

7. Aida Hozic, *Hollyworld: Space, Power, and Fantasy in the American Economy* (Ithaca, NY: Cornell University Press, 2001), 134.

8. John M. Ganim, "Framing the West, Staging the East: Set Design, Location and Landscape in Movie Medievalism," in *Hollywood in the Holy Land: Essays on Film Depictions of the Crusades and Christian-Muslim Clashes*, eds. Nicolas Haydock and E. L. Risden (Jefferson, NC: McFarland, 2009), 31.

9. For a graph showing the spike in zombie films after September 11, 2001, see Kyle William Bishop, *American Zombie Gothic: The Rise and Fall (and Rise) of the Walking Dead in Popular Culture* (Jefferson, NC: McFarland, 2010, 14).

10. Peter Dendle, "The Zombie as Barometer of Cultural Anxiety," in *Monsters and the Monstrous: Myths and Metaphors of Enduring Evil*, ed. Niall Scott (New York: Rodopi, 2007), 49.

11. Ibid., 48.

12. Kevin Alexander Boon, "Ontological Anxiety Made Flesh: The Zombie in Literature, Film and Culture," in *Monsters and the Monstrous: Myths and Metaphors of Enduring Evil*, ed. Niall Scott (New York: Rodopi, 2007), 36.

13. Dendle, "The Zombie as Barometer," 48.

14. Warren St. John, "Market for Zombies? It's Undead (Aaahhh!)" *New York Times* (March 26, 2006), 13, quoted in Bishop, *American Zombie Gothic*, 29.

15. Lant, "The Curse of the Pharaoh," 83–84.

16. Ibid., 83.

17. Michael Hoffman, The Hoffman Wire (date unknown), quoted in Jack Shaheen, *Reel Bad Arabs: How Hollywood Vilifies a People* (New York: Interlink Books, 2001), 334.

18. Susan Wloszczyna, "Effects New Curse of The Mummy," *USA Today* (May 7, 1999).

19. Kyle William Bishop, "The Sub-Altern Monster: Imperial Hegemony and the Cinematic Voodoo Zombie," *The Journal of American Culture* 31, no. 2 (2008): 141.

20. Joan Dayan, "Haiti's Unquiet Past," *Transition* 67 (1995): 160, quoted in Ken Gelder, "Postcolonial Voodoo," *Postcolonial Studies* 3, no. 1 (2000): 94.

21. Ibid., 143.

22. Leslie Halliwell, *The Dead That Walk: Dracula, Frankenstein, the Mummy and Other Favorite Movie Monsters* (London: Grafton, 1986), 242, quoted in Jennifer Dotson, *"Considering Blackness in George A. Romero's Night of the Living Dead: An Historical Explanation,"* Master's thesis (Middle Tennessee State University, 2004), 24.

23. Gelder, "Postcolonial Voodoo," 96.

24. James B. Twitchell, *Dreadful Pleasures: An Anatomy of Modern Horror* (New York: Oxford University Press, 1985), 273, quoted in Margaret Twohy, *"From Voodoo to Viruses: The Evolution of the Zombie in Twentieth Century Popular Culture,"* Master's thesis (Trinity College Dublin, 2008), 5.

25. Kyle James Twitchell, *Dreadful Pleasures: An Anatomy of Modern Horror* (New York: Oxford University Press, 1987), 15, quoted in Margaret Twohy, "From Voodoo to Viruses: The Evolution of the Zombie in Twentieth Century Popular Culture," Master's thesis (Trinity College Dublin, 2008), 5.

26. See H. P. Lovecraft, *The Best of H. P. Lovecraft: Bloodcurdling Tales of Horror and the Macabre* (New York: Random House, 1982), 51.

27. Richard Matheson, *I Am Legend* (New York: Tom Doherty Associates, 1995), 54.

28. Ibid., 180–181.

29. Ibid., 131.

30. Roger Bastide, "Color, Racism, and Christianity," *Daedalus* 96, no. 2 (Spring 1967): 319.

31. Interview in the 2008 Canadian documentary *Zombiemania*, dir. Donna Davis.

32. Saler and Ziegler, "Dracula and Carmilla," 219.

33. Asad, *On Suicide Bombing*, 66.

34. Goddu, "Vampire Gothic," 135.

35. Ibid.

36. Twohy, "From Voodoo to Viruses," iv.

37. Ils Hugyens, "Invasions of Fear: The Body Snatchers Theme," in *Fear, Cultural Anxiety, and Transformation: Horror, Science Fiction, and Fantasy Films Remade* (Lanham, MD: Lexington Books, 2009), 48.

38. Bishop, *American Zombie Gothic*, 26.

39. One only needs to Google "sick of Muslims" to see how common this phrase is.

40. Imran Awan, "Paving the Way for Extremism: How Preventing the Symptoms Does Not Cure the Disease of Terrorism," *Journal of Terrorism Research* 2, no. 3 (2011), 4–8.

41. Morgan, "Toward an Organic Theory," 70.

42. Ibid.

43. As Tanya Horeck argues, the spectacle of rape or rape scenarios on film involves a number of troubling questions. In at least one screening of *The Accused* (1988), male audience members applauded during the scene depicting the brutal rape of

the victim. See Horeck, "'They Did Worse Than Nothing': Rape and Spectatorship in 'The Accused,'" *Canadian Review of American Studies* 30, no. 1 (2000).

44. Sarah Projansky, "The Elusive/Ubiquitous Representation of Rape: A Historical Survey of Rape in U.S. Film," *Cinema Journal* 41, no. 1 (2001): 65.

45. Ibid., 70.

46. Raymond Ibrahim, ed., *The Al Qaeda Reader* (New York: Broadway Books, 2007), 202.

47. I. F. Clarke, "The Tales of Last Days, 1805–3794," in *Imagining Apocalypse: Studies in Cultural Crisis*, ed. David Seed (New York: St. Martin's Press, 2000), 22.

48. Slavoj Zizek, *Welcome to the Desert of the Real* (New York: Verso, 2002), 11.

49. Spigel, "Entertainment Wars," 120.

50. Anna Powell, *Deleuze and Horror Film* (Edinburgh: Edinburgh University Press, 2005), 17.

51. Elaine Tyler May, "Echoes of the Cold War: The Aftermath of September 11 at Home," in *September 11 in History: A Watershed Moment?* ed. Mary L. Dudziak (Durham, NC: Duke University Press, 2003), 36.

52. Powell, *Deleuze and Horror Film*, 15. Powell calls the psychoanalysis of film— that is, the study of how films affect the human psyche, "cinepsychoanalysis."

53. Todd McGowan and Sheila Kunkle, "Introduction: Psychoanalysis in Film Theory," in *Lacan and Contemporary Film*, eds. Todd McGowan and Sheila Kunkle (New York: Other Press, 1994), xxvii.

54. Lynn Spigel, "Entertainment Wars: Television Culture after 9/11," in *The Selling of 9/11: How a National Tragedy Became a Commodity*, ed. Dana Heller (New York: Palgrave Macmillan, 2005), 124.

55. Rosie DiManno, "A Nation's Confidence Is Among the Casualties," *Toronto Star*, September 12, 2001, sec. B, p. 1.

56. Kirsten Moana Thompson, *Apocalyptic Dead: American Film at the Turn of the Millennium* (Albany: State University of New York Press, 2007), 147.

57. Ibid.

58. Richard Devetak, "The Gothic Scene of International Relations: Ghosts, Monsters, Terror and the Sublime after September 11," *Review of International Studies* 31 (2005): 621.

59. George W. Bush, "State of the Union," January 29, 2002, and "Speech at West Point," June 1, 2002, quoted in Devetak, "The Gothic Scene," 639.

60. Tania Modleski, "The Terror of Pleasure: The Contemporary Horror Film and Postmodern Theory," in *The Film Cultures Reader*, ed. Greame Turner (New York: Routledge, 2002), 271–272.

61. *Taxi to the Dark Side*, dir. by Alex Gibney (2007; THINKfilm, 2008).

62. Charles H. Brower II, "The Lives of Animals, the Lives of Prisoners, and the Revelations of Abu Ghraib," *Vanderbilt Journal of Transnational Law* 37, no. 5 (2004): 1353. [accessed on 2/12/11].

63. Ibid.

64. Department of the Army, CID Report of Investigation—Final (CID 013-64389-6EID1/5C1B/5Y2B0/9GI). Fort Benning, GA (www.aclu.org/torture-foia/released/030705). Quoted in Mohamad G. Alkadry and Matthew T. Witt, "Abu Ghraib and the Normalization of Torture and Hate," *Public Integrity* 11, no. 2 (2009): 138 [accessed 2/12/11].

65. Graham, *Representations of the Post/Human*, 15.

66. Joshua L. Dratel, "The Legal Narrative," in *The Torture Papers: The Road to Abu Ghraib*, eds. Karen J. Greenberg and Joshua L. Dratel (New York: Cambridge University Press, 2005), xxi.

67. "Memorandum for Chairman of the Joint Chiefs of Staff," in *The Torture Papers: The Road to Abu Ghraib*, eds. Karen J. Greenberg and Joshua L. Dratel (New York: Cambridge University Press, 2005), 80.

68. "Memorandum: Request for Approval of Counter-Resistance Strategies," in *The Torture Papers: The Road to Abu Ghraib*, eds. Karen J. Greenberg and Joshua L. Dratel (New York: Cambridge University Press, 2005), 227–8.

69. See the large number of detainee statements that describe torture and death at Abu Ghraib in *The Torture Papers: The Road to Abu Ghraib*, eds. Karen J. Greenberg and Joshua L. Dratel (New York: Cambridge University Press, 2005), esp. 504, 508.

70. Carolyn Dinshaw, *Chaucer's Sexual Politics* (Madison: The University of Wisconsin Press, 1989), 4, quoted in Czarnowus, *Inscription on the Body*, 93.

71. Czarnowus, *Inscription on the Body*, 93.

72. Numerous journalists have commented on the popularity of Patai's book with members of the US government and military, including Seymour Hersh.

73. Nicholas Mirzoeff, "Invisible Empire: Visual Culture, Embodied Spectacle, and Abu Ghraib," *Radical History Review* 95 (Spring 2006): 25.

74. Ibid., 29.

75. Ibid.

76. See Sam Dagher, "Fresh Paint and Flowers at Iraqi House of Horrors," *New York Times* February 21, 2009.

77. Mirzeoff, "Invisible Empire," 31.

78. David Levi Strauss, "Breakdown in the Gray Room: Recent Turns in the Image War," in *Abu Ghraib: The Politics of Torture* (Berkeley: The Terra Nova Series, 2004), 97.

79. Eli Roth's 2004 film *Saw* was released the same year as images from Abu Ghraib. Later films, however, worked in imagery from the Iraqi prison.

80. Sardar makes this point in an online book review published on the New Statesman site, "The Holiday Snaps. Abu Ghraib Wasn't the Fault Just of US Politicians and Soldiers. Torture, Glamourized by Hollywood, Is Now Intrinsic to American Life." [Book Review] *New Statesman*, March 7, 2005.

81. Brooke Warner, "Abu Ghraib and a New Generation of Soldiers," in *Abu Ghraib: The Politics of Torture* (Berkeley: The Terra Nova Series: 2004), 74.

82. The US government described enemy combatants as members of Al Qaeda and the Taliban, a distinction that was quickly extended to whatever Muslims were around, including non-combatants. The fate of an Afghan cab driver named Dilawar, who was arrested and tortured to death at Bagram Air Base in 2002, is documented in Alex Gibney's film *Taxi to the Dark Side* (2007).

83. Ibid., 27.

Bibliography

300. DVD. Directed by Zach Snyder. Burbank, CA: Warner Brothers, 2007.

Ackerman, Spencer. "Frank Miller's Holy Terror Is Fodder for Anti-Islam Set." *Wired,* September 28, 2011.

Adams, Charles F., editor. *Familiar Letters of John Adams and His Wife, Abigail Adams, during the Revolution.* New York, 1876.

Ahmed, Leila. *Edward W. Lane: A Study of His Life and Works and of British Ideas of the Middle East in the Nineteenth Century.* London: Longman Group, 1978.

Akbari, Suzanne Conklin. "Placing the Jews in Late Medieval English Literature." In *Orientalism and the Jews,* edited by Ivan Davidson Kalmar and Derek J. Penslar, 32–50. Waltham, MA: Brandeis University Press, 2005.

Alighieri, Dante. *The Divine Comedy.* Translated by Henry Francis Cary. New York: Thomas Y. Crowell, 1897.

Al-Dami, Muhammad. *Arabian Mirrors and Western Soothsayers: Nineteenth-Century Literary Approaches to Arab-Islamic History.* New York: Peter Lang, 2002.

Alkadry, Mohamad G., and Matthew T. Witt. "Abu Ghraib and the Normalization of Torture and Hate." *Public Integrity* 11, no. 2 (Spring 2009): 135–154.

Allaire, Gloria. "Portrayal of Muslims in Andrea da Barberino's Guerrino il Meschino." In *Medieval Christian Perceptions of Islam: A Book of Essays,* edited by John Victor Tolan, 243–269. New York: Garland Publishing, 1996.

Almond, Ian. "Leibniz, Historicism, and the 'Plague of Islam.'" *Eighteenth-Century Studies* 39, no. 4 (2006): 463–483.

Anand, Dibyesh. "The Violence of Security: Hindu Nationalism and the Politics of Representing 'the Muslim' as a Danger." *The Round Table: The Commonwealth Journal of International Affairs* 94, no. 379 (2005): 203–215.

Anderson, Benedict. *Imagined Communities: Reflections on the Origin and Spread of Nationalism.* New York: Verso, 2006.

Andriano, Joseph. *The Immortal Monster: The Mythological Evolution of the Fantastic Beast in Modern Fiction and Film.* Westport, CT: Greenwood Press, 1999.

Anidjar, Gil. *The Jew, the Arab: A History of the Enemy*. Palo Alto, CA: Stanford University Press, 2003.

Anolik, Ruth Bienstock. "The Infamous Svengali: George Maurier's Satanic Jew." In *The Gothic Other: Racial and Social Constructions in the Literary Imagination*, edited by Ruth Bienstock Anolik and Douglas L. Howard, 163–193. Jefferson, NC: McFarland, 2004.

Anolik, Ruth Bienstock, and Douglas L. Howard, editors. *The Gothic Other: Racial and Social Constructions in the Literary Imagination*. Jefferson, NC: McFarland, 2004.

Arata, Stephen D. "The Occidental Tourist: 'Dracula' and the Anxiety of Reverse Colonization." *Victorian Studies* 33, no. 4 (Summer 1990): 621–645.

Aronstein, Susan. "'Not Exactly a Knight': Arthurian Narrative and Recuperative Politics in the Indiana Jones Trilogy." *Cinema Journal* 34, no. 4 (Summer 1995): 3–30.

Asad, Talal. *Genealogies of Religion: Discipline and Reasons of Power in Christianity and Islam*. Baltimore, MD: John Hopkins University Press, 1993.

———. *On Suicide Bombing*. New York: Columbia University Press, 2007.

Atkinson, Joshua, and Bernadette Calafell. "Darth Vader Made Me Do It! Anakin Skywalker's Avoidance of Responsibility and the Gray Areas of Hegemonic Masculinity in the Star Wars Universe." *Communication, Culture & Critique* 2 (2009): 1–20.

Aubrey, James R. "Race and the Spectacle of the Monstrous in *Othello*." *CLIO* 22, no. 3 (1993): 221–238.

Avramescu, Catalan. *An Intellectual History of Cannibalism*. Translated by Alistair Ian Blyth. Princeton, NJ: Princeton University Press, 2009.

Awan, Imran. "Paving the Way for Extremism: How Preventing the Symptoms Does Not Cure the Disease of Terrorism." *Journal of Terrorism Research* 2, no. 3 (2011): 4–9.

Backhouse, Janet. *The Luttrell Psalter*. New York: New Amsterdam Books, 1990.

Baepler, Paul. "The Barbary Captivity Narrative in American Culture." *Early American Literature* 39, no. 2 (2004): 217–246.

Bailey, David A. and Gilane Tawadrose, editors. *Veil: Veiling, Representation and Contemporary Art*. Cambridge, MA: MIT Press, 2003.

Bakhtin, Mikhail. *Rabelais and His World*. Translated by Helene Iswolsky. Cambridge, MA: MIT Press, 1968.

Barasch, Frances K. *The Grotesque: A Study in Meanings*. The Hague: Mouton, 1971.

Barlow, Ronald S. *Victorian Houseware, Hardware and Kitchenware: A Pictorial Archive with Over 2000 Illustrations*. Mineola, NY: Dover Publications, 2001.

Bastide, Roger. "Color, Racism, and Christianity," *Daedalus* 96, no. 2 (Spring 1967): 312–327.

Bateman, Stephen. *The Doome Warning All Men to the Judgment*. London: Newberry, 1581.

Beal, Timothy K. *Religion and Its Monsters.* New York: Routledge, 2002.

Beckett, Katharine Scarfe. *Anglo-Saxon Perceptions of the Islamic World.* New York: Cambridge University Press, 2003.

Beckford, William. "Vathek." In *Three Oriental Tales,* edited by Alan Richardson, 79–158. Boston: Houghton Mifflin, 2002.

Beckford, William. *Vathek.* London: Four Square, 1966.

Bederman, Gail. *Manliness and Civilization: A Cultural History of Gender and Race in the United States, 1880–1917.* Chicago: University of Chicago Press, 1996.

Behdad, Ali. "The Eroticized Orient: Images of the Harem in Montesquieu and His Precursors." *Stanford French Review* 13, no. 2–3 (1989): 109–126.

Bellah, Robert N. "Civil Religion in America." *Daedalus* 96, no. 1 [Religion in America] (Winter 1967): 1–21.

Bellin, Joshua David. *Framing Monsters: Fantasy Film and Social Alienation.* Carbondale: Southern Illinois Press, 2005.

Benjamin, Roger. *Renoir and Algeria.* New Haven, CT: Yale University Press, 2003.

Berglund, Jeff. *Cannibal Fictions: American Explorations of Colonialism, Race, Gender and Sexuality.* Madison: University of Wisconsin Press, 2006.

Bernardi, Daniel. "Introduction: Race and the Emergence of U.S. Cinema." In *The Birth of Whiteness: Race and the Emergence of U.S. Cinema,* edited by Daniel Bernardi, 1–11. New Brunswick, NJ: Rutgers University Press, 1996.

Bevir, Mark. "Foucault, Power, and Institutions." *Political Studies* 47, no. 2 (1999): 345–359.

Binski, Paul. *Medieval Death: Ritual and Representation.* Ithaca, NY: Cornell University Press, 1996.

Bishop, Kyle William. "The Sub-Subaltern Monster: Imperialist Hegemony and the Cinematic Voodoo Zombie." *The Journal of American Culture* 31, no. 2 (June 2008): 141–152.

———. "Dead Man Still Walking: Explaining the Zombie Renaissance." *Journal of Popular Film and Television* 37, no. 1 (2009): 16–25.

———. *American Zombie Gothic: The Rise and Fall (and Rise) of the Walking Dead in Popular Culture.* Jefferson, NC: McFarland, 2010.

Blurton, Heather. *Cannibalism in High Medieval English Literature.* New York: Palgrave Macmillan, 2007.

Boheemen-Saaf, Christine Van. *Joyce, Derrida, Lacan, and the Trauma of History.* Cambridge: Cambridge University Press, 1999.

Boiastuau, Pierre. *Certain Secret Wonders of Nature.* Translated by Edward Fenton. London, 1589.

Boon, Kevin Alexander. "Ontological Anxiety Made Flesh: The Zombie in Literature, Film and Culture." In *Monsters and the Monstrous: Myths and Metaphors of Enduring Evil,* edited by Niall Scott, 33–43. New York: Rodopi, 2007.

Boone, Joseph A. "Vacation Cruises; Or, the Homoerotics of Orientalism." *PMLA* 110 [Special Topic: Colonialism and the Postcolonial Condition], no. 1 (1995): 89–107.

Borden, Anthony. *The Bosnians: A War on Identity*. London: Institute for War and Peace Reporting, 1993.

Bourdieu, Pierre. *Outline of a Theory of Practice*. New York: Cambridge University Press, 1977.

———. *The Logic of Practice*. Translated by Richard Nice. Stanford: Stanford University Press, 1990.

———. *The Field of Cultural Production: Essays on Art and Literature*. New York: Columbia University Press, 1993.

———. *On Television*. Translated by Priscilla Parkhurst Ferguson. New York: The New Press, 1996.

Bourdieu, Pierre, and Loic J. D. Wacquant. *An Invitation to Reflexive Sociology*. Chicago: University of Chicago Press, 1992.

Bram Stoker's Dracula. DVD. Directed by Francis Ford Coppola. San Francisco: American Zoetrope, 1992.

Brault, Gerard J. *The Song of Roland: An Analytical Edition*. University Park: Pennsylvania State University Press, 1978.

Bringa, Tone. *Being Muslim the Bosnian Way: Identity and Community in a Central Bosnian Village*. Princeton, NJ: Princeton University Press, 1995.

Brock, Marilyn. "The Vamp and the Good English Mother: Female Roles in Le Fanu's *Carmilla* and Stoker's *Dracula*." In *From Wollstonecraft to Stoker: Essays on Gothic and Victorian Sensation Fiction*, edited by Marilyn Brock, 120–131. Jefferson, NC: McFarland, 2009.

Brower, Charles H. "The Lives of Animals, the Lives of Prisoners, and the Revelations of Abu Ghraib." *Vanderbilt Journal of International Law* 37, no. 5 (2004): 1353–1399.

Brown, Catherine. "In the Middle." *Journal of Medieval and Early Modern Studies* 30, no. 3 (Fall 2000): 547–574.

Brown, L. Carl. "The United States and the Maghrib." *The Middle East Journal* 30, no. 3 (1976): 273–290.

Brown, Michelle P. *The Holkham Bible Picture Book: A Facsimile*. London: The British Library, 2007.

Brown, Peter. *The Cult of the Saints: Its Rise and Function in Latin Christianity*. Chicago: University of Chicago Press, 1981.

Brown, William J. *"Marlowe's Debasement of Bajazet: Foxe's* Actes and Monuments *and* Tamburlaine, Part I." *Renaissance Quarterly* 24, no. 1 (Spring 1971): 38–48.

Bruce, James. *Travels to Discover the Source of the Nile: Volume I*. Dublin : G. G. J. and J. Robinson, 1790–1791.

Buchanan, Lindal. "A Study of Maternal Rhetoric: Anne Hutchinson, Monsters, and the Antinomian Controversy." *Rhetoric Review* 25, no. 3 (2006): 239–259.

Burley, Stephanie. "The Death of Zofloya; or, The Moor as Epistemological Limit." In *The Gothic Other: Racial and Social Constructions in the Literary Imagination*, edited by Ruth Bienstock Anolik and Douglas L. Howard, 197–211. Jefferson, NC: McFarland, 2000.

Burman, Thomas E. *Religious Polemic and the Intellectual History of the Mozarabs, c. 1050–1200.* New York: E. J. Brill, 1994.

Burnett, Mark Thornton. *Constructing 'Monsters' in Shakespearean Drama and Early Modern Culture.* New York: Palgrave Macmillan, 2002.

Burns, William E. "The King's Two Monstrous Bodies: John Bulwer and the English Revolution." In *Wonders, Marvels, and Monsters in Early Modern Culture*, edited by Peter G. Platt, 133–144. Newark: University of Delaware Press, 1999.

Bynum, Carolyn Walker. "The Female Body and Religious Practice in the Later Middle Ages." In *Zone: Fragments for a History of the Body*, edited by Michel Feher et al., Part I, 161–219. New York: Zone Books, 1989.

———. *The Resurrection of the Body in Western Christianity, 200–1336.* New York: Columbia University Press, 1995.

Calbi, Maurizio. "'Civil Monsters': Race, Eroticism and the Body in Early Modern Literature and Culture." *Sederi* 13 (2003): 11–21.

Calderwood, James L. *Shakespeare and the Denial of Death.* Amherst: University of Massachusetts Press, 1987.

Camille, Michael. *The Gothic Idol: Ideology and Image-making in Medieval Art.* Cambridge: Cambridge University Press, 1989.

———. *Image on the Edge: The Margins of Medieval Art.* Cambridge: Harvard University Press, 1992.

———. *Master of Death: The Lifeless Art of Pierre Remiet, Illuminator.* New Haven, CT: Yale University Press, 1996.

———. *Mirror in Parchment: The Luttrell Psalter and the Making of Medieval England.* Chicago: University of Chicago Press, 1998.

Camporesi, Piero. *The Incorruptible Flesh: Bodily Mutilation and Mortification in Religion and Folklore.* New York: Cambridge University Press, 2009.

Carter, Richard. "Mary Shelley's Nightmare (1797–1851): *Frankenstein*; Her Life, Literary Legacy, and Last Illness." *World Journal of Surgery* 23, no. 11 (November1999): 1195–1201.

Casillo, Robert. "The Desert and the Swamp: Enlightenment, Orientalism, and the Jews in Ezra Pound." *Modern Language Quarterly* 45, no. 3 (1984): 263–286.

Caton, Steven C. "Coetzee, Agamben, and the Passion of Abu Ghraib." *American Anthropologist* 108, no. 1 (2006): 114–123.

Cavallaro, Dani. *The Gothic Vision: Three Centuries of Horror, Terror and Fear.* New York: Continuum, 2002.

Cavanaugh, William T. *The Myth of Religious Violence: Secular Ideology and the Roots of Religious Conflict.* New York: Oxford University Press, 2009.

Chapman, Guy. *Beckford.* New York: Charles Scribner's Sons, 1937.

Chaplin, B. J. *"(Mis) Representation of Disability in the Film 300."* Master's thesis, University of Georgia, May 2008.

Charles, J. Daryl. "An Apocalyptic Tribute to the Lamb (Rev. 5:1–14)." *Journal of the Evangelical Theological Society* 34, no. 4 (December 1991): 461–473.

Chernus, Ira. *Monsters to Destroy: The Neoconservative War on Terror and Sin.* Boulder, CO: Paradigm Publishers, 2006.

Chew, Samuel C. *The Crescent and the Rose: Islam and England During the Renaissance.* New York: Oxford University Press, 1937.

Cheyette, Bryan. *Constructions of "the Jew" in English Literature and Society: Racial Representations, 1875–1945.* New York: Cambridge University Press, 1995.

Chronicles of Riddick. DVD (Director's Cut). Directed by David Twohy. Universal City: Universal Studios, 2004.

Cigar, Norman L. *Genocide in Bosnia: The Policy of "Ethnic Cleansing".* College Station: Texas A & M University, 1993.

Cirkovic, Sima. *The Serbs.* Translated by Vuk Tosic. Oxford: Blackwell Publishing, 2004.

Claassens, Geert H. M. "Jacob van Maerlant on Muhammad and Islam." In *Medieval Christian Perceptions of Islam: A Book of Essays,* edited by John Victor Tolan, 211–242. New York: Garland Publishing, 1996.

Clarke, I. F. "The Tales of the Last Days, 1805–3794." In *Imagining Apocalypse: Studies in Cultural Crisis,* edited by David Seed, 15–26. New York: St. Martin's Press, 2000.

Clayton, Antony. *London's Coffee Houses: A Stimulating Story.* London: Historical Publications, 2003.

Clissold, Stephen. *Conquistador.* London: Derek Verschoyle, 1954.

Cohen, D. H. "The Jew and the Shylock." *Shakespeare Quarterly* 31, no. 1 (1980): 53–63. http://www.jstor.org/stable/2869369 [accessed June 5, 2010].

Cohen, Jeffrey Jerome. *Medieval Identity Machines.* Minneapolis: University of Minnesota Press, 1992.

———. "Preface." In *Monster Theory: Reading Culture,* edited by Jeffrey Jerome Cohen, vii-xiii. Minneapolis: University of Minnesota Press, 1996.

———. *Of Giants: Sex, Monsters, and the Middle Ages.* Minneapolis: University of Minnesota Press, 1999.

———. *The Postcolonial Middle Ages.* New York: St. Martin's Press, 2000.

———. "On Saracen Enjoyment: Some Fantasies of Race in Late Medieval France and England." *Journal of Medieval and Early Modern Studies* 31, no.1 (Winter 2001): 113–146.

Cohn, Norman. *The Pursuit of the Millennium: Revolutionary Millenarians and Mystical Anarchists of the Middle Ages.* New York: Oxford University Press, 1970.

Cole, Richard G. "Sixteenth-Century Travel Books as a Source of European Attitudes toward Non-White and Non-Western Culture." *Proceedings of the American Philosophical Society* 116, no. 1 (1972): 59–67.

Colgrave, Bertram, and R. A. B. Mynors, eds. *Bede's Ecclesiastical History of the English People.* Oxford: The Clarendon Press, 1969.

Columbus, Christopher. *Journal of the First Voyage to America 1492–1493. Heath Anthology of American Literature Volume One.* Edited by Paul Lauter et al. Lexington, MA: Heath, 1994.

Comfort, William Wistar. "The Literary Role of the Saracens in the French Epic." *PMLA* 55, no. 3 (1940): 628–659. http://www.jstor.org/sici?sici=0030-8129%28194009%2955%3A3%3C628%3ATLROTS%3E2.0.CO%3B2-O [accessed February 1, 2007].

Corrigan, Kathleen. *Visual Polemics in the Ninth-Century Byzantine Psalters.* Cambridge: Cambridge University Press, 1992.

Coundouriotis, Eleni. "*Dracula* and the Idea of Europe." *Connotations* 9, no. 2 (1999–2000): 143–159.

Cronin, Ciarin. "Bourdieu and Foucault on Power and Modernity." *Philosophy & Social Criticism* 22 (1996): 55–85.

Cupples, Julie. "The Field as a Landscape of Desire: Sex and Sexuality in Geographical Fieldwork." *Area* 34, no. 4 (2002): 382–390.

Cushing, Eliza. *Saratoga: A Tale of the Revolution*, 2 vols. Boston: Cummings, Hollard, 1824.

Cutler, Allan Harris, and Helen Elmquist Cutler. *The Jew as Ally of the Muslim.* Notre Dame, IN: University of Notre Dame Press, 1986.

Czarnowus, Anna. *Inscription on the Body: Monstrous Children in Middle English Literature.* Katowice: Wydawnictwo Uniwersytetu Śląskiego (University of Silesia Press), 2009.

Dabashi, Hamid. "The '300' Stroke," *Al-Ahram Weekly*, August 2–8, 2007. http://weekly.ahram.org.eg/2007/856/cu1.htm [accessed March 22, 2011].

———. "The American Empire: Triumph or Triumphalism." *Unbound: Harvard Journal of Legal Left* 4 (2008): 82–95.

Dacre, Charlotte. *Zofloya, or The Moor.* New York: Oxford University Press, 2008.

Dahl, Curtis. "The Victorian Wasteland." *College English* 16, no. 6 (1955): 341–347. http://www.jstor.org/stable/372240 [accessed June 30, 2010].

Dahlberg, Gunilla. "The Theatre around Queen Christina." *Renaissance Studies* 23, no. 2 (2009): 161–185.

Dale, Thomas E. A. "The Monstrous." In *A Companion to Medieval Art: Romanesque and Gothic in Northern Europe*, edited by Conrad Rudolph, 253–273. Malden, MA: Blackwell Publishing, 2006.

Dalrymple, Roger. "*Torrent of Portyngale* and the Literary Giants." In *Cultural Encounters in the Romance of Medieval England*, edited by Corinne Saunders, 159–170. Cambridge: D. S. Brewer, 2005.

Daniel, John. *A Narrative of the Life and Astonishing Adventures of John Daniel.* London: M. Cooper, 1751.

Datta, Kitty Scoular. "Iskandar, Alexander: Oriental Geography and Romantic Poetry." In *Reorienting Orientalism*, edited by Chandreyee Niyogi, 35–64. New Delhi: Sage Publications, 2006.

Davidson, Arnold I. "The Horror of Monsters." In *The Boundaries of Humanity: Humans, Animals, Machines*, edited by James J. Sheehan and Morton Sosna 36–67. Berkeley: University of California Press, 1991.

Dayan, Joan. "Haiti's Unquiet Past." *Transition* 67 (1995): 150–64.

De La Motte Fouque, Baron. *The Magic Ring, or, The Castle of Montfaucon*. Translated by Robert Pearse Gillies. Chicago: Valancourt Books, 2006.

Delamotte, Eugenia. "White Terror, Black Dreams: Gothic Constructions of Race in the Nineteenth Century." In *The Gothic Other: Racial and Social Constructions in the Literary Imagination*, edited by Ruth Bienstock Anolik and Douglas L. Howard, 17–31. Jefferson, NC: McFarland, 2004, 24.

Delany, Sheila. "Chaucer's Prioress, the Jews, and the Muslims." *Medieval Encounters* 3, no. 2 (1999): 198–213.

Dendle, Peter. "The Zombie as Barometer of Cultural Anxiety." In *Monsters and the Monstrous: Myths and Metaphors of Enduring Evil*, edited by Niall Scott, 45–57. New York: Rodopi, 2007.

Dening, Greg. "Possessing Tahiti." *Archaeology in Oceania* 21, no. 1 (1986): 103–18.

Denitch, Bogdan. *The Tragic Death of Yugoslavia: Ethnic Nationalism*. Minneapolis: University of Minnesota Press, 1994.

Derrickson, Teresa. "Race and the Gothic Monster: The Xenophobic Impulse of Louis May Lacott's 'Taming a Tartar.'" *American Transcendental Quarterly (ATQ)* (March 2001): 43–58.

Devetak, Richard. "The Gothic Scene of International Relations: Ghosts, Monsters, Terror and the Sublime after September 11." *Review of International Studies* 31 (2005): 621–643.

Devisse, Jean, and Michel Mollat. "The Appeal to the Ethiopian." In *The Image of the Black in Western Art: From the Early Christian Era to the "Age of Discovery," Africans in the Christian Ordinance of the World*, edited by David Bindman and Henry Louis Gates, Jr., 83–152. Cambridge, MA: Harvard University Press, 2010.

De Weever, Jacqueline. *Sheba's Daughters: Whitening and Demonizing the Saracen Woman in Medieval French Epic*. New York: Garland Publishing, 1998.

De Wette, Wilhelm Martin Leberecht. *Biblische Dogmatik Alten und Neuen Testaments*. Berlin: G. Reiner, 1833.

Didier, Charles. "Le Maroc." *La Revue des Deux Mondes*. November 1, 1836: 241–269.

Dimmock, Matthew. *New Turkes: Dramatizing Islam and the Ottomans in Early Modern England*. Burlington, VT: Ashgate, 2005.

Dines, Gail. "King Kong and the White Woman: Hustler Magazine and the Demonization of Black Masculinity." *Violence Against Women* 4, no. 3 (June 1998): 291–307.

Dinshaw, Carolyn. *Chaucer's Sexual Politics*. Madison: The University of Wisconsin Press, 1989.

Dotson, Jennifer Whitney. *"Considering Blackness in George A. Romero's Night of the Living Dead: An Historical Explanation."* Master's thesis, Middle Tennessee State University, 2006.

Dratel, Joshua L. "The Legal Narrative." In *The Torture Papers: The Road to Abu Ghraib*, edited by Karen J. Greenberg and Joshua L. Dratel, xxi–xxiii. New York: Cambridge University Press, 2005.

Du Maurier, George. *Trilby*. New York: Oxford University Press, 1995.

Duncan, James S. *Writes of Passage: Reading Travel Writing*. New York: Routledge, 1998.

Edmond, Rod. *Representing the South Pacific: Colonial Discourse from Cook to Gaugin*. New York: Cambridge University Press, 1997.

Edmundson, Mark. *Nightmare on Main Street: Angels, Sadomasochism, and the Culture of Gothic*. Cambridge, MA: Harvard University Press, 1997.

Edwards, Brian T. "Kiddie Orientalism: A Cultural Critic's Struggle to Teach Post-9/11, *Star Wars*-Obsessed Youth about Tatooine and the 'Imagined Look of Evil.'" *The Believer* [June 2008]. http://www.believermag.com/issues/200806/?read=article_edwards.

Edwards, Holly. *Noble Dreams, Wicked Pleasures: Orientalism in America, 1870–1930*. Princeton, NJ: Princeton University Press, 2000.

Eisele, John. "The Wild East: Deconstructing the Language of Genre in the Hollywood Eastern." *Cinema Journal* 41, no. 4 (Summer 2002): 68–94.

El Fadl, Khaled Abou. "9/11 and the Muslim Transformation." In *September 11 in History, A Watershed Moment?* edited by Mary L. Dudziak, 70–111. Durham, NC: Duke University Press, 2003.

Ellul, Jacques. *Apocalypse*. New York: Seabury, 1977.

Elmer, Paul, editor. *The Complete Works of Lord Byron*. Cambridge: The Riverside Press, 1905.

Faas, Ekbert. *The Genealogy of Aesthetics*. New York: Cambridge University Press, 2002.

Fabian, Johannes. *Time and the Other: How Anthropology Makes Its Object*. New York: Columbia University Press, 2002.

Falkner, Silke R. "'Having It Off' with Fish, Camels, and Lads: Sodomitic Pleasures in German-Language *Turcica*." *Journal of the History of Sexuality* 13, no. 4 (October 2004): 401–427.

Faludi, Susan. *The Terror Dream: Fear and Fantasy in Post-9/11 America*. New York: Metropolitan Books, 2007.

Fanon, Frantz. "Algeria Unveiled." In *The New Left Reader*, edited by Carl Oglesby, 161–185. New York: Grove Press, 1969.

Farrier, Susan E. "Hungry Heroes in Medieval Literature." In *Food in the Middle Ages: A Book of Essays*, edited by Melitta Weiss Adamson, 145–160. New York: Garland Publishing, 1995.

Ferguson, George Wells. *Signs and Symbols in Christian Art*. New York: Oxford University Press, 1966.

Fichtner, Paula Sutter. *Terror and Toleration: The Habsburg Empire Confronts Islam, 1526–1850*. London: Reaktion Books, 2008.

Fincher, Max. *Queering Gothic in the Romantic Age: The Penetrating Eye*. New York: Palgrave Macmillan, 2007.

Flaubert, Gustave. *Salammbo*. New York: Modern Library, 1929.

Foster, Stephen William. "The Exotic as a Symbolic System." *Dialectical Anthropology* 7, no. 1 (1982): 21–30.

Foucault, Michel. *Madness and Civilization: A History of Insanity in the Age of Reason*. New York: Vintage Books, 1965.

———. *Language, Counter-Memory, Practice: Selected Essays and Interviews*. Edited by Donald F. Buchard. Translated by Donald F. Bouchard and Sherry Simon. Ithaca, NY: Cornell University Press, 1977.

———. *The History of Sexuality: An Introduction. Volume One*. Translated by Robert Hurley. New York: Vintage Press, 1979.

———. *Power/Knowledge: Selected Interviews and Other Writings*. Edited by C. Gordon. New York: Pantheon Press, 1980.

———. *The Order of Things: An Archaeology of the Human Sciences*. New York: Vintage Books Edition, 1994.

———. *The Politics of Truth*. Los Angeles: Semiotext(e), 2007.

Frantzen, Allen J. *Desire for Origins: New Language, Old English and Teaching the Tradition*. New Brunswick, NJ: Rutgers University Press, 1990.

Freedman, Paul, and Gabrielle M. Spiegel. "Medievalisms Old and New: The Rediscovery of Alterity in North American Medieval Studies." *The American Historical Review* 103, no. 3 (June 1998): 677–704.

Friedman, John Block. *The Monstrous Races in Medieval Art and Thought*. Syracuse, NY: Syracuse University Press, 2000.

Friedman, Lester D. "The Edge of Knowledge: Jews as Monsters/Jews as Victims." *MELUS* 11, no. 3, *Ethnic Images in Popular Genres and Media* (Autumn 1984): 49–62.

———. "Celluloid Palimpsests: An Overview of Ethnicity and the American Film." In *Unspeakable Images: Ethnicity and the American Cinema*, edited by Lester D. Friedman, 11–36. Urbana-Champaign, IL: Illini Books, 1991.

Fuchs, Barbara. "Virtual Spaniards: The Moriscos and the Fictions of Spanish Identity." *Journal of Spanish Cultural Studies* 2, no. 1 (2001): 13–26.

———. *Mimesis and Empire: The New World, Islam, and European Identities*. New York: Cambridge University Press, 2001.

———. *Exotic Nation: Maurophilia and the Construction of Early Modern Spain*. Philadelphia: University of Pennsylvania Press, 2009.

Gagnon, V. P. *The Myth of Ethnic War: Serbia and Croatia in the 1990's*. Ithaca, NY: Cornell University Press, 2004.

Ganim, John M. "Medieval Literature as Monster: The Grotesque before and after Bakhtin." *Exemplaria* 7, no. 1 (1995): 21–40.

———. "Framing the West, Staging the East: Set Design, Location, and Landscape in Cinematic Medievalism." In *Hollywood in the Holy Land: Essays on Film Depictions of the Crusades and Christian-Muslim Clashes*, edited by Nickolas Haydock and E. L. Risden, 31–46. Jefferson, NC: McFarland, 2009.

Geary, Patrick J. *The Myth of Nations: The Medieval Origins of Europe*. Princeton, NJ: Princeton University Press, 2003.

Gelder, Ken. "Postcolonial Voodoo." *Postcolonial Studies* 3, no. 1 (2000): 89–98.

Gilmore, David D. *Monsters: Evil Beings, Mythical Beasts, and All Manner of Imaginary Terrors*. Philadelphia: University of Pennsylvania Press, 2003.

Girard, Rene. *Evolution and Conversion: Dialogues on the Origins of Culture*. New York: Continuum Books, 2007.

Glover, David. "Travels in Romania: Myths of Origin, Myths of Blood." *Discourse* 16 (1993): 126–144.

———. *Vampires, Mummies, and Liberals: Bram Stoker and the Politics of Popular Fiction*. Durham, NC: Duke University Press, 1996.

Goddu, Teresa A. "Vampire Gothic." *American Literary History* 11, no. 1 (1999): 125–141.

Goetsch, Paul. *Monsters in English Literature: From the Romantic Age to the First World War*. New York: Peter Lang, 2002.

Goetz, Hermann. "Oriental Types and Scenes in Renaissance and Baroque Painting." *The Burlington Magazine for Connoisseurs* 73, no. 425 (August 1938): 50, 54–57, 60–62.

Golder, Harold. "Browning's Childe Roland." *PMLA* 39, no. 4 (December 1924): 963–978. http://www.jstor.org/stable/457257 [accessed June 30, 2010].

Gonzales, Antonio Ballesteros, and Ana Manzanas Calvo. "Monsters on the Island: Caliban's and Prospero's Hideous Progeny." *Atlantis* 19, no. 1 (1997): 15–20.

Goody, Jack. *Islam in Europe*. Malden, MA: Polity Press, 2007.

Gordon-Grube, Karen. "Anthropophagy in Post-Renaissance Europe: The Tradition of Medicinal Cannibalism." *American Anthropologist* 90, no. 2 (June 1988): 405–409. http://www.jstor.org/stable/677961 [accessed January 6, 2012].

Gottlieb, Richard M. "The Reassembly of the Body from Parts: Psychoanalytic Reflections on Death, Resurrection, and Cannibalism." *Journal of the American Psychoanalytic Association* 55, no. 4 (2007): 1217–1251. http://apa.sagepub.com/content/55/4/1217 [accessed February 21, 2011].

Gottschalk, Peter, and Gabriel Greenberg. *Islamophobia: Making Muslims the Enemy*. Lanham, MD: Rowman and Littlefield, 2008.

Graham, Elaine L. *Representations of the Post/Human: Monsters, Aliens and Others in Popular Culture*. New Brunswick, NJ: Rutgers University Press, 2002.

———. "Post/Human Conditions." *Theology & Sexuality* 10, no. 2 (2004): 10–32.

Graham-Brown, Sarah. *The Portrayal of Women in Photography of the Middle East 1860–1950: Images of Women*. New York: Columbia University Press, 1988.

Green, Andrew J. "Essays in Miniature." *College English* 3, no. 8 (May 1942): 722–724. http://www.jstor.org/stable/370511 [accessed April 15, 2011].

Greenberg, Karen J., and Joshua L. Dratel, eds. *The Torture Papers: The Road to Abu Ghraib*. New York: Cambridge University Press, 2005.

Gregory, Brad S. *Salvation at Stake: Christian Martyrdom in Early Modern Europe*. Cambridge, MA: Harvard University Press, 1999.

Hagen, Ross. "A Warning to England: Monstrous Births, Teratology and Feminine Power in Elizabethan Broadside Ballads," *Horror Studies* 4, no. 1 (April 2013): 21–41.

Haggard, Henry Rider. *Rider Haggard: The Great Adventures*. Lindley, UK: Jerry Mills Publishing, 2005.

Haggerty, George E. "Literature and Homosexuality in the Late Eighteenth Century: Walpole, Beckford, and Lewis." *Studies in the Novel* 18, no. 4 (Winter 1986): 341–352.

Hahn, Thomas G. "The Difference the Middle Ages Makes: Color and Race before the Modern World." *Journal of Medieval and Early Modern Studies* 31, no. 1 (Winter 2001): 1–37.

Halberstam, Judith. *Skin Shows: Gothic Horror and the Technology of Monsters*. Durham, NC: Duke University Press, 1995.

Halliwell, Leslie. *The Dead that Walk: Dracula, Frankenstein, the Mummy and Other Favorite Movie Monsters*. London: Grafton, 1986.

Hammerbeck, David. "Voltaire's *Mahomet*, the Persistence of Cultural Memory and Pre-Modern Orientalism." *Agora: Online Graduate Humanities Journal* 2, no. 2 January 11, 2007.

Hammond, Kim. "Monsters of Modernity: Frankenstein and Modern Environmentalism." *Cultural Geographies* 11 (2004): 181–198.

Han, Beatrice. *Foucault's Critical Project: Between the Transcendental and the Historical*. Translated by Edward Pile. Stanford, CA: Stanford University Press, 2002.

Harris, Stephen J. *Race and Ethnicity in Anglo-Saxon Literature*. New York: Routledge, 2003.

Haskins, Charles Homer. "European History and American Scholarship." *The American Historical Review* 28, no. 2 (1923): 215–227.

Hassig, Debra. *Medieval Bestiaries: Text, Image, Ideology*. Cambridge: Cambridge University Press, 1995.

Haydock, Nickolas. "'The Unseen Cross upon the Breast': Medievalism, Orientalism, and Discontent." In *Hollywood in the Holy Land: Essays on Film Depictions of the crusades and Christian-Muslim Clashes*, edited by Nickolas Haydock and E. L. Risden, 1–30. Jefferson, NC: McFarland, 2009.

Heath, Michael J. "Renaissance Scholars and the Origins of the Turks." *Biblioteque d'Humanisme et Renaissance* 41, no. 3 (1979): 453–471.

Hebron, Malcolm. *The Medieval Siege: Theme and Image in Middle English Romance*. Oxford: Clarendon Press, 1997.

Henthorne, Tom. "Boys to Men: Medievalism and Masculinity in Star Wars and E.T.: The Extra-Terrestrial." In *The Medieval Hero on Screen: Representations from Beowulf to Buffy*, edited by Martha W. Driver and Sid Ray, 73–90. Jefferson, NC: McFarland, 2004.

Hess, Jonathon M. "Johann David Michaelis and the Colonial Imaginary: Orientalism and the Emergence of Racial Antisemitism in Eighteenth-Century Germany." *Jewish Social Studies* 6, no. 2 (2000): 56–101.

Hieatt, Constance B., and Robin F. Jones. "Two Anglo-Norman Culinary Collections from British Library Manuscripts Additional 32085 and Royal

12.C.xii." *Speculum* 61, no. 4 (October 1986): 859–882. http://www.jstor.org/stable/2853971 [accessed May 24, 2010].

Hiebert, Paul J. "Western Images of Others and Otherness." In *This Side of Heaven: Race, Ethnicity, and Christian Faith*, edited by Robert J. Priest and Alvaro L. Nieves, 97–110. New York: Oxford University Press, 2007.

Higashi, Sumiko. "Touring the Orient with Lafcadio Hearn and Cecil B. DeMille." In *The Birth of Whiteness: Race and the Emergence of U.S. Cinema*, edited by Daniel Bernardi, 327–353. New Brunswick, NJ: Rutgers University Press, 1996.

Holsinger, Bruce W. "Medieval Studies, Postcolonial Studies, and the Genealogies of Critique." *Speculum* 77, no. 4 (October 2002): 1195–1227.

Holterhoff, Kate. "Liminality and Power in Bram Stoker's Jewel of the Seven Stars." In *From Wollstonecraft to Stoker: Essays on Gothic and Victorian Sensation Fiction*, edited by Marilyn Brock, 132–143. Jefferson, NC: McFarland, 2009.

Hoor, G. J. ten. "Legends of Saladin in Medieval Dutch." *Monatschefte* 44, no. 6 (October 1952): 253–256.

Hopkins, Lisa. *Screening the Gothic.* Austin: University of Texas Press, 2005.

Horeck, Tanya. " 'They Did Worse Than Nothing': Rape and Spectatorship in 'The Accused.' " *Canadian Review of American Studies* 30, no. 1 (2000): 1–21.

Howard, Deborah. *Venice and the East: The Impact of the Islamic World on Venetian Architecture 1100–1500.* New Haven, CT: Yale University Press, 2000.

Hoyland, Robert G. *Seeing Islam as Others Saw It: A Survey and Evaluation of Christian, Jewish and Zoroastrian Writings on Early Islam.* Princeton, NJ: The Darwin Press, 1997.

Hozic, Aida A. *Hollyworld: Space, Power, and Fantasy in the American Economy.* Ithaca, NY: Cornell University Press, 2001.

Hudson, Dale. "Vampires of Color and the Performance of Multicultural Whiteness." In *The Persistence of Whiteness: Race and Contemporary Hollywood Cinema*, edited by Daniel Bernardi, 127–156. New York: Routledge, 2008.

Hugyens, Ils. "Invasions of Fear: The Body Snatchers Theme." In *Fear, Cultural Anxiety, and Transformation: Horror, Science Fiction and Fantasy Films Remade*, edited by Scott A. Lukas and John Marmysz, 45–60. Lanham, MD: Lexington Books, 2009.

Hulme, Peter. *Colonial Encounters: Europe and the Native Caribbean 1492–1797.* London: Routledge, 1992.

Ibrahim, Raymond, translator and editor. *The Al Qaeda Reader.* New York: Broadway Books, 2007.

Ilby, Elfriede. "The Ladies' Carousel." Schonbrunn Palace publication, Vienna, Austria. Courtesy of Dr. Ilby via e-mail, June 14, 2010.

The Invasion. DVD. Directed by Oliver Hirschbiegel and James McTeigue. Los Angeles: Warner Brothers, 2007.

James, M. R. *The Canterbury Psalter.* London: Percy Lund, Humphries, 1935.

Japenga, Ann. "Bigfoot on the Mojave." Originally published as "Yucca Man" in Palm Springs Life (2001). In *True Tales of the Mojave Desert: From Talking Rocks to Yucca Man*, edited by Peter Wild, 210–212. Santa Fe, NM: The Center for American Places, 2004.

Jasper, David. *The Sacred Desert: Religion, Literature, Art, and Culture*. Malden, MA: Wiley-Blackwell, 2004.

Johnson, James William. "The Scythian: His Rise and Fall." *Journal of the History of Ideas* 20, no. 2 (April 1959): 250–257.

Johnson, Willis. "The Myth of Jewish Male Menses." *Journal of Medieval History* 24, no. 3 (1998): 272–295.

Jones, W. R. "The Image of the Barbarian in Medieval Europe." *Comparative Studies in Society and History* 13, no. 4 (October 1971): 376–407.

Joubin, Rebecca. "Islam and Arabs Through the Eyes of the Encyclopedie: The 'Other' as a Case of French Cultural Criticism." *International Journal of Middle East Studies* 32, no. 2 (May 2000): 197–217.

Judah, Tim. *The Serbs: History, Myth and the Destruction of Yugoslavia*. New Haven, CT: Yale University Press, 2000.

———. *Kosovo: War and Revenge*. New Haven, CT: Yale University Press, 2002.

Kabbani, Rana. *Europe's Myth of Orient*. Bloomington: University of Indiana Press, 1986.

Kahane, Claire. "The Gothic Mirror." In *The (M)other Tongue: Essays in Feminist Psychoanalytic Interpretation*, edited by Shirley Nelson Garner, Claire Kahane, and Madelon Sprengnether, 334–351. Ithaca, NY: Cornell University Press, 1985.

Kalman, Julie. "Sensuality, Depravity, and Ritual Murder: The Damascus Blood Libel and Jews in France." *Jewish Social Studies: History, Culture, Society* 13, no. 3 (Spring/Summer 2007): 35–58.

Kalmar, Ivan Davidson. "Jesus Did Not Wear a Turban: Orientalism, the Jews, and Christian Art." In *Orientalism and the Jews*, edited by Ivan Davidson Kalmar and Derek J. Penslar, 3–31. Waltham, MA: Brandeis University Press, 2005.

Kaplan, Matt. *Medusa's Gaze and Vampire's Bite: The Science of Monsters*. New York: Scribner, 2012.

Kaplan, Paul. "Black Turks: Venetian Artists and Perceptions of Ottoman Ethnicity." In *The Turk and Islam in the Western Eye, 1450–1750: Visual Imagery before Orientalism*, edited by James G. Harper, 4–68. Burlington, VT: Ashgate, 2011.

Katz, Dana E. "Painting and the Politics of Persecution: Representing the Jew in Fifteenth-Century Mantua." *Art History* 23, no. 4 (November 2000): 475–495.

———. *The Jew in the Art of the Italian Renaissance*. Philadelphia: University of Pennsylvania Press, 2008.

Kearney, Richard. *Strangers, Gods and Monsters: Interpreting Otherness*. New York: Routledge, 2003.

Kelly, Kathleen Coyne. "Medieval Times: Bodily Temporalities in *The Thief of Bagdad* (1924), *The Thief of Bagdad* (1940), and *Aladdin* (1992)." In *Hollywood in the Holy Land: Essays on Film Depictions of the crusades and Christian-Muslim Clashes*, edited by Nickolas Haydock and E. L. Risden, 200–224. Jefferson, NC: McFarland, 2009.

Kennedy, Randall L. "Who Can Say 'Nigger'? and Other Considerations." *The Journal of Blacks in Higher Education*, no. 26 (Winter, 1999–2000): 86–96. http://www.jstor.org/stable/2999172 [accessed May 7, 2011].

Kerslake, Patricia. *Science Fiction and Empire*. Liverpool: Liverpool University Press, 2007.

King, Richard. *Orientalism and Religion: Postcolonial Theory, India and 'The Mythic East.'* New York: Routledge, 1999.

Kinnard, Jacob. "Wisdom Divine: The Visual Representation of Prajna in Pala-Period Buddhism." PhD dissertation, University of Chicago, 1996.

Kinoshita, Sharon. *Medieval Boundaries: Rethinking Difference in Old French Literature*. Philadelphia: University of Pennsylvania Press, 2006.

Kline, Naomi Reed. "The World of Strange Races." In *Monsters, Marvels and Miracles: Imaginary Journeys and Landscapes in the Middle Ages*, edited by Leif Sondergaard and Rasmus Thorning Hansen, 27–41. Odense: University of Southern Denmark Press, 2005.

Knox, Thomas W. *Backsheesh! Or the Adventures in the Orient with Descriptive and Humorous Sketches of Sights and Scenes Over the Atlantic, Down the Danube, Through the Crimea; in Turkey, Greece, Asia-Minor, Syria, Palestine, and Egypt; Up the Nile, in Nubia, and Equatorial Africa, Etc., Etc.* Hartford, CT: A. D. Worthington, 1875.

Kovacs, Lee. *The Haunted Screen: Ghosts in Literature and Film*. Jefferson, NC: McFarland, 1999.

Kruger, Steven F. "Medieval Christian (Dis)identifications: Muslims and Jews in Guibert of Nogent." *New Literary History* 28, no. 2 (1997): 185–203.

———. "Becoming Christian, Becoming Male?" In *Becoming Male in the Middle Ages*, edited by Jeffrey Jerome Cohen and Bonnie Wheeler, 21–42. New York: Garland Publishing, 1997.

Lane, Edward William. *On the Manners and Customs of the Modern Egyptians*. London: J. M. Dent, 1860.

Lant, Antonia. "The Curse of the Pharaoh, or How Cinema Contracted Egyptomania." In *Visions of the East: Orientalism in Film*, edited by Matthew Bernstein and Gaylyn Studlar, 69–98. New Brunswick, NJ: Rutgers University Press, 1997.

Larwood, Jacob, and John Camden Hotten. *English Inn Signs: Being a Revised and Modernized Edition of History of Signboards*. London: Chatto and Windus, 1951.

Leibniz. *Theodicy*. Translated by E.M. Huggard. La Salle: Open Court, 1985.

Lewis, Reina. *Gendering Orientalism: Race, Femininity and Representation.* New York: Routledge, 1996.

Lewis, Suzanne. *The Art of Matthew Paris in the Chronica Majorca.* Berkeley: University of California Press, 1987.

———. *Reading Images: Narrative Discourse and Reception in the Thirteenth-Century Illuminated Apocalypse.* Cambridge: Cambridge University Press, 1995.

Lillywhite, Bryant. *London Signs: A Reference Book of London Signs from Earliest Times to about the Mid-Nineteenth Century.* London: George Allen and Unwin, 1972.

Lincoln, Bruce. *Holy Terrors: Thinking about Religion after September 11.* Chicago: University of Chicago Press, 2003.

Lionarons, Joyce Tally. "The Old English Legend of Saint Christopher." In *Marvels, Monsters and Miracles: Studies in the Medieval and Early Modern Imaginations,* edited by Timothy S. Jones and David A. Sprunger, 167–182. Kalamazoo: Western Michigan University, 2002.

Lockman, Zachary. *Contending Visions of the Middle East: The History and Politics or Orientalism.* New York: Cambridge University Press, 2004.

Loshitsky, Yosefa. "Orientalist Representations: Palestinians and Arabs in Some Postcolonial Film and Literature." In *Cultural Encounters: Representing 'Otherness,'* edited by Elizabeth Halam and Brian V. Street, 51–71. New York: Routledge, 2000.

Loti, Pierre. *The Marriage of Loti.* Honolulu: The University of Hawaii Press, 1976.

———. *Aziyade.* New York: Kegan Paul International, 1989.

Lovecraft, H. P. *The Best of H. P. Lovecraft: Bloodcurdling Tales of Horror and the Macabre.* New York: Ballantine Books, 1982.

Luchitskaja, Svetlana. "The Image of Muhammad in Latin Chronography of the Twelfth and Thirteenth Centuries." *Journal of Medieval History* 26, no. 2 (2000): 115–126.

MacLean, Gerald. *Looking East: English Writing and the Ottoman Empire before 1800.* New York: Palgrave Macmillan, 2007.

Majid, Anouar. *Freedom and Orthodoxy: Islam and Difference in the Post-Andalusian Age.* Stanford, CA: Stanford University Press, 2004.

Malchow, H. L. "Frankenstein's Monster and Images of Race in Nineteenth-Century Britain." *Past & Present* 139 (May 1993): 90–130.

Mango, Cyril, and Roger Scott, trans. *The Chronicles of Theophanes Confessor.* Oxford: Clarendon Press, 1997.

Manly, John Matthews. "Humanistic Studies and Science." *Speculum* 5, no. 3 (July 1930): 243–250.

Mansel, Philip. "The French Renaissance in Search of the Ottoman Empire." In *Re-Orienting the Renaissance,* edited by Gerald McClean, 96–107. New York: Palgrave Macmillan, 2005.

Marrow, James. *"Circumdederunt me canes multi*: Christ's Tormentors in Northern European Art of the Late Middle Ages and Early Renaissance." *The Art Bulletin* 59, no. 2 (1977): 167–181.

———. *Passion Iconography in Northern European Art of the Late Middle Ages and Early Renaissance*. Brussels: Van Ghemmert Publishing Company, 1979.

Marsh, Richard. *The Beetle*. Edited by Julian Wolfreys. Buffalo: Broadview Press, 2004.

Marshall, Herbert, and Mildred Stock. *Ira Aldridge: The Negro Tragedian*. London: Rockcliff, 195).

Mason, Peter. *Deconstructing America: Representations of the Other*. New York: Routledge, 1990.

Massad, Joseph A. *Desiring Arabs*. Chicago: University of Chicago Press, 2007.

Matar, Nabil I. "Muslims in Seventeenth-Century England." *Journal of Islamic Studies* 8, no. 1 (1997): 63–82.

———. "Renaissance England and the Turban." In *Images of the Other: Europe and the Muslim World Before 1700*, edited by David Blanks, 39–54. Cairo: The American University of Cairo Press, 1997.

Matheson, Richard. *I Am Legend*. New York: Tom Doherty Associates, 1995.

May, Elaine Tyler. "Echoes of the Cold War: The Aftermath of September 11 at Home." In *September 11 in History, A Watershed Moment?*, edited by Mary L. Dudziak, 35–54. Durham, NC: Duke University Press, 2003.

Mbembe, Achille. *On the Postcolony*. Berkeley: University of California Press, 2001.

McClintock, Anne. *Imperial Leather: Race, Gender, and Sexuality in the Colonial Contest*. New York: Routledge, 1995.

McClintock, Anne, Aamir Mufti, and Ella Shohat, editors. *Dangerous Liaisons: Gender, Nation, and Postcolonial Perspectives*. Minneapolis: University of Minnesota Press, 1997.

McClintock, Anne. "Paranoid Empire: Specters from Guantanamo and Abu Ghraib." *Small Axe* 13, no. 1 (2009): 50–74.

McCullouch, J. A. *Medieval Faith and Fable*. Boston: Marshall Jones, 1932.

McDonald, Nicola. "Eating People and the Alimentary Logic of *Richard Coeur de Lion*." In *Pulp Fictions of Medieval England: Essays in Popular Romance*, edited by Nicola McDonald, 124–150. Manchester: Manchester University Press, 2004.

McDow, Thomas F. "Trafficking in Persianness: Richard Burton between Mimicry and Similitude in the Indian Ocean and Persianate Worlds." *Comparative Studies of South Asia, Africa and the Middle East* 30, no. 3 (2010): 491–511.

McGann, Jerome. "Rethinking Romanticism." *ELH* 59, no. 3 (Autumn 1992): 735–754.

McGinn, Bernard. *Antichrist: Two Thousand Years of the Human Fascination with Evil*. New York: Harper Collins, 1994.

McGowan, Todd, and Sheila Kunkle. "Introduction: Psychoanalysis in Film Theory." In *Lacan and Contemporary Film*, edited by Todd McGowan and Sheila Kunkle, xi–xxix. New York: Other Press, 1994.

McJannet, Linda. *The Sultan Speaks: Dialogue in English Plays and Histories about the Ottoman Turks*. New York: Palgrave Macmillan, 2006.

McKeown, Simon. "Reading and Writing the Swedish Renaissance." *Renaissance Studies* 23, no. 2 (2009): 141–150.

Mellinkoff, Ruth. *Outcasts: Signs of Otherness in Northern European Art of the Late Middle Ages, Volume One: Text*. Berkeley: University of California Press, 1993.

————. *Outcasts: Signs of Otherness in Northern European Art of the Late Middle Ages, Volume Two: Text*. Berkeley: University of California Press, 1993.

————. *Antisemitic Hate Signs in Hebrew Illuminated Manuscripts from Medieval Germany*. Jerusalem: Hamakor Press, 1999.

Mellor, Anne K. "Frankenstein, Racial Science, and the Yellow Peril." *Nineteenth-Century Contexts* 23, no. 1 (2001): 1–28.

Menocal, Maria Rosa. *The Arabic Role in Medieval Literary History: A Forgotten Heritage*. Philadelphia: University of Pennsylvania Press, 1987.

Messerschmidt, James W. *Hegemonic Masculinities and Camouflaged Politics: Unmasking the Bush Dynasty and Its War Against Iraq*. Boulder, CO: Paradigm Publishers, 2010.

Meyer, Eric. "'I Know Thee Not, I Loathe Thy Race': Romantic Orientalism in the Eye of the Other." *ELH (English Literary History)* 58, no. 3 (Autumn 1991): 657–699.

Meyers, Joyce. "'Childe Roland to the Dark Tower Came': A Nightmare Confrontation with Death." *Victorian Poetry* 8, no. 4 (Winter 1970): 335–339. http://www.jstor.org/stable/40001455 [accessed June 30, 2010].

Michael, John. "Beyond Us and Them: Identity and Terror from an Arab American's Perspective." *The South Atlantic Quarterly* 102 (Fall 2003): 702–728.

Milton, John. *Paradise Lost*. Edited by Alastair Fowler. New York: Longman, 1998.

Mirzoeff, Nicholas. "Invisible Empire: Visual Culture, Embodied Spectacle, and Abu Ghraib." *Radical History Review* 95 (Spring 2006): 21–44.

Mitman, Gregg. "Cinematic Nature: Hollywood Technology, Popular Culture, and the American Museum of Natural History." *Isis* 84, no. 4 (December 1993): 637–661.

Mitter, Partha. *Much Maligned Monsters: A History of European Reactions to Indian Art*. Chicago: University of Chicago Press, 1992.

Modleski, Tania. "The Terror of Pleasure: The Contemporary Horror Film and Postmodern Theory." In *The Film Cultures Reader*, edited by Graeme Turner, 268–275. New York: Routledge, 2002.

Moore, R. I. *The Formation of a Persecuting Society*. Hoboken, NJ: Wiley-Blackwell, 2007.

More, Paul Elmer, editor. *The Complete Works of Lord Byron*. Cambridge: The Riverside Press, 1905.

Morgan, Jack. "Toward an Organic Theory of the Gothic: Conceptualizing Horror." *Journal of Popular Culture* 32, no. 3 (Winter 1998): 59–80.

———. *The Biology of Horror: Gothic Literature and Film.* Carbondale: Southern Illinois University Press, 2002.

Morris, Richard, editor. *Cursor Mundi.* London: 1875.

Moughrabi, Fouad M. "The Arab Basic Personality: A Critical Survey of the Literature." *International Journal of Middle Eastern Studies* 9 (1978): 99–112.

Mufti, Aamir R. "Critical Secularism: A Reintroduction for Perilous Times." *Boundary 2* 31, no. 2 (2004): 1–9.

Muir, John. *The Life of Mahomet.* London: Smith, Elder, 1861.

Munro, Dana Carleton. "The Western Attitude Toward Islam during the Period of the Crusades." *Speculum: A Journal of Mediaeval Studies* 6, no. 3 (1931): 329–343.

Murray, G. N. "Zack Snyder, Frank Miller and Herodotus: Three Takes on the 300 Spartans." *Akroterion* 52 (2007): 11–35.

Murray, Gabrielle. "Post 9/11 and Screen Violence." In *Understanding Violence: Contexts and Portrayals*, edited by Marika Giggisberg and David Weir, 3–14. Freeland: The Inter-Disciplinary Press, 2009.

Nandris, Grigore. "The Historical Dracula: The Theme of His Legend in the Western and in the Eastern Literatures of Europe." *Comparative Literature Series* 3, no. 4 (1966): 367–396.

Neill, Michael. "Unproper Beds: Race, Adultery, and the Hideous in Othello." *Shakespeare Quarterly* 40, no. 4 (1989): 383–412.

Nerval, Gerard de. *The Women of Cairo: Street Scenes of Life in the Orient (Voyage en Orient), Volume 2.* London: George Routledge & Sons, 1929.

Newcomb, Steven T. *Pagans in the Promised Land: Decoding the Doctrine of Christian Discovery.* Golden: Fulcrum Publishing, 2008.

Newman, Karen. "'And Wash the Ethiop White': Femininity and the Monstrous in Othello." In *Shakespeare Reproduced: The Text in History and Ideology*, edited by Jean E. Howard and Marion F. O'Connor, 143–162. New York: Methuen, 1987.

Nietzsche, Friedrich. *Beyond Good and Evil: Prelude to a Philosophy of the Future*, translated by Walter Kaufman. New York: Vintage, 1989.

Nimmo, H. Arlo. "The Cult of Pele in Traditional Hawai'i." *Bishop Museum Occasional Papers* 30 (June 1990): 41–87.

Nissan, Ephraim. "Ghastly Representations of the Denominational Other in Folklore, II, Thomas Nast's Crocodiles in the American River Ganges (New York, 1871)." *La Ricerca Folklorica* 57, *Visioni in movimento: Pratiche dello sguardo antropologico* (April 2008): 148–154.

Noble, Peter S. "Saracen Heroes in *Adenet le Roi*." In *Romance Epic: Essays on a Medieval Literary Genre*, edited by Hans-Erich Keller, 189–202. Kalamazoo: Medieval Institute Publications, 1987.

Norris, Andrew. "'Us' and 'Them': The Politics of American Self-Assertion after 9/11." In *The Philosophical Challenge of September 11*, edited by Tom Rockmore,

Joseph Margolis, and Armen T. Marsoobian, 19–41. Oxford: Blackwell Publishing, 2005.

Nyberg, Suzanna. "Men in Love: The Fantasizing of Bram Stoker and Edvard Munch," in *The Fantastic Vampire: Studies in the Children of the Night. Selected Essays from the Eighteenth International Conference on the Fantastic in the Arts*, edited by James Craig Holte, 45–58. Westport, CT: Greenwood Press, 2002.

Oertel, Robert. *Early Italian Painting to 1400*. New York: Frederick A. Praeger Publishers, 1968.

Olschki, Leonardo. "Asiatic Exoticism in Italian Art of the Early Renaissance." *The Art Bulletin* 26, no. 2 (June 1944): 95–106.

Orsi, Robert. *Between Heaven and Earth: The Religious Worlds People Make and the Scholars Who Study Them*. Princeton, NJ: Princeton University Press, 2006.

Oueijan, Naji B. *The Progress of an Image: The East in English Literature*. New York: Peter Lang, 1996.

Pagels, Elaine. *The Origin of Satan*. New York: Random House, 1995.

Paglia, Camille. *Sexual Personae: Art and Decadence from Nefertiti to Emily Dickinson*. New York: Vintage, 1991.

Park, Katherine, and Lorraine Daston, "Unnatural Conceptions: The Study of Monsters in Sixteenth-and Seventeenth-Century France and England," *Past and Present* 92 (1981): 20–54.

Park, Katharine. "The Criminal and the Saintly Body: Autopsy and Dissection in Renaissance Italy." *Renaissance Quarterly* 47, no. 1 (Spring 1994): 1–33.

Parry, Elwood. *The Image of the Indian and the Black Man in American Art: 1590–1900*. New York: George Braziller, 1974.

Pasto, James. "Islam's 'Strange Secret Sharer': Orientalism. Judaism, and the Jewish Question." *Comparative Studies in Society and History* 40, no. 3 (1998): 434–474. http://www.jstor.org/stable/179271 [accessed July 9, 2010].

Patai, Raphael. *The Arab Mind*. New York: Heatherleigh Press, 2002.

Patrides, C. A. " 'The Bloody and Cruell Turke' ": The Background of a Renaissance Commonplace." *Studies in the Renaissance* 10 (1963): 125–135.

Paull, Michael. "The Figure of Mahomet in the Towneley Cycle." *Comparative Drama* 6, no. 3 (Fall 1972): 187–204.

Pavlowitch, Stevan K. *Serbia: The History of an Idea*. New York: New York University Press, 2002.

Perryman, Judith, editor. *The King of Tars*. Heidelberg: Carl Winter, 1980.

Person, Leland S., Jr. "The American Eve: Miscegenation and a Feminist Frontier Fiction." *American Quarterly* 37, no. 5 (Winter 1985): 668–685.

Philby, H. J. B. *The Empty Quarter: Being a Description of the Great South Desert of Arabia Known As Rub' al Khali*. New York: Henry Holt, 1933.

Pickering, F. P., editor. *The Anglo-Norman Text of the Holkham Bible Picture Book*. Cambridge: Oxford University Press, 1971.

Poole, W. Scott. "Confederates and Vampires: Manly Wade Wellman and the Gothic Sublime." *Studies in Popular Culture* 26, no. 3 (2004): 90–98.

————. *Monsters in America: Our Historical Obsession with the Hideous and Haunting*. Waco, TX: Baylor University Press, 2011.

Powell, Anna. *Deleuze and Horror Film*. Edinburgh: Edinburgh University Press, 2005.

Prescott, Anne Lake. "Rabelaisian (Non) Winders and Renaissance Polemics." In *Wonders, Marvels, and Monsters in Early Modern Culture*, edited by Peter G. Platt, 133–144. Newark: University of Delaware Press, 1999.

Progler, J. A. "The Utility of Islamic Imagery in the West." *Al-Tawhid* 14 (Winter 1997), no. 4. http://www.al-islam.org/al-tawhid/default.asp?url=islamicimageryinwest.htm (accessed December 12, 2009).

Projansky, Sarah. "The Elusive/Ubiquitous Representation of Rape: A Historical Survey of Rape in U.S. Film." *Cinema Journal* 41, no. 1 (Autumn 2001): 63–90.

Punter, David. *The Literature of Terror: A History of Gothic Fictions from 1765 to the Present Day*. London: Longman Group, 1980.

Raedts, Peter. "Remembering and Forgetting: Images of the Classical and Medieval Past in the Era of Revolution and Restoration." In *The Revival of Medieval Illumination*, edited by Thomas Coomans and Jan de Maeyer, 23–35. Leuven: Leuven University Press, 2007.

Raftery, Mary Margaret. "(Type)Casting the Other: Representation of Jews and Devils in Two Plays of the Assumption." *European Medieval Drama: Papers from the International Conference on European Medieval Drama* 9 (2005): 35–60.

Ramadan, Tariq. *Western Muslims and the Future of Islam*. New York: Oxford University Press, 2004.

Ramey, Lynn Tarte. *Christian, Saracen and Genre in Medieval French Literature*. New York: Routledge, 2001.

Rawson, Claude. "'I Could Eat You Up': The Life and Adventures of a Metaphor." *Yale Review* 97, no. 1 (2009): 82–112.

Razack, Sherene H. "How Is White Supremacy Embodies? Sexualized Racial Violence at Abu Ghraib." *Canadian Journal of Women and Law* 17 (2005): 341–363.

Reeves, Minou. *Muhammad in Europe: A Thousand Years of Western Myth-Making*. New York: New York University Press, 2003.

Regnier, Claude. *Aliscans*. Paris: Honore Champion, 1990. Originally published in 1926.

Rice, Alan. "'Who's Eating Whom': The Discourse of Cannibalism in the Literature of the Black Atlantic from Equiano's *Travels* to Toni Morrison's *Beloved*." *Research in African Literatures* 29, no. 4 (Winter 1998): 106–121.

Rice, Raymond J. "Cannibalism and the Act of Revenge in Tudor-Stuart Drama." *Studies in English Literature, 1500–1900* 44, no. 2 (2004): 297–316.

Richardson, Alan, editor. *Three Oriental Tales*. New York: Houghton Mifflin, 2002.

Riess, Jonathon B. *The Renaissance Antichrist: Luca Signorella's Orvieto Frescoes*. Princeton, NJ: Princeton University Press, 1995.

Riquelme, John Paul. "Toward a History of Gothic and Modernism: Dark Modernity from Bram Stoker to Samuel Beckett." *Modern Fiction Studies* 46, no. 3 (Fall 2000): 585–605.

Roberts, Eric, and Eric Robertson. "The Giaour's Sabre: A Reading of Beckford's *Vathek*." *Studies in Romanticism* 35, no. 2 (Summer 1996): 199–211.

Robinson, Benedict S. *Islam and Early Modern English Literature: The Politics of Romance from Spenser to Milton.* New York: Palgrave Macmillan, 2007.

Robinson, Fred C. "Medieval, the Middle Ages." *Speculum* 59, no. 4 (October 1984): 745–756.

Robinson, J. W. "The Late Medieval Cult of Jesus and the Mystery Plays." *PMLA* 80, no. 5 (December 1965): 508–514.

Robinson, Juneko J. "Immanent Attack: An Existential Take on *The Invasion of the Body Snatchers* Films." In *Fear, Cultural Anxiety, and Transformation: Horror, Science Fiction, and Fantasy Films Remade*, edited by Scott A. Lukas and John Marmysz, 23–44. Lanham, MD: Lexington Books, 2009.

Rohde, David. *Endgame: The Betrayal and Fall of Srebrenica, Europe's Worst Massacre since World War Two.* Boulder, CO: Westview Press, 1997.

Rosenblatt, Naomi. "Orientalism in American Popular Culture." *Penn History Review* 16, no. 2 (Spring 2009): 51–63.

Rossky, William. "Imagination in the English Renaissance: Psychology and Poetic." *Studies in the Renaissance* 5 (1958): 49–73.

Roth, Norman. *Jews, Visigoths and Muslims in Medieval Spain.* Leiden: E. J. Brill, 1994.

Rubin, Miri. *Gentile Tales: The Narrative Assault on Late Medieval Jews.* Philadelphia: University of Pennsylvania Press, 1999.

Rustomji, Nerina. "American Visions of the Houri." *The Muslim World* 97, no. 1 (January 2007): 79–92.

Saglia, Diego. "William Beckford's 'Sparks of Orientalism' and the Material-Discursive Orient of British Romanticism." *Textual Practice* 16, no. 1 (2002): 75–92.

Sahas, Daniel. *John of Damascus On Islam: The "Heresy of the Ishmaelites."* Leiden: E. J. Brill, 1972.

Said, Edward. *Orientalism.* New York: Vintage Books, 1978. Reprint, New York: Vintage Books, 1994.

———. "A Devil Theory of Islam." *The Nation*, August 12, 1996.

———. "Islam Through Western Eyes." *The Nation*, April 26, 1980.

St. John, Warren. "Market for Zombies? It's Undead (Aaahhh!)." New York *Times*, March 26, 2006, sec. 9: 1.

Salamé, Ghassan. "Islam and the West." *Foreign Policy* 90 (Spring 1993): 22–37.

Sale, Kirkpatrick. *The Conquest of Paradise: Christopher Columbus and the Columbian Legacy.* New York: Alfred A. Knopf, 1990.

Salem, Elie. "The Elizabethan Image of Islam." *Studia Islamica*, no. 22 (1965): 43–54.

Saler, Benson, and Charles A. Ziegler. "Dracula and Carmilla: Monsters and the Mind." *Philosophy and Literature* 29, no. 1 (2005): 218–227.

Sanders, Edith R. "The Hamitic Hypothesis: Its Origin and Functions in Time Perspective." *The Journal of African History* 10, no. 4 (1969): 521–532.

Saniotis, Arthur. "Embodying Ambivalence: Muslim Australians as 'Other.'" *Journal of Australian Studies* 28, no. 82 (2004): 49–59.

Santich, Barbara. "The Evolution of Culinary Techniques in the Medieval Era." In *Food in the Middle Ages: A Book of Essays,* edited by Melitta Weiss Adamson, 61–82. New York: Garland Publishing, 1995.

Sardar, Ziauddin. "The Holiday Snaps. Abu Ghraib Wasn't the Fault Just of US Politicians and Soldiers. Torture, Glamourised by Hollywood, Is Now Intrinsic to American Life." [Book Review] *New Statesman,* March 7, 2005.

Schildgen, Brenda Deen. *Pagans, Tartars, Moslems, and Jews in Chaucer's Canterbury Tales.* Gainesville: University Press of Florida, 2001.

Schmitt, Cannon. *Alien Nation: Nineteenth-Century Gothic Fictions and English Nationality.* Philadelphia: University of Pennsylvania Press, 1997.

Schneider, Steven. "Monsters as (Uncanny) Metaphors: Freud, Lakoff, and the Representation of Monstrosity in Cinematic Horror." *Other Voices* 1, no. 3 (1999). [ejournal].

Schutte, Anne Jacobson. 'Such Monstrous Births': A Neglected Aspect of the Antinomian Controversy." *Renaissance Quarterly* 38, no. 1 (1985): 85–106.

Schwoebel, Robert. *The Shadow of the Crescent: The Renaissance Image of the Turk (1453–1517).* New York: St. Martin's Press, 1967.

Seabrook, William B. *Adventures in Arabia: Among the Bedouins, Druses, Whirling Dervishes and Yezidee Devil Worshippers.* New York: Paragon House, 1991.

Sekhon, Nirej. "Beefeaters." *Transition* 94, no. 4 (2003): 56–66.

Sells, Michael. *The Bridge Betrayed: Religion and Genocide in Bosnia.* Berkeley: University of California Press, 1996.

———. "Kosovo Mythology and the Bosnian Genocide." In *In God's Name: Genocide and Religion in the Twentieth Century,* edited by Omer Bartov and Phyllis Mack 180–206. New York: Berghahn Books, 2001.

Senf, Carol. *Science and Social Science in Bram Stoker's Fiction.* Westport, CT: Greenwood Press, 2002.

———. *Bram Stoker.* Cardiff: University of Wales Press, 2010.

Shafer, Jack. "The 9/11 Anniversary Racket: Blind Your Eyes and Plug Your Ears!" *Slate,* September 9, 2009. www.slate.com/id/2227796/ [accessed February 7, 2011].

Shaheen, Jack G. "Hollywood's Muslim Arabs." *The Muslim World* 90, no. 1–2 (Spring 2000): 22–42.

———. *Reel Bad Arabs: How Hollywood Vilifies A People.* Northampton: Interlink Publishing Group, 2001.

Shahid, Irfan. *Rome and the Arabs: A Prolegomenon to the Study of Byzantium and the Arabs.* Washington: Dumbarton Oaks, 1984.

———. *Byzantium and the Semitic Orient Before the Rise of Islam.* London: Valorium Reprints, 1988.

Sharafuddin, Mohammed. *Islam and Romantic Orientalism: Literary Encounters with the Orient.* New York: I. B. Tauris, 1994.

Sheehan, Bernard. *Savagism and Civility: Indians and Englishmen in Colonial Virginia.* Cambridge: Cambridge University Press, 1980.

Shelley, Mary. *Frankenstein or The Modern Prometheus: The 1818 Text.* New York: Oxford University Press, 2009.

Shelley, Percy Bysshe. *Hellas: A Lyrical Drama. A reprint of the original edition published in 1822, with the author's prologue and notes by various hands.* Edited by Thomas J. Wise. New York: Phaeton Press, 1970.

Shohat, Ella. "Gender in Hollywood's Orient." *Middle East Report*, no. 162 (Jan/Feb 1990): 40–2.

Shohat, Ella, and Robert Stam. *Unthinking Eurocentrism: Multiculturalism and the Media.* New York: Routledge, 1994.

Skelton, R. A. *Explorer's Maps.* West Sussex: Littlehampton Book Services, 1970.

Smith, Andrew. *Victorian Demons: Medicine, Masculinity, and the Gothic at the "Fin-de-siecle."* Manchester: Manchester University Press, 2004.

Smith, Anthony D. "The Problem of National Identity: Ancient, Medieval and Modern?" *Ethnic and Racial Studies* 17, vol. 3 (July 2004): 375–399.

Smith, Henry. "Luther and Islam." *The American Journal of Semitic Languages and Literatures* 39, no. 3 (April 1923): 218–220.

Smith, Jane. "French Christian Narratives Concerning Muhammad and the Religion of Islam from the Fifteenth to the Eighteenth Centuries." *Islam and Christian-Muslim Relations* 7, no. 1 (1996): 47–61.

Smith, Jay M. *Monsters of the Gévaudan: The Making of a Beast.* Cambridge, MA: Harvard University Press, 2011.

Sontag, Susan. "Regarding the Torture of Others." New York *Times Magazine*, May 23, 2004, 24–42.

Spanos, William V. *The Legacy of Edward W. Said.* Chicago: University of Illinois Press, 2009.

Spigel, Lynn. "Entertainment Wars: Television Culture after 9/11." In *The Selling of 9/11: How a National Tragedy Became a Commodity*, edited by Dana Heller, 119–154. New York: Palgrave Macmillan, 2005.

Spivak, Gayatri Chakravorty. "Three Women's Texts and a Critique of Imperialism." *Critical Inquiry* 12, no. 1 (Autumn 1985): 243–261.

Spurr, David. *The Rhetoric of Empire: Colonial Discourse in Journalism, Travel Writing, and Imperial Administration.* Durham, NC: Duke University Press, 1993.

Srivastava, Aruna. " 'The Empire Writes Back': Language and History in 'Shame' and 'Midnight's Children.' " *Ariel* 20 (1989): 62–77.

Stacey, Robert C. "From Ritual Crucifixion to Host Desecration: Jews and the Body of Christ." *Jewish History* 12, no. 1 (Spring 1998): 11–28. http://www.jstor.org/stable/20101321 [accessed March 22, 2011].

Stam, Robert, and Ella Shohat. *Race in Translation: Culture Wars Around the Postcolonial Atlantic.* New York: New York University Press, 2012.

Stephens, John Lloyd. *Incidents of Travel in Egypt, Arabia Petraea, and the Holy Land.* Norman: University of Oklahoma Press, 1970.

Stoker, Bram. *Dracula.* New York: Bantam Classic, 2004.

Stow, Kenneth. *Jewish Dogs: An Image and Its Interpreters: Continuity in the Catholic-Jewish Encounter.* Stanford, CA: Stanford University Press, 2006.

Strabac, Zan, and Ola Listhaung. "Anti-Muslim Prejudice in Europe: A Multilevel Analysis of Survey Data from 30 Countries." *Social Science Research* 37 (2008): 268–286.

Strauss, David Levi. "Breakdown in the Gray Room: Recent Turns in the Image War," in *Abu Ghraib: The Politics of Torture,* 87–101. Berkeley: The Terra Nova Series, 2004.

Strickland, Debra Higgs. *Saracens, Demons, and Jews: Making Monsters in Medieval Art.* Princeton, NJ: Princeton University Press, 2003.

Sullivan, Zohreh T. "Race, Gender and Imperial Ideology in the Nineteenth Century." *Nineteenth-Century Contexts* 13 (1989): 19–32.

Sweeney, Gael. "The Trashing of White Trash: Natural Born Killers and the Appropriation of the White Trash Aesthetic." *Quarterly Review of Film and Video* 18, no. 2: 143–155.

Taxi to the Dark Side. DVD. Directed by Alex Gibney Los Angeles, CA: THINKFilm, 2007.

Taylor, Charles. *A Secular Age.* Cambridge, MA: Harvard University Press, 2007.

The English Patient. Directed by Anthony Minghella. New York: Miramax Films, 1996.

The Harryhausen Chronicles. DVD. Directed by Richard Schickel. Burbank, CA: Rhino Theatrical (Warner Brothers), 2002.

Thompson, C. J. S. *The Mystery and Lore of Monsters.* London: Williams and Norgate, 1930.

Thompson, Kirsten Moana. *Apocalyptic Dead: American Film at the Turn of the Millennium.* Albany: State University of New York Press, 2007.

Thorp, Willard. "The Stage Adventures of Some Gothic Novels." *PMLA* 43, no. 2 (June 1928): 476–486.

Tinker, Tink, and Mark Freeland. "Thief, Slave Trader, Murderer: Christopher Columbus and Caribbean Population Decline." *Wicazo Sa Review* 23, no. 1 (Spring 2008): 25–50.

Tolan, John Victor, editor. *Medieval Christian Perceptions of Islam.* New York: Routledge, 1996.

———. "Mirror of Chivalry: Salah Al-Din in the Medieval European Imagination." In *Images of the Other: Europe and the Muslim World Before 1700,* edited by David Blanks, 7–38. Cairo: The American University of Cairo Press, 1997.

———. *Saracens: Islam in the Medieval European Imagination.* New York: Columbia University Press, 2002.

Tomaiuolo, Saverio. "Reading Between the (Blood)lines of Victorian Vampires: Mary Elizabeth Braddon's 'Good Lady Ducayne.'" In *From Wollstonecraft to*

Stoker: Essays on Gothic and Victorian Sensation Fiction, edited by Marilyn Brock, 102–119. Jefferson, NC: McFarland, 2009.

Toorawa, Shawkat M. "Muhammad, Muslims, and Islamophiles in Dante's *Commedia*." *Muslim World* 82, no. 1–2 (Jan.–Feb. 1992): 133–143.

Tracy, Robert. "Loving You All the Ways: Vamps, Vampires, Necrophiles and Necrophilles in Nineteenth-Century Fiction." In *Sex and Death in Victorian Literature*, edited by Regina Barecca, 32–59. Bloomington: Indiana University Press, 1990.

Traube, Elizabeth G. "'The Popular' in American Culture." *Annual Review of Anthropology* 25 (1996): 127–151.

Travers, Peter. "300." *Rolling Stone*, March 9, 2001.

Tropp, Martin. *Images of Fear: How Horror Stories Helped Shape Modern Culture (1818-1918)*. Jefferson, NC: McFarland, 1990.

Turhan, Filiz. *The Other Empire: British Romantic Writings about the Ottoman Empire*. New York: Routledge, 2003.

Turner, Bryan S. "A Note on Rodinson's *Mohammed*." *Religion* 3, no. 1 (1973): 79–82.

———. *Religion and Social Theory*. London: SAGE Publications, 1983.

Twitchell, Kyle James. *Dreadful Pleasures: An Anatomy of Modern Horror*. New York: Oxford University Press, 1985.

Twohy, Margaret. "From Voodoo to Viruses: The Evolution of the Zombie in Twentieth Century Popular Culture." Master's thesis, Trinity College Dublin, 2008.

Uebel, Michael. "Unthinking the Monster: Twelfth-Century Responses to Saracen Alterity." In *Monster Theory: Reading Culture*, edited by Jeffrey Jerome Cohen, 264–291. Minneapolis: University of Minnesota Press, 1996.

Van Duzer, Chet. "A Northern Refuge of the Monstrous Races: Asia on Waldeesmüller's 1516 *Carta Marina*." *Imago Mundi* 62, no. 2 (2010): 221–231.

Vasey, Ruth. "Foreign Parts: Hollywood's Global Distribution and the Representation of Ethnicity." *American Quarterly* 44, no. 4 [Special Issue: Hollywood, Censorship, and American Culture] (December 1992): 617–642.

Verner, Lisa. *The Epistemology of the Monstrous in the Middle Ages*. New York: Routledge, 2005.

Vinci, Tony M. "The Fall of the Rebellion; or, Defiant and Obedient Heroes in a Galaxy Far, Far Away: Individualism and Intertextuality in the *Star Wars* Trilogies." In *Culture, Identities and Technology in the Star Wars Films*, edited by Carl Silvio and Tony M. Vinci, 11–33. Jefferson, NC: McFarland, 2007.

Vitkus, Daniel J., editor. *Three Turk Plays from Early Modern England: Selimus, A Christian Turned Turk, and The Renegado*. New York: Columbia University Press, 2000.

———. *Turning Turk: English Theater and the Multicultural Mediterranean, 1570–1630*. New York: Palgrave Macmillan, 2003.

Voltaire. *Philosophical Dictionary*. New York: Penguin Books, 1972.

Warner, Brooke. "Abu Ghraib and a New Generation of Soldiers." In *Abu Ghraib: The Politics of Torture*, 71–86. Berkeley: The Terra Nova Series, 2004.

Warren, Louis S. "Buffalo Bill Meets Dracula: William F. Cody, Bram Stoker, and the Frontiers of Racial Decay." *The American Historical Review* 107, no. 4 (October 2002): 1124–1157.

Wasson, Richard. "The Politics of Dracula." *English Literature in Transition, 1880–1920* 9, no. 1 (1966): 24–27.

Weaver-Hightower, Rebecca. *Empire Islands: Castaways, Cannibals, and Fantasies of Conquest*. Minneapolis: University of Minnesota Press, 2007.

Webb, Diana. *Medieval European Pilgrimage: c. 700–c. 1500*. New York: Palgrave, 2002.

Weckmann, Luis. "The Middle Ages in the Conquest of America." *Speculum* 26, no. 1 (January 1951): 13–141.

Wedgwood, Ruth. "Gallant Delusions." *Foreign Policy* 132, no. 132 (2002): 44–46.

Weston, Lisa. "The Saracen and the Martyr: Embracing the Foreign in Hrotsvit's Pelagius." In *Meeting the Foreign in the Middle Ages*, edited by Albrecht Classen, 1–10. New York: Routledge, 2002.

Wheatcroft, Andrew. *Infidels: A History of the Conflict Between Christendom and Islam*. Westminster, MD: Random House, 2005.

White, David Gordon. *Myths of the Dog-Man*. Chicago: University of Chicago Press, 1991.

Wilcox, Rebecca. "Romancing the East: Greeks and Saracens in *Guy of Warwick*." In *Pulp Fictions of Medieval England*, edited by Nicola McDonald, 217–240. Manchester: Manchester University Press, 2004.

Willoughby, John W. "Childe Roland to the Dark Tower Came." *Victorian Poetry* 1, no. 4 (1963): 291–299. http://www.jstor.org/stable/40001219 [accessed June 30, 2010].

Wilson, Philip K. "Eighteenth-Century 'Monsters' and Nineteenth-Century 'Freaks': Reading the Maternally Marked Child." *Literature and Medicine* 21, no. 1 (Spring 2002): 1–25.

Wilson, Veronica A. "Seduced by the Dark Side of the Force: Gender, Sexuality, and Moral Agency in George Lucas's Star Wars Universe." In *Culture, Identities and Technology in the Star Wars Films*, edited by Carl Silvio and Tony M. Vinci, 134–152. Jefferson, NC: McFarland, 2007.

Winsser, Johan. "Mary Dyer and the 'Monster' Story," *Quaker History* 79, no. 1 (1990): 20–34.

Wittkower, Rudolf. "Marvels of the East. A Study in the History of Monsters." *Journal of the Warburg and Courtauld Institutes* 5 (1942): 159–197. http://www.jstor.org/sici?sici=0075-4390%281942%295%3C159%3AMOTEAS%3E2.0.CO%3B2-Z [accessed January 20, 2011].

Wohl, Anthony S. "Ben JuJu: Representations of Disraeli's Jewishness in the Victorian Political Cartoons." *Jewish History* 10, no. 2 (Fall 1996): 89–134. http://www.jstor.org/stable/ 20101269 [accessed July 2, 201].

Wolf, Kenneth Baxter. *Christian Martyrs in Muslim Spain: Cambridge Iberian and Latin American Studies*. Cambridge: Cambridge University Press, 1988.

———, editor. *Conquerors and Chroniclers of Early Medieval Spain*. Liverpool: Liverpool University Press, 1990.

———. "Muhammad As Antichrist in Ninth-Century Cordoba." In *Christians, Muslims, and Jews in Medieval and Early Modern Spain*, edited by Mark D. Meyerson and Edward D. English, 3–19. Notre Dame, IN: University of Notre Dame Press, 2000.

Wood, Robin. *Hollywood from Vietnam to Reagan*. New York: Columbia University Press, 1986.

Wright, Ronald. *Stolen Continents: 500 Years of Conquest and Resistance in the Americas*. New York: Mariner Books, 2005.

Wright, Rosemary Muir. *Art and Antichrist in Medieval Europe*. Manchester: Manchester University Press, 1995.

Young, Lola. *Fear of the Dark: 'Race,' Gender and Sexuality in the Cinema*. New York: Routledge, 1996.

Young, Robert. *Colonial Desire: Hybridity in Theory, Culture and Race*. New York: Routledge, 1995.

Zimmerman, Warren. *Origins of a Catastrophe: Yugoslavia and Its Destroyers— America's Last Ambassador Tells What Happened and Why*. New York: Times Books, 1996.

Zizek, Slavoj. "Welcome to the Desert of the Real," September 15, 2001. *Reconstructions: Reflections on Humanity and Media after Tragedy*. http://web.mit.edu/cms/reconstructions/interpretations/desertreal.html [accessed 2/6/11].

———. "Welcome to the Desert of the Real: Reflections on WTC (Third Version)," October 7, 2001. http://lacan.com/relections.htm [accessed 2/6/11].

———. *Welcome to the Desert of the Real*. New York: Verso, 2002.

———. *The Puppet and the Dwarf: The Perverse Core of Christianity*. Boston: MIT Press, 2003.

———. *Violence: Six Sideways Reflections*. New York: Picador, 2008.

Zombiemania. Netflix. Directed by Donna Davies. Toronto, Canada: SPACE Channel, January 3, 2008. Zoom, Doktor. "Tatooine Not Constantinople: Austrian Turks Go To 'Red Alert' Over Star Wars Lego Set." *Wonkette*, January 26, 2013. http://wonkette.com/498528/austrian-turks-go-to-red-alert-over-star-wars-lego-set.

Index